D0146739

The Early Years of Art History
in the United States

Edited by CRAIG HUGH SMYTH and PETER M. LUKEHART

THE EARLY YEARS OF ART HISTORY

IN THE UNITED STATES

The Early Years of Art History in the United States

in the United States

NOTES AND ESSAYS ON DEPARTMENTS,
TEACHING, AND SCHOLARS

EDITED BY

Craig Hugh Smyth

AND

Peter M. Lukehart

DEPARTMENT OF ART AND ARCHAEOLOGY

PRINCETON UNIVERSITY

RANDALL LIBRARY UNCW

Copyright © 1993 by the Trustees of Princeton University
Published by the Department of Art and Archaeology,
Princeton University, Princeton, New Jersey 08544-1018

ALL RIGHTS RESERVED

Library of Congress Cataloging-in-Publication Data

The early years of art history in the United States : notes and
essays on departments, teaching, and scholars / edited by
Craig Hugh Smyth and Peter M. Lukehart
p. cm
Includes bibliographical references and index.
ISBN 0-691-03645-4
1. Art—Historiography. 2. Art—Study and teaching
(Higher). 3. Art schools—United States—History.
I. Smyth, Craig Hugh. II. Lukehart, Peter M., 1955- .
N385.E27 1993
707′.2—dc20 93-23894

This book is printed on acid-free paper,
and meets the guidelines for permanence and
durability of the Committee on Production Guidelines
for Book Longevity of the Council on Library Resources.
Printed in the United States of America
by Princeton University Press
Princeton, New Jersey 08540

10 9 8 7 6 5 4 3 2 1

N
385
.E27
1993

Contents

Acknowledgements

THE EDITORS want to cite here those who have taken part at various stages in the developments which led to this volume, and to express thanks to all: to Irving Lavin for having suggested the subject of the plenary session for the 1987 meeting of the College Art Association of America in Boston and his efforts to see the papers of the session published; to Jeffrey Muller, chair of that meeting, for his encouraging watchfulness and suggestions as the session was planned; to Elizabeth Sears, who first had the idea that the papers of that session might be published by Princeton's Department of Art and Archaeology—with, if possible, additional contributions to fill out its brief account of art history in this country; to William A. P. Childs, then chair of the Princeton department, who willingly engaged the department to take on publication, and to Slobodan Ćurčić and Yoshiaki Shimizu, subsequent chairs, for their kind interest and reaffirmation of this engagement; to Claire Sherman for suggesting inclusion of papers from the session that Donald Preziosi organized for the meeting of the College Art Association at San Francisco in 1989; to Donald Preziosi for his readiness to fall in with her suggestion; and to Henry Millon, not only for his parallel cooperation in connection with the session of the College Art Association that he chaired at Houston in 1988, but for making available to us the facilities of CASVA (Center for Advanced Study in the Visual Arts) at the National Gallery of Art, including its computer, an indispensable aid. With a warm sense of gratitude we think of the help given by Prudence Steiner at Cambridge, when the Boston session was in preparation, and by three members of CASVA's staff—Cecelia Gallagher, Curtis Millay, and Helen Tangires—who supplied many needs for our efforts.

For designing, copy-editing, and acting as managing editor of this book, Christopher Moss, Editor of Publications for Princeton University's Department of Art and Archaeology, has our sincerest thanks and admiration. He, and we, have had help with obtaining photographs from a number of people: we think especially of Elizabeth Gombosi, Michael Nedzwecki, and also Eve Borsook for Harvard; and Joan Liebovitz, for N.Y.U.

It was, however, Jane Timken who made publication of the illustrations in this volume possible. Having her doctorate from N.Y.U.'s Institute of Fine Arts and her own publishing firm for art and art history, she saw the illustrations as a historic necessity and supported the cost. We record profound gratitude to her on behalf of all concerned with our past.

THE EDITORS

Preface

IN EACH of the years 1987, 1988, and 1989, the College Art Association of America devoted a session of its annual meetings to the self-analytical and reflective task of examining the early history of some departments of the history of art in the United States and the achievements of a few of the individuals who pioneered our study and teaching of art history. This volume contains papers from those three sessions and is symptomatic of a concern of art historians in recent years to know more about the history of their subject. When the first session was held, the purpose was to recall something of art history's early development in the United States while there were still people close enough to it to help in the endeavor. The sessions of the second and third years represent efforts to go on from the first session and probe the early years a good bit further.

The papers in this volume do not seek, nor were they intended, to represent an exhaustive study. The three sessions were planned independently. Only after they took place did we realize that the papers from all three might be published together. We had begun simply by responding to requests to make papers from the first session available alone. As it turns out, the contributions together represent diverse ideological and methodological approaches to the historiography of art. Generally the authors were responding to the specific requirements of the session chairs, but they interpreted the prescriptions of their chairs in different ways. Thus, no claim can be made for this collection as a definitive, much less unified, history of the discipline. It does provide, however, a considerable amount of information and a good deal to think about. We have not imposed an arbitrary homogeneity on the contents or presentation of the papers. We have tried only to bring a modicum of consistency to their mechanical details.

The papers are arranged in the chronological order of the sessions, beginning with the plenary session of the meeting at Boston in 1987. This session, suggested by Irving Lavin and chaired by Craig Smyth, was entitled "Glimpses of Some Early Departments of the History of Art in the United States." Since the plenary session was scheduled after cocktails and dinner, its papers were to be short and informal, and numerous enough to give something of an overview. Included are first-hand experiences and some informed reminiscences of early departments of art history at the then segregated Ivy League universities and women's colleges, Vassar, Harvard, Princeton, Yale, and Smith, as well as those at Columbia and New York University—to list them in roughly the order of their beginnings, as they now emerge in these papers. The authors either attended these schools or have had long-standing associa-

tions with their departments of art history, and several have made their own investigations of the history of departments in which they themselves have worked. The papers help shed light on the nature of early departments of art history in the United States, their founders, their faculties, and their philosophies. (Added here are two brief contributions about the Harvard department not heard at the session of 1987: by John Coolidge, who was to have spoken but was abroad, and Otto Wittmann, one of the students of Harvard who went out to museum careers across the land.)

Henry Millon chaired the second session, on "Three Decades of Art History in the United States (1910–1940): Five Figures," at the meeting of the College Art Association in Houston in 1988. The participants focused on a few luminaries in art history, touching on their training, scholarly contributions, and personalities, as well as on their pedagogical, methodological, and, in the case of Arthur Kingsley Porter, even mythological legacies. Berenson, Porter, Morey, Kimball, and Offner—these are among the names that brought art history as practiced by Americans to international recognition. In the future there are sure to be contributions concerning other early figures that will illuminate our past.

Donald Preziosi proposed to the speakers in his session at the College Art Association meeting in San Francisco in 1989 the topic "Institutionalizing Art History: The Early Discipline in the United States." He managed to get valuable accounts of Wellesley and Bryn Mawr, which were missing in the other sessions, and an evocation of the beginnings of instruction in art history at Yale University, Syracuse University, and, surprisingly, Rockford Female Seminary, which was nearer to those beginnings than most readers will ever have supposed: art history developed in our provinces, too. The essays in Preziosi's session bring out differences between men's and women's institutions and the professional roles of the men and women involved. It includes also a welcome analysis of the beginnings of the Department of Fine Arts at Harvard, combining thoughtful textual criticism with history. Still one more paper on Princeton stresses especially the architecture that was created to serve the new discipline.

These backward looks coincide with a time of questioning art history's purposes and methods, and the emergence of new developments in its theory and practice, including a new critical art history supported by innovations in style and vocabulary. The contributors to this volume focus on the past. As the new developments become more widespread, the papers here will be viewed in various lights. The information they contain and the atmosphere of the past they have managed to capture will be relevant, we hope, to future perspectives.

PETER M. LUKEHART CRAIG HUGH SMYTH
Dickinson College Harvard University, Emeritus

 17 May 1990

Notes on the Contributors

PAMELA ASKEW, Professor Emeritus of Art, Vassar College, studied at New York University's Institute of Fine Arts and the Courtauld Institute in London. In 1988 she received the College Art Association's Great Teacher Award. Among her publications are fundamental works on Domenico Fetti, and *Caravaggio's Death of the Virgin* (1990). She is currently writing a comprehensive history of the Vassar College art department and gallery which will examine their role in the formation of the discipline of art history, and their response to changing social, artistic, and educational movements and ideologies.

LAUREN WEISS BRICKER holds a Ph.D. in art history from the University of California, Santa Barbara, where she was assistant curator of the architectural drawings collection. She has also been architectural historian at the Foundation for San Francisco's Architectural Heritage, and currently has a consulting practice in architectural history in San Francisco. She is the co-author of *A Catalogue of Architectural Drawings, University Art Museum, University of California at Santa Barbara* (1983), and *The Architecture of Gregory Ain: The Play Between the Rational and High Art* (1980). Her research has focused on the contributions of Fiske Kimball and Talbot F. Hamlin to the study of American architecture.

JOHN COOLIDGE graduated from Harvard in 1935 and went on to earn his Ph.D. at New York University's Institute of Fine Arts. He taught architectural history at Harvard from 1947–1985, and was director of the Fogg Museum from 1948–1968. In addition to publications on Vignola, nineteenth- and twentieth- century architecture, and the architecture of art museums (*Patrons and Architects: Designing Museums in the Twentieth Century* [1989]), he has written an innovative urban study of Lowell, Massachusetts (*Mill and Mansion. A Study of Architecture and Society in Lowell, Massachusetts* [1942]), as well as seminal articles on the little domes of St. Peter's and on the Villa Giulia.

JULIUS S. HELD, Professor Emeritus of Barnard College, was educated at the Universities of Heidelberg, Freiburg, Berlin, and Vienna. Following an apprenticeship under Max Friedlaender at the Staatliche Museen, Berlin, he lectured at New York University for several years, and in 1937 began teaching at Barnard and Columbia. His articles, mostly in the area of Northern European art, have appeared in many periodicals; his most recent books include *Rubens and his Circle* (1982), *Rubens, Selected Drawings* (second, enlarged edition, 1986), and *Rembrandt Studies* (second, enlarged edition, 1991).

SYBIL GORDON KANTOR, a native New Yorker, currently lives in Columbus, Ohio and Lugano, Switzerland. She is completing a doctoral dissertation, "Alfred H. Barr, Jr., and the Culture of Modern-

ism in America," for the City University of New York. Her contribution to this volume is adapted from her dissertation, which will appear as a book.

GEORGE KUBLER is Emeritus Professor of Fine Arts at Yale University, where he was both undergraduate and graduate student. In addition to the influential book *The Shape of Time: Remarks on the History of Things* (1962), he is the author of a number of fundamental works on the art and architecture of Latin America, Spain, and Portugal, including *Building the Escorial* (1981), and the Pelican volume *The Art and Architecture of Ancient America* (third edition, 1982). A collection of his essays, *Studies in Ancient American and European Art*, was published in 1985. His most recent book is *Esthetic Recognition of Ancient Amerindian Art* (1991), and he is currently at work on a volume which will discuss the relationship of art history to evolutionary theory.

MARILYN ARONBERG LAVIN, author of *The Eye of the Tiger: The Founding and Development of the Department of Art and Archaeology, 1883–1923, Princeton University* (1983), has been Visiting Lecturer with the Rank of Professor at Princeton since 1976. She did her own graduate work at the Institute of Fine Arts, New York University. Her many publications include *Seventeenth-Century Barberini Documents and Inventories of Art* (1975), which won the College Art Association's Charles Rufus Morey award. Most recently she has published *The Place of Narrative: Mural Decoration in Italian Churches, 431–1300 A.D.* (1990), and a monograph, *Piero della Francesca* (1992). Her current work focuses on an electronic imaging project for use in an experimental seminar on Italian frescoes.

PHYLLIS WILLIAMS LEHMANN is the William R. Kenan, Jr., Professor Emeritus of Art at Smith College, where she was formerly dean. She also serves as advisory director to the excavations in Samothrace sponsored by New York University's Institute of Fine Arts, where she did her graduate work. In addition to several volumes of the Samothrace series, she has written on *Roman Wall Paintings from Boscoreale in the Metropolitan Museum of Art* (1953), and, with Karl Lehmann, *Samothracian Reflections: Aspects of the Revival of the Antique* (1973). She is also well known for her work on antique/Renaissance problems, much of which has been published in the *Art Bulletin*.

PETER M. LUKEHART, currently Director of The Trout Gallery at Dickinson College, was a graduate student at Temple University and The Johns Hopkins University, taking his doctorate at Hopkins in 1988. Following two years at the Center for Advanced Study in the Visual Arts at the National Gallery of Art, he joined the faculty of George Mason University. For the National Gallery he edited and contributed essays to *The Artists' Workshop* (1993). He has also written the entries on seventeenth- and eighteenth-century Genoese painting for the National Gallery's systematic catalogue (forthcoming).

HAYDEN B. J. MAGINNIS, Professor of the History of Art at McMaster University, Hamilton, Ontario, received his Ph.D. from Princeton University in 1975. His principal subject of study is the art of Siena during the thirteenth and fourteenth centuries, and he is the author of numerous articles on early Italian painting. His 1984 article "Pietro Lorenzetti: A Chronology," published in the *Art Bulletin*, was awarded the Arthur Kingsley Porter Prize by the College Art Association. He has also

edited Millard Meiss's *Francesco Traini* (1983) and the final volume of Offner's *A Critical and Historical Corpus of Florentine Painting* (1981).

HENRY MILLON, organizer of the second session, is Dean of the Center for Advanced Study in the Visual Arts, the National Gallery of Art, a position he has held since 1979. Educated at Tulane and Harvard, he has served as Visiting Professor at Massachusetts Institute of Technology since 1980, where he was Professor of History of Architecture and Architectural Design from 1960 to 1980. He was Resident Art Historian at the American Academy in Rome in 1966 and served as director from 1974–1977. He is the author of *Michelangelo Architect* (with Craig H. Smyth, 1988), *Filippo Juvarra: Drawings from the Roman Period, 1704–1714* (1984), *Key Monuments of the History of Architecture* (1964), and *Baroque and Rococo Architecture* (1961).

AGNES MONGAN began at the Fogg Museum as a research assistant in 1928 and finished there as its director. Meanwhile she was the curator of drawings for 38 years and with Paul Sachs wrote the drawing catalogue, widely regarded as a model work (*Drawings in the Fogg Museum of Art* [1940], second edition [1946]). She has taught at Harvard whenever she had time, and has served as visiting professor at other institutions, including the Universities of Texas, California, and Louisville, and as Kress Professor at the National Gallery of Art. Awards continue to come her way: most recently the Harvard Medal on its 350th anniversary and the Benemerenti Medal from Pope John Paul II.

DONALD PREZIOSI, organizer of the third session, is Professor of Art History at the University of California, Los Angeles, and the author of various writings on the historiography of the discipline (*Rethinking Art History: Meditations on a Coy Science* [1989]), as well as works on the history of architecture (*The Origins of the Built World and its Semiotic Organization* [1979], *Minoan Architectural Design: Formation and Signification* [1983]). He is presently completing a volume on museology and the origins of modernism.

MICHAEL RINEHART, Editor-in-Chief of *BHA/Bibliography of the History of Art*, studied with Roberto Longhi in Florence (1956–1957), and with Johannes Wilde and John Shearman at the Courtauld. He is the former librarian of the Biblioteca Berenson at I Tatti. His publications focus on Italian sixteenth-century painting, and include the revised illustrated Phaidon edition of Bernard Berenson's *Italian Pictures of the Renaissance* (1968) and the exhibition catalogue *Fifty Years of Berensoniana (1887–1937)*. In 1973, Michael Rinehart was persuaded by H. W. Janson to accept the editorship of *BHA*, which under his leadership has become the principal international bibliographical tool for the history of art.

LINDA SEIDEL, Professor in Art at the University of Chicago, studied at Barnard and Radcliffe, receiving her Ph.D. from Harvard University. While Professor Seidel's primary scholarly focus has been on medieval sculpture (*Romanesque Sculpture from the Cathedral of Saint-Etienne, Toulouse* [1977]; *Songs of Glory: the Romanesque Facades of Aquitaine* [1981]), she has also written on Frank Lloyd Wright, and her most recent book is *Jan van Eyck's Arnolfini Portrait: Stories of an Icon* (1993). Her current project, a book on Romanesque portal design, though much indebted to Arthur Kingsley Porter, reconsiders his theory of pilgrimage road art and places many of the monuments he made so familiar in a different critical context.

CLAIRE RICHTER SHERMAN is affiliated with the Center for Advanced Study in the Visual Arts, National Gallery of Art, Washington, where she edits the annual directory *Sponsored Research in the History of Art*. She has written extensively on the contributions of women scholars to the development of the discipline of art history, and was editor of the volume *Women as Interpreters of the Visual Arts* (1981). Her most recent publication is "Beyond the Photo Archive: Imaging the History of Psychology," in *Visual Resources* IX/1 (1993). Her forthcoming book (University of California Press) is entitled *Imaging Aristotle: Verbal and Visual Representations in Fourteenth-Century France*.

CRAIG HUGH SMYTH, organizer of the first session as well as contributor, is Professor Emeritus of Fine Arts, Harvard University. He was both undergraduate (1934–1938) and graduate student (1938–1941) at Princeton University. He began his career at the National Gallery of Art. In the U.S. Navy during World War II, at the War's end he was officer-in-charge and director of the Central Art Collecting Point in Munich. After serving on the staff of the Frick Collection, he joined the faculty of the Institute of Fine Arts in 1950, succeeding Walter W. S. Cook as acting director from 1951 to 1953 and as director from 1953 to 1973. From 1973 to 1985 he was director of the Harvard University Center for Italian Renaissance Studies, Villa I Tatti, in Florence. His publications include *Mannerism and Maniera* (1963; rev. ed. 1992), *Bronzino as Draughtsman* (1971), and *The Repatriation of Art from the Collecting Point in Munich after World War II* (1988), as well as collaborative publications with Henry Millon on Michelangelo and St. Peter's.

MARY ANN STANKIEWICZ has been Associate Professor in the Department of Art, California State University at Long Beach, Program Officer at the Getty Center for Education in the Arts, and is currently Assistant Vice President for Academic Affairs at the Ringling School of Art and Design in Sarasota. She is the coeditor, with Donald Soucy, of *Framing the Past: Essays on Art Education* (1990); her articles have appeared in *Woman's Art Journal*, *Studies in Art Education*, *The Journal of Aesthetic Education*, *The Journal of Art and Design Education* (Great Britain), and elsewhere. Her research interests include the history and philosophy of art education, women's issues in the history of art education, and, most recently, interpretation and narrative in art education history.

DAVID VAN ZANTEN is Professor and Chair of the Art History Department at Northwestern University. He did his graduate work at Princeton, and has worked as architect at the Sardis excavations, and edited for publication Donald Drew Egbert's *The Beaux-Arts Tradition in French Architecture* (1980). He is the author of numerous articles and books on art and architectural history, including, most recently, *Designing Paris: The Architecture of Duban, Labrouste, Duc and Vaudoyer* (1987).

EDWARD M. M. WARBURG†, philanthropist and benefactor of the arts, graduated from Harvard in 1930. There he had joined fellow undergraduates Lincoln Kirstein and John Walker in forming the Harvard Society for Contemporary Art, which provided precedent for the aims of the Museum of Modern Art, of which he was an early advisor and trustee, as well as the organizer of its film library. Beginning in 1933, he was, with Kirstein, a founding father of the American Ballet. An admiring nephew of the art historian Aby Warburg, he himself taught modern art at Bryn Mawr for two years just out of college, and was an active collector. In the 1970s he was with the Metropolitan Museum as vice director for public affairs and in 1983 was named an honorary trustee. Sad to say, Warburg died in September, 1992, when this volume was in press.

OTTO WITTMANN, a member of the Harvard class of 1933, succeeded Lincoln Kirstein as head of the Harvard Society for Contemporary Art, and, with Perry Rathbone, mounted the first show of surrealism ever seen in Boston. After serving as curator of prints at the Nelson Gallery in Kansas City, he returned to postgraduate work, studying under Paul Sachs and acting as his assistant. His distinguished museum career includes a long tenure as director of the Toledo Museum of Art and thereafter as trustee and consultant to the J. Paul Getty Trust as well as the Getty Museum. He has received the Distinguished Service Award from the American Association of Museums, the nation's highest museum recognition.

List of Illustrations

THE EARLY YEARS OF ART HISTORY

IN THE UNITED STATES

Part I

GLIMPSES OF SOME EARLY
DEPARTMENTS OF THE HISTORY OF ART
IN THE UNITED STATES

Introduction to Part I

———

CRAIG HUGH SMYTH

OUR TITLE is "Glimpses of Some Early Departments of the History of Art in the United States." "Glimpses" is the word I want to stress. Contributors have accepted the invitation to discuss some of the early departments, each according to his own views and lights. The request to organize and present something on this subject for the plenary session of the 1987 meeting of the College Art Association came to me because, when in Italy, I had been asked to talk about Charles Rufus Morey at an art-historical congress in Rome dedicated to Morey.[1] In view of the questions we ask nowadays about the nature and purposes of art history, that was a thought-provoking assignment, just as this assignment is now.

The history of art has been a recognizable subject for study in colleges and universities of this country for only a little more than 100 years. There were a few intimations earlier: an archaeology course at Princeton in 1831, Samuel F. B. Morse's appointment to teach "principles of the arts of design" at New York University in 1832, the lectures by Colonel John Trumbull at Yale in 1839. But nothing grew from those beginnings. By now, there is a brief bibliography on the history of the history of art in this country. It consists by and large only of statistics and chronology: for example, an article by Robert Goldwater in 1943[2] and the book of the Ritchie committee in 1966.[3] A small book of 1934 by Priscilla Hiss and Roberta Fansler gives something more and is worth reading.[4] Erwin Panofsky wrote an article that offers some characterizations and estimates, including the following words of praise:[5]

> ... after the First World War [art history in the United States] began to challenge the supremacy, not only of German-speaking speaking countries, but of Europe as a whole. This was possible, not in spite, but because of the fact that its founding fathers were not

[1] The suggestion for the session at the College Art Association was Irving Lavin's. This Introduction opened the session.

[2] Robert Goldwater, "Teaching of Art in the Colleges of the United States," *College Art Journal*, II, no. 4, part 2, supplement (May 1943), 1–31.

[3] Andrew Carduff Ritchie, et al., *The Visual Arts in Higher Education*, New York (1966).

[4] Priscilla Hiss and Roberta Fansler, *Research in Fine Arts in the Colleges and Universities of the United States*, New York (1934). See, too, W. Eugene Kleinbauer, *Modern Perspectives in Western Art History, an Anthology of the 20th-Century Writings on the Visual Arts*, New York (1971), introduction; and C. Isler, "*Kunstgeschichte* American Style," in *The Intellectual Migration, Europe and America 1930–1960*, eds. D. Fleming and B. Bailyn, Cambridge (1969), 545ff.

[5] Erwin Panofsky, "The History of Art," in *The Cultural Migration: The European Scholar in America*, ed. W. R. Crawford, Philadelphia (1953), 82–111; republished as "Three Decades of Art History in the United States: Impressions of a Transplanted European," in Panofsky's *Meaning in the Visual Arts. Papers in and on Art History*, Garden City, New York (1955), 321–346.

products of an established tradition but had come from classical philology, theology and philosophy, literature, architecture, or just collecting.[6]

In the American chapter of the book that James Ackerman and Rhys Carpenter wrote twenty-five years ago about the study of art and archaeology, Ackerman stressed its "scientific" aims in this country after World War I, and contrasted it with the earlier gentlemanly and ethically oriented art history, exemplified by Charles Eliot Norton's teaching at Harvard in the 1870s, 1880s and 1890s.[7] For Michael Podro, in his book of a few years ago, *The Critical Historians of Art*, the chief characteristic of American art history altogether is its "scientific," "factual," or, in his terminology, "archaeological" approach. He sees critical art history as almost exclusively European.[8]

A plenary session after an official cocktail hour is not the place to try for comprehensive, systematic history or analysis. Instead we offer glimpses of the past that may pique curiosity. They were glimpses largely from the time *before* art history in the United States felt the effect of the many Europeans who enriched it after settling here in the mid-1930s. The mid-1930s is our approximate termination, and we are able to bring into view only a few departments. We come upon some of the "founding fathers" to whom Panofsky referred, and some founding mothers—but by no means all of either.

There is certainly no single, unified approach. We are fortunate that there are a few among us who can testify from personal experience, from what they themselves observed. It is becoming late to find many such people. Contributing, too, are a few others who, though not eyewitnesses to what they tell about or comment on, were themselves, at a later date, faculty members of the departments they describe, and have worked to recreate the past.

[6] Panofsky (as in note 5 [1955]), 324.

[7] James S. Ackerman and Rhys Carpenter, *Art and Archaeology*, Englewood Cliffs, N.J. (1963), esp. 187–191.

[8] Michael Podro, *The Critical Historians of Art*, New Haven and London (1982).

Princeton: The Beginnings
Under Marquand

MARILYN ARONBERG LAVIN

IN 1912, Professor Adolfo Venturi was planning the Tenth International Congress of Art Historians, to be held in Rome in October of that year. Curious about the state of art history in the New World, he wrote to the chairman of the department at Princeton University, Professor Allan Marquand.[1] By 1912 Marquand was very well known in Italy. He had made his first trip there precisely thirty years earlier, in 1882, when he was asked by President McCosh and the trustees of the College of New Jersey to give up the career he had begun, teaching philosophy and Latin, and initiate courses in the history of art. Having received no graduate training in the subject (indeed there was no place in the United States to do so at the time), Marquand had taken off for Europe immediately. In the following year, 1883, with $60,000 having been raised from the estate of Marquand's uncle Frederick, the young instructor was made a full professor (Fig. 1) and the Department of Art and Archaeology was founded.[2] Like any well-educated postdoctoral scholar of this period, Marquand was versed in Latin and other languages, biblical history, historic sites, ancient literature, and classical mythology. But the history of art was another matter. He, and many of the men who later came to teach with him were largely self-taught in this field, rapidly becoming experts in several areas simultaneously. Early in his career Marquand published on ancient art, and later specialized in Italian Renaissance sculpture. In the decades that followed his inaugural year, he became a familiar figure in the libraries and archives in Florence and Rome, preparing what ultimately turned into a seven-volume work on the Della Robbia family.

By 1912 Marquand had hired five faculty members besides himself, including Princetonian Howard Crosby Butler (Fig. 2), archaeologist and architectural historian, Charles Rufus Morey (Fig. 5), who had studied classics at Michigan but became the expert in medieval art, and Frank Jewett Mather, Jr. (Fig. 4), who left journalism in 1910 to teach "modern," that is, Renaissance and post-Renaissance painting. In 1896 the college had become Princeton University, and one of the first graduate courses to be offered by the university was

[1] A letter of 1901, found in a book in the Marquand Library, records what must have been the beginning of the Venturi-Marquand correspondence. The letter, in English, is transcribed as Appendix I below.

[2] Much of the material that follows is drawn from my *The Eye of the Tiger: The Founding and Development of the Department of Art and Archaeology, 1883–1923, Princeton University*, Princeton (1983).

in the Department of Art and Archaeology. By 1912 there were in the department several young men, unique in the country, on their way to having advanced degrees. It was not by chance, therefore, that when the leading scholar in Italy wanted information about art history in America, he wrote to his colleague in Princeton, New Jersey.

To respond to Venturi's questions, Marquand assigned the task to the then Fellow in Art and Archaeology, E. Baldwin Smith (Fig. 7) of later dome and architectural symbolism fame.[3] Smith joined the faculty as an instructor in 1916, but in 1912 he was still a graduate student and did what he was told. And he did it with the flair of the scholar he was to become. By sending out circulars and consulting current catalogues, under the guidance of Marquand, Smith surveyed the 400 institutions of learning where liberal arts were taught in four-year programs. He found that, of the 400, 95 gave courses in some kind of art. In 27 of these institutions, the courses were offered by instructors from other departments. The other 68 offering such courses did so, according to Baldwin Smith, "adequately"; that is to say, they had a special chair in art and archaeology. On the basis of other statistics Smith then drew the following conclusions. Of the one million students in the United States, 163,000 had the possibility of participating in some kind of art course. Of these, 145,000 studied in departments entirely dedicated to the history of art. Of the 14,434 instructors in the country, a mere 117, or .8%, taught art history exclusively. There were 420 art history courses given annually in the country, or an average of four and a half courses per institution, with 88 fields within the history of art treated separately.

To publicize what he clearly thought was an insufficient number of courses to go around, Smith published the results of his survey in a 45-page pamphlet printed by Princeton University Press in 1912, and sold at a cost of fifty cents a copy, postpaid.[4] In it he listed, in alphabetical order, the 95 institutions teaching art history, giving the title of each art course, the name of the instructor, hours per week of class meetings, the year in which the course was founded, and whether it was required or optional. Beyond these institutions, others were listed that had student bodies of over a thousand but no classes in art (such as Purdue and St. Louis University), in order to underscore the need for expansion in the field.

The entries paint the following picture. Boston University and Bowdoin College each had one course taught by non-art people, but both had access to fine art collections. Brown University offered four courses: Greek, Roman, Renaissance, and modern, all taught by the same man. Bryn Mawr gave eight classes and had a resident fellowship of $525. Columbia College taught art appreciation, while the School of Architecture taught nine specialized period courses and boasted 25,000 photographs and 9,000 lantern slides. Dartmouth offered eleven art courses, mostly Greek and Roman, with one in Italian painting, one in northern painting, and one on the principles of criticism; it warned of limited library facilities. Harvard by now had 18 courses: nine in classical sculpture, two in medieval, three in Renaissance, one

[3] *The Dome, a Study in the History of Ideas*, Princeton Monographs in Art and Archaeology, XXV, Princeton (1950); *Architectural Symbolism of Imperial Rome and the Middle Ages*, Princeton Monographs in Art and Archaeology, XXX, Princeton (1956).

[4] *The Study of the History of Art in the Colleges and Universities of the United States*, Princeton (1912). This remarkable document is reprinted here as Appendix II, pp. 12–36.

in late Gothic sculpture, two reading courses, and what was surely the first specialized course in the country—in Japanese art. Normal College of the City of New York, that is, City College, offered ten courses, all handled by women, the Misses Christianson, Reid, Riblet, and Tanzer (this last from the Classics Department). Oberlin had six surveys and one course on Rembrandt. The University of Nebraska had eight courses, including two in the modern period, one in painting and one in architecture. The Universities of Michigan and of Chicago, where Breasted was teaching, each had eleven courses; Iowa had six; Smith and Berkeley had five, all classical; the University of Pennsylvania had thirteen surveys, divided by medium, plus a valuable collection of archaeological antiquities and seven fellowships for architects— and so on through Wellesley with eleven courses, four in ancient and one graduate seminar in Italian painting; and Yale, which owned the Jarves Collection and gave seven courses in Greek and Roman art.

Not until we get to the entry for Princeton, however, do we finally arrive at the focal point of this list. The Department of Art and Archaeology offered no fewer than 34 courses, undergraduate and graduate, taught by a battery of professors, on outlandish topics such as sixteenth-century Italian sculpture, Masaccio and the Florentine realists, Bellini and Correggio, and the iconography of Christian art. The Art Museum possessed paintings and sculpture and a large collection of casts. There were 40,000 photographs in the study collection. The university published a series of art monographs and offered two fellowships in art and archaeology, one of $400 and one of $600. Anyone browsing through this pamphlet, wishing to take the art-historical temperature of America, would see at a glance that the boiling point, in the year 1912, was Princeton, New Jersey.

Even so, the pamphlet tells only part of the story, that is, the academic part. From the very beginning, Princeton's museum had played a role in the basic plan. The philosophy behind the idea was set forth in a tract written in 1881 by two alumni advisors: William Cowper Prime, a New York lawyer, and George B. McClellan, ex-general and Civil War hero. They wrote:

> It is a profound absurdity of our systems of education, that a vast majority of accomplished and instructed men and women, seated at luxurious tables, are unable to tell whether their plates and cups are of pottery or porcelain, and have no conception of the meaning or uses of the enamels which they handle. It is an equal subject of regret and shame, that neglect of instruction in colleges and schools of learning has left so large a portion of the intelligent men and women of our country at the mercy of ignorant teachers, whose profound absurdities, and jargon of technical terms and phrases, have contributed to a prevalent impression that the word Art implies a mystery, which can be penetrated by only a few intellects.[5]

As a remedy, therefore, along with the academic courses, there would be a "Museum of Historic Art," with examples of all things beautiful made by hand. A fireproof building was then duly commissioned from A. Page Brown, and the center portion was completed by 1888 (seven years before the Fogg). The structure was made of rustic Newark brownstone in the

[5] William C. Prime and George B. McClellan, *Suggestions on the Establishment of a Department of Art Instruction in the College of New Jersey*, Trenton, N.J. (1882), 15–16.

lower part, and fine Tiffany brick above (Fig. 3).[6] The Perth Amboy Terracotta Company donated a handsome facsimile of the Parthenon frieze, which was installed under the eaves.

Allan Marquand was the museum's first director, holding the post for more than forty years. He bought additions for the collection on his trips to Europe, and added more objects through personal gifts. He wisely established the tradition of alumni giving, both from Princeton classes and from individuals. Education of the students remained the focal point of the museum's program, with casts of famous objects from all periods vying in importance with original works of art. Much time and expense was spent on keeping the museum building open during lunch hours and after dinner in the evening.

Two more concerns were to occupy Marquand in the last two decades of his tenure. One was providing a library for the students. His wealth allowed him to amass a huge collection of books for his own work. By 1908 he formally deeded this personal accumulation to the university, and, as it continued to grow, it became one of the greatest in the land.

The other major undertaking was the building of McCormick Hall (Figs. 11–13).[7] In 1919–1920 it was decided that instruction in architecture and the history of architecture had become too large and too self-sufficient to remain under the aegis of the original department. The School of Architecture was made a separate entity, with many practical courses, such as drafting and rendering, added to the curriculum. Yet, at the same time, the school's commitment to historical studies remained firm and, in fact, was exemplified by the shape of the new hall. The building was designed by the Boston firm of Cram and Ferguson in "Sienese Gothic" style. It housed the Department of Art and Archaeology in the north wing and the School of Architecture in the south, with Marquand Library on the top floor of the central portion, tying them together.

After the building was inaugurated in 1923, Marquand (Fig. 6) retired, and his formidable job was split in two. Frank Jewett Mather, Jr. took over as director of the museum, and Mr. Charles Rufus Morey (Fig. 9) became the chairman of the department. But the personal style of Marquand remained a guiding principle. One of his students[8] was to recall that "even in his own field of the Della Robbias, Marquand took the attitude that we knew as much about it as he did, and in that way gave us a sort of professional courage."

[6] Lavin (as in note 2), p. 15, fig. 8.
[7] Ibid., p. 25 and fig. 20.
[8] Quoted in Alexander Leitch, *A Princeton Companion*, Princeton (1978), 315.

Appendix I: Venturi Letter
to Marquand

————————

L'ARTE
Direzione; Vicolo Savelli, 48
Roma

Rome, May 13th, 1901

My dear Sir,

I received your letter and have given orders at once to my publisher to forward hence-forth direct to you the numbers of *L'Arte*. As for the back numbers that you ask for, I have given orders to the publisher to ascertain whether and to whom they have been sent: if they were not forwarded, he will send them at once; if they were addressed to someone else the publisher will arrange so that you will get them.

I take this opportunity to ask you if you will be so kind as to send me for my journal every now and then, like many other collaborators of *L'Arte* do from different parts of Europe, some American art news. I mean notices of exhibition, news of recent public purchases, sales, restorings

As now America absorbs the greater part of the Art works of the European markets, it would be still more interesting to have for my journal some American correspondence and none could favor me better than you, that follow all the artistic movement in America, and I shall be very glad to number you as one of my collaborators.

The news naturally must regard especially Christian art, medieval, modern italian (*sic*) art; you can write in english (*sic*) and we will think about translating it.

I remember having had the pleasure of making your acquaintance and I hope one day I shall be able to see you again.

Hoping to have favorable reply, I remain, yours faithfully.

Adolfo Venturi

Appendix II: The Study of the History of Art in the Colleges and Universities of the United States*

E. BALDWIN SMITH

PREFATORY NOTE [iii]

This pamphlet has been issued in response to a request from Prof. Adolfo Venturi in view of the 10th International Congress of Art Historians, which meets in Rome in October, 1912. I issued a call for information to all the Universities and Colleges in the United States. From a number of these no reply was received; in such cases the required information has been taken from published catalogues. It was necessary to condense the statements received, so as to secure some degree of uniformity. The labour of arranging this material for the press has been done by Mr. E. Baldwin Smith, who will be grateful to be set straight if in any case the information here published should be defective.

It is not to the Roman Congress, however, that this pamphlet should be of most interest. To all Universities concerned with teaching the History of Art, to those which should be but are not yet doing so, and to all students desirous of knowing where they can find the instruction they require, this conspectus will be of service.

ALLAN MARQUAND
Princeton University
Sept. 15, 1912

INTRODUCTION [v]

The present report on the Study of the History of Art in American institutions of learning assumes that it will be of interest largely to those who already realize the urgent necessity of Art History in our Colleges and Universities and are themselves actively in sympathy with its

* This study was originally published as a pamphlet by Princeton University Press in 1912. It is reprinted here with minor corrections and with the original pagination indicated in square brackets ([]).

advancement. It is hoped, however, that the information here gathered may also be of some value in libraries and colleges where those who contemplate further work in the History of Art may find out the nature and extent of the courses offered by the Colleges and Universities, and thereby choose the place where they will carry on their advanced study.

The material has been gathered from the catalogues of the leading Colleges and Universities and from circulars, asking specific information, sent to four hundred institutions. All those Colleges and Universities not offering any work in the subject have been omitted, save the ones that have more than one thousand students in attendance. These have been included in order that it may be seen how many large Universities and Colleges are failing to meet an educational responsibility. Although many small Colleges have failed to remail the circular asking for information, it will not be far wrong to assume that of the four hundred institutions listed in the World's Almanac for 1911 the following list of ninety-five Colleges and Universities offering Art courses is nearly complete and may, therefore, be used for certain generalizations.

There are approximately four hundred institutions of learning in the United States where the Liberal Arts are taught for a period of four years. Of these, ninety-five Colleges and Universities give Art History courses, but only sixty-eight adequately. For adequate Art courses we assume a special chair in Art History or Archaeology. The result is that of the one million students in American Colleges and Universities but one hundred and sixty-three thousand have the advantage of any Art courses, and only one hundred and forty-five thousand have the privilege of adequate departments in this field. [vi]

At the present time in the institutions offering Art courses out of a total of fourteen thousand four hundred and thirty-four instructors one hundred and seventeen are exclusively teachers of the History of Art. In other words but eight-tenths of one percent of the teaching body is devoted to Art or Archaeology. Furthermore twenty-seven of these ninety-five institutions have no chair devoted to Art History, but offer the courses under the instructors of other departments. That it may be seen what phases of Art History are intrusted to these departments a list is here given with the departments offering the courses:

Archaeology

Christian (1 course by Classics Dept., 1 by Biblical Literature)
Egyptian (1 course by Semitic Languages Dept.)
Greek (6 courses by Classics Dept.)
Roman (3 courses by Classics Dept.)

Architecture

Classic (3 courses by Classics Dept.)
Greek (1 course by Classics Dept.)
General (1 course by French Dept.)
Roman (2 courses by Classics Dept.)

Art

Ancient (2 courses by Classics Dept., 1 by History Dept.)
Classic (4 courses by Classics Dept.)
General (3 courses by Classics Dept., 1 by Romance Languages Dept.)
Greek (16 courses by Classics Dept., 1 by French Dept.)
Mediaeval (1 course by Classics Dept., 1 by History Dept.)
Renaissance (2 courses by Classics Dept.)
Roman (3 courses by Classics Dept.)
Roman Antiquities (3 courses by Classics Dept.)
Greek Topography (3 courses by Classics Dept.)
Greek Epigraphy (3 courses by Classics Dept.)
Roman Topography (11 courses by Classics Dept.)

Painting [vii]

Italian (1 course by Classics Dept., 1 by Romance Language Dept., 1 by History Dept.)
General (1 course by French Dept., 1 by History Dept.)

Sculpture

General (2 courses by Classics Dept., 1 by French Dept.)
Greek (3 courses by Classics Dept.)

There are today given in these colleges four hundred and twenty courses in Art History with eighty-eight different phases of Art History treated as separate courses. The general average of Art courses for these institutions is four and one half courses each. For the purpose of ascertaining the extent and nature of the field covered and of offering a basis of comparison to show the relative importance of the various Art topics in the eyes of the college authorities a list of the courses are given with the number of times each is given.

Art

American, 3
Ancient, 19
Art Appreciaton, 3
Art Commentary on Greek Literature, 1
Art Forms, 1
Belgian, 1
Classic, 5
Christian Symbolism and Iconography, 1
Eastern, 1
English, 1
Etruscan, 2
French, 2

Greek, 25
History of, 30
History of the Printed Book, 1
History of Engraving, 1
History of the Crafts, 1
Historical Design, 1
Holland, 1
Important Part Played by Catholic
 Church in the Development of Art, 1
Introduction to, 1
Italian, 6
Japanese, 1

Mediaeval, 17
Modern, 11
Northern, 2
Oriental, 1
Origin of, 1
Pictorial Composition, 1

Ancient, 2
Christian, 10
Classic, 10
Egyptian, 4
Etruscan, 1
Greek, 9
Greek Antiques, 2
Greek Epigraphy, 3

Ancient, 8
Cathedral, 1
Christian, 2
Classic, 8
Gothic, 4
Greek, 2
History of, 25

Ancient, 1
History of, 8

Ancient, 1
Central Italian, 1
Early Flemish, 1
English, 1
Florentine, 1
French, 1
Giotto and his Associates, 1
History of, 18
Italian, 16
Leonardo da Vinci, 1
Masaccio and the Florentine Realists, 1

Primitive, 1 [viii]
Principles of Criticism, 1
Renaissance, 16
Roman, 8
Theory of, 2

Archaeology

Greek Monuments, 2
Greek Numismatics, 3
Greek Topography, 8
Greek Vases, 5
Roman, 6
Roman Antiques, 4
Roman Numismatics, 1
Roman Topography, 15

Architecture

Italian, 1
Mediaeval, 14
Modern, 10
Oriental, 1
Renaissance, 13
Roman, 2

Ornament

Mediaeval, 1
Modern, 1

Painting

Modern, 7
Northern, 7
Rembrandt, 1
Renaissance, 5
Sienese, 1
Seventeenth and Eighteenth Century, 1
Sixteenth and Seventeenth Century, 1
Spanish, 1
The Bellini and Correggio, 1
Venetian, 1

Sculpture [ix]

Classic, 4 Italian, 9
German, 1 Renaissance, 1
Greek, 11 Roman, 2
History of, 16

These generalizations and comparisons have been given only to facilitate those who are interested in realizing the relative importance and position of the study of Art History in American Colleges and Universities. If any further comparative information is desired it may be gained from the statistics which follow. As it may prove to be worthwhile to republish a revised list at a later date, any suggestions, corrections, or additions will be gratefully received.

E. Baldwin Smith
Merwick, Princeton, N.J.
[x]

Notice: Under the separate Colleges and Universities is given the title of each art course, the name of the instructor giving the course, the year in which the course was founded, whether required, elective, or optional, and the number of hours a week that the course is given during the year. [1]

History of Art in the Colleges

Adelphi College, Brooklyn, N.Y.

Founded 1896, instructors 30, students 458

1. History of Ancient and Mediaeval Art. Bruno Roselli
 1894, elective, 3 h. a week for one semester.
2. History of Roman Art (omitted 1912–13). Bruno Roselli
 1894, elective, 3 h. a week for one semester.
3. History of Modern Art. Bruno Roselli
 1894, elective, 3 h. a week for one semester.
4. History of Renaissance Art (omitted 1912–13). Bruno Roselli
 1894, elective, 3 h. a week for one semester.

Remarks.—Lantern, several thousand slides, 250 books, some photographs, and a collection of casts; the college has a Fine Arts Department.

Alma College, Alma, Mich.

Founded 1887, instructors 29, students 302

1. Greek and Roman Art (1913–14). J. T. Ewing (Classical Dept.)
 1913, elective, ———.

Remarks.—Small equipment.

Amherst College, Amherst, Mass.

Founded 1821, instructors 47, students 480

1. Greek Art (omitted 1912–13). H. de F. Smith (Greek Dept.)
 1904, elective, 3 h. a week for one semester.
2. Roman and Italian Art (omitted 1912–13). [2] A. H. Baxton (Romance Languages Dept.)
 1905, elective, 3 h. a week for one semester.

Remarks.—A large collection of casts, two cases of Eastern antiquities, and about 1,000 photographs and slides.

BELOIT COLLEGE, Beloit, Wis.

Founded 1864, instructors 31, students 394

1. Greek and Roman Art. T. L. Wright (Greek Dept.)
 ——, elective, 3 h. per week, one semester.
2. Renaissance Art. T. L. Wright (Greek Dept.)
 ——, elective, 3 h. per week, one semester.
3. Prehistoric and Ancient Archaeology. I. M. Buell
 ——, elective, 2 h. per week, one year.

Remarks.—Books, photographs, slides, and the collection of antique casts made by Greek Government for the World's Fair of 1892–93.

AUGUSTANA COLLEGE, Rock Island, Ill.

Founded 1860, instructors 40, students 550

1. Aesthetics and History of Art. E. F. Bartholomew
 1909, elective, 2 h. a week for one semester.

BARNARD COLLEGE, New York, N.Y.

Founded 1889, instructors 70, students 742

1. Mediaeval Architecture. A. D. F. Hamlin and R. F. Bach
 ——, elective, 2 h. a week for one semester.
2. Modern Architecture. A. D. F. Hamlin and R. F. Bach
 ——, elective, 2 h. a week for one semester.
 (these courses are given at Columbia University.)
3. Art Appreciation; History of Art. A. H. Dow
 1908, elective, 1½ h. a week through year.

Remarks.—For equipment see Columbia University.

BOSTON UNIVERSITY, Boston, Mass.

Founded 1869, instructors 161, students 1,274

1. History of Greek Art. W. G. Aurelis (Greek Dept.)
 1890, elective, 2 h. a week for one semester.

Remarks.—Use is made of Museum of Fine Arts and Boston Public Library. [4]

BOWDOIN COLLEGE, Brunswick, Maine

Founded 1794, instructors 64, students 398

1. History of the Fine Arts. Henry Johnson (Romance Language Dept.)
 1912, elective, 3 h. per week for one year.

Remarks.—Walker Art Building, designed by McKim, Mead, and White, contains Egyptian, Assyrian, Cypriote, Greek and Roman objects, original drawings by old masters, and paintings principally Early American and Modern European; a collection of antique casts, and about a thousand books, photographs, and slides.

BATES COLLEGE, Lewiston, Maine

Founded 1863, instructors 24, students 485

1. Italian Art. Miss M. Woodheal
 1911, elective, 3 h. a week through year. [3]
2. Art of Northern Countries (alternate years). Miss M. Woodheal
 1912, elective, 3 h. a week through year.

Remarks.—Photographs and University Prints.

BROWN UNIVERSITY, Providence, R.I.

Founded 1764, instructors 85, students 931

1. Classic and Renaissance Art. W. C. Poland
 ——, elective, 3 h. a week throughout year.
2. Modern Art. W. C. Poland
 ——, elective, 3 h. a week throughout year.

BELLEVUE COLLEGE, Bellevue, Neb.

Founded 1820, instructors 20, students 170

1. History of Art. Miss L. M. Carter
 1912–13, elective, ——.

Remarks.—Collection of slides and photographs.

3. Renaissance Art (advanced course). W. C.
 Poland
 ———, elective, 3 h. a week throughout year.
4. Greek and Roman Sculpture. W. C. Poland
 ———, elective, 3 h. a week throughout year.

Remarks.—Art Museum containing a collection of casts, several antique marbles, many Old Masters, and numerous examples of Modern Painting; slides, and photographs.

BRYN MAWR COLLEGE, Bryn Mawr, Pa.

Founded 1885, instructors 60, students 425

1. Greek and Roman Architecture. New instructor
 ———, elective, 3 h. a week throughout year.
2. Introduction to Classical Archaeology. New instructor [5]
 ———, elective, 1 h. a week throughout year.
3. Greek and Roman Sculpture. Miss Taylor
 ———, minor, 3 h. a week throughout year.
4. Ancient Painting. New instructor
 ———, elective, 2 h. a week throughout year.
5. Italian Painting of Renaissance. Miss King
 ———, elective, 3 h. a week throughout year.
6. Renaissance Sculpture. Miss King
 ———, elective, 2 h. a week throughout year.
7. XVIIth and XVIIIth Century Painting. Miss
 King
 ———, minor, 2 h. a week throughout year.
8. Gothic Architecture. Miss King
 ———, elective, 3 h. a week throughout year.

Remarks.—Slides, books, photographs, vases, coins, etc., and a resident Fellowship of $525.

BUCKTEL COLLEGE, Akron, Ohio

Founded 1870, instructors 17, students 282

1. History of Greek Sculpture. J. C. Rockwell
 (Classical Dept.)
 1903, elective, 2 h. a week through year.
2. Classical Archaeology. J. C. Rockwell (Classical
 Dept.)
 ———, elective, 2 h. a week for one semester.

Remarks.—400 large photographs and 600 slides.

CATHOLIC UNIVERSITY OF AMERICA,
Washington, D.C.

Founded 1889, instructors 54, students 400

1. History of Architecture. F. V. Murphy
 1910, required, 3 h. a week throughout year.
2. Semitic and Egyptian Archaeology. H. Hyvernat (Semitic Dept.)
 ———, ———, 2 year course. [6]

CENTRAL UNIVERSITY OF KENTUCKY, Danville, Ky.

Founded 1819, instructors 27, students 123

1. Introduction to Ancient Art. T. L. Blayney
 ———, elective, 2 h. a week for one semester.
2. Mediaeval Art. T. L. Blayney
 ———, elective, 2 h. a week for one semester.
3. Renaissance Art (1913). T. L. Blayney
 ———, elective, 2 h. a week for one semester.

Remarks.—A good collection of slides and photographs.

[CITY UNIVERSITY OF NEW YORK: see COLLEGE OF
CITY OF NEW YORK and NORMAL COLLEGE OF
CITY OF NEW YORK]

CLARK UNIVERSITY, Worcester, Mass.

Founded 1889, instructors 25, students 116

No courses offered.

Remarks.—A $100,000 endowment for Art Department, at present expended in books and periodicals.

COLLEGE OF CITY OF NEW YORK

Founded 1847, instructors 120, students 1,862

1. History of Art. F. Dielman
 1852, required, 2 h. a week for one semester.

Remarks.—400 lantern slides, photographs, books, and casts.

COLUMBIA UNIVERSITY, New York, N.Y.

Founded 1754, instructors 657, students 9,086

(a.) Columbia College

1. Art Appreciation; History of Art. A. H. Dow
 1904, elective, 2 h. a week through year.
2. Public Lectures on Art History. Art Department
 1902, ——, Wednesday afternoon at 4 o'clock.

(b.) School of Design

1. History of Art. E. R. Smith (Ref. Lib. of Avery
 Library)
 1906, optional, 8 h. a week through year. [7]
2. History of Art (advanced). E. R. Smith
 1906, optional, 4 h. a week through year.

(c.) Teachers College

1. Art Appreciation—History of Art. A. H. Dow
 1904, required, 2 h. a week through year.
2. Introduction to the History of Art (extension
 course). E. R. Smith
 1908, optional, 1½ h. a week through year.

(d.) School of Architecture

1. Ancient and Mediaeval Architecture. A. D. F.
 Hamlin
 1912, elective, 1 h. a week through year.
2. Modern and Oriental Architecture. A. D. F.
 Hamlin
 1912, elective, 1 h. a week through year (alternate with no. 1).
3. Ancient Architecture. A. D. F. Hamlin
 1882; 1912, elective, 2 h. a week through year.
4. Mediaeval Architecture. A. D. F. Hamlin
 1882; 1912, elective, 2 h. a week through year.
5. Renaissance and Modern Architecture. A. D. F.
 Hamlin
 1882; 1912, elective, 2 h. a week through year.
6. Ancient Ornament. A. D. F. Hamlin
 1883, required, 1 h. a week through year.
7. Mediaeval Ornament. A. D. F. Hamlin
 1883, required, 1 h. a week through year.
8. Modern Ornament. A. D. F. Hamlin
 1883, required, 1 h. a week through year.
9. Advanced Research. E. R. Smith
 1906, optional, 8–10 h. a week through year.

Remarks.—*Books*: Art Library, 1,910; Avery Collection, 19,066; General Library, 4,560; Arch. Dept.

Library, 56; Barnard College, 960; Teachers College, etc., 1,030; total, 27,582. *Photographs*: Avery Collection, 7,000; Architectural Dept., 18,000; Classical Dept., large collection. *Lantern Slides, etc.*: Architectural Dept. has 9,000 slides, 3 lanterns, a reflectoscope, and a large collection of casts and architectural models. [8]

CORNELL UNIVERSITY, Ithaca, N.Y.

Founded 1868, instructors 652, students 5,624

1. History of Architecture. A. C. Phelps
 circa 1880, elective (all save architectural students), 3 h. a week for a year and a half.
2. Historic Ornament. A. C. Phelps
 1904, elective (all save architectural students), 3 h. a week for one semester.
3. History of Sculpture and Painting. A. C. Phelps
 1907, elective (all save architectural students), 1 h. a week through year.
4. History of Art in Italy. H. S. Gutsell
 1904, elective, 2 h. a week through year.
5. History of Art North of Alps. H. S. Gutsell
 1904, elective, 2 h. a week through year.
6. Historical Seminary. A. C. Phelps
 1907, elective, 1 h. a week through year.
7. Modern Architecture. A. C. Phelps
 ——, elective, 2 h. a week for one semester.

Remarks.—Some thousands of photographs, thirty periodicals, large library, nine-thousand lantern slides, and a large collection of casts.

DARTMOUTH COLLEGE, Hanover, N.H.

Founded 1767, instructors 116, students 1,300

1. Roman Topography. H. E. Burton
 ——, elective, 3 h. a week for one semester.
2. Greek Life and Monuments. H. E. Burton
 ——, elective, 3 h. a week for one semester.
3. Greek Art (General course). H. E. Burton
 ——, elective, 3 h. a week for one semester.
4. Roman Art (General course). H. E. Burton
 ——, elective, 3 h. a week for one semester.

5. Topography and Monuments of Greece. H. E.
 Burton [9]
 ——, elective, 3 h. a week for one semester.
6. Greek Sculpture. H. E. Burton
 ——, elective, 3 h. a week for one semester.
7. Italian Painting. H. E. Keyes
 ——, elective, 3 h. a week for one semester.
8. Netherlands and German Painting. H. E. Keyes
 ——, elective, 3 h. a week for one semester.
9. Outlines of Architecture. H. E. Keyes
 ——, elective, 3 h. a week for one semester.
10. Introduction to Greek Epigraphy. H. E. Burton
 ——, elective, 3 h. a week for one semester.
11. Principles of Criticism. H. E. Keyes
 ——, elective, 2 h. a week for one semester.

Remarks.—In Archaeology there is a collection of casts, photographs and reproductions; in Modern Art there are 2000 photographs and an increasing number of lantern slides; library facilities are limited.

DENISON UNIVERSITY, Granville, Ohio

Founded 1831, instructors 45, students 604

1. Theory of Art. Miss L. B. Parsons
 1912, elective, 2 h. for one semester.
2. Appreciation in Art. Miss B. G. Loveridge
 1902, required, 1 h. for one semester.
3. History of Painting. Miss B. G. Loveridge
 1902, elective, 4 h. for one semester.
4. History of Architecture. Miss B. G. Loveridge
 1902, elective, 4 h. for one semester.
5. History of Sculpture. Miss B. G. Loveridge
 1902, elective, 4 h. for one semester.

Remarks.—A collection of casts, photographs, and books. [10]

DE PAUW UNIVERSITY, Greencastle, Ind.

Founded 1837, instructors 59, students 1,040

No courses offered.

Remarks.—An Art School with Art History library of 75 volumes.

DOANE COLLEGE, Crete, Neb.

Founded 1872, instructors 24, students 238

1. Greek Architecture and Sculpture. D. G. Burrage (Classical Dept.)
 ——, elective, 2 h. a week for one semester.
2. History of Italian Painting. D. G. Burrage (Classical Dept.)
 ——, elective, 2 h. a week for one semester.

Remarks.—Photographs and books.

DRAKE UNIVERSITY, Des Moines, Iowa

Founded 1881, instructors 150, students 1,827

No courses offered.

FAIRMOUNT COLLEGE, Wichita, Kan.

Founded 1895, instructors 20, students 328

1. History of Art. Miss E. Sprague
 1903, elective, 2 h. a week through year.

Remarks.—Inadequate equipment.

FORDHAM UNIVERSITY, Fordham, N.Y.

Founded 1841, instructors 116, students 1,015

No courses offered.

GEORGETOWN UNIVERSITY, Washington, D.C.

Founded 1789, instructors 145, students 1,165

No courses offered. [11]

GEORGE WASHINGTON UNIVERSITY,
Washington, D.C.

Founded 1821, instructors 176, students 1,277

1. History of Art. M. Carroll
 1902, elective, 2 h. a week through year.
2. Classical Archaeology. M. Carroll
 ——, elective, 2 h. a week through year.

3. Ancient Life and Art. M. Carroll
 ——, elective, 2 h. a week through year.
4. Life and Art in Homeric Age. M. Carroll
 ——, elective, 2 h. a week through year.

Remarks.—Students use resources of Library of Congress, National Museum and Corcoran Gallery of Art.

GRINNELL COLLEGE, Grinnell, Iowa

Founded 1847, instructors 44, students 607

1. Greek and Roman Art. Miss C. E. Millerd (Greek Dept.)
 ——, elective, 2 h. a week for one semester.
2. Renaissance Art. ——
 ——, elective, 2 h. a week for one semester.

Remarks.—A large number of slides, collection of Art books, and 600 photographs.

HARVARD UNIVERSITY, Cambridge, Mass.

Founded 1636, instructors 639, students 4,128

1. History of Ancient Art. G. H. Chase
 1912, elective, 3 h. a week for one semester.
2. History of Mediaeval and Modern Art. A. Pope
 1912, elective, 3 h. a week for one semester.
3. History of Classic Architecture. H. L. Warren
 1894, elective, 3 h. a week through year.
4. History of Greek Sculpture. G. H. Chase
 1912, elective, 3 h. a week for one semester.
5. History of Mediaeval Architecture. H. L. [12] Warren
 1894, elective, 3 h. a week through year.
6. Central Italian Painters of the Renaissance. G. H. Edgell
 1912, elective, 3 h. a week for one semester.
7. History of the Printed Book. W. C. Lane
 1910, elective, 3 h. a week for one semester.
8. History of Japanese Art. L. Warner
 1912, elective, 3 h. a week for one semester.
9. Art and Culture of Italy in the Middle Age and the Renaissance. C. R. Post
 1910, elective, 3 h. a week through year.

10. Florentine Painting in the 15th Century. E. W. Forbes
 1910, elective, 3 h. a week for one semester.
11. Greek Archaeology. G. H. Chase
 ——, elective, 3 h. a week for one semester.
12. Etruscan and Roman Archaeology. G. H. Chase
 ——, elective, 3 h. a week for one semester.
13. Topography and Monuments of Ancient Rome. G. H. Chase
 ——, elective, 3 h. a week for one semester.
14. Elder Pliny's Account of the History of Ancient Art. G. H. Chase
 ——, elective, 3 h. a week for one semester.
15. Greek Vases. G. H. Chase
 ——, elective, 3 h. a week for one semester.
16. Greek Numismatics. G. H. Chase
 ——, elective, 3 h. a week for one semester.
17. Research. G. H. Chase
 ——, elective, 3 h. a week for one semester.
18. German Religious Sculpture in the Middle Ages. K. Francke (German Dept.)
 ——, elective, 2 h. a week for one semester.

Remarks.—The William Hayes Fogg Art Museum contains a small collection of original works of Ancient Art, Paintings of the Old Masters, a collection of drawings by the masters of the early English water color school, the Gray and Randall print collection numbering over 20,000, a large collection of casts, 1,192 books, 3,654 lantern slides, and more than 42,000 photographs. [13]

HOWARD UNIVERSITY, Washington, D.C.

Founded 1867, instructors 105, students 1,382

1. History of Ornament. W. G. Decatur
 ——, required, 2 h. a week for one semester.
2. Modern Architecture. W. G. Decatur
 ——, architects, 3 h. a week through year.
3. History of Architecture. W. G. Decatur
 ——, architects, 1 h. a week through year.

Remarks.—The University has a school of Architecture.

[HUNTER COLLEGE: see NORMAL COLLEGE OF THE CITY OF NEW YORK]

ILLINOIS STATE NORMAL UNIVERSITY, Normal, Ill.

Founded 1857, instructors 63, students 2,703

1. Art in History (given twice each year). Miss
 C. E. Ela
 1900, elective, 1 h. a day for one-third year.

Remarks.—Collection of casts, books, photographs,
and slides.

THE JAMES MILLIKIN UNIVERSITY, Decatur, Ill.

Founded 1908, instructors 76, students 1,144

1. History of Painting. W. M. Hekking
 1905, required, 2 h. a week for one semester.
2. History of Sculpture. J. D. Rogers (Classical
 Dept.)
 1905, required, 2 h. a week for one semester.
3. History of Architecture. W. M. Hekking
 1905, required, 2 h. a week for one semester.
4. History of the Crafts. Miss I. Handlin
 1906, required, 4 h. a week for one semester.

Remarks.—A collection of casts, books, photographs,
and slides.

JOHNS HOPKINS UNIVERSITY, Baltimore, Md.

Founded 1876, instructors 200, students 775

1. Roman Archaeology (Graduate course). H. L.
 Wilson [14]
 ——, elective, 2 h. a week for one semester.
2. Greek Vase Painting and Mythology (Graduate
 course). D. M. Robinson
 ——, elective, 2 h. a week for one semester.
3. Roman Sculpture (Graduate course). H. L.
 Wilson
 ——, elective, 1 h. a week for one semester.
4. Topography and Monuments of Ancient Rome
 (Graduate course). H. L. Wilson
 ——, elective, 1 h. a week for one semester.
5. Greek Antiquities (Graduate course). D. M.
 Robinson
 ——, elective, 1 h. a week for one semester.
6. Outlines of Classical Archaeology. H. L. Wilson
 ——, elective, 3 h. a week through year.

Remarks.—The material includes a large collection
of Greek and Roman antiquities supplemented by
photographs, slides, and the collections of the Pea-
body Institute and the Walters Gallery.

KANSAS WESLEYAN UNIVERSITY, Salina, Kan.

Founded 1886, instructors 41, students 1,272

No courses offered.

KENYON COLLEGE, Gambier, Ohio

Founded 1824, instructors 20, students 125

1. History of Art. B. Newhall (Greek Dept.)
 1906, elective, 3 h. a week through year.

Remarks.—2,000 reference books and 1,000 photo-
graphs and prints.

KNOX COLLEGE, Galesburg, Ill.

Founded 1837, instructors 31, students 616

1. History of Painting. J. R. Holmes (History
 Dept.)
 1908, elective, 2 h. a week through year.

Remarks.—300 photographs and 2,000 Art postal-
cards for use in projectoscope. [15]

LAWRENCE COLLEGE, Appleton, Wis.

Founded 1847, instructors 43, students 643

1. Ancient Art and Culture. O. Fairfield
 1901, elective, 3 h. a week for one semester.
2. Roman and Mediaeval Art. O. Fairfield
 1901, elective, 3 h. a week for one semester.
3. Italian Renaissance. O. Fairfield
 1901, elective, 3 h. a week for one semester.
4. Northern Renaissance. O. Fairfield
 1901, elective, 3 h. a week for one semester.
5. 19th Century European Art. O. Fairfield
 1901, elective, 2 h. a week for one semester.
6. American Art. O. Fairfield
 1901, elective, 2 h. a week for one semester.

Remarks.—A collection of photographs, slides, and
art books.

LELAND STANFORD, JR., Stanford University, Cal.

Founded 1891, instructors 146, students 1,770

1. Roman Art and Monuments. H. R. Fairclough (Latin Dept.)
———, elective, 2 h. a week through year.

Remarks.—A Graphic Art Department and a Museum possessing collections of Greek, Roman, Japanese, Chinese, American, and European Art.

LOUISIANA STATE UNIVERSITY, Baton Rouge, La.

Founded 1860, instructors 70, students 1,241

No courses offered.

MASS. INST. OF TECH., Boston, Mass.

Founded 1861, instructors 260, students 1,575

1. Ancient Architecture. E. B. Homer
———, required of architects, 1 h. a week for one semester. [16]
2. Roman and Mediaeval Architecture. E. B. Homer
———, required of architects, 2 h. a week for one semester.
3. Romanesque and Gothic. E. B. Homer
———, required of architects, 3 h. a week for one semester.
4. Renaissance Architecture. E. B. Homer
———, required of architects, 3 h. a week for one semester.
5. Architectural History (Graduate Research). E. B. Homer
———, elective, ———.
6. History of Ornament. C. H. Walker
———, required of architects, 1 h. a week for one semester.

Remarks.—The Architectural Department contains 4,000 volumes, all the architectural periodicals, 16,000 photographs, 15,000 lantern slides, casts and architectural models. Students have free access to the Boston Public Library and the Museum of Fine Arts.

MIAMI UNIVERSITY, Oxford, Ohio

Founded 1809, instructors 50, students 500

1. History of Greek Art. F. L. Clark (Classical Dept.)
1908, elective, 2 h. a week through year.

Remarks.—600 lantern slides, 100 photographs, 200 stereoscopic views, and about 75 volumes in the library.

[MILLIKIN UNIVERSITY: see JAMES MILLIKIN UNIVERSITY]

MOUNT HOLYOKE COLLEGE, South Hadley, Mass.

Founded 1837, instructors 90, students 754

1. History of Ancient Art. Miss G. S. Hyde
1912, elective, 3 h. a week through year.
2. Egyptian Archaeology (omitted 1912–13). Miss L. F. Randolph
1897, elective, 3 h. a week for one semester.
3. Greek and Roman Archaeology (omitted 1912–13). Miss E. H. Hall
1908, elective, 3 h. a week through year.
4. Greek Sculpture (omitted 1912–13). Miss E. H. Hall
1902, elective, 3 h. a week for one semester.
5. Italian Sculpture. Miss L. R. Jewett [17]
1911, elective, 3 h. a week through year.
6. Painting in Northern and Western Europe. Miss F. W. Foss.
1903, elective, 3 h. a week through year.
7. Mediaeval and Renaissance Architecture. Miss G. S. Hyde
1911, elective, 3 h. a week through year.
8. Historic Ornament. Miss L. R. Jewett
1909, elective, 3 h. a week through year.
9. Italian Painting. Miss L. R. Jewett
1902, elective, 3 h. a week through year.
10. Advanced Archaeology (omitted 1912–13). Miss E. H. Hall
1908, elective, 3 h. a week through year.

Remarks.—Dwight Art Building includes 8 lecture rooms, 6 studios, 3 galleries, and a department library of 2,500 books, 10,000 photographs, 1,500 lantern slides, 356 casts, and a large collection of antique and modern art works.

NEW ROCHELLE COLLEGE, New Rochelle, N.Y.

Founded 1904, instructors 25, students 225

1. Introduction to History of Art.
2. Origin and Beginning of Art.
3. History of Architecture.
4. History of Sculpture.
5. History of Painting.
6. Important Part Played by Catholic Church in Art Development.
7. Art in Far East.

NORMAL COLLEGE OF THE CITY OF NEW YORK

Founded 1870, instructors 186, students 3,000

1. History of Architecture. Miss E. S. Christianson
 1904, optional, 1 h. a week through year.
2. History of Painting. Miss M. C. Reid
 1904, optional, 2 h. a week for one semester.
3. History of Sculpture. Miss M. C. Reid [18]
 1907, optional, 2 h. a week for one semester.
4. Italian Renaissance. Miss G. E. Riblet
 1907, optional, 1 h. a week through year.
5. Renaissance and Modern Painting. Miss M. C. Reid
 1910, optional, 2 h. a week for one semester.
6. Recent Painting. Miss M. C. Reid
 1912, optional, 2 h. a week for one semester.
7. Gothic Architecture. Miss E. S. Christianson
 1912, optional, 2 h. a week for one semester.
8. Arts and Crafts of Middle Ages. Miss E. S. Christianson
 1913, optional, 2 h. a week for one semester.
9. Roman Topography. Miss H. H. Tanzer (Classical Dept.)
 ——, optional, ——.
10. Greek Art. Dr. Bennett (Classical Dept.)
 ——, optional, 2 h. a week for one semester.

Remarks.—400 reference books, 59 photographs, and 2,000 prints, 1,217 lantern slides, and 10 casts.

NORTHWESTERN UNIVERSITY, Evanston, Ill.

Founded 1851, instructors 435, students 4,753

1. History of Painting and Sculpture. Miss S. Skinner
 1907, elective, 2 h. a week for two years.
2. Christian Archaeology. A. W. Pattern (Biblical Lit. Dept.)
 ——, optional, 2 h. a week through year.

Remarks.—Inadequate supply of books, photographs, and slides.

OBERLIN COLLEGE, Oberlin, Ohio

Founded 1833, instructors 141, students 2,043

1. History of Ancient Art. C. B. Martin
 1895, elective, 2 h. a week through year.
2. History of Art in Italy. C. B. Martin
 1911, elective, 2 h. a week through year. [19]
3. Greek Sculpture. C. B. Martin
 1893, elective, 2 h. a week through year.
4. Topography of Ancient Rome. C. N. Cole (Classical Dept.)
 ——, elective, 2 h. a week for one semester.
5. Roman Archaeology. C. N. Cole
 ——, elective, 5 h. a week through summer.
6. History of Italian Painting. C. B. Martin
 ——, elective, 3 h. a week through summer.
7. Rembrandt. C. B. Martin
 ——, elective, 2 h. a week through summer.

Remarks.—3,200 photographs, 3,000 slides, 1,500 books, and small number of casts.

OHIO NORTHERN UNIVERSITY, Ada, Ohio

Founded 1871, instructors 37, students 1,768

No courses offered.

OHIO STATE UNIVERSITY, Columbus, Ohio

Founded 1870, instructors 267, students 3,439

1. History of Architecture. J. N. Bradford
 1899, required, 3 h. a week through one year.
2. Art Appreciation. M. R. Laver
 1909, required, 3 h. a week for one semester.

3. Pictorial Composition. M. R. Laver
 1909, required, 3 h. a week for one semester.
4. Historical Design. M. R. Laver
 1909, required, 3 h. a week for one semester.
5. Greek Art. J. Smith (Classical Dept.)
 1883, elective, 3 h. a week through year.
6. Mediaeval Art. J. Smith (Classical Dept.)
 1883, elective, 3 h. a week through year.

Remarks.—800 photographs, 3,000 slides, 500 casts, 2,000 photogravures, and 800 books and periodicals.

[20]

OHIO UNIVERSITY, Athens, Ohio

Founded 1804, instructors 70, students 1,687

No courses offered.

OHIO WESLEYAN UNIVERSITY, Delaware, Ohio

Founded 1842, instructors 65, students 1,345

1. History of Sculpture. Miss C. A. Nelson (French Dept.)
 1880, elective, 1 h. a week through year.
2. History of Painting. Miss C. A. Nelson (French Dept.)
 1880, elective, 2 h. a week for one semester.
3. History of Architecture. Miss C. A. Nelson (French Dept.)
 1880, elective, 2 h. a week for one semester.
4. History of Greek Architecture and Sculpture. R. Parsons (Classics Dept.)
 ——, elective, 2 h. a week for one semester.

Remarks.—500 lantern slides, 600 photographs, 500 books, and a few casts.

PENNA. STATE COLLEGE, State College, Pa.

Founded 1855, instructors 190, students 2,006

1. Lectures on Historic Art. Miss A. E. Redifer
 1907, required (in certain courses), 1 h. a week for one semester.

2. Architectural Forms. Miss A. E. Redifer
 1909, required (in certain courses), 4 h. a week for one semester.
3. Masterpieces of Painting and Sculpture. Miss A. E. Redifer
 1910, required (in certain courses), 3 h. a week for one semester.

Remarks.—About 200 casts, 1,000 photographs, and a small collection of Art books.

PRATT INSTITUTE, Brooklyn, N.Y.

Founded 1887, instructors 174, students 3,553

1. Lectures on History of Art. W. C. Perry
 ——, required, 1 h. a week through year.

Remarks.—The Institute has a Fine and Applied Arts Department and an Architectural Department; an Art Gallery for various exhibitions; the Art Library has a large collection of books and lantern slides and more than 17,000 photographs. [21]

PRINCETON UNIVERSITY, Princeton, N.J.

Founded 1746, instructors 174, students 1,521

1. Ancient Art. G. W. Elderkin
 1884, elective, 3 h. a week for one semester.
2. Mediaeval Art. C. R. Morey
 1889, elective, 3 h. a week for one semester.
3. Ancient Architecture. H. C. Butler
 1882, elective, 3 h. a week for one semester.
4. Mediaeval Architecture. C. Ward
 1882, elective, 3 h. a week for one semester.
*5. Greek Sculpture. A. Marquand
 1885, elective, 3 h. a week for one semester.
*6. Italian Sculpture. A. Marquand
 1887, elective, 3 h. a week for one semester.
*7. Revival of Painting in Italy. F. J. Mather, Jr.
 1887, elective, 3 h. a week for one semester.
*8. Northern Painting. F. J. Mather, Jr.
 1887, elective, 3 h. a week for one semester.
*9. Elements of Architecture. H. C. Butler, C. Ward
 1903, elective, 3 h. a week through year.
 * Open to graduates and undergraduates.

10. Italian Sculpture from the IVth to XIth centuries (Graduate course). A. Marquand
 1912, elective, 3 h. a week for one semester.
11. Italian Sculpture from the XIth to XVth centuries (Graduate course). A. Marquand
 1912, elective, 3 h. a week for one semester.
12. Christian Architecture (Graduate course). H. C. Butler
 1887, elective, 3 h. a week through year.
13. Renaissance Architecture (Graduate course). H. C. Butler
 1891, elective, 3 h. a week for one semester.
14. Sienese Painters of the XIIIth and XIVth centuries (Graduate course). F. J. Mather, Jr.
 1912, elective, 3 h. a week for one semester.
15. Leonardo da Vinci (Graduate course). F. J. Mather, Jr. [22]
 1912, elective, 3 h. a week for one semester.
16. Christian Symbolism and Iconography (Graduate course). C. R. Morey
 1912, elective, 3 h. a week for one semester.
17. Classical Numismatics (Graduate course). C. R. Morey, G. W. Elderkin
 1912, elective, 3 h. a week through year.
18. Etruscan Art (Graduate course). G. W. Elderkin
 1885, elective, 3 h. a week for one semester.
19. Olympia, Delphi, and Epidaurus (Graduate course). G. W. Elderkin
 1912, elective, 3 h. a week for one semester.
 Given in 1913–14.
20. Italian Sculpture of the XVth century (Graduate course). A. Marquand
 1913, elective, 3 h. a week for one semester.
21. Italian Sculpture of the XVIth century (Graduate course). A. Marquand
 1913, elective, 3 h. a week for one semester.
22. Masaccio and the Florentine Realists (Graduate course). F. J. Mather, Jr.
 1913, elective, 3 h. a week for one semester.
23. Early Flemish Painters (Graduate course). F. J. Mather, Jr.
 1913, elective, 3 h. a week for one semester.
24. Mediaeval Art (Graduate course). C. R. Morey
 1913, elective, 3 h. a week through year.

25. Greek Archaeology (Graduate course). G. W. Elderkin
 1886, elective, 3 h. a week for one semester.
26. Greek Vase Painting (Graduate course). G. W. Elderkin
 1909, elective, 3 h. a week for one semester.
 Given in 1914–15.
27. Problems in Greek Sculpture (Graduate course). A. Marquand
 1899, elective, 3 h. a week for one semester.
28. Theory of Art (Graduate course). A. Marquand
 1914, elective, 3 h. a week for one semester.
29. Giotto and his Associates (Graduate course). F. J. Mather, Jr. [23]
 1910, elective, 3 h. a week for one semester.
30. The Bellini and Correggio (Graduate course). F. J. Mather, Jr.
 1910, elective, 3 h. a week for one semester.
31. Early Christian Archaeology (Graduate course). C. R. Morey
 1890, elective, 3 h. a week for one semester.
32. Roman Archaeology (Graduate course). C. R. Morey
 1885, elective, 3 h. a week for one semester.
33. Greek Archaeology (Graduate course). G. W. Elderkin
 1886, elective, 3 h. a week for one semester.
34. Art Commentary on Greek Literature (Graduate course). G. W. Elderkin
 1914, elective, 3 h. a week for one semester.

Remarks.—The Art Museum possesses a large collection of casts from Classical, Oriental, Mediaeval, and Renaissance sculpture, 40,000 photographs, 4,000 lantern slides, and 5,000 volumes besides 1,000 volumes which are in the General Library. The University publishes a series of Art Monographs and offers two Fellowships in Art and Archaeology, one of four-hundred dollars and one of six-hundred dollars.

PURDUE UNIVERSITY, Lafayette, Ind.

Founded 1869, instructors 162, students 1,885

No courses offered. [24]

RADCLIFFE COLLEGE, Cambridge, Mass.

Founded 1879, instructors 127, students 547

1. History of Ancient Art. G. H. Chase
 1890, elective, 3 h. a week for one semester.
2. History of Mediaeval and Modern Art. A. Pope
 ——, elective, 3 h. a week for one semester.
3. History of Greek Sculpture. G. H. Chase
 ——, elective, 3 h. a week for one semester.
4. Art and Culture in the Middle Ages and the Renaissance. C. R. Post
 ——, elective, 3 h. a week for one semester.
5. Painting of the XVIth and XVIIth Centuries. A. Pope
 ——, elective, 3 h. a week for one semester.

Remarks.—For equipment see Harvard College.

RHODE ISLAND STATE COLLEGE, Kingston, R.I.

Founded 1892, instructors 26, students 190

1. History of Art. Miss M. D. Eldred
 1909, required, 2 h. a week for one semester.
2. History of American Art. Miss M. D. Eldred
 1911, elective, 1 h. a week for one semester.

Remarks.—75 casts, 200 books, 500 photographs and 3,000 University Prints.

ROANOKE COLLEGE, Salem, Va.

Founded 1853, instructors 19, students 206

1. History and Appreciation of the Fine Arts. H. T. Hildreth (Greek Dept).
 1901, elective, 3 h. a week through year.

Remarks.—Small equipment. [25]

RUTGERS COLLEGE, New Brunswick, N.J.

Founded 1766, instructors 65, students 450

1. History of Sculpture and Painting. J. C. Van Dyke
 ——, elective, 2 h. a week for one semester.

2. History of Architecture. C. Ward
 ——, elective, 2 h. a week for one semester.

Remarks.—Over 500 casts, 1,500 photographs, 1,500 lantern slides, and a good Art Library.

SIMMONS' COLLEGE, Boston, Mass.

Founded 1899, instructors 91, students 811

1. History of Art. F. M. Greene
 1911, elective, 2 h. a week for one semester.
2. Art Appreciation. F. M. Greene
 1912, elective, 1 h. a week for one semester.

Remarks.—The courses are given at the Boston Museum of Fine Arts.

SMITH COLLEGE, Northampton, Mass.

Founded 1871, instructors 138, students 1,511

1. Greek and Roman Archaeology. W. D. Gray (Classical Dept.)
 ——, elective, 2 h. a week through year.
2. History of Ancient, Mediaeval, and Renaissance Art. A. V. Churchill
 1906, elective, 2 h. a week through year.
3. History of Painting. A. V. Churchill
 1906, elective, 2 h. a week through year.
4. History of Greek Sculpture. S. Dean
 1912, elective, 2 h. a week through year.
5. History of Design. L. G. Monté
 1912, elective, 2 h. a week through year.

Remarks.—2,500 slides, 1,000 photographs, 384 casts, and a collection of American painting. [26]

SOUTHWESTERN UNIVERSITY, Georgetown, Texas

Founded 1873, instructors 63, students 1,222

1. History of Art. Miss N. C. Clement
 ——, required in Fine Arts School, ——.

Remarks.—The University has a Fine Arts School.

[STANFORD UNIVERSITY: see LELAND STANFORD, JR.]

STATE UNIVERSITY OF IOWA, Iowa City, Iowa

Founded 1847, instructors 166, students 2,090

1. History of Ancient Art. C. H. Weller
 ——, elective, 2 h. a week through year.
2. History of Mediaeval and Renaissance Art.
 C. H. Weller
 ——, elective, 2 h. a week through year.
3. Greek Vase Painting. C. H. Weller
 ——, elective, 1 h. a week through year.
4. History of Painting. C. H. Weller
 ——, elective, 1 h. a week through year.
5. History of Architecture. C. H. Weller
 ——, elective, 2 h. a week through year.
6. Topography and Monuments of Athens. C. H.
 Weller
 ——, elective, 2 h. a week through year.

Remarks.—An Art Museum containing a collection
of casts and many original art works, 3,000 books,
and several hundred photographs.

ST. LOUIS UNIVERSITY, St. Louis, Mo.

Founded 1818, instructors 218, students 1,371

No courses offered.

SYRACUSE UNIVERSITY, Syracuse, N.Y.

Founded 1870, instructors 250, students 3,300

1. History of the Fine Arts. Miss Irene Sargent
 1873, required, 1 h. a week for two years.[27]
2. History of Architecture. Miss Irene Sargent
 1873, required, 2 h. a week for two years.
3. History of Ornament. Miss Irene Sargent
 1873, required, 2 h. a week for two years.
4. History of French Art. Miss Irene Sargent
 1912, elective, 1 h. a week for one year.
5. Greek Epigraphy. E. A. Emens (Greek Dept.)
 ——, elective, 1 h. a week for one year.
6. Greek Archaeology. E. A. Emens (Greek Dept.)
 ——, elective, 1 h. a week for one year.
7. Topography and Antiquities of Greece. E. A.
 Emens (Greek Dept.)
 ——, elective, 1 h. a week for one year.

8. Topography and Monuments of Rome. H. L.
 Cleasby (Latin Dept.)
 ——, elective, 1 h. a week for one year.

Remarks.—4,000 plates, 1,000 photographs, 1,000
lantern slides, 200 books in department library, 200
casts, and one lantern.

TEMPLE COLLEGE, Philadelphia, Pa.

Founded 1884, instructors 240, students 3,153

1. History of Art. Miss L. H. Carnell
 1906, elective, 1 h. a week through year.
2. History of Renaissance Art. Miss L. H. Carnell
 1906, elective, 1 h. a week through year.
3. History of Modern Painting. Miss L. H. Car-
 nell
 1906, elective, 1 h. a week through year.

Remarks.—Equipment small; use may be made of
the Philadelphia Public Library, which contains
25,000 art books, and of the Pennsylvania Academy
of Fine Arts Collection.

TRINITY COLLEGE, Hartford, Ct.

Founded 1823, instructors 21, students 240

1. Greek Life and Archaeology. F. C. Babbitt
 (Greek Dept.) [28]
 ——, elective, 3 h. a week for one semester.
2. Latin Epigraphy and Antiquities. L. C. Barrett
 (Latin Dept.)
 ——, elective, 3 h. a week for one semester.

TUFTS COLLEGE, Tufts College, Mass.

Founded 1852, instructors 225, students 1,107

1. Greek and Roman Architecture. W. K. Denison
 (Latin Dept.)
 1900, elective, 3 h. a week for one semester.
2. Greek and Roman Sculpture. C. S. Wade
 (Greek Dept.)
 1900, elective, 3 h. a week for one semester.

Remarks.—About 2,500 lantern slides, several thou-
sand photographs (privately owned), and a valuable
collection of books.

TULANE UNIVERSITY, New Orleans, La.

Founded 1834, instructors 192, students 2,469

1. History of Ancient and Classic Architecture. W. Woodward
 ——, elective, 2 h. a week for one semester.
2. History of Mediaeval and Modern Architecture. W. Woodward
 ——, elective, 2 h. a week for one semester.
3. Greek Civilization and Art. W. Woodward
 ——, elective, 1 h. a week for one semester.
4. History of Ornament and Painting. W. Woodward
 ——, elective, 1 h. a week for one semester.

Remarks.—A school of Arts and Architecture, Newcomb Art Museum, and the Linton-Surght Hall Museum, which contains besides many original art works, about 2,000 volumes.

TUSKEGEE INSTITUTE, Tuskegee, Ala.

Founded 1881, instructors 183, students 1,702

No courses offered. [29]

UNION UNIVERSITY, Schenectady, N.Y.

Founded 1795, instructors 30, students 334

1. Outlines of Architecture. J. A. Callan
 ——, required, 2 h. a week for one semester.

Remarks.—Architectural models, lantern slides, and about 50,000 photographs, engravings, etc.

UNIVERSITY OF ARKANSAS, Fayetteville, Ark.

Founded 1871, instructors 125, students 1,463

1. History of Ancient and Mediaeval Art. Miss E. Galbraith
 ——, required (in Art Dept.), 1 h. a week through year.
2. History of Renaissance and Modern Art. Miss E. Galbraith
 ——, required (in Art Dept.), 1 h. a week through year.

3. History of Art (Biography of Artists). Miss E. Galbraith
 ——, required (in Art Dept.), 1 h. a week through year.

UNIVERSITY OF CALIFORNIA, Berkeley, Cal.

Founded 1860, instructors 386, students 3,450

1. History of Greek Art. O. M. Washburn
 ——, optional, 2 h. a week for one semester.
2. Introduction to Classical Archaeology. O. M. Washburn
 1907, optional, 2 h. a week for one semester.
3. Greek and Roman Architecture. O. M. Washburn
 1912, optional, 2 h. a week through year.
4. Virgil from the Monuments. O. M. Washburn
 1909, optional, 3 h. a week for one semester.
5. History of Architecture. J. G. Howard
 ——, optional, 2 h. a week for one semester.

Remarks.—Art museum contains three pieces of sculpture and seventy-five paintings, a large collection of Egyptian antiquities obtained from the Hearst Egyptian Expedition, a large collection of casts and coins, 4,000 lantern slides, and a valuable collection of books and photographs. [30]

UNIVERSITY OF CHICAGO, Chicago, Ill.

Founded 1892, instructors 354, students 6,466

1. Oriental Art. J. H. Breasted
 ——, optional, 3 h. a week for one semester.
2. Greek Art. F. B. Tarbell
 ——, optional, 3 h. a week for one semester.
3. Roman Art. F. B. Tarbell
 ——, optional, 3 h. a week for one semester.
4. Fifth Century Greek Sculpture. F. B. Tarbell
 ——, optional, 3 h. a week for one semester.
5. Greek Coins. F. B. Tarbell
 ——, optional, 2 h. a week for one semester.
6. American Art. G. B. Zug
 ——, optional, 3 h. a week for one semester.
7. Introduction to Study of Art. G. B. Zug
 ——, optional, 3 h. a week for one semester.

8. Flemish and Dutch Painting. G. B. Zug
 ——, optional, 3 h. a week for one semester.
9. Venetian and Spanish Painting. G. B. Zug
 ——, optional, 3 h. a week for one semester.
10. Italian Painting. G. B. Zug
 ——, optional, 3 h. a week for one semester.
11. Gothic and Renaissance Architecture. G. B. Zug
 ——, optional, 3 h. a week for one semester.

Remarks.—Use is made of the Art Institute of Chicago; a fairly extensive collection of photographs, books, and lantern slides.

UNIVERSITY OF CINCINNATI, Cincinnati, Ohio

Founded 1870, instructors 199, students 1,316

1. Greek Art and Life. J. E. Harry (Greek Dept.)
 1909, elective, 2 h. a week through year.
2. History of Art (Teachers College). Miss Kellogg
 ——, required, 2 h. a week through year.

Remarks.—About thirty Greek statues and a collection of books, photographs, and lantern slides. [31]

UNIVERSITY OF COLORADO, Boulder, Col.

Founded 1876, instructors 187, students 1,300

1. Art Forms. J. R. Brackett (English Dept.)
 1889, elective, 2 h. a week for one semester.
2. Greek Art. F. B. Hellems (Latin Dept.)
 1901, elective, 2 h. a week for one semester.
3. Greek and Roman Archaeology. F. B. Hellems
 (Latin Dept.)
 ——, elective, 2 h. a week for one semester.

Remarks.—Over 200 photographs, two dozen casts, 200 books, 400 folios of illustration, and 5,000 lantern slides.

UNIVERSITY OF DAKOTA WESLEYAN,
Mitchell, S. Dak.

Founded 1883, instructors 34, students 429

No courses offered.

Remarks.—The University has an Art School.

UNIVERSITY OF DENVER, Univ. Park, Col.

Founded 1864, instructors 104, students 1,214

1. Primitive Arts. A. F. Flynn
 ——, elective, 3 h. a week for one-fourth year.
2. Topography of Crete, Troy, Mycenae, Tiryns, Olympia, and Delphi. Miss G. H. Beggs (Greek Dept.)
 ——, elective, 3 h. a week for one-fourth year.
3. Topography and Monuments of Athens. Miss G. H. Beggs (Greek Dept.)
 ——, elective, 3 h. a week for one-fourth year.
4. History of Greek Sculpture. Miss G. H. Beggs (Greek Dept.)
 ——, elective, 3 h. a week for one-fourth year.
5. Topography and Monuments of Rome. A. H. Harrops (Latin Dept).
 ——, elective, 3 h. a week for one-fourth year.
 [32]

UNIVERSITY OF ILLINOIS, Urbana, Ill.

Founded 1867, instructors 550, students 5,207

1. History of Fine Arts. E. J. Lake
 1900, elective, 2 h. a week through year.
2. History of Architecture. N. C. Ricker
 ——, required of architectural students, 2 h. a week through year.
3. History of Architecture (Graduate course). N. C. Ricker
 ——, required of architectural students, 2 h. a week through year.

Remarks.—10,300 lantern slides, 2,500 photographs and plates, 2,400 stereoscopic views, 1,800 volumes on art, and a collection of casts. A small museum of Classical and Germanic Art is established this year.

UNIVERSITY OF INDIANA, Bloomington, Ind.

Founded 1820, instructors 80, students 2,431

1. History of Architecture. A. U. Brooks
 1898, elective, 5 h. a week through year.
2. History of Renaissance Painting. A. U. Brooks
 1900, elective, 2 h. a week through year.

3. History of Modern Painting. R. E. Burke
 1910, elective, 18 lectures.
4. History of Engraving. A. U. Brooks
 1912, elective, 10 lectures.
5. Topography and Monuments of Ancient Rome.
 L. G. Berry (Latin Dept.)
 ———, elective, 1 h. a week through year.

Remarks.—Some casts, 250 lantern slides, 2,000 photographs, and 450 Art books.

UNIVERSITY OF KANSAS, Lawrence, Kan.

Founded 1866, instructors 172, students 2,500

1. Greek Architecture (Graduate or Undergraduate course). A. M. Wilcox (Greek Dept.) [33]
 ———, elective, 2 h. a week for one semester.
2. Greek Sculpture (Graduate or Undergraduate course). A. M. Wilcox (Greek Dept.)
 ———, elective, 3 h. a week for one semester.
3. Topography of Rome (Graduate or Undergraduate course). Miss H. Oliver (Latin Dept.)
 ———, elective, 2 h. a week for one semester.
4. History of Modern Painting (School of Fine Arts). W. A. Griffith
 ———, optional, 1 h. a week for one semester.
5. History of Design (School of Fine Arts). W. A. Griffith
 ———, optional, 2 h. a week for one semester.
6. History of Greek Art (School of Fine Arts). A. M. Wilcox (Greek Dept.)
 ———, optional, 2 h. a week for one semester.

Remarks.—The University has a School of Fine Arts.

UNIVERSITY OF MICHIGAN, Ann Arbor, Mich.

Founded 1837, instructors 320, students 5,381

1. History of Greek Art. M. L. D'ooge (Greek Dept.)
 ———, elective, 3 h. a week for one semester.
2. Monumental History of Rome. F. W. Kelsey (Latin Dept.)
 ———, elective, 3 h. a week for one semester.

3. General Introduction to Fine Arts H. R. Cross
 1910, elective, 3 h. a week for one semester.
4. Roman and Mediaeval Art. H. R. Cross
 1910, elective, 3 h. a week for one semester.
5. Renaissance Art. H. R. Cross
 1910, elective, 3 h. a week for one semester.
6. Late Renaissance and Modern Art. H. R. Cross
 1910, elective, 3 h. a week for one semester.
7. History of Ancient Architecture. P. Ash
 ———, elective, 2 h. a week for one semester.
8. History of Mediaeval and Renaissance Architecture. P. Ash
 ———, elective, 2 h. a week for one semester.
9. General Course in Architecture. P. Ash [34]
 ———, elective, 2 h. a week for one semester.
10. Mediaeval Architecture. P. Ash
 ———, elective, 2 h. a week for one semester.
11. Renaissance and Modern Architecture. P. Ash
 ———, elective, 2 h. a week for one semester.

Remarks.—The Museum of the Fine Arts contains over 200 casts, a large collection of antique coins, and a good equipment for Art instruction.

UNIVERSITY OF MINNESOTA, Minneapolis, Minn.

Founded 1869, instructors 296, students 6,024

1. Greek Archaeology. J. C. Hutchinson (Greek Dept.)
 1898, elective, 2 h. a week through year.
2. Roman Architecture and Life. J. E. Granrud (Latin Dept.)
 1907, elective, 1 h. a week for one semester.
3. Roman Art. J. E. Granrud (Latin Dept.)
 1907, elective, 1 h. a week for one semester.
4. History of Modern Painting. H. C. Clopath
 1910, elective, 1 h. a week for one semester.

Remarks.—The University has an Art School.

UNIVERSITY OF MISSOURI, Columbia, Mo.

Founded 1839, instructors 213, students 3,141

1. History of Greek Art. J. Pickard
 1892, elective, 3 h. a week through year.
2. Renaissance Painting. J. Pickard
 1896, elective, 3 h. a week through year.

3. French and English Painting. J. Pickard
 1900, elective, 2 h. a week through year.
4. Modern Painting. J. Pickard
 1905, elective, 2 h. a week through year.

Remarks.—The Museum contains a collection of casts, several original marbles, 7,000 lantern slides, 2,000 photographs, and a fair Art Library. [35]

UNIVERSITY OF NEBRASKA, Lincoln, Neb.

Founded 1869, instructors 333, students 4,624

1. Greek Archaeology. J. T. Lees (Greek Dept.)
 ——, elective, 1 h. a week for one semester.
2. Roman Archaeology. G. E. Barber (Latin Dept.)
 ——, elective, 1 h. a week for one semester.
3. Roman Antiquities. G. E. Barber (Latin Dept.)
 ——, elective, 1 h. a week for one semester.
4. Italian Art. W. F. Dann
 ——, elective, 3 h. a week through year.
5. Dutch and Flemish Painting. W. F. Dann
 ——, elective, 3 h. a week for one semester.
6. Modern Painting. W. F. Dann
 ——, elective, 2 h. a week for one semester.
7. Cathedral Architecture. W. F. Dann
 ——, elective, 2 h. a week for one semester.
8. Modern Architecture. W. F. Dann
 ——, elective, 2 h. a week for one semester.

Remarks.—The University has a Fine Arts School; the Museum contains a valuable collection of casts, and the general equipment consists of 1,000 photographs, 500 slides, and about 300 books.

UNIVERSITY OF NOTRE DAME, Notre Dame, Ind.

Founded 1842, instructors 87, students 1,005

1. History of Architecture. R. Adelsperger
 ——, elective, 4 h. a week through year.
2. History of Ornament. R. Adelsperger
 ——, elective, 2 h. a week for one-fourth year.
3. History of Sculpture. R. Adelsperger
 ——, elective, 2 h. a week for one-fourth year.
4. History of Painting. R. Adelsperger
 ——, elective, 2 h. a week for one semester.

Remarks.—The University has a Fine Arts School.
 [36]

UNIVERSITY OF NORTH DAKOTA, Grand Forks, N.D.

Founded 1883, instructors 85, students 967

1. History of Ancient and Mediaeval Art. W. N. Stearns (History Dept.)
 ——, elective, 2 h. a week for one semester.
2. Greek Art. G. E. Hult (Greek Dept.)
 ——, elective, 2 h. a week for one semester.

UNIVERSITY OF OREGON, Eugene, Ore.

Founded 1876, instructors 113, students 1,484

1. Greek Art. J. Straub (Greek Dept.)
 ——, elective, 1 h. a week for one semester.
2. Topography of Rome. F. S. Dunn (Latin Dept.)
 ——, elective, 2 h. a week through year.
3. Ancient and Mediaeval Art. Mrs. Pennell
 1912, elective, 3 h. a week through year.
4. Modern Art. Mrs. Pennell
 1912, elective, 3 h. a week through year.
5. History of Architecture. ——.
 ——, elective, 3 h. a week through year.

Remarks.—The University has a small equipment at present.

UNIVERSITY OF PENNSYLVANIA, Philadelphia, Pa.

Founded 1740, instructors 540, students 5,200

1. Greek Epigraphy. W. N. Bates (Greek Dept.)
 ——, elective, 2 h. a week for one semester.
2. Introduction to Roman Archaeology. J. C. Rolfe (Latin Dept.)
 ——, elective, 2 h. a week for one semester.
3. Private Antiquities. W. B. McDaniel (Latin Dept.)
 ——, elective, 2 h. a week for one semester.
4. Ancient and Mediaeval Architecture. C. F. Osborne [37]
 ——, required for architectural students, 5 h. a week for one semester.
5. Renaissance and Modern Architecture. C. F. Osborne
 ——, required for architectural students, 6 h. a week for one semester.

6. History of Painting (lectures). H. E. Everett
———, required for architectural students, 1 h. a week for one semester.
7. History of Sculpture (lectures). H. E. Everett
———, required for architectural students, 1 h. a week for one semester.
8. History of Italian Painting. H. E. Everett
———, elective, 2 h. a week through year.
9. History and Theory of Architecture. C. F. Osborne
———, elective, 2 h. a week through year.
10. History of Italian Sculpture. H. E. Everett
———, elective, 2 h. a week through year.
11. Advanced Architectural History. C. F. Osborne
———, elective, 2 h. a week through year.
12. Advanced Research in History of Painting. H. E. Everett
———, elective, 2 h. a week through year.
13. Research in History of Sculpture. H. E. Everett
———, elective, 2 h. a week through year.

Remarks.—Equipment of Architectural School comprises 1,000 volumes, the leading periodicals, 20,000 photographs and lantern slides, and a collection of architectural casts; seven Fellowships are available to architectural students; the University Museum is divided into five sections, American, Eastern, Babylonian, Egyptian, and Mediterranean, all of which contain valuable collections of antiques.

UNIVERSITY OF PITTSBURGH, Pittsburgh, Pa.

Founded 1787, instructors 225, students 1,699

1. History of Greek Art. H. S. Scribner (Greek Dept.)
———, elective, 3 h. a week for one semester.

Remarks.—Use is made of the equipment of the Carnegie Institute Collections. [38]

UNIVERSITY OF ROCHESTER, Rochester, N.Y.

Founded 1850, instructors 32, students 450

1. Greek Archaeology. R. M. Kendrick (Greek Dept.)
———, elective, 5 h. a week for one-third year.

2. Roman Topography ahd Architecture. H. F. Burton (Latin Dept.)
———, elective, 5 h. a week for one-third year.
3. Italian Art. Miss E. H. Denio
———, elective, 3 h. a week through year.
4. The Art of France and England. Miss E. H. Denio
———, elective, 3 h. a week for two-thirds years.
5. The Art of Belgium and Holland. Miss E. H. Denio
———, elective, 3 h. a week for two-thirds years.
6. History of Architectural Styles. Miss E. H. Denio
———, elective, 3 h. a week through year.

UNIVERSITY OF SOUTHERN CALIFORNIA, Los Angeles, Cal.

Founded 1880, instructors 196, students 1,802

No courses offered.

UNIVERSITY OF TENNESSEE, Knoxville, Tenn.

Founded 1794, instructors 170, students 1,681

1. Greek Art. R. S. Radford (Latin Dept.)
———, elective, 3 h. a week for one semester.
2. Roman Life and Art. R. S. Radford (Latin Dept.)
———, elective, 3 h. a week for one semester.
3. History of Art (lectures). Miss Wiley
———, elective, 1 h. a week through year.

UNIVERSITY OF TEXAS, Austin, Texas

Founded 1883, instructors 107, students 2,758

1. Greek Art. W. J. Battle (Greek Dept.)
1901, optional, 2 h. a week through year. [39]
2. History of Architecture. H. F. Kuehne
1910, required for architects, 1 h. a week through year.
3. History of Ornament. H. F. Kuehne
———, required for architects, 1 h. a week through year.

Remarks.—A fair collection of books, 2,000 lantern slides, and about 60 casts of ancient Art.

UNIVERSITY OF UTAH, Salt Lake City, Utah

Founded 1850, instructors 61, students 1,845

1. Greek Archaeology. B. Cummings (Classics Dept.)
 ——, elective, 2 h. a week for one semester.

Remarks.—The University offers courses in Graphic Art.

UNIVERSITY OF VERMONT, Burlington, Vt.

Founded 1791, instructors 75, students 561

1. Greek Art. S. E. Bassett
 ——, elective, 3 h. a week for one semester.
2. Monuments of Ancient Athens. S. E. Bassett
 ——, elective, 1 h. a week for one semester.

UNIVERSITY OF VIRGINIA, Charlottesville, Va.

Founded 1819, instructors 74, students 725

1. Graeco-Roman Art. T. Fitzhugh (Latin Dept.)
 1902, required, 2 h. a week through year.
2. Ancient Art. T. Fitzhugh (Latin Dept.)
 1910, optional, 2 h. a week through summer.

Remarks.—A small collection of casts, 200 lantern slides, and a fair equipment of photographs.

UNIVERSITY OF WASHINGTON, St. Louis, Mo.

Founded 1853, instructors 195, students 1,075

1. Greek and Roman Art. H. Smith
 ——, elective, 3 h. a week for one semester.
2. Mediaeval Art. H. Smith
 ——, elective, 3 h. a week for one semester.
3. Renaissance Art in Italy. H. Smith
 ——, elective, 3 h. a week for one semester.
4. Modern Painting. H. Smith [40]
 ——, elective, 3 h. a week for one semester.
5. History of Painting. H. Smith
 ——, elective, 1 h. a week for one semester.

6. History of Sculpture. H. Smith
 ——, elective, 1 h. a week for one semester.
7. Ancient Architecture. J. B. Robinson
 ——, required of architects, 2 h. a week through year.
8. Mediaeval Architecture. J. B. Robinson
 ——, required of architects, 2 h. a week through year.
9. Renaissance and Modern Architecture. J. B. Robinson
 ——, required of architects, 2 h. a week through year.
10. History of Art Lectures (Fine Arts School). E. H. Wuerpel
 ——, optional, 1 h. a week through year.

Remarks.—The School of Architecture possesses 3,000 lantern slides, a large library, and the Russell Sturgis Collection of 20,000 photographs and 4,000 photogravure prints; the School of Fine Arts is equipped with its own art collections of books, photographs, and casts.

UNIVERSITY OF WASHINGTON, Seattle, Wash.

Founded 1861, instructors 128, students 2,156

1. Roman Antiquities. T. R. Sidney (Classical Dept.)
 ——, elective, 2 h. a week for one semester.

UNIVERSITY OF WISCONSIN, Madison, Wis.

Founded 1848, instructors 516, students 5,539

No courses offered.

VALPARAISO UNIVERSITY, Valparaiso, Ind.

Founded 1873, instructors 191, students 5,523

No courses offered.

Remarks.—The University has an Art School. [41]

VANDERBILT UNIVERSITY, Nashville, Tenn.

Founded 1872, instructors 120, students 990

No courses offered.

VASSAR COLLEGE, Poughkeepsie, N.Y.

Founded 1861, instructors 120, students 1,054

1. Ancient Art. O. S. Tonks
 ——, elective, 3 h. a week for one semester.
2. Mediaeval and Renaissance Architecture. O. S. Tonks
 ——, elective, 3 h. a week for one semester.
3. Italian Painting. O. S. Tonks
 ——, elective, 3 h. a week for one semester.
4. Northern Painting. O. S. Tonks
 ——, elective, 3 h. a week for one semester.

Remarks.—The Hall of Casts contains works of classic, mediaeval, and renaissance sculpture.

WASHINGTON STATE COLLEGE, Pullman, Wash.

Founded 1892, instructors 113, students 1,463

1. Ancient, Classic, and Mediaeval Architecture. H. T. Dysland
 ——, required of architects, 4 h. a week for one semester.
2. Gothic, Renaissance, and Modern Architecture. H. T. Dysland
 ——, required of architects, 4 h. a week for one semester.
3. History of Art. O. Jacobson [42]
 ——, required of Art students, 3 h. a week through year.

Remarks.—A fair equipment of books, slides, photographs, and casts.

[WASHINGTON UNIVERSITY: see UNIVERSITY OF WASHINGTON, St. Louis]

WELLESLEY COLLEGE, Wellesley, Mass.

Founded 1875, instructors 123, students 1,418

1. Introduction to Classical Archaeology. Miss Walton
 ——, elective, 3 h. a week for one semester.
2. Topography of Greek Cities. Miss Walton
 ——, elective, 3 h. a week for one semester.
3. History of Greek Ceramics. Miss Walton
 ——, elective, 3 h. a week for one semester.

4. History of Architecture. Miss Newkirk
 ——, elective, 3 h. a week through year.
5. Classical Sculpture. Miss Walton
 ——, elective, 3 h. a week through year.
6. XVth Century Italian Painting. Miss Abbot.
 ——, elective, 3 h. a week through year.
7. Italian Renaissance Architecture. Miss Newkirk
 ——, elective, 3 h. a week through year.
8. High Renaissance Italian Painting. Miss Brown
 ——, elective, 3 h. a week through year.
9. Outline of the History of Art. Miss Brown, Miss Abbot
 ——, elective, 3 h. a week through year.
10. Italian Painting (Graduate course). ——.
 ——, elective, ——.
11. Topography of Rome. Miss Walton
 ——, elective, 3 h. a week for one semester.

Remarks.—The Farnsworth Art Building, opened in 1889, contains lecture rooms, galleries for collections, studios, a large library and about 11,000 photographs. [43]

WELLS COLLEGE, Aurora, N.Y.

Founded 1868, instructors 38, students 200

1. Ancient and Classic Archaeology. T. J. Preston, Jr.
 ——, elective, 3 h. a week for one semester.
2. Northern Painting. T. J. Preston, Jr.
 ——, elective, 2 h. a week for one semester.
3. History of Italian Sculpture. T. J. Preston, Jr.
 ——, elective, 2 h. a week for one semester.
4. Christian Architecture of Northern Europe. T. J. Preston, Jr.
 ——, elective, 3 h. a week for one semester.
5. Italian Architecture. T. J. Preston, Jr.
 ——, elective, 2 h. a week for one semester.
6. Revival of Painting in Italy. T. J. Preston, Jr.
 ——, elective, 3 h. a week for one semester.

Remarks.—A small library, a number of casts, and over 10,000 photographs.

WESLEYAN UNIVERSITY, Middletown, Ct.

Founded 1831, instructors 37, students 390

1. Roman Topography and Public Buildings. K. P.
 Harrington (Latin Dept.)
 ——, elective, 3 h. a week for one semester.

THE WESTERN COLLEGE FOR WOMEN, Oxford, Ohio

Founded 1855, instructors 39, students 230

1. Topography and Monuments of Ancient Rome.
 Miss E. L. Bishop (Latin Dept.)
 ——, elective, 3 h. a week for one semester.
2. History of Architecture and Sculpture. Miss
 E. L. Hall
 1892, elective, 3 h. a week for one semester.
3. History of Painting. Miss E. L. Hall
 1892, elective, 3 h. a week for one semester.
4. Modern Art. Miss E. L. Hall [44]
 1908, elective, 3 h. a week for one semester.

Remarks.—A small collection of casts, and lantern
slides, several hundred photographs, and about 500
books.

WESTERN RESERVE UNIVERSITY, Cleveland, Ohio

Founded 1826, instructors 278, students 1,302

1. Ancient History (special reference to Art). H. N.
 Fowler (Greek Dept.)
 1895, elective, 3 h. a week through year.
2. History of Art (given alternate years). H. N.
 Fowler (Greek Dept.)
 1896, elective, 3 h. a week through year.

Remarks.—A few casts, a few hundred photographs,
and about 100 books.

WEST VIRGINIA UNIVERSITY, Morgantown, W. Va.

Founded 1867, instructors 95, students 1,172

1. Greek Art. W. J. Leonard
 ——, elective, 3 h. a week for one semester.
2. Mediaeval and Modern Art. W. J. Leonard
 ——, elective, 3 h. a week for one semester.

Remarks.—The University has a Fine Arts Department.

WILLIAMS COLLEGE, Williamstown, Mass.

Founded 1793, instructors 57, students 534

1. Ancient Art. K. E. Weston
 1897, elective, 3 h. a week for one semester.
2. Mediaeval Art. K. E. Weston
 1897, elective, 3 h. a week for one semester.
3. Renaissance Art. K. E. Weston [45]
 1897, elective, 3 h. a week for one semester.
4. Modern Art. K. E. Weston
 1897, elective, 3 h. a week for one semester.

YALE UNIVERSITY, New Haven, Ct.

Founded 1701, instructors 410, students 3,282

1. Greek Sculpture. P. V. C. Baur
 ——, elective, 3 h. a week for one semester.
2. The Greek Lesser Arts. P. V. C. Baur
 ——, elective, 3 h. a week for one semester.
3. Greek Architecture. P. V. C. Baur
 ——, elective, 3 h. a week for one semester.
4. Roman and Etruscan Art. P. V. C. Baur
 ——, elective, 3 h. a week for one semester.
5. Topography and Monuments of Athens.
 P. V. C. Baur
 ——, elective, 3 h. a week for one semester.
6. History of Architecture. R. H. Dana, Jr.
 ——, elective, 2 h. a week through year.
7. Trowbridge Lecture Course. Invited Lecturers
 ——, optional, ——.

Remarks.—The Jarves Gallery of Italian Art numbers one hundred and twenty paintings; Trumbull Gallery of historical portraits numbers fifty-four pictures; the Alden Collection of Belgian wood-carvings, a collection of one hundred and fifty casts, seven-hundred volumes in the Art Library, a collection of photographs, and four Fellowships for advance study in Art.

The Princeton Department
in the Time of Morey

CRAIG HUGH SMYTH

WHAT FOLLOWS is a glimpse of the Princeton department, just after Allan Marquand, in the regime of Charles Rufus Morey. Professor Morey (Figs. 5 and 9) succeeded Marquand as chairman in 1924 and continued to head the department until his retirement in 1945.[1]

In the late 1930s, John Coolidge (Fig. 39) and I sometimes talked under the trees by McCormick Hall at Princeton, while he was a graduate student at New York University's Institute of Fine Arts, but living in Princeton, and I was a graduate student in the Princeton department. On one of those occasions John characterized art history in general as having become a discipline concerned chiefly with facts and the evidence for facts, and as lacking, so far, a method to relate these facts to spiritual and cultural history except by intuition. A pointed observation for the time.

Factual art history had certainly been native to the Princeton department from the beginning—perhaps especially because of Marquand's having taken his graduate degree in philosophy at Johns Hopkins. Hopkins, founded in 1876, championed a "scientific" approach to the study of history on the example of von Ranke. That was also the time, as Felix Gilbert has recently stressed, when American higher education was beginning to aim at promoting professionalism and at forming research scholars[2] —true of Marquand's Princeton department. Morey, in his turn, reinforced momentum in the direction Marquand had originally led. In addition, he and his colleagues had critical concerns as well.

[1] For Morey's succession to the chairmanship as well as his beginnings in the department and information about other faculty members, see the singularly good account by Marilyn Lavin, *The Eye of the Tiger: The Founding and Development of the Department of Art and Archaeology, 1883–1923, Princeton University*, Princeton (1983). For excellent accounts of Morey's whole career, see the very fine obituary by Erwin Panofsky, "Charles Rufus Morey (1877–1955)," *Yearbook of the American Philosophical Society*, Philadelphia (1956), 482–491; and the informative obituary by Rensselaer Lee in the *Art Bulletin*, XXXVI, no. 4 (Dec. 1955), iii–vii. Also see the contribution concerning Morey in Part 2 of the present volume. (As printed here, this paper on Princeton differs somewhat from the paper delivered at the meeting of the College Art Association in 1987. Originally there was more on Morey. This has been reduced since the present volume includes the paper on Morey from the meeting of the following year. Hence there was room for more on other members of the department, added now in this version.)

[2] Felix Gilbert, "Leopold von Ranke and the American Philosophical Society," *Proceedings of the American Philosophical Society*, CXXX, no. 3 (1986), 362–366.

Mr. Morey had begun as a classicist, with an M.A. from Michigan. In 1900, when he became a Fellow at the American School of Classical Studies in Rome, he moved toward archaeology of the late antique and early Christian period. On this route he was exposed to archaeology's concern with discovery, assemblage, verification, analysis, and classification. By the academic year 1907–1908, he was giving his first course in medieval art at Princeton, becoming a self-taught medievalist, while continuing at the same time to study late antiquity.

In 1924, the year he succeeded Marquand as chairman, Morey brought out major publications in each of these two fields, late antique and medieval. Both publications are among his most admired, and together they represent a range of approach worth noting. One is a book about a sarcophagus discovered during the Department of Art and Archaeology's excavation in Asia Minor, certainly a prime candidate to exemplify archaeological art history in the United States.[3] It starts with a description of the sarcophagus and its discovery, proceeds then to catalogue all known Asiatic sarcophagi, and ends in an essay on the evidence. The other publication is Morey's article on the sources of medieval style, which is an interpretation above all, a critical theory concerning the development of four varieties of medieval style across a wide sweep of time and space, starting in antiquity.[4] Morey's course of lectures on medieval art for undergraduates followed the framework of this theory—replete with information, but with memorable characterizations of works of art, their relationships within the history of art, and their historical and cultural background.

The years 1917–1918 had presented another sharp contrast. In 1917 Morey invented the Index of Christian Art, the most factual of instruments for study, but in 1918 he published a sensitive critical essay on the sculpture of Rodin, in order to show how it marked an end to the classical tradition in European sculpture.[5]

Undergraduates experienced both aspects of Morey. To them he was a quietly imposing man of learning whose lectures, read to them evenly, firmly, without showmanship, were dense with facts, works of art, descriptions, and judgments, requiring much study and thought on the students' part. In graduate seminars he habitually assigned a work, or works, of art for research that could open up art-historical problems and possible solutions, could help in imparting his scrupulous methods of research and deliberation, and could lead students more often than not to publication in the medieval field, whether or not they intended to become medievalists. I think, for instance, of the excellent medieval articles of Alexander Soper, orientalist-to-be, resulting from Morey seminars.

It may be added in this connection that in Morey's regime, at least in my generation's time, seminars were nearly the only graduate courses in the Princeton department. Besides those given by faculty members, in the later 1930s Erwin Panofsky (Fig. 95) came fairly often from the Institute for Advanced Study to give a seminar, and also occasionally a series of lectures: my generation heard him lecture on Dürer and on iconology, for us an unprecedented

[3] C. R. Morey, *The Sarcophagus of Claudia Antonia Sabina and the Asiatic Sarcophagi*, Sardis: Publications of the American Society for the Excavation of Sardis V, Part 1, Princeton, 2 vols. (1924).

[4] C. R. Morey, "The Sources of Mediaeval Style," *Art Bulletin*, VII (1924), 35–50.

[5] C. R. Morey, "The Art of Auguste Rodin," *Art Bulletin*, I (1918), 145–154.

experience. Meanwhile graduate students having any important gaps in their undergraduate art-historical education were encouraged to start making up for them by auditing undergraduate lecture courses. In the end, it was each graduate student's responsibility, using the library, to prepare by himself (males only at that time) for the written examination given at the end of three years of graduate study. The examination extended "from the pyramids to Picasso" (the students' words), with at least something from the Far East. It lasted a five-day week: from a first nine-hour day of art-historical problems (a small list was given out in the morning from which to choose several from different periods), through a day of rest, to a nine-hour day reserved for questions of fact, through a another day of rest, to a final nine-hour day on one critical theme (here, too, there was a choice).

The contrasting examples from Mr. Morey's published work cited earlier and the equal emphasis upon facts, problems, and criticism in the final examination are symptomatic of a range of concerns in Princeton's department that need to be included in generalizations about it. Frank Jewett Mather, Jr. (Fig. 4) had been a member of the department for years. It is no accident that the College Art Association's award for criticism is named after Mather, whom Alfred Barr singled out for discerning the importance and stature of Matisse as a draftsman.[6] During Morey's chairmanship the faculty consisted mainly of Morey's own former students: together they made Princeton in the twenties and thirties a renowned world center of philological medieval studies. One of these medievalists was Albert M. Friend, Jr. (Fig. 8), known especially for his work on manuscripts which, though he published little, was profoundly admired by those who, like Kurt Weitzmann, knew it best.[7] Friend's contribution and wide influence as a medievalist have been well stated by Kleinbauer in his book of 1972 on art history.[8] But Friend was also the acknowledged source of "much of the critical analysis" that went into the philosopher T. M. Greene's *The Arts and the Art of Criticism*.[9]

This was a book that emerged from interest at Princeton in critical study in the humanities, sparked by Paul Elmore More, to whose circle both Friend and Greene belonged.[10]

[6] Alfred Barr, *Matisse: His Art and His Public*, New York (1951), 115: "[Mather's] review of Matisse as a draftsman [in 1910] . . . may well surpass any previous critical article on Matisse in any language for its objective analysis and sense of history." Paragraphs from Mather's review are reprinted by Barr in an appendix on page 556.

[7] See Kurt Weitzmann, quoted in Karl Sandin and Kristen Van Ausdall, "An Interview with Kurt Weitzmann," *Rutgers Art Review*, v (1984), 70–85. Among Friend's published works one thinks especially perhaps of "Portraits of the Evangelists in Greek and Latin Manuscripts," *Art Studies*, v (1927), 115–147, and vii (1929), 3–29. For more on Friend's contributions as a scholar, as well as on contributions of Morey and other Morey students to the study of Byzantine art (incorporated as a major constituent of their work on late antique and medieval art), see Kurt Weitzmann, "The Contribution of the Princeton University Department of Art and Archaeology to the Study of Byzantine Art," in *Byzantium at Princeton, Byzantine Art and Archaeology at Princeton University, Catalogue of an Exhibition at Firestone Library, Princeton University, August 1 through October 26, 1986*, ed. S. Ćurčić and A. St. Clair, Princeton (1986), 12–16.

[8] W. Eugene Kleinbauer, *Modern Perspectives in Western Art History*, New York (1971), 1.

[9] T. M. Greene, *The Arts and the Art of Criticism*, Princeton (1940). That the book was published just after war began in Europe was a great obstacle to its being known and having influence there.

[10] Students of my time who took courses at Princeton in Western literature (whether ancient Greek and Roman or modern European), or in the arts, or in history, or in philosophy, felt the influence of More's circle through a number of their teachers. It was from this circle that Princeton's Special Program in the Humanities, a purposely interdisciplinary program, was brought into being in 1936. Greene was one of the program's original prime movers, and E. Baldwin Smith of the Department of Art and Archaeology one of its most effective proponents with the university administration: see Wallace Irwin, Jr., "The Legacy of S.P.H.: How a Small Program in the Humanities [Eventually] Changed Princeton's Entire

Even before publication, Greene's book became important to a very considerable amount of study and teaching of the arts and literature in the 1930s at Princeton. For Greene worked closely with university colleagues as he was thinking and writing, and over a period of years he continually tried out the text on these colleagues, as well as in an annual undergraduate course that attracted many students. Through Greene, the influence of Friend's critical analysis reached deep and far in the university and ultimately to the book's wide audience beyond.

But the influence of Friend's critical thought also reached students directly. To juniors and seniors Friend offered a course entitled "Northern Renaissance Art." To quote one who took the course in the 1930s, "This was the high point of my education and became part of my life"—the words of a person who was later a combat pilot, a student and friend of Moholy-Nagy, an assistant to Herbert Bayer, and had a design career of his own. Many others might say the same. In twenty-four typewritten lectures—one of which he handed out at the beginning of each class, then read aloud and commented on—Friend gave an account of Western religious and philosophical thought: from the early Greeks to Augustine, Erigena, and Dionysius the Areopagite, to Scholasticism, mysticism, and Renaissance natural philosophy, Neoplatonism, and magic. The purpose he gave? To provide background for understanding what the later Middle Ages thought was "real." Accompanying the lectures, but purposely kept quite separate from them and always, so to say, ahead of them, were weekly preceptorials, given by Friend himself, on the art of the Rhine countries, France, and Spain. The preceptorials were not devoted to enumerating facts, but (as he finally explained explicitly in the last lecture) to an investigation of the "real" in the plastic arts and, concurrently, to an investigation of artistic expression, of the experience of the work of art as material and representation, of aesthetic experience and of spiritual experience, of the beholder's levels of consciousness, and of the evidence art gives, consciously and unconsciously, about thought, feeling, and life—of thinkers, yes, and also of people who make a civilization. There was no examination in the course. But somewhere in mid-term came an essay, to be written within ten days after the subject was announced. Usually, perhaps always, the subject was "the dignity of man." Submission of the papers was followed by meetings of each student with Mr. Friend, individually, for a long discussion, starting from the essay.

It may seem odd now to hear professors referred to as "Mister," as I have been referring to Morey and Friend here and there. When addressing faculty members at Princeton in those days, one said "Mister" as much as or more than "Professor," but rarely, if ever, "Doctor." As it happens, neither Morey nor Friend had a Ph.D. Nor was a Ph.D. the goal of

Curriculum," *Princeton Alumni Weekly*, LXXXVI (January 14, 1987), 11–19. Irwin's account includes a quotation (p. 18) from a statement by Professor Friend on the humanities—interesting to read now in a time that stresses the study of art in context. Faculty spokesmen, from various departments, tended to refer to the humanities as "studies which man makes of himself," having "an essential preoccupation with the realm of human value," with questions of good and evil (and of responsible action), and thus "forming the great balance wheel of man's life" (p. 16). Theirs was an inclusive view: in the words of Irwin, himself a graduate of the program in its earliest years, "If S.P.H. could be said to have an ideology, it was a belief in the supreme value, and the interconnectedness, of all studies relating to the human condition" (p. 15). Panofsky observed that "as the [Princeton] department [of art and archaeology] grew into an international center of research, it became, on the campus, a stronghold of the humanistic point of view (doubly important at a time when the validity of this point of view was beginning to be questioned)." See Panofsky (as in note 1), 487. One may think, in this connection, of Friend's course on the northern Renaissance, described below.

graduate study in the Department of Art and Archaeology. Students finished graduate study there with the M.F.A. At the time, an M.F.A. from Princeton had the job-getting power of a doctorate. Sooner or later after leaving graduate work one could submit a published book for the Ph.D. if one liked. This all changed after Morey, and the Ph.D. became what it was and is elsewhere.

Another major faculty member—and later chairman, following Morey—was E. Baldwin Smith, nicknamed "Baldy" (Fig. 7). He did have a Ph.D., awarded by the Princeton department in Marquand's time for a dissertation in the Early Christian field that followed soon upon his graduate study. To undergraduates Smith taught courses on ancient and medieval architecture which were generally considered introductory to the department (there were no art history surveys). These courses stood out as not only preeminently solid, but eye-opening, thought-provoking, and among the courses most vividly remembered by students—providing to many of them, one might guess, a structure for considering ancient and medieval history.[11] Smith also taught undergraduates the history of modern painting from the seventeenth century into the twentieth, a course many students in my time were grateful for. Although it may seem surprising that modern painting was entrusted to an architectural historian and odd, too, that Smith's stentorian delivery and his matter-of-fact manner could make a good vehicle for the subject, the course drew students in large numbers and stood up well for the time—at least until it came to recent painting, for much of which the lecturer made it clear he had no sympathy. To graduate students, meanwhile, Smith was all architectural historian. Anyone who knows his book *The Dome: A Study in the History of Ideas* can imagine how widely and deeply his seminars could probe,[12] while his pro-seminars were the department's standard initiation to graduate work.

Professor George Rowley (Fig. 10), too, excelled in the department, teaching and writing on Far Eastern art. Rowley imparted his very individual view of the principles of Chinese art in reference to the culture from which it came, a view remarkably inspiring to students, graduate and undergraduate, and of much interest to other scholars, even those who questioned some of its aspects. Something of what he gave in his courses can be gleaned from his book *Principles of Chinese Painting*.[13] Rowley was a critical historian of art. Among his graduate students were Alexander Soper and Wen Fong, a remarkable legacy.[14] Like Rowland at Harvard, Rowley had a wide reach, having begun in the trecento, to which later in life he returned once more with his book on Ambrogio Lorenzetti.[15] For undergraduate

[11] As mentioned in note 10 (Irwin, 13–14), Baldwin Smith was also a key figure in bringing Princeton's new Special Program in the Humanities into existence.

[12] This book is among Smith's best-known publications on architecture: E. Baldwin Smith, *The Dome. A Study in the History of Ideas*, Princeton (1950).

[13] George Rowley, *Principles of Chinese Painting, with Illustrations from the Du Bois Schank Morris Collection*, Princeton (1947).

[14] For an appreciation, see Alexander Soper's addendum to an article by Rowley reprinted by Soper: G. Rowley, "A Chinese Scroll of the Ming Dynasty: Ming Huang and Yang Kuei-fei Listening to Music," *Artibus Asiae*, XXXI (1969), 5–31. [I owe this reference to Elizabeth Childs-Johnson, who includes something on Rowley's influence in her article, "Professor Alexander C. Soper," *Observations*, XXI, i (1990), 27.]

[15] George Rowley, *Ambrogio Lorenzetti*, Princeton (1958).

advisees he was likely to urge senior thesis topics far from his specialties: "Bernini and the Baroque" is one I know of.

To convey a picture of the department properly one should mention much else: for example, that the small preceptorials for undergraduate lecture courses were taught by nearly all the department's faculty members, however renowned. Preceptorials might even stimulate the wish to be an art historian, as one given by George Forsyth did in my case. There should be mention—much more than mention—of other teachers and their courses. In the mid-thirties Kurt Weitzmann arrived, but in his first years he taught only graduate students in a manuscript course with Friend. Professors Donald Egbert, Ernest DeWald, George Elderkin, and Frederick Stohlman—each in his own way was informative, sensitive, and generally satisfying to students.[16] Richard Stillwell was a strength for graduate students. Preceptors whom I can remember as serving briefly and effectively in my time were Franklin Biebel, Joseph Sloane, and Alexander Soper—all three had the M.F.A. before they taught, and all became well known in their later careers on leaving Princeton.

Yet it should be said that for the most part courses for undergraduates appeared to present the history of art as settled, as having no problems to solve. Under the Princeton trees John Coolidge spoke of the Princeton department in the thirties as no longer interested in anything but checking up on details. Graduate seminars—like those, for example, on manuscripts with Weitzmann and Friend or on architecture with Smith—showed that this was not true. But John Coolidge's view is understandable, for he was looking at Princeton from the graduate department at New York University with its newly arrived faculty members from Germany: that did suddenly seem to be the place where new ferment and new ideas were concentrated.

[16] I think, for instance, of the credit Thomas Hoving often gave Mr. Stohlman's seminars for his decision to go on in art history.

An Undergraduate's Experience of Fine Arts
at Harvard in the 1920s

EDWARD M. M. WARBURG†

AT THE GRADUATION ceremony in June, 1930, I was Class Orator. These ceremonies took place in Memorial Hall, in that section called Sanders Theater. In my oration I attacked the Harvard tutorial system so violently that the magazine *The Nation*, under the heading "Fair Harvard," commented, "Only Fair, Says Edward M. M. Warburg, Class Orator of the Class of 1930."

Two rather embarrassed members of my audience were Professor Paul J. Sachs (Figs. 33, 37, and 38), outstanding member of the Department of Fine Arts at Harvard and my faculty advisor, and my father, a friend of Sachs. In the early days of the new Fogg Art Museum (Fig. 28), they had worked hard together as a fund-raising team to develop this institution. They naturally hoped that on this day they would be given the opportunity to bask in the warm words of praise that would waft in their direction from the speaker's platform. But that was not to be. The theme of my attack was the lack of contact during the student's undergraduate years between the students and the professors and even the instructors. The one possible exception was the tutors, who had been mainly chosen from among the ranks of the instructors. Their primary interest, at this stage of their careers, was *not* in teaching, but rather in achieving their next academic degree, M.A. or Ph.D.

When asked my view of the Harvard system of teaching art history, I can only talk from the worm's-eye view of an undergraduate. I guess the position of graduate students was reserved for those glow worms who shone in the dark. I never had any contact, other than sitting at a lecture, with the great professors who were the stars in the great lecture halls. One of these stars was Chandler Post (Fig. 33). He was the epitome of the scholar-academician, who required his students to memorize the points he made both in his lectures and in his books, which were required reading. Under each heading he indicated which questions he might ask in the exam, and one had to memorize every point he made. I often wondered whether he ever really particularly enjoyed the paintings, or the sculpture, or the architecture he was talking about. He certainly knew all the facts about them. And these facts he continued to pass on, year after year, to his students at Harvard. I did find out a secret interest of his: he was a great fan of Greta Garbo. This I found encouraging. The lack of contact with our star professors was also true of Professors George Chase, Langdon Warner, George Edgell, and Arthur Pope (Fig. 33), from whom we learned about glazes, oil and tempera, as

well as watercolor (Fig. 32)—even to the up-and-coming men like Leonard Opdyke and Arthur McComb.

In the four years of my undergraduate life, however, three people do stand out as most positive forces in my education in the fine arts at Harvard. The first was Professor Sachs himself. He had formerly been in the banking world, in Goldman-Sachs. Both he and my father, who had been pulled into his family firm by his father-in-law, soon recognized that this was not the field in which they wanted to spend the rest of their lives. Sachs and father had in common their interest in the fine arts. Through contacts that Sachs had at Cambridge, mainly Edward Forbes (Fig. 33), Sachs joined the university. Father never made the clean cut from the world of banking, but he did become involved with the Cambridge scene, helping Sachs and Forbes as they developed the department and established new quarters for the museum.

As a young man Sachs collected avidly and traveled extensively throughout Europe. His field was mainly that of prints and drawings, but his discerning eye found much of interest in all forms of art. He finally moved his family and his treasures to Charles Eliot Norton's house, Shady Hill (Fig. 25), and there played host to thousands of students and scholars, not only from Harvard, but anyone who happened to be passing through Cambridge. Undergraduates, and I was one of them, often came to consult him at Shady Hill and in his office. He became particularly well known for that one thing which is synonymous with his name, the museum course (Fig. 38). The museum course was mainly for graduate students; I never had the chance to attend. Suffice it to say that Sachs here instilled in the future leadership of the art world not only his knowledge of the arts, but his understanding of museum administration and the complicated world of art collecting. At that time he was the major force in training the museum directors and curators of this country, and in pulling together the necessary trustees to support and back their programs. Not until much later did other centers for the study of art rival the patterns and personalities emerging into the museum world from Harvard.

Sachs had numerous connections here and abroad, and always armed anyone traveling to Europe with letters of introduction to the collectors and the dealers, enabling them to see as much as possible of the treasures of Europe, not only in the great public institutions, but in the nooks and crannies, and particularly in the private collections. During Easter vacations Sachs took his whole class to New York, to Philadelphia, or to nearby collections, giving students a chance not only to see the collections, but to talk with those who collected them. He would get the collector to stand and answer questions: why he had chosen a particular object, how it came into his collection, what the story of the object was, making possible an evaluation of both the object and the man who had collected it.

Paul Sachs was a builder. He created both the demand for and the supply of qualified personnel to manage and to staff institutions old and new. I found soon that as I traveled in this country, no matter where I went I always ran into a Fogg-trained person, ready to offer hospitality and guidance. And Sachs had put his stamp on all of them. It was his set of values that shaped so many of us.

The second force in my education in the fine arts at Harvard was Agnes Mongan (Fig. 41). No doubt others would say the same. Sachs's discerning eye spotted the young graduate of Bryn Mawr College. He asked her to come and assist him with his world-famous collection of drawings. Over the course of the years she has become internationally revered and, before she retired, was the director of the Fogg Museum. She claims she is retired, but the only thing that seems to slow her from time to time are problems of health. To this day she is advising young people who are starting out in the field. She's had to swim upstream against the Harvard tradition of bias in treating members of the female sex. But more than anybody she has been the observer *par excellence* of generations of undergraduates and, when requested, served as their mother confessor. All of us who admire her are delighted that, belatedly, Harvard, the Women's Caucus for the Arts, and even the Vatican itself, have found means of honoring her.

But I think I learned the most about the fine arts while at Harvard from a classmate. Again, no doubt, others of various Harvard generations might say the same. The classmate in my case was Lincoln Kirstein (Fig. 40). Our families had had business connections, and each of us had been told firmly before entering our freshman year that we must look each other up. This delayed our getting together for many months. But we met, and have been friends ever since, though it has not always been easy.

Many consider Lincoln Kirstein to be a genius. A year older than most of his classmates, he was many years older in intellectual maturity: avid reader, competent painter, and a student—but awkward practitioner—of the art of dance. He was an avid art hunter who knew his museums, here and abroad, as well as the dealers' galleries, artists' studios, and book stores. He frequented them all, particularly whenever he traveled. In the freshman dorms we had many bull sessions on the subject of art. It was in these discussions that I was made especially aware of art patronage. Also, Lincoln had a theory: that the best way for artists to earn a living was through cooperative effort in theatrical performances. He thought box office receipts would yield an adequate living for each. He was thinking especially of ballet, and later, of course, he originated the School of American Ballet. Meanwhile, as an undergraduate, he founded the now famous magazine *Hound and Horn*, persuading W. H. Auden, T. S. Eliot, and e e cummings to be contributors, also publishing much on photography, music, architecture, and the related arts.

He persuaded me and another undergraduate friend, John Walker, to join him in founding the Harvard Society for Contemporary Art. Our purpose was to supply a need that the Department of Fine Arts had not yet set out to fill. We rented two rooms over the Harvard Coop and exhibited contemporary art, borrowed from collectors, artists' studios, and dealers, from as far away as New York. We did our homework while doubling as guards and trying to answer visitors' questions. On one occasion Sandy Calder made an exhibition of his work for us on the spot with his tools. What began then continued after graduation: we worked together on various committees on the arts. Lincoln concentrated his patronage on specific artists. We both kept Lachaise busy. And there were others like Paul Cadmus, Tchelitchew, and Nadelman, not to mention the promotion of the renaissance of St. Gaudens.

John Walker, of course, went on to become chief curator and then director of the National Gallery of Art.

Certainly the influence of the Department of Fine Arts has affected the whole cultural scene in America. Sachs himself and the people he helped educate, including Alfred Barr of the Museum of Modern Art and John Walker of the National Gallery, are testimony to the golden years when Harvard supplied both personnel and training for the art museums of America.*

* EDITORS' NOTE: Sad to say, Edward Warburg died in 1992. He had shortened this paper when editing it for publication, evidently thinking some parts, touching on his family (one of his uncles was Aby Warburg) and on his friends at Harvard, more appropriate to a book, then in prospect, about Edward Warburg, Lincoln Kirstein, and their circle. This has recently appeared (Nicholas Fox Weber, *Patron Saints. Five Rebels who Opened America to a New Art 1928–1943*, New York [1992]). For more on the Harvard Department of Fine Arts, see besides the immediately following contributions the historical account by Sybil Gordon Kantor in Part 3 of this volume, pp. 161–174.

Harvard and the Fogg

AGNES MONGAN

Wᴴᴱᴺ I accepted the invitation to discuss the early days of the Department of Fine Arts and the Fogg, I had no idea of how little I knew of certain circumstances. Since that day, I have found material I did not even know existed. It has altered my point of view in a number of ways. For example, I have known something about Charles Eliot Norton (Fig. 24) for years, but clearly it was not enough. Earlier this year the American Academy of Arts and Sciences, of which I am chairman of the House Committee, requested that I give a talk on Charles Eliot Norton because the new house of the academy is where Shady Hill, as the Norton house was known, used to stand (Fig. 25). I checked many sources in preparation. In fact, I thought I had almost enough material to write a biography of Norton. A number of things surprised me. I had significant dates, but for this occasion I have found many more. I can perhaps indicate to you certain directions of inquiry that might be followed.

Charles Eliot was the president of Harvard in the middle years of the nineteenth century. It was he who asked Charles Eliot Norton, his first cousin and also a Harvard man, to give up what he was doing in Boston and come to Harvard to give a course on the fine arts. What were Norton's qualifications for giving such a course? What was he doing?

As a young man he had gone to Europe several times, especially to England and to Italy. He had translated and interpreted Dante, and written on the churches of the Middle Ages. He loved the Gothic style. Once on a walk in Switzerland, Norton had run into a man named John Ruskin (Fig. 26). They quickly became friends and remained friends as long as they lived. It was a friendship that had a deep influence on Ruskin as well as on Norton. When John Ruskin died, Norton became the executor of his will, and the papers that detail his task as executor are now in the Houghton Library at Harvard.

Norton was a good friend not only of Ruskin, but also of Longfellow, James Russell Lowell, and a number of other poets. Norton, too, was a writer. When he accepted the Harvard appointment to give what is generally said to be the first fine arts course given anywhere in America or England,[1] he was the editor of the *New England Review*. He had just been asked to become the editor of the *Atlantic Monthly*, and was considering accepting that appointment, but decided to come to Harvard instead.

He gave his lectures in Sanders Theater at twelve o'clock. Roughly twelve-hundred students came to every lecture. There were no slides. There were no photographs. There was

[1] But see now the article by Pamela Askew in this volume, pp. 57–63.

no one to take attendance. In addition to the students, there was a young lady who, to his surprise, came several times. He watched her, became interested, and asked to be presented to her. Her name was Isabella Stewart Gardner. We know something of the results of the meeting: it is believed that Norton introduced Bernard Berenson to Mrs. Gardner. Berenson had taken Norton's course as an undergraduate—the same year that Grenville Winthrop took it. It was Mrs. Gardner who made it possible for Berenson to go abroad after his graduation. Had it not been for Charles Eliot Norton, she might not have met Berenson, and Berenson might not have gone into the fine arts.

It was Norton who invited Charles Herbert Moore, a painter of landscapes, to become director of the first Fogg building, which was finished in 1895 (Figs. 29 and 31). Moore, who lived from 1840 to 1930, had come to Harvard as the instructor in draftsmanship at the Lawrence Scientific School. He was to teach scientists how to draw. I had not known about his work when I first came to the Fogg in the fall of 1928. The *new* Fogg, as it was then called, had opened in 1927 (Figs. 28 and 30). On the fourth floor I saw that the staff was putting many watercolors and drawings together in piles. I suddenly realized that some members of the Department of Fine Arts—one of them was Arthur Pope—were not interested in the work of these watercolorists. They were not putting the watercolors on display, they were putting them away. Watercolors by Moore were among them.

This is a somewhat strange but not unusual story about taste. C. H. Moore was considered by Frank Jewett Mather, Jr. to be one of the great painters of the nineteenth century. But Mather's view was not shared by Pope. Mather (Fig. 4) wrote a small book about Moore, which was finished, but not published, before Mather died. It was brought out in 1957, long after Moore's death, by his friends as a proper memorial, not only for Charles Herbert Moore, but for Frank Jewett Mather, the art historian who wrote it.[2]

I can remember seeing, at that time, photographs of Moore's work as well as original drawings. Now I am intrigued to know more about Moore. I intend to go back to the Fogg to see if I can find those eighty-one drawings and watercolors.

As I commented a moment ago, the new Fogg—the red brick building (Fig. 28)—opened in 1927. That is the building where classes and exhibitions have taken place for the last sixty-five years (Figs. 30 and 32). As I also mentioned, the old Fogg, which no longer exists, had opened in 1895. I have been asked over and over again, "Why Fogg? Who was Fogg?"

William Hayes Fogg was not a Harvard man. He was a gentleman from Berwick, Maine, who went into the China trade and made a fortune. Mr. and Mrs. Fogg lived in New York. He was very taken with certain Chinese pictures and with certain types of Chinese art. When he died, his wife went to her lawyer—the Foggs were childless—and said she wanted to make a worthy memorial to her husband. What did the lawyer think could be done? The lawyer—he must have been a Harvard graduate—suggested, "Why don't you give the money to Harvard to build a museum?" She thought it was a wonderful idea and did just that. That is why it is called the William Hayes Fogg Art Museum.

[2] Frank Jewett Mather, Jr., *Charles Herbert Moore, Landscape Painter*, Princeton (1957).

Charles Eliot Norton had already been teaching for two decades, in the 1870s and 1880s, before Moore arrived. Moore held the post of Director of the Fogg until 1909. A year after Charles Eliot Norton's death in 1908, Henry James, one of Norton's friends and a former student, who lived near Shady Hill, wrote three and a half pages about Charles Eliot Norton for the 1909 fall number of the *Burlington Magazine*. By that time the Fogg Museum was fairly well known. Charles Herbert Moore and Charles Eliot Norton had both continued their friendships with the English scholars and English artists they had known. They also continued their trips, especially to Italy, where they looked at early Italian paintings.

In 1909, Edward Forbes (Figs. 32 and 33) followed Moore as Director of the Fogg. Forbes, who had been a Harvard undergraduate, used to describe the original Fogg as "a building where there was a lecture hall in which you could not hear, a gallery in which you could not see, working rooms in which you could not work, and a roof that leaked like a sieve." I can remember him saying it over and over. But works of art had begun to accumulate. In 1915 Forbes succeeded in persuading Paul Sachs to come to Cambridge and join him in running the Fogg.

Paul Sachs, class of 1900, had been a member of the Fogg's Visiting Committee since 1911 (Figs. 33, 37, and 38). As a young boy he had collected photographs of works of art and original prints. He continued to collect prints and then added drawings. By the time that Edward Forbes persuaded him to come to Cambridge, Paul Sachs was able to convince his father that he had a legitimate reason for moving. His father had wanted him to stay on Wall Street and succeed him as head of Goldman-Sachs, but Paul had never wanted to remain on Wall Street. It was his service during the First World War that made the difference. I cannot say that he had a brilliant war career, but it was a very unusual one. Paul Sachs was just five feet tall. When he tried to enlist early in the First World War, the Army turned him down. So he joined the Red Cross and became a colonel in the Red Cross. He worked with the wounded soldiers of the French and American armies on the western front. When he came home, he was something of a hero to the many wounded he had helped. His father was then perfectly willing to let him go to Cambridge. Paul Sachs and his family moved into the house where Norton had lived.

It was in that house that Sachs began the museum course, the first of its kind anywhere. When he settled in at Shady Hill (Fig. 25), the wooded hillside was still known as Norton's woods. Sachs had not been born soon enough to have gone to Charles Eliot Norton's lectures as an undergraduate, but he had known Norton, and he knew well the history of the house. He carried on its reputation for hospitality in a wonderful way. As his assistant, I met many of the famous scholars, several famous poets, and some of the famous painters and musicians who came to dinner there as Sachs's guests. Paul Sachs always invited the holder of the Norton lectureship to come to Shady Hill to be entertained at a dinner party and, more often than not, to give a lecture after dinner.

Sachs had been impressed by Edward Forbes's course on the history of techniques. I believe this was the first course on the history of techniques. Among students it was known as the "egg and plaster course" (Fig. 32). Following precisely the instructions of the fourteenth-century writer Cennino Cennini (except for finding under the dining room table the chicken

bones to supply the needed calcium) each member of the Forbes class had to do a fresco using trecento techniques. We also had to make a silverpoint drawing, paint a small tempera panel, make a painting using the techniques of the Venetians, and one using a nineteenth-century technique. This was so we would all recognize immediately the technical characteristics of such works of art.

Sachs, whose approach was different, added something just as distinct. The museum course met at Shady Hill more often than at the Fogg, and the class was held in the long drawing room. That room was bordered by bookshelves, which were about four feet high. On the top of every single one of those shelf divisions there would be one or two works of art. We would sit facing Paul Sachs, who sat at a small table. He would get up and take an object off one of the shelves. It might be a small bronze Assyrian animal, a Persian miniature; in another case, a trecento ivory, occasionally a small Khmer bronze head. He would put it in our hands, wait a minute, and then say, "What does it say to you? Is it a work of art? What do you think of the material? Is it well handled?" And there you would sit with some incredibly rare object in your own two hands, looking at it closely. It would stir you deeply—you could never go into a museum and touch a work of art, you could never feel it quite this way. "What is it? Is it worth paying attention to?" If it wasn't worth paying attention to, you were to say so. Not every object was a great work of art.

Each year Paul Sachs took the class to New York, and sometimes to Philadelphia and Washington. He took us not only to the great museums, but also to the great private collections, to the dealers, and to the auction houses. He made us look at works of art everywhere, and later would ask us what we thought of them. We did not say in their presence what we thought of them, but had to remember.

I have to add one little story. Paul Sachs once took us to Duveen's on Fifth Avenue. I do not know how it happened, but Lord Duveen, Paul Sachs, and I were going up in the elevator together. Suddenly the elevator stopped between the second and third floors. Duveen went into a fury. P. J. (as we called Paul Sachs among ourselves) had a temper, but he kept perfectly calm. Duveen made enough noise so that somebody came and opened the gate above. With the help of Paul Sachs, Duveen got up, and with the help of hands pulling him, he got out. Eventually, we, too, were rescued. I shall not forget that visit to Duveen's!

Arthur Pope (Fig. 33) followed Edward Forbes and Paul Sachs as director of the Fogg. It was a great change. At that time Pope was known well beyond the Harvard world for the book that his noted course made familiar to a large audience of artists and art historians, *An Introduction to the Language of Drawing and Painting*.[3] He continued to teach until he retired in 1948. John Coolidge (Fig. 39) followed Arthur Pope as director, but John's appointment takes us beyond the early glimpse I was asked to give you.

[3] Arthur Pope, *An Introduction to the Language of Drawing and Painting*, 2 vols., Cambridge, Mass. (1929–31).

The Harvard Fine Arts Department

JOHN COOLIDGE

I KNEW the Harvard Fine Arts Department as an undergraduate from the fall of 1931 until the spring of 1935. My impressions at the time were minimal. It was only after several years of the vivid experience of studying at the Institute of Fine Arts of New York University that I thought back about Harvard and tried to define the way it contrasted.

The department I knew consisted of three groups. First, an all-powerful and close-knit old guard (Fig. 33): Professors George Chase, Chandler Post, Paul Sachs, and Arthur Pope. Kingsley Porter (Figs. 34, 35) taught only half-time, and then mostly graduate students. Wilhelm Koehler (Fig. 36) was only a nominal member of this group, appearing magisterially but erratically at their committee meetings. Second, a variety of distinguished part-time teachers who had no interest in or responsibility for the department, men like Edward Forbes, the director of the Fogg, Langdon Warner, the Curator of Oriental Art, and the scintillating George Edgell, then Dean of the School of Architecture (Fig. 33). Third, and very much in addition, some men approaching, or in, their thirties: Charles Kuhn, Ben Rowland, Frederick Deknatel, among others. They taught no courses then and, though sympathetic personally, appeared to have no influence whatever (although Charles Kuhn must have already begun to build the collections of the Busch-Reisinger, for which he, more than anyone else, must have the credit). That there was in addition a professional staff at the Fogg Museum, we undergraduates had no concept.

I took the obligatory one-year introductory historical survey, also the obligatory one-year introduction to the traditional methods of drawing and painting. (I flunked this the first year, and with difficulty obtained a D the second time around.) For the other twelve semester-courses in fine arts, I took perhaps a third in architecture, primarily with Leonard Opdyke and Kenneth Conant (Fig. 33). The remainder were pretty well scattered east and west. No course on twentieth-century art was offered.

I was lucky as an undergraduate to have had Porter's last course, to have spent a summer at Cluny with Kenneth Conant, and also to have taken a course with T. S. Eliot the year he was visiting professor. In summer school, shortly after graduation, I took a course in late nineteenth-century French painting with Paul Sachs. I rank him with Karl Lehmann of New York University's Institute as the best fine arts teacher I ever had. Sachs (Figs. 37 and 38) imparted an intimate, sensuous knowledge of individual objects, much like a passionate gardener's informed affection for specific plants. But if referred to as a scholar, he would protest with that same mixture of astonishment and faint disdain that a gardener would

exhibit if called a botanist. Less luckily, I had to dissolve the Harvard Society for Contemporary Art; our final letter of appeal was sent out the day before Roosevelt closed the banks.

The pillars, Pope, Post, Sachs, and kindly Chase (then Dean of the Faculty) were distant. Accosted after class, they would answer a question pleasantly and then rush off to their next engagement. Porter clearly was less remote, but his disappearance in Ireland occurred soon after I arrived.

Chandler Post (Fig. 33) seems to have set the intellectual tone. His was a memory of western art and history since Constantine that was as comprehensive, accurate, and non-discriminatory as the white pages of the phone book. A candidate for the Ph.D. was expected to have a universal knowledge of the history of art when he took his oral general examination. Reputedly, on one such occasion Post said: "Mr. So-and-so, will you tell us who were the popes between Martin V and Innocent X?" The student was interrupted and corrected as he replied. Then: "Now, Mr. So-and-so, who made their portraits?"

We were largely unaware that the faculty members were engaged in research. We knew they were learned—that is, they had obviously spent many years in a wearisome accumulation of facts. The idea that research was an ongoing, exciting activity, fueled by finding something new every week, was one of the astonishing discoveries for me at N.Y.U.

Langdon Warner taught a seminar on Chinese and Japanese sculpture, much of it conducted in the galleries and storerooms of the Fogg Museum and the Boston museums. This was the only course I took which involved direct study of original works of art. Toward the end of senior year we had to take an oral examination, and rumor had it that Paul Sachs would ask us to name the finest works of art in the Fogg Museum. We crammed accordingly, and were not disappointed. I did look at buildings and in the end wrote my honors thesis about Gothic Revival churches in New York and New England. This was neither applauded nor condemned.

As I look back, the Fogg seemed a great mechanism. There was no sense of direction, little individual instruction (in marked contrast to what my roommates received in "History and Literature"). The oligarchy and the drones carried out the rules, much as the administrators and the postmen accepted and delivered mail. There was no corporate life in the student body. It astonishes me now, but did not then, that I knew neither Robert Smith, a year ahead of me, nor Sydney Freedberg, a year behind. I can't imagine how Perry Rathbone and Otto Wittmann scented me out to ask me to take over from them the Harvard Society for Contemporary Art.

In fact, the Fogg I knew was midway between two revolutions. Just before my time there had been that extraordinary young group of students who largely established the awareness of twentieth-century art in this country. Edward Warburg has touched on this in his contribution to this volume. Although they had been at hand and were well known to the powers that were, none was asked to join the club. On the contrary. Russell Hitchcock was allowed to flunk his general examination for the Ph.D. Alfred Barr found a job teaching at Wellesley; there was nothing for him at Harvard. (We were astonished in the 1940s when he registered for his Ph.D., proposing his *Picasso: Fifty Years of His Art* as a thesis.) None of their group individually, nor all of them collectively, left any lasting mark on the institution. I

initially proposed to write my honors thesis on the aesthetic evolution of automobile design; it was deemed unacceptable.

In the second revolution, the coming of the refugees, Harvard participated early. Wilhelm Koehler (Fig. 36) was appointed in 1932 or 1933, Jacob Rosenberg in the mid-thirties. But Koehler had no ambition to influence, let alone to lead the department. Rosenberg was too conscious of himself as a curator with a courtesy professorial title to play an active part in undergraduate education. It was only after my return in 1947 that I came to realize how much these two had in fact accomplished, Koehler as a teacher of individual graduate students, Rosenberg in reforming the abominable traditional oral examination for the Ph.D., and in building up a splendid collection of twentieth-century prints.

In general, it now seems to me that our leading American scholars and administrators of that era—Charles Rufus Morey (Figs. 5 and 9), even Walter Cook (Fig. 96)—admired the refugees as brilliant individual specialists, be it a Goldschmidt or a Panofsky (Fig. 95). They had no concept that what the body of refugees brought to this country was in essence a new discipline. Only one senior American art historian (and he the most remarkable of them all) ever showed me any sign of recognizing this. Late in his life, on two separate occasions a year or more apart, Fiske Kimball (Fig. 104) remarked, "I was too old when I came to understand Wölfflin. I could no longer change."

Harvard Postscript

OTTO WITTMANN

MY WHOLE professional life would never have happened had it not been for my years as an undergraduate at Harvard. While I took Paul Sachs's museum course as a graduate student four years after graduation, it was those undergraduate years of being exposed to the faculty of the art department at Harvard that really formed my career. I had grown up in a community where there was no museum or any original art, and it was only by chance through a course I took as a freshman that I became fascinated with the subject of art and, with great pleasure, spent the rest of my life in the museum world (except for five and a half years during the war in the air force and later with the O.S.S. assisting in the return of art seized by the Nazis).

I believe most students concentrating in Harvard's Fine Arts Department in my time felt the faculty was stimulating, interesting, and knowledgeable. Langdon Warner (Fig. 33), for instance, was a professor I admired greatly. From him I got my first understanding and appreciation of oriental art. He had had the advantage of traveling extensively in Asia at a time when this was difficult. He was supportive of his students, especially with an eye to their going into museum work. To cite one case, it was he who persuaded the Nelson Gallery in Kansas City to employ a young student of his, Laurence Sickman, then studying the Chinese language in Peking, to buy works of art for the Nelson Gallery. Sickman produced one of the great collections of oriental art in the United States with a very small amount of money; then he returned from China to become curator of oriental art at the Nelson Gallery and ultimately its director. To this he added distinguished work as a scholar and thus was chosen to be co-author, with Alexander Soper, of the Pelican volume on Chinese art and architecture.[1]

Arthur Pope (Fig. 33) was another whose lectures I found of much interest. It was his introductory course that influenced me to change my major from English to fine arts. His method of teaching by comparing art of various periods and countries rather than presenting it in any chronological sequence was probably more aesthetics than art history. It effectively gave a basis for understanding art principles and was popular with undergraduates from various fields other than fine arts. Moreover, when I began taking my own first steps toward originals, he helped. He used to talk about Japanese prints, and I remember asking him where I could buy some. It turned out they were available in Boston from several dealers.

[1] Laurence Sickman and Alexander Soper, *The Art and Architecture of China*, Harmondsworth (1956; second edition 1960; third edition 1968; rev. edition 1971).

The first original work of art I ever bought was a Japanese print, probably for $5.00, from a dealer recommended by Professor Pope. I still have it.

With Professors George Chase and George Edgell (Fig. 33) I took one course each but had little contact. Paul Sachs (Figs. 37 and 38) gave a stimulating, intense undergraduate course in the history of French art, often illustrated with anecdotes of his own collecting. From this course came my own enthusiasm for French painting, which was to guide me to acquire enough French art during my tenure at Toledo's museum to fill several galleries. While Sachs was one of the most influential and helpful people I encountered at Harvard, Edward Forbes (Figs. 32 and 33), co-responsible with Sachs for the Fogg Museum, was also influential, if more remote. Chandler Post (Fig. 33), a great scholar of Spanish painting, stressed an almost photographic memorization of facts, which was of less interest to me. As a person, however, he was not exactly cold, and could be warm and helpful on occasion. In my experience he knew many of his undergraduate students by name and was keenly interested in their scholarly progress. One classmate obtained his first museum job through the good offices of Chandler Post. He was not known as "Uncle Chandler" for nothing. Among younger members of the department it was Charles Kuhn whom I found of real interest. Much concerned with contemporary art, he was most helpful to us with the Harvard Society for Contemporary Art. The combination of these distinguished professors and scholars in the department helped launch me into the museum world.

However, I was only one of several undergraduates at Harvard during those years who would later devote their careers to museums. There was also Perry Rathbone (Fig. 32), who was to become director of the St. Louis Art Museum and later director of the Boston Museum of Fine Arts, as well as Charles Cunningham, Sr. (Fig. 32), who was director of the Wadsworth Atheneum, Hartford, and subsequently director the Chicago Art Institute.

The most notable example of Harvard's stimulation of undergraduates in fine arts in my time concerns two other classmates of mine, Henry McIlhenny (Fig. 32) and John Newberry. Both came from families who collected old-master paintings, both concentrated in fine arts, both became protégés of Paul Sachs. Under his guidance they collected impressionist and post-impressionist drawings as undergraduates. All of us lived in the then newly established Dunster House, at the outset of the "house system" at Harvard. It was marvelous to behold the friendly but intense rivalry of these two students on weekends in New York as, on Sachs's advice, they bought great drawings from the leading dealers. Each would return in triumph to show his latest acquisitions at his room in Dunster House. Both went on to distinguished museum careers. Jack Newberry became curator of prints and drawings at the Detroit Art Institute and bequeathed his collection to that museum. Henry McIlhenny was curator, trustee and subsequently president of the Philadelphia Museum of Art. He, too, was most generous, bequeathing his collection, his house, and other assets to that museum. Both continued to collect throughout their lifetimes, but I am inclined to believe that their collecting as undergraduates at Harvard equaled or surpassed the collecting they did later. Certainly, the influence of Harvard's Fine Arts Department shaped their lives and in turn the museums they served, as it did in the case of many others, whether as professionals, museum trustees, or interested museum visitors and supporters.

The Department of Art
at Vassar: 1865–1931

PAMELA ASKEW*

WHEN three-hundred-fifty young women crossed the threshold of Vassar College in the year of its opening, 1865, they confronted a single building that accommodated the entire college. Main Hall (Fig. 42), which has recently been declared a national monument, was designed by James Renwick, Jr., and modeled on the Palace of the Tuileries in Paris. Its regal grandeur symbolized the nobility of Matthew Vassar's daring enterprise: the establishment of a college for American women which would offer an education equivalent to that received by young men. In Vassar's own words: "It occurred to me that woman, having received from her Creator the same intellectual constitution as man, has the same right as man to intellectual culture and development. It is my hope to be the instrument in the hand of Providence of founding an institution which shall accomplish for young women what our colleges are accomplishing for young men."[1]

Although colleges for women were not unknown, the high aspirations attendant on Matthew Vassar's college, which for the first time offered a full liberal arts curriculum to women, distinguished it from any previously existing institution. So did the scale of his investment. An extraordinary richness of equipment and scientific apparatus precluded any doubt about its worthiness and ability to fulfill its purpose, as in 1865 it sprang fully-armed from the heads of the founding trustees—with Minerva as its emblem—to become what its first president promised Matthew Vassar it would be, a monument to him "more lasting than the pyramids."[2]

Matthew Vassar, who appears in a portrait by Charles Loring Eliot (Fig. 43), ran a brewery business that made him the richest man in Poughkeepsie. He was a Baptist by

* I am grateful to the Interlibrary Loan and Special Collections divisions of the Vassar College Library for their help in obtaining and making accessible materials used for this essay. In particular, I should like to thank Katherine A. Waugh, Interlibrary Loan Librarian, Nancy S. MacKechnie, Curator of Rare Books and Manuscripts, and Melissa O'Donnell, Administrative Secretary of Special Collections.

[1] Address of Matthew Vassar at the first meeting of the Board of Trustees, February 26, 1861. Quoted in the *Vassar College Catalogue* of 1927–1928, 13–14.

[2] James Monroe Taylor, *Before Vassar Opened: A Contribution to the History of Higher Education of Women in America*, Boston and New York (1914), 92. On Mount Holyoke as precedent, and on the factors that distinguished Vassar College from it and from other colleges for women, see Helen Lefkowitz Horowitz, *Alma Mater: Design and Experience in the Women's Colleges from their Nineteenth-Century Beginnings to the 1930s*, Boston (1986), 37.

persuasion, civic-minded and magnanimous of spirit, and no doubt desirous of joining the social ranks of the "mercantile princes" of the Eastern seaboard.[3] Vassar's civic-mindedness was appealed to by the Baptist Rev. Milo P. Jewett, who was largely responsible both for formulating the concept of the college and for persuading Matthew Vassar of its educational and social value. Jewett became Vassar's first president, holding office during the years of planning before its opening.

An art gallery was included in the architectural plans from the outset. At the first meeting of the trustees in 1861, Matthew Vassar expressed the wish that the course of study should embrace, "Aesthetics, as treating of the beautiful in Nature and Art . . . to be illustrated by an extensive Gallery of Art"[4] Jewett, too, wrote: "A Gallery of Art is a feature of our plans." He called it "novel" and "instructive," and spoke of its importance in terms of "elegant culture," "moral power," and public attraction.[5] Although several colleges had museums or galleries before the founding of Vassar,[6] Vassar is the first college known to me in which art and education were structurally integrated in a single building (Fig. 44). It has been suggested that this kind of integration may be traced, not to any precedent offered by a male college, but more specifically to the Cottage Hill Seminary for Girls in Poughkeepsie, which owned an art collection and was headed by Matthew Vassar's niece.[7]

Broadly speaking, the origins and growth of art history at Vassar may be seen as springing from a three-branched root: first, it was launched with the physical conjunction of a gallery and studio; second, it took shape within a matrix of what can only be called an American cultural nationalism or nationally oriented aesthetics; and third, it gained scholarly approbation and intellectual rigor through its approach to an education in the classics, although not immediately. I shall try to sketch these three often intertwined branches of development.

First of all, in planning for a gallery from the start, many of the founding trustees were profoundly aware of the importance of the fine arts for a liberal arts curriculum. In the words of the charter trustee Benson Lossing, author of the work *Outline History of the Fine Arts* (1840), the fine arts "have a powerful tendency to elevate the standard of intellect and consequently morals; and form one of the mighty levers which raise nations as well as individuals

[3] The phrase, quoted by Lillian B. Miller, *Patrons and Patriotism: The Encouragement of the Fine Arts in the United States 1790–1860*, Chicago and London (1966), 159, from *The Cosmopolitan Art Journal*, I (June, 1857), is noted by Ella Foshay, "The Legacy of Elias Lyman Magoon's Art for All Seasons," in *All Seasons and Every Light, Nineteenth-Century American Landscapes from the Collection of Elias Lyman Magoon*, exhib. cat., Vassar College Art Gallery, Poughkeepsie (1983), 9.

[4] "Mr. Vassar's Statement," in *Proceedings of the Trustees of Vassar Female College at their First Meeting in Poughkeepsie* (February 26, 1861), 15.

[5] Milo P. Jewett, "Origin of Vassar College" (1879), 117 (ms., Vassar College Library, Special Collections). This section is not transcribed in the typed copy of the ms. in the Vassar College Library, Special Collections.

[6] The colleges of Amherst, Bowdoin, Dartmouth, Yale, the U.S. Military and Naval Academies, and possibly Michigan, already had galleries or museums (Jean C. Harris, *Collegiate Collections 1776–1876*, exhib. cat., Mount Holyoke College, South Hadley, Massachusetts [June 15–December 15, 1976], 8, n. 6, and passim). This does not mean, however, that they all taught the history of art.

[7] Sally Mills, "The Development of an Art Gallery at Vassar College, 1856–1865," in *Transformations of an American County, Dutchess County, New York, 1683–1983, Papers of the Tercentenary Conference, April 23 and 24, 1983*, ed. Joyce C. Ghee et al., Poughkeepsie (1986), 169–170. I am indebted to Elizabeth A. Daniels for this reference. For the role of Matthew Vassar's niece, Lydia Booth, in the founding of the college, see also Taylor (as in note 2), 86–87.

to the highest point in the scale of civilization."[8] Another trustee, the Baptist Rev. Elias L. Magoon, who was a master of oratorical hyperbole, easily persuaded Matthew Vassar to purchase his entire art collection for $20,000. Samuel F. B. Morse (Fig. 45), also a founding trustee, had painted Magoon's portrait about ten years earlier (Fig. 46).[9] Magoon was one of the first collectors of American art in this country,[10] and for the Vassar gallery (Fig. 47) he had prescriptive ideals. He wanted what he called "a living American art" to have "its first fair play in the history of education." Three-fifths of the Vassar collection, he stipulated, should be American landscapes.[11] This is not surprising in view of Magoon's calling, the place of landscape painting in the American ethos, and the fact that he had personally patronized the group of gifted landscape painters then active in New York state, the Hudson River School. Along with his paintings, Magoon also sold the college his art library, both carefully built, as he put it, "to illustrate human progress under and along the Divine purpose,—*Christianity Illustrated by Its Monuments*."[12]

Writings of this period amply demonstrate that art, nature, and Christianity, or morals, were viewed as an educative trinity whose power could shape the social good and forge a national identity. Bound up with aesthetics as the study of beauty, art became inseparable from "truth." Historically, this view coincided with the emergence of art as the instrument of a cause. As Neil Harris has shown, during the religious upheaval generated by the Civil War, the clergy played an important part in redeeming art from its former (pre-1830) association with luxury and corruption, elevating it to a desirable ideal as an instrument of social mission.[13] At Vassar, art was built into the collegiate stucture so that it might play a moral role in the development of American civilization. It was thought that through the influence of cultivated womanhood art would operate in the formation of American character, particularly since women at the close of the Civil War were called upon to play a more active part in the national destiny.[14]

[8] Benson John Lossing, *Outline History of the Fine Arts. Embracing a View of the Rise, Progress, and Influence of the Arts among Different Nations, Ancient and Modern, with Notices of the Character and Works of Many Celebrated Artists*, New York (1840), iii.

[9] See Paul J. Staiti, "Ideology and Politics in Samuel F. B. Morse's Agenda for a National Art," and Nicolai Cikovsky, Jr., "'To Enlighten the Public Mind . . . to Make the Way Easier for Those that Come After Me': Samuel Morse as a Writer and Lecturer," in *Samuel F. B. Morse, Educator and Champion of the Arts in America*, New York (1982), 9–54 and 55–76.

[10] Foshay (as in note 3), 8, observes that Magoon's collecting of American art in the 1850s was in keeping with a trend among collectors at the time.

[11] Elias L. Magoon, letter to Matthew Vassar, May 30, 1864 (Magoon file, Vassar College Library, Special Collections), noted by Edward R. Linner, *Vassar: The Remarkable Growth of a Man and His College 1855–1865*, ed. Elizabeth A. Daniels, Poughkeepsie (1984), 161.

[12] *Report of the Committee on the Art Gallery of Vassar Female College, February 23, 1864*. Originally printed in 500 copies and republished in Thomas McCormick and Agnes Rindge Claflin, *Vassar College Art Gallery, Selections from the Permanent Collection*, Poughkeepsie (1967), xi.

[13] Neil Harris, *The Artist in American Society, The Formative Years 1790–1860*, Chicago and London (1966, 1982), 300–316.

[14] "Dr. Hague's Address," in *Proceedings of the Trustees of Vassar Female College* (as in note 4), 19–24; see also Elizabeth Hazleton Haight and James Monroe Taylor, *Vassar*, New York (1915), 122.

The art gallery (Fig. 47) was placed on the fourth floor opposite the chapel (Fig. 48). In charge of the art gallery was the Professor of Drawing and Painting, the Dutch-born painter Henry Van Ingen (Figs. 49 and 50).[15] The inaugural history of art lectures, given by Van Ingen in 1867–1868, made Vassar the first women's college to offer a course in art history.[16]

There were two courses, the more significant being "History of Painting, Sculpture, and Architecture," illustrated by the works and lives of the great artists. These lectures, supplementing courses in the practice of art, led in 1877 to the establishment of a separate extra-collegiate school of art granting its own diploma. Ten years later, Van Ingen's lectures in the history of art were declared an elective open to all college classes. They were topical rather than chronological, treating such subjects as Leonardo and Michelangelo, Egyptian architecture, and modern sculpture. In becoming an elective, art history had gained its autonomy as a curricular subject, and it is significant that at Vassar it was never attached to another field such as literature, moral philosophy, or archaeology.

The landmark year, however, was 1892, when it was announced that the adjunct school was abandoned, and "the history and theory of the arts have been placed on a level with other college work as counting toward the Baccalaureate degree." Meanwhile, the M.A. was also offered. The first M.A. degree in fine arts in the United States was awarded by Vassar in 1876 for a thesis on "The Progress of Art in Ancient Times."[17] By the end of his career, in 1898, Van Ingen was offering three historical courses in addition to studio courses. The most ambitious was entitled "Theory of Architecture, Sculpture, and Painting, with Special Reference to the Principles of Criticism." Attempting to establish a theoretical basis for art, this course held out a cornucopia of theoretical issues, ranging from architectural construction, to the human form, to categories of subject matter. Work in all three courses was said, moreover, to be further impressed upon the student's mind at the close of the year by twelve illustrated stereopticon lectures which brought all of the prominent works of art before them on a large scale.

The stereopticon had been introduced into the Vassar chapel/classroom in 1879. Teaching the history of art required equipment which, in turn, affected the function of the art gallery. In 1876, nearly 1000 Braun autotypes had been given to the gallery. *Scribner's Monthly* hailed this gift as equipping the gallery for teaching art historically.[18] In just a little over ten years, the gallery had become viewed by the public as an instrument of art history rather than of spiritual sensibility. But what Van Ingen found most useful for his art history students, as well as those in studio, were plaster casts of classical and Renaissance sculpture (Figs. 51 and 53). As early as 1866 his request for a greater variety of plaster casts was looked

[15] Benson J. Lossing, *Vassar College and Its Founder*, New York (1867), 131.

[16] The only colleges to precede Vassar in offering any instruction in art history were, it appears, the College of the City of New York, New York University, Princeton, and the University of Vermont. See Priscilla Hiss and Roberta Fansler, *Research in Fine Arts in the Colleges and Universities of the United States*, New York (1937), 7, and, for the peculiar situation at Michigan, 7–8. The art history offerings at some of these institutions appear to have been lectures rather than courses.

[17] Ibid., 38, 195.

[18] "The Art Collection of Vassar College," *Scribner's Monthly*, XI, no. 4 (February, 1876), 593–594. I am grateful to Joan E. Murphy for calling this article to my attention.

upon favorably by the trustees, and by 1869 casts arrived in quantity from Paris, Berlin, and New York. By 1875, the art gallery had moved into a building which had originally been built as a gymnasium and riding academy (Fig. 52). It was rechristened the museum, and in it Van Ingen arranged what became known as the hall of casts (Fig. 53).[19] These casts gave to the history of art a kind of visual anatomy, literally and figuratively. Running parallel to it was the art studio (Fig. 54), at the other end of which was the art gallery (Fig. 55). But studio art, which at Vassar had never received academic credit, was abandoned altogether on Van Ingen's death in 1898.

Special emphasis has been given to these early years to the gallery, and to Van Ingen partly, in the interest of historical priority, but also because the early development of an art history curriculum at Vassar was not "an offshoot of classics and philology," as the art history curriculum in this country is so often presumed to be.[20] It is important to stress that the study of the history of art at Vassar was generated by an interest in art itself.

The new century saw the department run by Lewis Frederick Pilcher, again an active practitioner of the arts, for he was an architect with his own firm in New York City (Fig. 56). A graduate of Columbia University's School of Architecture, he headed the Vassar department from 1901 to 1911. Relating to the first two branches of growth—the conjunction of studio and gallery—and to cultural nationalism, Pilcher's declared objective was to build a gallery illustrating American art. By the first decade of the century, however, technology was changing the study of art history, and Pilcher responded to it. He exclaimed in 1904 that he needed six times as many photographs as the number he then had, which was 3000. In 1902, the installation of opaque window shades in the Vassar chapel made it possible to use lantern projection to illustrate lectures. In 1908, Pilcher requested an electric light stereopticon and a "motion projection apparatus," which was, perhaps, an electric slide projector.[21]

Pilcher's demand for reproductions was linked to his change of the curriculum to emphasize the historical development of art in periods and countries. He gave four courses, three of which bore the word "history" in their titles. The course in Italian painting he defined as a critical treatment of early Christian, Byzantine, Gothic, and Renaissance painting. Another was described as the "history of Renaissance and modern painting in France, Spain, the Lowlands, Germany, England, and America." Pilcher's classifications according to period and country and his chronology of art in each time and place provided a structure that could embrace all art and present it as a sequence of formal types. His catalogue descriptions introduced such phrases as the "evolution of art form," and the "conditions that have influenced the various manifestations of its development." This seems to imply a desire to give a scientific or Darwinian substratum to a perceived historical order.

[19] A history of the building that housed the calisthenium and riding academy, including its function as a museum, has been written by Elizabeth A. Daniels, *Main to Mudd: An Informal History of Vassar College Buildings*, Poughkeepsie (1987), 20–22.

[20] See Andrew C. Ritchie, *The Visual Arts in Higher Education*, New York (1966), 21.

[21] Marilyn Aronberg Lavin, *The Eye of the Tiger: The Founding and Development of the Department of Art and Archaeology, 1883–1923, Princeton University*, Princeton (1983), 13, summarizes the changes in projection machines in the late nineteenth century.

One guesses that Pilcher felt the need for an expanded department and curriculum, a hypothesis supported by E. Baldwin Smith's report of 1912, which reveals that by this date several universities, as well as Bryn Mawr, Mount Holyoke, and Wellesley colleges, were offering more courses in the history of art than Vassar.[22] Resigning in 1911, Pilcher told President Taylor that courses covering American art and Italian sculpture should be added to the existing four.

Succeeding Pilcher was Oliver S. Tonks (Fig. 57). He introduced the third branch of growth—the classics. Oliver Tonks was not an artist, but a scholar/teacher, and a product of the new approaches of the research universities. In 1903 he had received the first doctorate in classical archaeology conferred by Harvard. He was also the first Harvard student to hold the Charles Eliot Norton Fellowship for study in archaeology at the American School of Classical Studies at Athens, which, incidentally, Vassar and Mount Holyoke were the first womens' colleges to support.[23] After beginning his teaching career at Princeton as an instructor in Greek, Tonks moved to the Department of Art and Archaeology in 1905, where he acted as preceptor for Allan Marquand's course in Greek sculpture, and also taught Flemish and Dutch painting.[24] Tonks could speak of his "training" as having been "classical, then archaeological, and then concerned with the history of art."[25]

At Vassar, Tonks made many changes, including reinstating studio art by hiring the painter Clarence K. Chatterton in 1915. He also inaugurated new methods of instruction, including the preceptorial system which he imported from Princeton. Art history was approached as a serious academic discipline. But if American art had been central to Pilcher's credo, classical art was the touchstone for Tonks—what he called the "inimitable standard." He promptly offered a course outside the department listed under Greek archaeology: Greek Vases. The word "styles" suddenly appears in his catalogue description of the course. A new course on Italian sculpture he illustrated not only with lantern slides but with casts from the ever-expanding hall of casts (Fig. 58). Its effects of installation, however, became increasingly Hellenistic, when in 1915 the casts were moved to a new building (Fig. 59).

In the new building, Taylor Hall (Fig. 60), the art gallery, studio, art history classrooms, lecture theater, etc., were for the first time assembled together under one independent, fire-proof roof. Taylor Hall was built in the Gothic style to complement the styles of the library and chapel, now separate buildings, which it connected spatially. It gave to art a central position and, one might say, made it a connecting link between the secular to its left and the sacred to its right. Principally, however, it formed a grand gateway to the college precinct as a whole, its orange-tinted stone making it a *porta aurea* to the liberal arts and higher learning. Even if more concerned with facade than function, it nevertheless accommodated the expansion of the department and curriculum that began in 1916, when Tonks was joined in teaching ancient art by Elizabeth Pierce, Vassar '10, later to receive a Ph.D. from

[22] E. Baldwin Smith, *The Study of the History of Art in the Colleges and Universities of the United States*, Princeton (1912): 45 (Bryn Mawr), 16–17 (Mount Holyoke), 42–43 (Wellesley), 41 (Vassar). The entire study is republished on pp. 12–36 above.

[23] Harris (as in note 13), 52, n. 7.

[24] Lavin (as in note 21), 19–21, for the courses taught by Tonks at Princeton.

[25] Oliver S. Tonks, "Museums of Art and Teachers of the Classics," in *Art Museums and Schools*, New York (1913), 98.

Columbia in classics and to marry the archaeologist Carl Blegen. Tonks and Pierce also shared the course in Italian sculpture, with its casts overflowing into various rooms (Figs. 61 and 62), with the Quercia tomb of Ilaria del Carretto providing a grandiose *memento mori* for Vassar girls who might think that they alone were in Arcadia as they proceeded toward the new art gallery (Fig. 63).

It was with new seriousness of historical purpose that Tonks continued to expand the curriculum of the department as well as its faculty. In the decade of the twenties, ten of the sixteen persons hired, however temporarily, were women, and Vassar alumnae were now qualifying for the jobs. But the faculty men are better known: Hyatt Mayor in 1922–1923, Alfred Barr in 1923–1924, Arthur McComb from 1924 to 1926, Henry-Russell Hitchcock in 1927–1928, and, from 1932 to 1941, John McAndrew. Course descriptions now mentioned environment, meaning cultural context, and the concept of the great "schools" of painting offered cultural nationalism as a means of ordering a mass of material. Tonks, noting that handbooks on Italian art lacked a "coherent, consecutive statement," wrote a textbook himself, *A History of Italian Painting*, published in 1927. In chapters on "The School of Gubbio" and the like he sought to surmount what might be called an inventory approach to artists and their works, employing such sweeping statements as: "For [Taddeo Gaddi], as for those who follow in the fourteenth century, the gift of seeing things was simply lost."[26] In 1924–1925 under Tonks, Chatterton, McComb, and Rindge a "coherent, consecutive statement" was comprehensively realized with the institution of a "General Introduction to Art." Vassar was far from the first in this. However, the years 1928–1929 saw the introduction of major fields, and in 1931–1932 a course in architectural drafting was initiated, the first, as far as I know, to be offered in a women's college.

Agnes Rindge, later Claflin (Fig. 64), opened the decade of the thirties with what must have been one of the earliest courses in Italian Baroque painting in this country. In the following academic year, 1931–1932, a new instructor was Leila Cook Barber (Fig. 65). Agnes Rindge and Leila Barber, since they became its two permanent members, largely shaped the department during the next decades, retiring in 1965 and 1968 respectively. By the 1930s, greatly strengthened in number and vitality and with its curriculum expanded to encompass the major historical epochs, the department was ready to receive from Europe such distinguished scholars as Adolf Katzenellenbogen and Richard Krautheimer.

In Palmer and Holton's report for the Association of American Colleges, published in 1934, the general optimism about the firm position that art history had attained in this country is expressed by Agnes Rindge. She is quoted as saying, "The fine arts are being more and more recognized as concrete checks on historical and archaeological endeavour." She continued, "This recognition of the cogency of the matter of fine arts is alone sufficient to insure the status of the field in the liberal arts college." And she concluded, "The subject is no longer a cause."[27]

[26] Oliver S. Tonks, *A History of Italian Painting*, New York (1927), 36.
[27] Archie M. Palmer and Grace Holton, *College Instruction in Art*, New York (1934), 6.

The Study of Art at Smith College

PHYLLIS WILLIAMS LEHMANN

SMITH COLLEGE was founded in 1871. The first class of fourteen students entered in 1875 under the presidency of L. Clark Seelye (Fig. 66). Seelye, a former minister and a professor at Amherst, was a firm believer in the "ministry of beauty." Already in the catalogue of 1877, it was stated that "the study of Art . . . is a part of the regular intellectual work at the College The Art Gallery has already been furnished with casts of noted statues and several hundred autotype copies illustrating the different schools of painting Lectures on the history and principles of Fine Arts . . . will be given to all students, and practical instruction in Drawing [and] Painting . . . to those who have requisite talent and taste for it." Later, it was stated that "Art has not been treated at Smith College as a mere accomplishment, but as a serious pursuit which demands strenuous intellectual work in order to prosecute it successfully It requires no less thoughtful study than some of the sciences with which it has often been depreciatingly contrasted." "Surely," President Seelye remarked, "the intelligent study of Michelangelo's statues may be as profitable . . . as the dissection of a fish or flower." And, he added subsequently, "Practical experience has demonstrated that those who have elected Art have frequently been among the best students in other departments, and have been able to do their work better from the strength and inspiration they have gained in this congenial study."[1]

College Hall (Fig. 67), where Seelye was inaugurated in 1875, initially contained all the facilities for Smith, from recitation rooms to offices, a library, laboratory, a chapel, an assembly hall for students, as well as an art gallery (Fig. 68), and, in its attic, a studio. By 1882, a separate building, the Hillyer Gallery, provided rooms for classes, studios, and the growing collection of paintings by such artists as George Inness, Winslow Homer, and Thomas Eakins. Figure 69 shows a view of students drawing from casts; Figure 70 is a scene in 1912 showing Dwight W. Tryon, Professor of Art, seated, and, at the right, Alfred Vance Churchill, Professor of the History and Theory of Art and first director of the subsequent Tryon Art Gallery, which was opened in 1926. It was named for the painter, collector and donor (Fig. 71), and it supplemented the classroom, library, and slide quarters of the Hillyer Gallery with a building solely for the exhibition of works of art. Under Churchill (Fig. 72), an artist, critic, and art historian, the theme of the museum became "the development of

[1] L. Clark Seelye, *The Early History of Smith College, 1871–1910*, Cambridge, Mass. (1923), 105–106.

modern art," beginning with the French Revolution. His acquisitions, and those of his successor, Jere Abbott, in the fields of nineteenth- and twentieth-century American and European, especially French, painting, were superb, and, together with the extraordinary print and drawing cabinet in the present Museum of Art (completed in 1972), constitute one of the finest collections in the country.

Oliver W. Larkin (Fig. 73) was appointed instructor in drawing and painting in 1924, carrying on the activities of Tryon. Trained at Harvard, he was a gifted artist, producing not only splendid watercolors, but also stage-sets for plays and operas as well as, late in life, marionettes. Gradually his scholarly interests came to the fore, and he gave the first course at Smith in the history of American art, leading to his Pulitzer Prize-winning book *Art and Life in America*, published in 1949. Larkin was a brilliant and witty lecturer, a man devoted to social justice, actively participating in liberal political movements throughout his life.

Larkin had been appointed by William Allen Neilson, who became president of Smith in 1917. Almost immediately after assuming the presidency he made two appointments that were of prime importance for the development of the art department at Smith: in 1917, Clarence Kennedy as instructor in art, and, in 1919, Ruth Wedgwood Doggett as instructor in the Department of Economics—only later did she become a member of the art department and the wife of Clarence Kennedy.

Kennedy was appointed to teach the history and practice of architecture (having received an M.A. in architecture at the University of Pennsylvania) and also the history of Italian Renaissance painting and sculpture. He appears in Figure 74, late in his life, in a photograph by Ansel Adams. In 1920–1921 he had studied at the American School of Classical Studies at Athens, and he received instruction in the cleaning and photographing of sculpture from the well-known German scholar Franz Studniczka. From this grew his specialty in photographing works of art, especially sculpture. In the early twenties, he photographed details of the Erechtheum (Fig. 75) and of the Charioteer of Delphi (Fig. 76). Later, he photographed the Rossellino Tomb of the Cardinal of Portugal in S. Miniato in Florence (Fig. 77), and the bust of Ippolita Maria Sforza d'Aragona by Laurana (Fig. 78). A superb photographer, he believed passionately that it was impossible to photograph a work of art without understanding both the monument itself and the intention of the artist.

In 1924 Clarence Kennedy completed his Ph.D. at Harvard with a thesis on "The Effect of Lighting on Greek Sculpture." From 1924 to 1933, he served as Director of Graduate Study for Smith in Paris and, with his wife, Ruth Wedgwood Kennedy, offered alternate years of graduate study in Paris and Florence, a program resumed in Italy in 1949. He was active as a consultant in later years, collaborating, for example, with the Meriden Gravure Company on the development of collotype and offset processes. In 1938 he founded the Cantina Press, having become involved in the art of typography, and from 1949 on taught courses in the art department in both photography and typography. Thus, like Larkin, Kennedy largely reversed his fields, in Kennedy's case beginning primarily as an art historian but achieving his greatest fame as a photographer and typographer. Kennedy and Larkin taught at Smith forty-three and forty years respectively.

Ruth Wedgwood Doggett was a Radcliffe graduate. After her appointment as instructor in the Department of Economics, she continued in this field until 1923. But in 1921 she had married Clarence Kennedy, and she served as his assistant in his years as Director of Graduate Study in Paris and Florence. In the course of these years, Ruth Kennedy was transformed into an art historian; and when she returned to Smith in 1933, she became lecturer in the Department of Art—an astonishing phenomenon. Ultimately, she became a splendid scholar in the field of Italian Renaissance art, author of books, articles, reviews, and member of editorial boards, including those of the *Renaissance News* and *The Art Bulletin*. It is a pleasure to include Ansel Adams's photograph of Ruth Kennedy (Fig. 79), a photograph taken later in her life. It has recaptured much of her style and beauty, of her keen intelligence and humor, her impulsiveness and warm generosity of spirit. I count it a great privilege to have known her as a colleague and friend for more than two decades.

I have tried to characterize the personalities and contributions of a few of the people who were of fundamental importance in the history of the Art Department at Smith. Many others have carried on their tradition in later years—not least Agnes Mongan (Fig. 41), the Kennedys' most brilliant graduate student.

Arts at Yale University

GEORGE KUBLER

THE CONTRIBUTORS to this part of the volume were asked to produce "glimpses" of departments of art history here and there in this country. "Glimpse" is from a Middle English verb; the current sense is "a momentary and imperfect view, a passing sight."[1] This definition implies a frustrated attempt to see something distinctly.

As a freshman in 1929, I glimpsed the dean of the School of the Fine Arts as he was lecturing to 400 men and women students of the history of architecture in the newly dedicated art gallery (Fig. 80) designed by Egerton Swartout. It is the third of four galleries at Yale (Figs. 81 and 82). The dean, Everett Victor Meeks, governed the art school, the gallery, the architectural school, and the drama school. There was no history of art department. Dean Meeks taught the history of architecture because he was an architect, just as the histories of painting and sculpture had been taught at Yale mainly by painters and sculptors since the Civil War.

Thus the Yale School was like the École des Beaux-Arts in Paris, an academy where students learned with artists, from whom they imbibed some history of art (Fig. 83). And so it remained at Yale until 1940.

Perhaps the most remarkable product of this academy was the medievalist Arthur Kingsley Porter, B.A. Yale, 1904 (Figs. 34, 35). His *Medieval Architecture, Its Origins and Development* appeared in two volumes published by Yale University Press in 1909. They were written at Columbia University, where he was a graduate student using the Avery Library. Yale appointed him from 1915 to 1919, when he taught his first classes as lecturer and assistant professor, commuting from New York. Harvard named him professor in 1920, after the appearance of *Lombard Architecture* (1915–1917). He had also studied architecture, becoming Bachelor of Fine Arts in 1917 at Yale. But his pioneering books on medieval art and architecture mark his mind as open to the expansion of art history, abandoning the then conventional view of the Middle Ages as the long night between classical art and its renaissance. In effect he moved from French to Italian and Irish medieval studies, when his contemporaries in New England still ignored them.

The Yale he left continued, with artists teaching history of art until the 1930s. Then a wholly new program at the Graduate School was offered as "History, the Arts and Letters" to

[1] *Oxford English Dictionary*, Oxford (1933), IV, 219; *Shorter Oxford English Dictionary*, Oxford (1933), I, 800.

candidates for master's and doctor's degrees, where many of us enrolled, encouraged by openings in new museums across the land and in colleges and universities that were surviving the worst years of the world depression.

In 1940, a Department of the History of Art was organized on proposals prepared by Henri Focillon (Fig. 84), then visiting professor at Yale from the Sorbonne. This program, made at the request of President Charles Seymour, may be said still to govern the work of the department. Professor Focillon's words begin as follows:

> This plan does not envisage a splendid isolation. On the contrary, it is founded on collaboration with other departments. It is defined as an organ of *liaison*. Its novelty is essentially a novelty of structure, in the division of subjects taught and in their arrangement. It is devised to fulfill the double need of a great university: culture in the formation of mankind; and training for research in the formation of scholars. It will *continue* with the formation of artists, for whom the teaching of the history of art was initially conceived and for whom it remains entirely open. The general courses exist to make known the principal topics of the history of art, beginning with introductory work and continuing to research courses offering to future specialists every means of becoming established scholars. Finally, the same special courses will complement the professional instruction given in other departments.

These aims still govern our work after nearly half a century, during which Yale has provided other universities and museums with art historians trained in its collections under teachers brought together from many parts of the world.

The double emblem of the department is based on a portrait medal of Leone Battista Alberti of ca. 1438 (Fig. 85) acquired by Charles Seymour for the gallery in 1953, and on a corresponding directional design commissioned from Joseph Albers for the graduate program in 1960 (Fig. 86). The query "quid tum" (what next?), used by Terence and Cicero, is explained by Alberti himself in the dialogues called *Anuli*: "the eye is more powerful than anything, swifter, more worthy; what more can I say? It is such as to be the first chief, king, like a god of human parts. Why else did the ancients consider God as something akin to an eye, seeing all things and distinguishing each separate one."[2]

Theodore Sizer (Fig. 87), director of the Art Gallery, left incomplete at his death in 1957 a "History of the Visual Arts at Yale." Still unpublished, it tells in four chapters the story, from 1761 to 1913, as a theatrical event. The opening chapter, titled "Before the Curtain," deals with Elihu Yale, whose art collections at his death in 1721 included 9,000 paintings in London, sold in six auctions during forty days. Chapter II, "The Curtain Rises," tells of Colonel John Trumbull, who in 1831 gave paintings by himself to Yale in the museum of his design, assisted by Ithiel Town and Alexander Jackson Davis (Fig. 81). The first lectures on art to undergraduates were by the colonel in 1839. The third chapter, "The Great Awakening," leads to the foundation of the School of Fine Arts, endowed by Augustus Russell

[2] Trans. Renée Watkins, "L. B. Alberti's Emblem, the Winged Eye, and His Name Leo," *Mitteilungen des Kunsthistorichen Institutes Florenz*, IX nos. 3/4 (Nov. 1960), 257.

Street in 1864. Its first dean was a painter and son of a painter. John Ferguson Weir (Fig. 88) opened the school alone in 1869 with four students in a building by Peter Wight, still called Street Hall (Fig. 89), where some classrooms and offices of the history of art are housed today.

Dean Weir's *Personal Recollections* (New York, 1957) record the first eight of forty-four years of his administration. Two years after opening, in 1871, seventy students were enrolled, including women as required by the Street endowment. The James Jackson Jarves collection of Italian paintings came to the gallery in 1868, as did a professor of history and criticism of art, Daniel Cody Eaton (1837–1912), who had studied in Berlin, but was unsalaried at Yale. Another professor was James Mason Hoppin, who was also on the faculty of the Divinity School as professor of homiletics. Eaton wrote on French painting and sculpture; and Hoppin on ancient Greek art.

By 1913, enrollment in the courses of the school rose to over 400, taught by a faculty of seven, "as a distinct department of the university . . . beside the departments of law, medicine, science, and theology," as they were then called.

Between the two World Wars, Theodore Sizer came to the directorship of the gallery; he was among the most scholarly directors of his day. Everett Meeks was dean of the school during construction of the gallery building (Figs. 80 and 90), which opened in 1928, designed by Egerton Swartout with some decorations designed by Sizer.

During the war in Korea, Louis Kahn was commissioned to build an addition to the 1928 building (Figs. 91 and 92). Its structure, based on reinforced concrete spans of tetrahedral design, reflects the shortage of steel in 1953. Rapid expansion of both art and architectural divisions of the School soon required the building of a gallery designed by Paul Rudolf and finished in 1961 (Fig. 93). The most recent increment to the collections of art at Yale was the donation by Paul Mellon of his works of English art in the British Art Center designed by Louis Kahn (Fig. 94), who died before its completion in 1977. Its staff is separate from the History of Art Department, but both staffs cooperate when needed, as do the staffs of Art and Architecture.

Thus we all continue the tradition of the school begun with Dean Weir, seeking the unison of practice with history, but without losing the autonomy of each enterprise. This at least is the pluralist "glimpse" we now have of the future of our studies.

The Department of Fine Arts for Graduate Students at New York University

CRAIG HUGH SMYTH

ERWIN PANOFSKY (Fig. 95) has left us a glimpse of the Graduate Department of Fine Arts at New York University in 1931, just before it grew into the Institute of Fine Arts under the leadership of Walter W. S. Cook (Fig. 96). The Institute, wrote Pan:

> grew out of the small graduate department which it was my good fortune to join in 1931, and which, at that time, had about a dozen students, three or four professors, no rooms, let alone a building, of its own, and no equipment whatsoever. Both lecture and seminar courses were held in the basement of the Metropolitan Museum, commonly referred to as "the funeral parlor," where smoking was forbidden under penalty of death and stern-faced attendants would turn us out at 8:55 P.M., regardless of how far the report or discussion had proceeded. The only thing to do was to adjourn to a nice speakeasy on 52nd Street; and this arrangement, laying the basis for several lasting friendships, worked very well for a term or two. But the days of speakeasies were numbered, and it was felt that the students of a big-town university needed a place, however small, where they might meet . . . in close proximity to the Metropolitan Museum. Thus, a tiny apartment was rented on the corner of 83rd and Madison Ave., housing such lantern slides as had been accumulated by the individual lecturers and one of those standard sets of art books which could be obtained, upon request, from the Carnegie Corporation.[1]

When Panofsky first came, Richard Offner (Fig. 97) headed the graduate section of fine arts at New York University.[2] Helen Frank tells that it was he, connoisseur-historian of connoisseur-historians, who invited Panofsky, a scholar so different from himself, to come for a semester from Hamburg as visiting professor in 1931 and to continue coming annually for a semester at a time thereafter. The Department of Fine Arts—the same name as Harvard's department—was only eight years old. It had been founded in 1923 at N.Y.U.'s Washington Square College under the chairmanship of Fiske Kimball (Fig. 104), Harvard-educated architect and architectural historian, whose writings are a landmark in architectural history in this country. His appointment set a high standard for the department from the start.

[1] Erwin Panofsky, "Three Decades of Art History in the United States, Impressions of a Transplanted European," in *Meaning in the Visual Arts: Papers in and on Art History*, Garden City, New York (1955), 331.

[2] See the account of the N.Y.U. department by Harry Bober, "The Gothic Tower and the Stork Club," *Arts and Sciences*, the first issue of a periodical publication of New York University (Spring 1962), 1–8.

In 1925, Kimball was appointed director of the Philadelphia Museum of Art, but he had by then brought together a small faculty that from the beginning included Offner, Harvard class of 1912, with a doctor's degree from Vienna (earned under Dvořák), following a fellowship from the American Academy in Rome, and Rudolph Riefstahl, German-born and -educated, the department's first faculty member from Germany, a specialist in Near Eastern and Islamic art (then an exotic field), who taught and wrote on rugs, textiles, pottery, painting, and also Turkish architecture, until his early death in 1936—this was a real loss to the department. Gertrude Wolf came at the beginning as departmental secretary: "secretary, housemother and central intelligence agency," as Harry Bober wrote in a vivid account of the department's beginnings and history up to 1962.[3] She was still secretary in the 1950s, when she helped teach me about the history and workings of the Institute of Fine Arts on my becoming its head. Shortly, Kimball also brought A. Philip McMahon, Harvard educated (later of Leonardo fame), whose concerns were both the history of art and the philosophy of art, and John Shapley (subsequently of the University of Chicago, remembered as a brilliant speaker, and known now perhaps especially for having been editor of the *Art Bulletin* many years longer than anyone else), who succeeded Kimball as chairman from 1926 to 1929. Shapley brought into the department Walter W. S. Cook (again from Harvard, a student of Chandler Post in Spanish art), and, briefly, Walter Pach and Thomas Wittemore, passionate Byzantinist, who had studied with Rufus Morey. In addition, Shapley began bringing visitors to give courses: first Mather and Rowley from Princeton, then Coomaraswamy, David Robinson (specialist in Greece and Rome), and also Meeks from Yale.

Welling up in the little faculty was an urgent desire to establish art history for graduate students as a separate department, independent of undergraduate art history, to be close to the Metropolitan Museum with its collections for teaching and study, and to give high priority to research on the part of both students and faculty. No precedent existed in the United States. I suspect Richard Offner was a principal source of the idea, thanks especially to his experience at the University of Vienna, and perhaps Shapley was as well—he, too, had studied at Vienna. There was opposition in N.Y.U., but also support. The vicissitudes of the struggle would take long to tell.[4]

By the time Panofsky arrived in 1931, Shapley had left, and a small section of the department, then under Richard Offner, had begun to separate itself from undergraduate education. It gave graduate courses, a heady offering benefiting from the results of new research, new hypotheses, new syntheses—an offering tending to change continually from year to year (the department's standard practice ever after). Courses continued to be taught in part by visitors, mostly renowned visitors. Morey (Figs. 5 and 9), for instance, commuted regularly from Princeton to give seminars as well as specialized lecture courses of a kind he rarely, if ever, offered in these years at Princeton, especially on illuminated manuscripts. Besides Panofsky, Adolph Goldschmidt and Arthur Haseloff came from Germany for a semester as visiting teachers. In the next few years came Marcel Aubert and Henri Focillon (Fig. 84)

[3] Ibid., 1.
[4] Bober's account (ibid.) does not attempt to describe the complexities nor the crossing of swords.

from France. Courses were mainly about what the department's faculty members and its visitors were actively working on: "a great à la carte bill of fare and poor table d'hôte," in the approving words of Helen Frank, who had come to New York from Wellesley in 1929 to study with Morey—impossible to do at Princeton, where women were not allowed. (Morey later assigned her a desk in the Princeton department's graduate study room, against all odds.) The study of modern art was not rejected: it was Offner who suggested the topic of Robert Goldwater's dissertation, *Primitivism and Modern Art*, a classic after it was published. Panofsky was so caught up by the free-wheeling uniqueness of the department that he decided its slogan—and America's slogan—must be: "Why not?"

Students could enroll on a part-time basis, a boon for those who had to support themselves with jobs in the city. Interested members of the public could attend lecture courses; among them was Helen Frick, in the years when she was forming the Frick Art Reference Library. For each lecture course it became the practice by 1929 to make a comprehensive syllabus, lecture by lecture, with the help of one or two students. The syllabi minimized the need for note-taking in class and were available thereafter to students of other years who had missed the courses when given—and even to students and scholars elsewhere. Certainly the N.Y.U. syllabi that reached Princeton opened new vistas for us as graduate students there.

My picture of the department's early days has come from conversations over the years, especially with Walter Cook (there should have been tape-recordings of all that he had to tell) and with Gertrude Wolf, also with students of the time, including Millard Meiss and, most recently, Helen Frank and Bernard Meyers (Meyers was one of the first graduate students and the first to take a Ph.D.). It has been strengthened by Harry Bober's account, and much aided also from my experience of lectures and seminars with Erwin Panofsky at Princeton in the late 1930s and then from knowing Richard Offner as a colleague in later years, talking with him at leisure and hearing him teach when duties of my own allowed. Meiss (Fig. 99) came to N.Y.U.'s department in 1929 to study with Offner after beginning graduate work at Harvard. He also began working closely with Panofsky from the time Panofsky first came from Germany. Offner and Panofsky: "the microcosm and the macrocosm," as they were called.

Offner's seminars met in his apartment, with his large collection of photographs at hand, many made expressly for him to his exacting standards. Slides had also to meet these standards, always in black and white, since he found the colors of color reproductions too misleading. A seminar could go on all day and then adjourn to museums (sometimes as far away as Philadelphia and New Haven), where Offner brought students face to face with problems of condition and restoration, besides questions of attribution and criticism. Offner's teaching was rooted, like his scrupulous scholarship, in his conviction that the history of art "should be evolved directly out of its concrete examples" and begin with the single object, freeing it of "the verbal system with which the literature of art has overlaid it."[5] After a brief

[5] Richard Offner, *A Critical and Historical Corpus of Florentine Painting*, section III, vol. I, New York (1931), iii–iv. See also my introduction to the final supplementary volume of Offner's *Corpus* after his death (before the continuation of the *Corpus* under Italian auspices): idem, *A Critical and Historical Corpus of Florentine Painting, A Legacy of Attributions*, ed. Hayden B. J. Maginnis, Locust Valley, N.Y. (1981), x–xi.

statement of a seminar's subject and aims, it was typical of him to begin immediately by having students look with him at one of the paintings central to the seminar (likely, more often than not, to be on Tuscan painting of the late thirteenth and fourteenth centuries) and asking them to comment about what they saw. At the outset there could be long silences. Students would feel impelled to break them at last. Then Offner would encourage and question, seeking more clarity of statement, quenching jargon and cliché, bringing out photographs relevant to the comments; rephrasing, summarizing; sharpening discernment; motivating penetration of the work of art—its representation and meaning, its iconography, form and expression—while at the same time uncovering its relations to other works and to the time when it was made. Thus the seminar would continue, painting after painting in the same protracted, intense way: important paintings, less important, and minor ones, week after week, as students worked (in class and in assigned independent study and research) to construct, under Offner's guidance, a piece of the "landscape" of art's history out of its individual examples.

In lecture courses, while Offner tended to concentrate on short, crucial periods, he could on occasion unroll a long landscape of his making. There exists a detailed syllabus of a course he once gave entitled "Development of Illusionism of Form and Space in Classic Painting and Relief." The course began in the Hellenistic Age and ended, after thirty lectures, in thirteenth-century Italy.[6] But such sweeps were not characteristic. A lecture course on Florentine painting from Giotto to Leonardo might not reach beyond the end of the fourteenth century or Masaccio before the semester ended. He liked to deliver lectures slowly, thoughtfully, sharing his thoughts a word at a time.[7]

By contrast, Panofsky's lectures were swift, manifestly innovative, brilliant, sometimes even temporarily paralyzing to an American student who had not encountered anything like them before. But, to any student who came to him with questions, he was habitually gentle, encouraging, and generous with his time. He was always ready with further explanations and with suggestions for reading and reference. Even then a student might be struck with momentarily disabling amazement on being told to look up a text, illustration, or footnote on a specific page of the *Jahrbuch der königlichen preussischen Kunstsammlungen*, volume such and such of the year such and such—all of this from Pan's memory. His seminars were of a kind familiar in Germany: several weeks of introduction and bibliography on his part, followed by full-scale reports by students for the rest of the semester on research they had been assigned from the outset. His teaching could, of course, balance Offner's courses with Netherlandish and German subjects. But his Italian strengths could show as well, as in the case of an innovative lecture course he gave on the Baroque in Italy at a time when it had hardly begun to be a subject for art history in this country.[8] Its essence is preserved in some copies in

[6] A copy can be found at the Institute of Fine Arts, New York University. There are certainly other copies in the libraries of former Institute students; there is one in my possession.

[7] See the paper by Hayden Maginnis on pp. 133–144 of this volume for Offner's connoisseurship.

[8] A course on the Baroque (with an introduction on Mannerism) had been offered for the department in 1929/30 by Arthur McComb, visiting teacher from Harvard (and father of Pamela Askew). In the Institute's archive are announcements of the department's courses going back to 1923/24, all in the same format as now.

typescript,[9] but he never went on to commit its originality and richness to publication. Richard Offner demanded much of his students and was a hard grader; Erwin Panofsky stimulated as much effort and generally gave everyone A's.[10]

Lack of personal knowledge regarding other members of the department discourages my attempting to evoke something of them and their teaching—except in the case of Walter Cook (Fig. 96). He had been away in Spain conducting his own research when Panofsky arrived, but by 1932 he had returned and was listed as chairman officially the following year, 1933/34.[11] As a teacher he was in the factual tradition of his principal mentor, Chandler Post. At the same time he inspired in his students both devotion to the study of Spanish art of the Middle Ages and a great love of Spain. There developed also among students of the department in general a great devotion to him. He always had time for any and all of them. He was remarkable for finding funds during the Depression for any student in need. Under his visionary, driving leadership the department grew in four years to be the Institute of Fine Arts with something like seventy graduate students, and housed in the monumental former mansion of Paul Warburg, brother of Aby Warburg, at 17 East 80th Street—as close as possible to the works of art in the Metropolitan Museum. How did it happen that N.Y.U.'s Institute of Fine Arts was reputed not to be object-oriented (in addition to all the other interests it stood for), and even with Richard Offner there until the 1960s?

After Hitler came to power in Germany in 1933, Walter Cook concentrated on bringing German scholars to the faculty. Erwin Panofsky, in New York for his annual semester of teaching when a telegram informed him that his professorship at Hamburg had been taken from him, was immediately asked by Cook to move to New York University; and he accepted. There followed Karl Lehmann and Walter Friedlaender, Alfred Salmony, Martin Weinberger, and, on a part-time basis, but by no means least, Richard Krautheimer, commuting weekly for a course one semester each year from Vassar.[12] Still later, and part-time, too, came Guido Schoenberger. Richard Ettinghausen and Julius Held were briefly there.[13] And younger people who had been educated in the department began teaching: Dmitri Tselos and Robert Goldwater. Although Erwin Panofsky was soon called to the Institute for Advanced Study (at the suggestion of Morey), he always continued giving lecture courses and seminars at the Institute of Fine Arts, remaining a fundamental part of his old New York University department until his death.[14]

There had thus come together an extraordinary combination of scholars from the United States and abroad. Walter Cook used to say "Hitler shook the tree, and I picked up the apples." He found financial backing especially from Michael Friedsam, Percy Strauss, Mrs. Murray Crane, and Robert Lehman. It was a remarkable achievement. The story of

[9] As in the case of the Offner syllabus cited in note 6.

[10] For much on Panofsky, see M. A. Holly, *Panofsky and the Foundations of Art History*, Ithaca and London (1984).

[11] Before leaving for Spain, Cook had already served as chairman at least part of the year 1929/30.

[12] Richard Krautheimer became a full-time member of the Institute's faculty in 1952.

[13] Richard Ettinghausen was called back to be a member of the faculty in the 1960s.

[14] Panofsky was ultimately named the Institute's Samuel F. B. Morse Professor of the Literature of the Arts of Design, after his retirement from the Institute for Advanced Study. He continued in this professorship as long as he lived.

the Institute *after* the arrival of the scholars from Germany in the mid-thirties is beyond our boundary for glimpses of early departments. Now, however, with the Institute's cooperation, the association of the Institute's alumni and alumnae, under its president, Professor Blanche Brown, has begun to collect material for a proper history.*

* Owing to a bout of illness, Blanche Brown could not accept the invitation to contribute a paper to the 1987 session. Hence the present paper.

History of Art at Columbia University

JULIUS S. HELD

LET ME BEGIN by saying that my situation is somewhat different from that of the other contributors. Whereas they all are essentially products of the American educational system and based their reports by and large on an insider's understanding as well as on personal experience, I grew up in a very different academic tradition and environment. Nevertheless, I am not entirely unqualified to make a short contribution to this volume. While my record does not equal that of Agnes Mongan, who is my exact contemporary in terms of years, I joined the American academic establishment at about the same time as did George Kubler and Phyllis Lehmann.

In fact, when I looked through some old material to refresh my memory on this subject, I came across a particularly fitting document. It is the program of the twenty-fourth annual meeting of the College Art Association, held in Washington, D.C. in May of 1935. Each day, from Wednesday to Friday, there was one session in the morning, one in the afternoon, and one in the evening—nine altogether. A tenth was on Saturday morning, with a trip on the SS *Potomac* scheduled in the afternoon (which I skipped). I had arrived in the States the year before. The paper I read on that Wednesday afternoon was my maiden appearance before an American learned audience. The same was probably true for Robert Goldwater, who took part in the same session, and for George Kubler who read a paper (on Poussin's *Seven Sacraments*!) on Friday afternoon. While Kubler represented Yale, Robert Goldwater and Julius Held represented N.Y.U.

I had just been picked up by Walter Cook (Fig. 96), to use his favorite expression, as one of the apples, a small one to be sure, that had fallen from the German art-historical tree shaken by Hitler. For six years I taught part-time at Cook's Institute (all my classes were given at the Metropolitan Museum) and I vividly remember the burdensome task that came with the job: writing, often with the help of my students, the syllabi of the lectures. Walter Cook insisted on getting them, and he freely distributed them to any student, even those who had never taken the course, so that they, in turn, could teach these courses in other institutions. I remember the unforgettable secretary of the Institute, Gertrude Wolf. Nor have I forgotten one afternoon in 1935 when I was working in the old library of the Metropolitan Museum, which resembled the nave of a baroque church with lateral chapels. During a brief conversation with Margaretta Salinger, whom I had met early on, she pointed out a young man with a head of curly black hair who was reading in a 'chapel' on the other side. "That

young man is Dr. Schapiro," she said. "He is supposed to be one of the brightest lights at Columbia University."

Two years later, starting in September 1937, I was not only Schapiro's colleague, but for many years shared office space with him, and not rarely with a third person. A large group of mostly young teachers was shoe-horned into the eighth floor of Schermerhorn Hall, even if they taught in other parts of the school: Columbia College, Barnard College, or General Studies. I was two-thirds Barnard and one-third graduate school (the "load" was invariably three courses), but most of us used the same slide collection and worked in the same Fine Arts Library, it, too, located on the eighth floor. (Only much later was a more spacious place found for the slide collection.) In general there was little contact between the Barnard departments and their corresponding ones at Columbia's graduate school; they were separated by more than Broadway. Whatever frictions there might have been in *our* field—and which academic institution is without them?—belonging to different sections of the University was not one of their causes.

In retrospect, however, it would seem to me that in those years the teaching of art history had only a low degree of priority with the Columbia administration. Not only did we work in cramped spaces; promotions, too, were very slow. It may come as a surprise to some of the young, and possibly impatient, members of the profession (though hardly as a consolation) that Meyer Schapiro (Fig. 98), who entered Columbia College in 1920 and received his doctorate (with his famous study of Moissac) in 1931, served as lecturer for eight years, as assistant professor for ten, and associate professor for six—a total of twenty-four years before he advanced to a full professorship.

Nor was it much different for Millard Meiss (Fig. 99), who in 1934 had come with degrees from Princeton and N.Y.U., and after eighteen years was still associate professor, when, in 1953, he left for greener pastures. I mention these two scholars first, not only because we worked in such close proximity for so long, but because I felt personally closer to them in those early years of my career at Columbia than to anyone else at the school—until the great changes that came to the department in the mid-fifties, changes about which I shall say a few words at the end.

But how had it all begun on upper Broadway, and what were the major areas of instruction before my time, when the department was in its infancy? Before I came to this country, in January 1934, my very rudimentary knowledge of higher education in the United States encompassed chiefly Harvard and Princeton, and I had heard of N.Y.U. when Richard Offner (Fig. 97) came to Berlin in the early 1930s to supervise the printing of plates for all the volumes of his *Historical and Critical Corpus of Florentine Painting* and to recruit assistants. I also remember having attended a lecture by Paul Sachs (Fig. 37), given at the Kunsthistorische Gesellschaft in Berlin (around 1932), about the teaching of art history in the New World. Unfortunately, the only thing that stuck in my mind was that at the end of his talk he said with great dignity "Ich danke für Ihre Aufmerksamkeit" (I thank you for your attention). I was very much impressed, since no German professor would ever have said that.

I might have been more aware of Columbia had I been more deeply involved with classical antiquity and the history of architecture. Ever since the establishment of the School

of Architecture at Columbia in 1881, the history of architecture was part of its program, and increasingly so after the celebrated Avery Architectural Library had been bequeathed to the University in 1890. Yet the courses were essentially surveys, given by William Ware and Alfred Dwight Foster Hamlin. A late product of this phase was the book *Architecture through the Ages*, published in 1940 by Talbot Hamlin, the son of Alfred Hamlin, who was then the librarian at Avery.

Art history in the sense in which we now think of it began at Columbia only in 1921. (I should perhaps add that the practice of art had been taught for a long time as part of the program of Teachers College, although I cannot here go into the later history of Columbia's School of the Arts.) By virtue of a will drawn up several years before, the university received in 1920 a legacy of $100,000 from the estate of the art collector Hugo Reisinger, to be applied to a professorship in the history of art. It was used for the appointment, to the rank of assistant professor in fine arts, of Butler Murray, Jr., who lived in Princeton, and previously had taught at Wells College. Since Nicholas Murray Butler was then president of Columbia, I wonder whether Butler Murray owed his appointment primarily to his name. At any rate, from all I have heard, his courses were essentially survey courses; nor have I ever seen his name connected with any publication. After some run-ins with younger instructors, he resigned in 1933.

The chairmanship then went to William Bell Dinsmoor (Fig. 100), professor in the School of Architecture and head of Avery Library, a fine scholar who in 1926 had set up a program of courses of archaeology offered by the Departments of Fine Arts, Greek and Latin, Semitic Languages, and Chinese and Japanese. Archaeology of the Americas remained with the Department of Anthropology. In 1934, when Dinsmoor became executive officer of the department, its name was changed to Department of Fine Arts and Archaeology; and even when "Fine Arts" was replaced in 1960 by "Art History"—on the suggestion of Jacques Barzun, who was then provost—"Archaeology" remained, and is still part of the name of the department.

During Butler Murray's term various additions were made to the number of instructors. Among them was Ernest DeWald, whose appointment was at Barnard, but who left after a couple of years to go to Princeton. Charles Rufus Morey (Figs. 5 and 9) came several times from Princeton to teach at Columbia. Courses in Far Eastern Art were offered by Alan Priest, a curator at the Metropolitan Museum. And Clarence Young, a member of the Department of Greek and Latin, offered courses in ancient art. That field was strengthened in 1926 with the appointment of Emerson Swift (Fig. 101)—who preferred living in Princeton, even though he taught full-time at Columbia—and in 1929 of Marion Lawrence, a pupil of Morey's, who during most of my time at Barnard was chairman of the department. I never knew my predecessor at Barnard, Walter Haring, who taught Spanish art and has been described to me as an amiable man with a drinking problem. It was his resignation in 1937 that provided the opening for me.

Whatever the reasons, Columbia lagged behind most other institutions (above all N.Y.U.) in availing itself of the opportunities provided by the influx to this country in the 1930s of highly qualified scholars from abroad. Margarete Bieber (Fig. 102), a noted

specialist in ancient sculpture and previously at the University of Giessen, was appointed in 1934; she evidently fitted perfectly the prevailing bias of instruction. Yet her rank never exceeded that of associate professor. For about twenty years, as far as I can ascertain, she and I were the only European-trained members of the Department of Art History and Archaeology at Columbia.

It was in the mid-1930s when the history of art assumed a growing importance in undergraduate teaching in response to increasing professional opportunities offered by museums, the art market, and new forms of publication. At Barnard, for instance, art history was regularly the second largest department in terms of students enrolled, right after English. At Columbia, a broadly conceived freshman program in the humanities gave an important place to the history of art. Everard Upjohn, Howard Davis, and George Collins were chiefly involved in its planning and instruction in the 1940s; Collins also taught art history in the School of General Studies. Paul Wingert began exploring African and Oceanic art, and the offerings of the graduate department were augmented by yet another commuting Princetonian, Rensselaer Lee (1948–1954).

Strong internal tensions, however, had been building up and came into the open on Dinsmoor's retirement in 1954. Since the members of the department could not agree on a chairman from their own midst, the administration appointed Professor Albert Hofstadter of the Department of Philosophy as acting chairman. Heading the department for two years (1955–1957) and handling the situation with wisdom and tact, he succeeded in calming the waters. During this period Edith Porada joined the department to teach art of the ancient Near East (1955), Otto Brendel came from Bloomington to beef up the classical field, and in the year of his death (1954) Hans Tietze gave a course on Venetian Art—I believe his only teaching appointment since he had come from Vienna.

Most fortunate for the department was the appointment of Rudolf Wittkower ("Wittkauer"), who, after leaving Germany in 1934, had been with the Warburg Institute in London. Acceptable to all factions, he took over the chairmanship in 1957. With "Rudi," as he was affectionately called, a new and dynamic phase began. The graduate school attracted a larger number of students; its offerings were augmented by visiting scholars, among them Philip Pouncey, who conducted a seminar on the connoisseurship of drawings, as did, somewhat later, Janos Scholz. Charles Tolnay lectured and conducted seminars on Italian Renaissance artists (Leonardo and Michelangelo), and Heinrich Schwarz surveyed the graphic artists. (As acting chairman at Barnard I once invited Werner Hofmann for one term; he later became known as the imaginative director of the Hamburg Kunsthalle.) Most important, however, was the fact that young American scholars were appointed to teaching positions at Columbia. If I confine myself only to those who joined the Department before 1960, there were Milton Lewine (1954), Douglas Fraser (1955), Robert Branner and Ted Reff (1957), Barbara Novak (1958), and Howard Hibbard (1959). Tragically, four of these— Lewine, Fraser, Branner and Hibbard—died long before their time, and I should like to use

this opportunity to express my personal sorrow at the loss of such an exceptional group of promising scholars.

Their places have, of course, been taken by yet another group of young men and women, each upholding the standards set by their predecessors while at the same time, in keeping with the broadening of our discipline, extending research into areas previously less well represented, or not represented at all—American art, Asiatic art, Precolumbian art (even, as one hears these days, "low art")—or pursuing methodological questions that were not even asked by their elders.

Yet it is precisely in this connection that I come back again to the man who was the first student to obtain an advanced degree in art history from Columbia (even though then known as a degree in Fine Arts) and who, still alert and ever open to new ideas, has been one of the first to ponder the possible application of semiotics to the field of art history. It may, therefore, not be inappropriate for me, at the end of my short account, to offer a salute to one who not only brought honor to art history at Columbia, but has been an inspiration to all people who study and love art: Meyer Schapiro.

Part II

THREE DECADES OF ART HISTORY
IN THE UNITED STATES
(1910–1940): FIVE FIGURES

Introduction to Part II

HENRY A. MILLON

THE PAPERS gathered in Part II were presented as part of a session at the Annual Meeting of the College Art Association in Houston in February 1988. The chair of the art history sessions, Thomas Reese, had originally intended that the session be devoted to art history in the United States in the period 1953–1983—the thirty years following the three decades discussed by Erwin Panofsky in an essay that included examination of the impact of the migration of European scholars to the United States between the two world wars.[1] Stephen Graubard was to have chaired that session, but withdrew when it became apparent he was overcommitted. Tom Reese, left in a difficult situation, asked if I might be able to help. It was by then clear that the original intention would have to be abandoned. After discussing the situation with Craig Smyth, who was at the time Kress Professor at the Center for Advanced Study at the National Gallery, I thought it might be possible to address what Panofsky had not, that is, to concentrate on a group of scholars from the U.S. who were at work during the same period. Tom Reese agreed to the change in the focus of the session.

Craig Smyth had chaired a session the previous year in Boston that considered the early teaching of the history of art at six institutions: Princeton, Harvard, Vassar, Smith, Yale, Columbia, and the Institute of Fine Arts at New York University. It seemed that it would be complementary to review the preparation and scholarly production of some individuals who were influential in the early years of this century. The problem became twofold: to identify and assemble a roster of art historians who helped to shape the discipline in these years and to find scholars who had done sufficient work on them (or been interested enough to have gathered appropriate documentation) to be able to prepare papers in the relatively short time remaining before the meeting. Willibald Sauerländer had hoped to speak about Kingsley Porter, because Porter's scholarship brought about a fundamental change in scholarship in Germany, but a conflict caused his withdrawal. Linda Seidel was persuaded to take his place. The result of the selection process cannot claim to be comprehensive or thematically consistent, but marks a step toward representative treatment of figures outstanding in the early history of art history in this country.

[1] Erwin Panofsky, "The History of Art," in *The Cultural Migration: The European Scholar in America*, ed. W. R. Crawford, Philadelphia (1953), 82–111; republished as an epilogue to Panofsky's *Meaning in the Visual Arts. Papers in and on Art History*, Garden City, New York (1955), 321–346, and entitled "Three Decades of Art History in the United States: Impressions of a Transplanted European."

The five art historians discussed here—Bernard Berenson, Arthur Kingsley Porter, Charles Rufus Morey, Sidney Fiske Kimball,[2] and Richard Offner—did not mature at the same time. Berenson and Morey received their undergraduate degrees before the turn of the century; Porter graduated in 1904; Fiske Kimball and Offner took their graduate degrees in 1912 and 1914 respectively, after Berenson, Morey, and Porter had produced significant publications. While they may have come from different generations, they grew to appreciate each other. Linda Seidel records the trips Berenson and Porter took together, and Lauren Weiss Bricker notes an affinity Fiske Kimball felt for Porter's perception of historic time and the research process. Hayden Maginnis touches on the relation of Offner to Berenson; Michael Rinehart examines it again in defining Berenson's achievements. Twelve years separate the birth of Berenson and Morey, and Morey was six years older than Porter. In turn, Porter was five years older than Kimball, who was a year ahead of Offner. Twenty-four years thus separated Berenson from Offner. But all five began publishing when they were between 26 and 29, and each had made a major contribution by age 40.

Many other individuals from these generations could equally well have been addressed had we found people prepared to speak about them. Allan Marquand, Chandler Post, Frank J. Mather, Jr., William Ivins, Howard Crosby Butler, Frederick Mortimer Clapp, Walter Cook, Albert Friend, E. Baldwin Smith—all would have been apt subjects. Had archaeological excavation not been excluded, Harriet Boyd Hawes (1871–1945), Esther Boise van Deman (1862–1937), and Hetty Goldman (1881–1972) would have been likely individuals for study.

In the article of Panofsky that gave rise to this session, he noted that after the publication of Porter's ten volumes on Romanesque sculpture in 1923,[3] Morey's "Sources of Mediaeval Style" of 1924 in the *Art Bulletin*,[4] and Albert Friend's location of a Carolingian School at St. Denis in 1923,[5] "no European scholar . . . could remain blind to the fact that the United States had emerged as a major power in the history of art." Though Berenson was not mentioned by Panofsky, Offner was cited as "developing connoisseurship in the field of Italian primitives with the closest possible approximation to an exact science." Fiske Kimball's contributions to the history of architecture in the United States were not mentioned by Panofsky, perhaps because of the context, but he did recognize Kimball's "epoch-making studies in the architecture and decoration of the Louis XIV, Régence, and Rococo styles."[6]

This session hoped to provide evidence of emerging theoretical bases for the history of art and the development of methods of approach to the study of works of art. These essays may help to establish a basis for further discussion of the varieties of art history that flourished in the United States as art history grew into an accepted academic discipline.

[2] Joseph Rishel, curator of European painting at the Philadelpia Museum of Art, presented a paper focused on Fiske Kimball when he was director of the Philadelphia Museum of Art.

[3] A. Kingsley Porter, *Romanesque Sculpture of the Pilgrimage Roads*, 10 vols., Boston (1923).

[4] C. R. Morey, "The Sources of Mediaeval Style," *Art Bulletin*, VII (1924), 35–50.

[5] Albert Friend, "Carolingian Art in the Abbey of St. Denis," *Art Studies*, I (1923), 67–75.

[6] Unmentioned by Panofsky were S. Fiske Kimball's *Thomas Jefferson, Architect*, Cambridge, Mass. (1916), and *Domestic Architecture of the American Colonies and Early Republic*, New York (1922, 2nd edition 1962).

Bernard Berenson

MICHAEL RINEHART

I WANT first to consider Berenson in the context of the overall theme of today's program: the American contribution to art history between 1910 and 1940. Whatever Berenson's contribution to art history may have been, I think it is reasonable to ask if it was in any way specifically American.

Berenson (Fig. 103) personally considered himself American, despite the fact that he spent only twelve of his ninety-four years in this country. With a typical contradictoriness, he dreaded returning to America, and yet frequently complained of feeling rootless. One cannot help thinking he could not have been what he was, or have done what he did, had he remained in this country. Nevertheless, he was American, but in a particular way, uniting two characteristic though distinct types: the immigrant and the expatriate.

If we examine the medium through which Berenson's contribution was made, we must conclude that it was primarily through his publications—and the early reception and influence of these in England and France was at least as great as it was in America, and probably greater. Unlike the other subjects of these papers, Berenson never taught or lectured, and he had no active part at all in the development of art history as an academic discipline in this country. In fact, he remained deliberately aloof from it, and I think it is fair to say that he envisaged his institute at I Tatti as in some ways an antidote to what he perceived as the rigidity of academic life and of art history as it was practiced in the classroom. Furthermore, his influence on the development of the museum profession cannot be compared to that of someone like Paul Sachs (Fig. 37), even though we must acknowledge his role in the formation of American collecting taste (and therefore in the formation of American public collections) at a turning point in its history.

We must recognize, too, that our definition (if indeed we have one) of art history has changed greatly since 1910. Panofsky, writing of American art history in 1953, defined it as "the historical analysis and interpretation of man-made objects to which we assign a more than utilitarian value" and opposed it to "aesthetics, criticism, connoisseurship and 'appreciation,'"[1] a distinction that would exclude Berenson altogether from art history proper. In

[1] Erwin Panofsky, "The History of Art," in *The Cultural Migration: The European Scholar in America*, ed. W. R. Crawford, Philadelphia (1953), 83; republished as "Three Decades of Art History in the United States: Impressions of a Transplanted European," in *Meaning in the Visual Arts: Papers in and on Art History* Garden City, New York (1955), 322.

fact, Panofsky did not name Berenson among the "founding fathers" of American art history, although he did refer to another figure discussed here, Charles Rufus Morey (Figs. 5 and 9).

The lines of Panofsky's distinction had been drawn as early as 1903 in Warburg's now famous, half-humorous, letter to Adolph Goldschmidt, in which he classified Berenson as an "enthusiast" and an "Attributzler."[2] Yet in this country, at least, the College Art Association was still holding discussions in 1917 to determine the appropriate instruction for future "writers on art" and "museum workers," giving the impression that the terms "art historian" and "curator" were unknown. The term "art critic" was widely used in England and America, but without attempting to differentiate those who wrote about contemporary art from those who wrote about the art of the past. In England, Ellis Waterhouse could declare in 1952 that any Englishman over the age of forty would surely be altogether suspicious of the term "art history."[3]

By 1940 Panofsky's distinction between historical analysis and connoisseurship was certainly well established, but if we were to take it as the context for measuring Berenson's contribution to the history of art during the preceding thirty years we should be distorting his significance. Those were the years in which Kenneth Clark, representing quite a different camp, could declare that connoisseurship "had a prestige similar to that of textual criticism in classical studies."[4]

One last general observation, which sets Berenson apart from the other subjects of these papers, has to do with his longevity and the bountiful biographical and autobiographical evidence which—together with the overlay of myth that resulted in part from his longevity—can hardly be avoided in approaching the narrower subject of his contribution to art history. Berenson's longevity is not without relevance: he lived long enough to try to shape his own image for posterity. I will admit to an interest in the biographical aspect of the subject, but I shall limit myself to one or two references to Berenson's early life which I think reveal his starting point and the formation of his original goals.

In the early letters to Isabella Gardner, recently published by Rollin Hadley,[5] we witness Berenson's transition from aspiring writer to connoisseur. This one was written from Oxford in 1888, when he was twenty-two (and I condense):

> I am getting much discontented with myself I accomplish little in reading, and nothing at all in writing I have cut with the pack of would-be universal scholarship, I do not see at all what I am to do Meanwhile I am drifting[6] I feel at times that I am going to pieces . . . but . . . I have not the least desire as yet to take these pieces and reconstruct another self out of them. I have never drifted so in all my life I have cut with scholarship So I am drifting . . . having a kind of faith that some day I will get to a jumping off place.[7]

[2] Ernst H. Gombrich, *Aby Warburg. An Intellectual Biography*, London (1970), 143.

[3] Ellis Waterhouse, "Art as a Piece of History," *The Listener* (November 6, 1952), 761.

[4] Kenneth Clark, "The Work of Bernard Berenson," in *Moments of Vision*, New York (1981), 115.

[5] *The Letters of Bernard Berenson and Isabella Stewart Gardner*, ed. Rollin Hadley, Boston (1987).

[6] Hadley, ed. (as in note 5), 14.

[7] Hadley, ed. (as in note 5), 17.

Scarcely two years later, then aged twenty-five, we find him declaring his commitment to a vocation as connoisseur in lines that, though more enthusiastic than poetic, recall Pater's famous phrase "To burn . . . with [a] hard, gem-like flame . . . is success in life."[8] Here is Berenson in 1890 as we must envision him through the veil of reminiscence, for there is no contemporary account of this scene (and again I condense):

"You see," he recalled saying to his friend Enrico Costa, "nobody before us has dedicated his entire activity, his entire life to connoisseurship. Others have taken to it as a relief from politics, as in the case of Morelli and Minghetti, others still because they were museum officials, still others because they were teaching art history. We are the first to have no idea before us, no ambition, no expectation, no thought of reward. We shall give ourselves up to learning to distinguish between the authentic works of an Italian painter of the fifteenth and sixteenth century, and those commonly ascribed to him"[9]

This scene took place at a cafe in Bergamo, and its inspiration was, of course, Giovanni Morelli.

Berenson's earliest work was shaped by literary art criticism and 'scientific' connoisseurship, and his models were Pater and Morelli. Within the next five years he had launched himself as an art critic and connoisseur with several publications on Venetian painting. These included the first of his four best-known works: the little essay on Venetian painting of 1894, Paterian in brevity if not in eloquence;[10] the notorious criticism of the New Gallery exhibition of 1895;[11] and his only full-length monograph, the Lotto, also of 1895,[12] which he regretted was not understood as the illustration of general theory that he intended it to be. This theory—at the time he called it "Constructive Art Criticism"—he never elaborated fully in print. The closest he came is in the essay entitled "Rudiments of Connoisseurship," written in 1894 but not published until 1902.[13]

The Venetian essay exemplified Berenson's intention of integrating Pater and Morelli, and was accompanied, beginning with its original edition, by lists of Berenson's attributions (lists in which the author already sought to establish the authority of his personal "eye, beg[ging] . . . to call attention to the fact that . . . he has mentioned no pictures that he has not seen").[14] Still, the essay by itself is a conventional piece of popular historical criticism. In the second and altogether more ambitious of the four essays on Italian painting, *The Florentine*

[8] Walter Pater, *The Renaissance*, ed. D. L. Hill, Berkeley (1980), 189.

[9] Bernard Berenson, *Sketch for a Self-Portrait*, New York (1949), 60.

[10] Bernard Berenson, *The Venetian Painters of the Renaissance*, New York and London (1894).

[11] Bernard Berenson, "Venetian Painting, Chiefly before Titian, at the Exhibition of Venetian Art," reprinted in *The Study and Criticism of Italian Art*, London (1901), 90–146.

[12] Bernard Berenson, *Lorenzo Lotto. An Essay in Constructive Art Criticism*, New York and London (1895). See also Berenson's remarks on his intention in writing the Lotto monograph in *The Study and Criticism of Italian Art*, second series, London (1902), vi–vii.

[13] Berenson, *Study and Criticism* (as in note 12), 111–148.

[14] Berenson (as in note 10). See also the preface to the second edition, 1895.

Painters of the Renaissance of 1896,[15] he encompassed still another objective in the brief span of ninety small pages: the enunciation of general aesthetic principles based, as Gombrich[16] and others have shown, on theories of the psychology of perception developed by Fiedler and Hildebrand, James, and Bergson. It was here that Berenson developed the vocabulary of "tactile values" and "ideated sensations," largely forgotten today, although long so well known.

This is perhaps the place to say a word about the style of these essays. They were widely read for a generation and more, in many editions and translations. Addressed to a general audience, they were brief, elliptical, aphoristic, informal, conversational yet assertive, occasionally arbitrary and personal—a curious mixture of dogma and offhandedness (part Morelli and part Pater in this respect, too). At the time they were written one could not assume on the part of the reader a direct knowledge of the works discussed. The reader entrusted himself to the author's judgement—whether Berenson or Pater—having for the most part no way to assess it, not firsthand experience, and not even illustrations. Sidney Colvin's review of Pater's *Renaissance* might have been written of Berenson: "The information to be found in any one of these essays . . . will be accurate as far as it goes, but will go only just far enough to carry the criticism, the impression . . . made upon the writer individually."[17]

It was far from Berenson's intention to attempt a reconstruction of the past on its own terms. It was rather *his* terms that he explored, taking the task of aesthetic criticism as Pater had defined it: "In aesthetic criticism the first step towards seeing one's object as it really is, is to know one's impression as it really is, to discriminate it, to realize it distinctly . . . ," to ask, "What is this to me? What effect does it really produce on me?"[18] Neither historian nor antiquarian, the self-referential quality of Berenson's Paterian criticism gave him a free hand. He had "cut with scholarship," but found in the Morellian method systematic support for his aestheticism.

Berenson's thought was not original in any of the areas I have indicated. It is his attempt to integrate them that is original: art criticism as literature addressed to a general audience, connoisseurship as a succinct and quasi-exact science having narrow but precise goals, and all resting on a foundation of general principles about the aim of art and the effect of art on the beholder. For better or worse, these goals seem remote today. Art history has tended to separate itself from art criticism on the one hand and aesthetics on the other. Art criticism pertains almost exclusively to contemporary art, and connoisseurship has receded from the foreground, as its major accomplishments have come to be taken for granted; its most intractable problems have been recognized as insoluble without recourse to other means. One of its early battlegrounds, Giorgione, comes to mind.

It was not long after the publication of the *Florentine Painters* that Roger Fry wrote to R. C. Trevelyan (1898):

[15] Bernard Berenson, *The Florentine Painters of the Renaissance*, New York and London (1896).

[16] Ernst H. Gombrich, *Art and Illusion*, Princeton (1960), 16.

[17] S. Colvin in the *Pall Mall Gazette* (March 1, 1873), 11–12. Quoted by Adam Phillips in his introduction to Walter Pater's *The Renaissance*, Oxford (1986), x.

[18] Pater (as in note 8), xix.

I've just been reading Pater's Miscellanies. It is a pity he makes so many mistakes about pictures; but the strange, and for a Morelliite, disappointing thing is that the net result is so very just. What is wanted now in the way of criticism is someone who will make appreciations as finely and imaginatively conceived and take them into greater detail as well. Perhaps Berenson will get to this if he gets over his theories.[19]

This might be taken as a charter for Berenson's subsequent work. In a sense he did "get over his theories," in that he never really developed them further; and one certainly feels that he set himself the goal of creating "finely conceived" and greatly detailed "appreciations."

Although complementary, the essays and lists have little enough in common. Their juxtaposition suggests the uneasiness of the alliance between Paterian criticism and Morellian connoisseurship. Ultimately Berenson separated them, combining the essays in 1930 under the new title *Italian Painters of the Renaissance*,[20] and reissuing the lists in greatly expanded form in 1932 and 1936.[21] The lists were the end product of his connoisseurship (Kenneth Clark called them a "sharp weapon used to assault an inert mass of tradition").[22] But to understand the methods and procedures behind them one must consult his other publications during the twenty-five years of work that led up to these editions of the lists: altogether approximately 120 articles between 1894 and 1935, originally published for the most part in *Art in America*, the *Gazette des Beaux-Arts*, and *Rassegna d'arte*, perhaps half of them collected in various volumes—all dealing with specific problems in the attribution of fourteenth-, fifteenth-, and sixteenth-century paintings, and the construction or reconstruction of "artistic personalities"—work that Kenneth Clark called the business of "saying who painted what."[23]

Nevertheless, it is in this body of work that Berenson's major contribution is to be sought and measured, as Philip Pouncey recognized when he wrote, "Paradoxically, that part of [Berenson's] achievement which has been least clearly charted is the essential part and we are, in fact, still without any precise idea of the degree to which he added to our knowledge of his field of Italian art."[24] To chart this achievement is a nearly impossible undertaking, for it would require assessing many thousands of attributions (more than 18,000 works by 400 painters, according to one reviewer of the 1932 edition), sorting out Berenson's own attributions from those traditional or received attributions he incorporated into the lists, and sifting his own changing opinions over five or six decades; assessing the role played by his work for the art market; examining the result in the light of subsequent publications that have added to or subtracted from the corpus; and assessing along the way the degree of consensus that has

[19] Roger Fry, *The Letters of Roger Fry*, ed. D. Sutton, New York (1972), 171–172.

[20] Bernard Berenson, *Italian Painters of the Renaissance*, Oxford (1930).

[21] Bernard Berenson, *Italian Pictures of the Renaissance*, Oxford (1932), and *Pitture italiane del rinascimento*, Milan (1936).

[22] Clark (as in note 4), 119.

[23] Clark (as in note 4), 112.

[24] Philip Pouncey, review of Bernard Berenson, *I disegni dei pittori fiorentini*, Milan (1961), in *Master Drawings*, II (1964), 278.

been reached in every case. To all of this we should have to add an analysis of his large and fundamental work on Florentine drawings—fundamental because it was the first to undertake a comprehensive study and catalogue of the whole field—first published in 1903 and again in greatly expanded form in 1938.[25] Merely to outline such a task is to recognize the scope, if not the precise measure, of Berenson's work.

It is easier perhaps, and certainly also necessary, to recognize the limitations and failings of Berenson's connoisseurship: his exaggerated estimate of Alvise Vivarini, the fatality of Amico di Sandro, his blind spot about Michelangelo's drawings for Sebastiano, and many errors in the early lists that seem incomprehensible today, but give us a sense of the uncharted terrain Berenson had entered. These early errors include also his rejection of the Mantegna *Judith*, his estimation of Titian's so-called *Schiavona* in London as a copy of Giorgione, his attribution of the Caen *Sposalizio* to Lo Spagna (which he maintained to the end), the attribution of the Raphael cartoon for the Mackintosh *Madonna* to Brescianino, and the attribution of his own Domenico Veneziano to Baldovinetti. Finally, one remembers his inadequate attention to the fourteenth century in the early editions of the lists and the erratic and distorting selectivity of his approach to the sixteenth century even in his later work.

A detailed evaluation of the lists is of course beyond the scope of this discussion. If, however, we ask in more general terms what Berenson's contribution to art criticism and connoisseurship was, I think we can indicate two areas. One I have already mentioned: the attempt to integrate it with aesthetic criticism. The other concerns not merely the specific results of connoisseurship as applied to individual works, but its procedures and purposes. Besides advancing the classification of a body of Italian paintings and drawings, did he improve the tools of connoisseurship beyond Morelli?

I think it is fair to say that Berenson added the concept of "artistic personality" to Morelli's methods. Although the notion exists embryonically in Morelli's "Tommaso," it was Berenson who developed it as a real instrument for organizing, classifying, and interpreting groups of paintings—with varying success, as we all know—yet it remains a valid procedure today. The bravado with which Berenson introduced his Amico di Sandro ("I attempted without the aid of a single document or a single literary hint to construct an artistic personality")[26] was ill fated, though others of his *creati* have survived and even found acceptable historical identities: think of Alunno di Domenico, "Utili," Ugolino Lorenzetti. And through all the vagaries of the literature, the Master of San Miniato, created by Berenson in the Johnson catalogue of 1913,[27] with a core of ten works, remains alive and well today, an "artistic personality" with more than fifty attributions to his name, though still without an historical identity. (Recalling Panofsky's contrast between art history and connoisseurship, it must be said that Millard Meiss's 1931 stylistic analysis of Berenson's Ugolino Lorenzetti

[25] Bernard Berenson, *Drawings of the Florentine Painters*, London (1903); second edition, Chicago (1938).

[26] Bernard Berenson, "Amico di Sandro," reprinted in *The Study and Criticism of Italian Art* (as in note 12), 46–69.

[27] Bernard Berenson, *Catalogue of a Collection of Paintings and Some Art Objects*, vol. I, *Italian Paintings*, Philadelphia (1913), 23–24.

and DeWald's Ovile Master as a single artistic personality makes more interesting reading than his documentation of the same artist as the historical Bartolommeo Bulgarini five years later.)[28]

As an extension of the concept of a constructed artistic personality, Berenson explored problems of internal dating and chronology more deeply than Morelli. More problematically, he attempted to incorporate issues of what he called qualitative analysis—in relation no doubt to the Paterian concept of aesthetic criticism—which Morelli preferred to ignore. It is here that he seems closest to his goal of uniting Pater and Morelli. Yet in introducing the concept of qualitative analysis, Berenson obliged Morelli's so-called 'scientific' method to yield to the idea of "giftedness" ("the sense of quality," he wrote, "must exist as God's gift")— thereby calling into question the whole notion of 'scientific' connoisseurship. Later, in 1927, he affirmed that connoisseurship demands "no magical endowment, no special senses,"[29] but he seemed to create a distinction between classification and evaluation.

We see an evolution in Berenson's theories from their first formulation in the essay on the "Rudiments of Connoisseurship," from the positive dogma of "the perfect determination of artistic personality" to the more flexible attitude enunciated in the preface to the Sienese essays of 1918: "Argument in our field can never be conclusive: it can only be directive."[30] The function of connoisseurship, we are told, is "to canalize guessing."[31] Indeed, already in 1902 (the very year of the publication of the essay on connoisseurship) he declared he was no longer interested in method.[32] Similarly, there is a change in the vocabulary of analysis: the ovals, ears, and fingernails of the Lotto monograph give way to more impressionistic, allusive demonstrations. There is a constant tension between remarks such as "obviously close to Cossa" (or indeed the textless lists themselves) and the desire to document his conclusions. One can sympathize with Roger Fry's complaint, reviewing Berenson's *Three Essays in Method* (1927): "We have to go through fifty pages of argument before we are allowed to say the pictures in question are Veronese and painted between 1480 and 1490. Then and only then may we mention the name of Domenico Morone which to tell the truth, Berenson must have arrived at long before a tenth part of these facts had been clear to his mind."[33]

Accompanying this evolution was what we may call a gradual relaxation of Berenson's original rigid standards, and this influenced the shape of the later editions of the lists (1932 and 1936). Whereas he limited the early lists to attributions based on firsthand examination, Berenson later considered photographs sufficient for the "archaeological purpose of determining when and where and by whom a design was invented."[34] And he expanded his

[28] Millard Meiss, "Ugolino Lorenzetti," *Art Bulletin*, XIII (1931), 376–397; and idem, "Bartolommeo Bulgarini altrimenti detto 'Ugolino Lorenzetti'?" *Rivista d'arte*, XVIII (1936), 113–136.
[29] Bernard Berenson, *Three Essays in Method*, Oxford (1927), vii.
[30] Bernard Berenson, *Essays in the Study of Sienese Painting*, New York (1918), vi.
[31] Berenson (as in note 29), ix.
[32] Berenson, *Study and Criticism* (as in note 12), vii.
[33] Roger Fry, "The Berensonian Method," *Burlington Magazine*, LII (1928), 47.
[34] Berenson (as in note 29), viii.

standard to include under an artist's name "every work that shows the distinct trace of [his] creative purpose,"[35] even if it was not autograph, a position that Offner deplored as "retrograde."[36]

Berenson's effort to distinguish and define the methods of Morellian connoisseurship and his commitment to purely formal analysis isolated him from other methods of analysis and interpretation. Yet his indifference to condition and particularly to setting and physical context is surprising. No doubt this indifference was reinforced by his concentration on panel and canvas, as opposed to fresco, and by the new role of photography. While photography allowed close comparisons of paintings, it obscured the issues of context and condition. Berenson was equally indifferent to iconography, patronage, and documentary evidence, the latter all the more surprising given the important contributions to putting order into the Vasarian tradition that had been made by Gaye and Milanesi. With these limitations he could never have given us a full understanding of Raphael's and Michelangelo's drawings for the Chigi Chapel in Santa Maria della Pace, for example, as such an understanding is dependent on the interaction of all these factors.

All told, I believe that Berenson's contribution rests primarily on his spadework in recording and classifying an enormous body of material in Italian painting and drawing, from the fourteenth to the sixteenth century. I have also mentioned his development of the concept of the "artistic personality" as a tool of the connoisseur. If his tendency to make the work of art itself the sole object of the art historian's attention is, from today's perspective, specious, nevertheless the emphasis on its centrality still strikes me as essential. The application of art criticism, as literature and as aesthetic interpretation, to the art of the past is certainly moribund now, if not defunct—and regrettably so.

The various strands indicated here, which Berenson sought to fuse and then disengage, remain distinct in most art-historical writing today. His work as a connoisseur was advanced most significantly by Offner—indeed Morelli, Berenson, and Offner may be called the Bellini, Giorgione, and Titian of connoisseurship. The thread that deals with the psychology of perception can be followed preeminently in the work of Gombrich and others. And the Paterian search for an adequate literary expression ("to discriminate [one's impression], to realize it distinctly") is perpetuated in the work of Sydney Freedberg. Inasmuch as Berenson's specific contribution to all these areas is either too elusive or too pervasive to be measured precisely, from our vantage point we are left with the impression that much of his work and influence has simply been absorbed into the very substance of art history, as he has been absorbed into its lore.

[35] Berenson, *Italian Pictures* (as in note 21), iii.

[36] Richard Offner, *A Critical And Historical Corpus of Florentine Painting*, section III, vol. I, *The Fourteenth Century*, New York (1931), x.

Arthur Kingsley Porter:
Life, Legend, and Legacy

LINDA SEIDEL

Arthur Kingsley Porter's sudden disappearance from the art-historical community at the age of fifty drew a mythic shroud around his life and foreclosed prematurely on the intellectual investments he had so boldly made during the preceding twenty-five years (Fig. 35). His voice, as young as the discipline he helped shape, traversed the decades that framed the Great War. At the start of his career he had been a Jamesian hero abroad, affluent and innocent, enamored of an Edwardian Europe only privileged Americans could know. A dozen years later, the monuments he had so recently come to love lay in ruins; as he toured the battle grounds to inventory the shattered fragments, he was forced to acknowledge the illusory status of that love—claiming, nonetheless, that its objects constituted a necessary protective lie against the onslaught of both mechanism and Bolshevism. Porter openly and passionately defended the necessity of illusion. Truth, he wrote in 1928, had never been what he sought. Rather, the study of medieval archaeology—which for Porter meant pre-modern architecture and sculpture as an ensemble—was "an ephemeral product of an ephemeral age."[1] In the early 1930s, despairing over the mind control that loomed over the eastern European landscape, he retreated into the myths of medieval Ireland in his search for coherence. Throughout his life, Porter was deeply aware of the circumstances of the age in which he lived and of the role that art played in social practice. He addressed these issues in essays and plays published between 1918 and 1929, the years in which the controversial theories on Romanesque sculpture he had formulated toward the end of the war were being debated by European colleagues. But Porter's academic and critical writings provide limited perspectives on his foreshortened life; his personal qualities are better projected in the letters he exchanged with contemporaries and in those they wrote about him. This varied literary production, on which I draw here, tracks the emergence of Porter's legend and integrates his legacy with the worldly events and historical figures that shaped his career. Both the scholarship and the man

[1] *Spanish Romanesque Sculpture*, 2 vols., Florence (1928), I, vii. In the preface to his play, *The Seven Who Slept* (Boston [1919], 14–15), Porter wrote that "The arts depend upon lies for the very breath of life. One and all they demand that we imagine to be what is not In the Temple of life, side by side with the lamp of truth, there burns with equal brightness, and to be disregarded only at the gravest risk, the lamp of lies."

can best be understood in the context of a privileged life lived in remarkable decades in the company of exceptional acquaintances.[2]

Porter's wife Lucy provided posterity with the basic introduction to her husband's biography. In her prefatory remarks to the two volumes of papers that were published in his memory in 1939, facts and an elite point of view ineffably merge into a familiar fiction:

> Arthur Kingsley Porter was born at Stamford, Connecticut. Timothy Hopkins Porter, a banker, was his father; Maria Louisa Hoyt, his mother. He was prepared for college at the Browning School in New York—too well prepared, he used to say. Being a Connecticut boy, he was sent, as a matter of course, to Yale College, where his father and brothers had preceded him. As he looked back on his life he sometimes wondered how different it might have been had he gone to Harvard instead of Yale and sat under men of such caliber as Santayana, William James, and Charles Eliot Norton. He graduated from Yale fourth in his class although he had spent the greater part of his sophomore year accompanying his older brother (who had undergone a serious operation) on a trip around the world.[3]

Porter is seen, posthumously, in his wife's eyes as a man of destiny; the seeds of an epic tale are firmly planted in her prose. He would overcome the deficiencies of education and embark on an extraordinary journey, one that would transform him and set him on his life's course. Little is said in her hagiography of the personal tragedies of Porter's early years and of how they may have affected his choices. In his Class Book of 1904, "Art" (as he was called) noted a bit frivolously that "the pleasantest event in his college course" had been the "rush" when he was a freshman.[4] That had been the year in which his father died, leaving Arthur and his older brother Louis orphans. The boys' mother had passed away nearly a decade before, and a teenage brother had died a few years after that.[5] Thus the trip which Lucy mentioned brought the surviving members of the family together under circumstances that were more dramatic than she allowed.

As an undergraduate (Fig. 34) Porter had taken studio classes at the Yale Art School. He received his degree from Yale College with distinction, and spent the summer after graduation in Europe "before beginning the study of law in order to become his brother's junior partner." But a "conversion experience" at the cathedral of Coutances altered the course of

[2] Nora Nercessian evaluated some of the same material I use here in her contribution to the conference held at Harvard on the centennial of Porter's birth. It was subsequently published as "In Desperate Defiance: A Modern Predicament for Medieval Art," *Res: Anthropology and Aesthetics*, vii/viii (Spring/Autumn 1984), 137–146.

[3] Lucy Kingsley Porter, "Arthur Kingsley Porter," in *Medieval Studies in Memory of A. Kingsley Porter*, ed. Wilhelm R. W. Koehler, 2 vols., Cambridge, Mass. (1939), I, xi.

[4] *Yale College Class Book, 1904*, ed. Henry L. Foote, New Haven (1904), 113. I am profoundly grateful to Prof. Betsy Fahlman for generously sharing with me information about the young Porter and Yale, to which I make reference here and in the following notes.

[5] Fuller biographical information on Porter than that provided by Lucy is contained in the obituary published in the *Obituary Record of Graduates of Yale University* (1933–1934), 121–122; the entry in *The National Cyclopaedia of American Biography, Being the History of the United States*, xl (1955), 572–573; and in an autobiographical note published in the *Sexennial Record of the Class of 1904, Yale College*, ed. G. Elton Parks, New Haven (1911), 204. We learn from these sources that Porter's father graduated from Yale College in 1848, attended the Yale Divinity School in 1852–1853 and died on New Year's Day, 1901; his mother received her B.A. from Vassar in 1868; she died when her youngest son was eight years old.

his future. "When he awoke," Lucy wrote, "he knew he could never be a lawyer."[6] In the fall of 1904, Porter entered the Columbia School of Architecture and pursued a program of technical training before leaving in the spring of the following year to begin work on his first book. His decision to devote himself to the study of archaeology "for which . . . his scholarly type of mind better fitted him," rather than architectural design, would, in retrospect, seem natural.[7] The beaux-arts training to which he had been exposed at Columbia would provide that pursuit with a particular orientation toward objects and design, and would mark it with distinction.

Porter's first published work, *Medieval Architecture: Its Origins and Development*, drew on the experience of his early travels and training. He explained in the preface that the book was "for the general reader, to put him in possession of such knowledge as is indispensable for the appreciation and enjoyment of the great masterpieces of Gothic Architecture."[8] The book, he claimed, assumed no prior knowledge on the reader's part, for he had not sought to write a history of monuments; he identified his work, rather, as a history of styles:

> It has long been recognized in the field of political history that the historian who would convey a true understanding of a period must go beyond a mere catalogue of kings, battles and dates. Similarly in architectural history, there has been a decided tendency of late years to lay greater emphasis on the broader significance of events, to see in the general course of development something far deeper, more vital than the individual building[9]

Porter then separated the technical, monographic material that was customary in the "time-honored form of architectural history," into an annotated list that followed his discursive text on building from the fall of Rome to the rise of the Gothic. The attention he paid to work in Normandy and the Île-de-France emphasized the role of patrons and master builders in the development and execution of architectural design. His theories about the use of models as an aid to construction and the integration of all the arts in a unified conception were instantly influential: Raymond Pitcairn incorporated Porter's notions into his plans for a cathedral in Bryn Athyn, Pennsylvania, for which the Boston architect Ralph Adams Cram was engaged to draw the design.[10] Porter subsequently praised the work as "an epoch-making masterwork of architectural art, created with joy, full of artistic conscience."[11]

Porter's next work, a short essay on the construction of Lombard and Gothic vaults, was published by Yale University Press in 1911, when he was twenty-eight. The book presented the thesis that the introduction of the rib-vault was prompted by a desire to economize on the

[6] Lucy Porter (as in note 3), xi.

[7] Ibid.

[8] Arthur Kingsley Porter, *Medieval Architecture: Its Origins and Development*, New York (1909). The two-volume study, although published in 1909, was copyrighted by Porter during the fall of 1908. The quotation is from page v.

[9] Ibid., vi.

[10] Jane Hayward and Walter Cahn, *Radiance and Reflection. Medieval Art from the Raymond Pitcairn Collection*, New York (1982), 33.

[11] Arthur Kingsley Porter, "Art and the General," in *Beyond Architecture*, Boston (1918), 190.

use of wood for the construction of centering (an argument, Porter noted, that Choisy had put forward in relation to Roman architectural practice in 1873).[12] Porter maintained that the scarcity of wood in the Lombard plain led to the invention of the rib vault: "Its introduction in the naves of certain churches never occurred in areas of Italy where wood was abundant." The French, he observed, who learned the technique from the Lombards, discovered that the doming of the vault further facilitated construction without solid centering. In Porter's eyes, a practical, cost-effective approach to construction had contributed to the invention of a design element which a subsequent generation of scholars would appreciate for its formal and aesthetic properties alone.

Porter then pursued the theories set out in this short essay. He worked on the monumental study *Lombard Architecture* while living and traveling in Europe in the years immediately preceding the war.[13] Lucy Bryant Wallace, whom he married in 1912, "henceforth accompanied him on all his archaeological journeyings," as she noted in her biographical comments on her husband.[14] She became his companion and helpmeet, protecting his never-too-robust health and organizing both his photographs and his social life.[15] Her assistance in the photographic enterprise that served as the backbone of the North Italian project (954 illustrations) and subsequent and still more monumental *Romanesque Sculpture of the Pilgrimage Roads* (one volume of text and 1527 plates) was especially critical. It was through that legacy, stored unmounted in tin file drawers in the Fogg Museum, that I, like so many others, first came to know both the Porters and Romanesque art. In *Lombard Architecture*, published in four volumes in a limited edition of 750 in 1915, and available at a cost of $50,[16] Porter argued that the rib-vault had been in use in northern Italy since the late eleventh century. With the aid of carefully collected records, he constructed a chronology that revised the existing conjectural scheme, which had been based primarily on a notion of "consistent development" rather than on documentation. The book won the Grande Médaille de Vermeil de la Société Française d'Archéologie, and Porter's career was launched. He was invited to teach at Yale even though, as Lucy reported, "because of the suspicion attached to a course in art it was deemed wiser to announce his lectures as a course in history."[17]

In fact, the circumstances were more complex and more interesting. Yale's art school was devoted, at the time, to the teaching of techniques to art students. There was only incidental instruction for undergraduates (such as that which Porter himself had earlier pursued). Porter, however, believed that art history should be integrated into an art curriculum and made available to all undergraduates; college students, to his mind, were "pathetically

[12] Auguste Choisy, *L'Art de bâtir chez les romains*, Paris (1873). Porter may have known the nearly two dozen translated installments of Choisy's work by Arthur J. Dillon that appeared in *The Brickbuilder* between 1894 and 1897.

[13] For a detailed chronology of Porter's whereabouts, see, in addition to the Yale obituary, the entry in the *Twenty-Fifth Anniversary Record of the Class of 1904, Yale College*, ed. Henry H. Stebbins, Jr., Brattleboro, Vermont (1930), 250–251.

[14] Lucy Porter (as in note 3), xii.

[15] Chandler Post, Edward Waldo Forbes, and Kenneth John Conant, "Minute on the Life of A. Kingsley Porter," *Bulletin of the Fogg Art Museum, Harvard University*, III, no. 1 (1933), 3.

[16] Edna Louise Lucas, *List of Books for a College Library, Compiled for the College Art Association*, New York (1929).

[17] Lucy Porter (as in note 3), xii.

untrained and undeveloped along the lines such studies require."[18] Toward that end, he offered Yale a bequest of half a million dollars in 1916 for the establishment of a "Faculty of the History of Art in the College." He added, however, that "it is entirely immaterial whether the Department of Art History should be established in the College or in the Art School provided the courses be open to academic students and count for the B.A. degree."[19] He subsequently noted: "It is because I am certain that the adequate study of the history of art would tend to raise, rather than lower, the present loose standard of scholarship, that I am so anxious to see it added to the curriculum."[20] But within a year the fear of economic realities of wartime made it impossible for Yale to consider adding new departments, and the matter was dropped.[21] Porter was promoted to assistant professor of the history of architecture and, while teaching, succeeded in completing requirements for a B.F.A. degree of his own, his only graduate degree, in 1917.

The following year, Porter went on leave to accept the French government's invitation, the only one extended to a foreigner, to join a war commission for the oversight of endangered monuments. Here he was brought face to face with the destruction of many of the buildings whose historical past he had labored so hard to reconstruct during the previous decade. From the academic perch to which he returned, he confronted the public with the importance of such material in an improved collegiate education, for which he was the outspoken advocate of his time. He also saw to it that real objects were acquired by the Department of Fine Arts at Harvard, which he joined in 1920, to supplement the use of plaster casts, slides, and photographs.[22]

Porter's writing from the late war years displays a loosening of bonds with the structures that had, in the decade before the war, shaped his approach to monuments. Documents still mattered deeply to him, but his attention turned from vaulted edifices to sculptural fragments, from regional definitions to a concentration on international movements with itinerant uprooted artists serving as the links in an ever-lengthening chain. Porter's direct experience of the monuments and his on-site inspections were paralleled by concern for the tangible issue of sculptors' movements across the countryside from one project to another. In contrast to his French contemporaries, such as Emile Mâle, who studied and then illustrated books with photos of the plaster casts in the Musée des Monuments Historiques in Paris,[23] Porter's own photos were made on the spot and developed in hotel closets across the continent. They demonstrated his palpable fascination with immediate issues of carving

[18] Porter's letter to Yale president Arthur T. Hadley, dated February 3, 1916, in the collection of the latter's papers, Records of President Arthur Twining Hadley (YRG 2-A-14) Yale University Archives, Manuscripts and Archives, Yale University, cited with permission. Professor Fahlman kindly directed me to this material. The same ideas are expressed more generally and publicly in Porter's essay "Problems of the Art Professor," *Scribners Magazine*, LXV (1919), 125–128.

[19] Porter's letter to President Hadley, January 28, 1916 (as in note 18).

[20] Porter's letter to President Hadley, February 3, 1916 (as in note 18).

[21] President Hadley's letter to William Kendall, Dean of the Yale School of Fine Arts, February 16, 1917 (as in note 18).

[22] Arthur Kingsley Porter, "Romanesque Capitals," *Fogg Art Museum Notes*, I (June 1922), 23–36.

[23] See, for example, E. Mâle's *L'Art religieux du XIIe siècle en France, Étude sur l'origine de l'iconographie du Moyen âge*, Paris (1922), figs. 23, 32, 53. Mâle also made use of severely cropped photos which radically decontextualized sculptured reliefs from their setting.

practices and idiosyncracies of manner, issues that might allow the attribution of bodies of work to individual medieval artists. It is no surprise, then, to learn that one of Porter's closest contacts in the post-war period was with Bernard Berenson (Fig. 103).

In the summer of 1917 Yale University Press sent Berenson a copy of the four volumes of Porter's *Lombard Architecture*, and Berenson wrote back for more information about the author. He then sent an appreciative letter to Porter, who responded: "I have read and reread and admired your work so intensely, that an autograph from you carries with it the romance of a relic."[24] Porter cited Berenson in his essay "Art and the General" of 1918 before actually meeting him in Paris in the summer of 1919, while serving as liaison to the French government for the preservation of art in the war zone. Their friendship flowered during a long motor trip they took together through Burgundy. In the summer of 1920, the Porters stayed at I Tatti, paying all the bills, including the wages of the gardener, an arrangement that made it possible for Berenson to go off to the States. Porter called his visit to I Tatti "a moment of pure joy," and he set about looking for a villa in Florence; he was unable to find one to his liking.[25]

In April 1923 the Porters and Berensons met in Athens where, as Berenson noted, the hotels were filled with fugitives from Asia Minor.[26] They traveled primarily by chauffeured limousine or, when on impassible roads—as to Hosios Loukas—on horseback; sometimes they rode donkeys. Mrs. Berenson recalled May 15 as " . . . one of the most awful days of my life. 6 hours on a donkey, on a frightful path of rocks, going and coming from Bassae."[27] An accompanying motor truck carried field beds and a cook, should country inns fail to provide adequate comfort.[28] They either took along a tea basket so Porter could eat as they drove from site to site, or they parked the car at a restaurant while they enjoyed a more leisurely meal with fine wine: Porter's "Bacchic habits" were well known. At one stop, on the quay at Colchis, the brakes on the car slipped, possibly because local children had been playing with them, and the auto rolled into the sea. "It wasn't very deep and they got it hauled up, but I fear quite ruined. What bad luck!" Mary Berenson noted in her diary.[29] Nicky Mariano, who found Porter's pace to be a bit slow, reported that Berenson would rage out against his younger colleague for concentrating his interests too narrowly on Byzantine art and on classical art in its archaic form.[30] Even though he didn't approve of the ugly things that appealed to Porter, Berenson found in Porter one of the most intellectually rewarding friendships of his life.[31] And Porter thanked Berenson in a letter, saying: "I wonder if you realize how much [I am fond of you] and how deeply you have influenced my way of looking at things."[32] In

[24] Ernest Samuels, *Bernard Berenson: The Making of a Legend*, Cambridge, Mass. (1987), 223–224.

[25] Ibid., 262, 265, 279.

[26] Nicky Mariano, *Forty Years with Berenson*, London (1966), 73; for further details of this trip, 74–77.

[27] Mary Berenson, *Mary Berenson: A Self-Portrait from her Letters and Diaries*, ed. Barbara Strachey and Jayne Samuels, London (1983), 247.

[28] Samuels (as in note 24), 312.

[29] Mary Berenson (as in note 27), 247. The incident is also recounted by Mariano (as in note 26), 74.

[30] Mariano (as in note 26), 76.

[31] Samuels (as in note 24), 224.

[32] Ibid., 406. Porter was expressing his thanks to Berenson for encouraging his interest in Spanish Romanesque.

1927 the Porters and Berenson met in Hamburg and spent a long, unforgettable afternoon, in Berenson's words, at Warburg House meeting Gertrude Bing and "some young art historians working at the Institute"; Heydenreich was among them.[33] Porter went on to receive an honorary degree from Marburg, yet another demonstration, along with the earlier French medal, of his exceptional European reputation.

The post-war years marked an increased concern on Porter's part with the political and social ramifications of art. From 1918 on, he attacked the concentration of power in the hands of the moneyed elite whose appreciation of art, he observed, created a demand that separated art more and more from the masses. He deplored cosmopolitanism's capacity to erode creativity, observing that "art has, indeed, generally, flourished best in provincial cities."[34] During these years of European residence, Porter was an outspoken advocate of art education and of the newly founded College Art Association. He proclaimed art to be the only agent that could effectively break the circle of materialism and ignorance into which Americans had slipped and urged that the education of the artist take place in an environment free of commercialism. The Middle Ages seemed to him to provide a model of a time when art had not been slave to material gain.

In his best-known work on Romanesque sculpture, Porter appropriated for art the French scholar Joseph Bédier's theory of the development of medieval epic.[35] If songs and stories had been composed and communicated, as Bédier claimed, along the pilgrimage routes that crisscrossed France, why then couldn't artistic motifs and modes have followed the same channels of communication, Porter asked. The query was subversive insofar as it implied that there were no real boundaries for art—regional or national. Instead, according to this view, the continent formed an international school with major roads that followed the outlines of the old Roman trade routes like great rivers "formed by many tributaries which have their sources in the far regions of Europe."[36] The protest the book provoked was caused by its challenge to newly established systems of classification and to chronological priorities, the scientific structure that was so essential to French scholarship and which Porter was coming to abhor.[37] Equally ominous threats to prevailing scholarship could be felt in Porter's dynamic concept of art and his cross-disciplinary approach to it. In imagining sculptors as independent brokers of their own commodities, he unharnessed stoneworkers from the institutional control of the church.

[33] Mariano (as in note 26), 153–154.

[34] Porter (as in note 11), 176.

[35] Arthur Kingsley Porter, *Romanesque Sculpture of the Pilgrimage Roads*, 10 vols., Boston (1923), I, 171–196.

[36] Ibid., 175.

[37] The French held for the primacy of southern French sculpture in the development of Romanesque art; Porter, in contrast, argued that role for either Spain or Burgundy. See Porter's review of Mâle's book on religious art of the twelfth century, "Spain or Toulouse? And Other Questions," *Art Bulletin*, VII (1924), 3–25, as well as the earlier paper written in response to a piece by Mâle: "The Rise of Romanesque Sculpture," *American Journal of Archaeology*, sec. ser., XXII (1918), 399–427. Marcel Aubert, in an obituary, attributed Porter's perspective to his American temperament: "Fils d'une race jeune, où la science d'archéologie était encore en formation, il n'a pas nos certitudes; il n'a pas surtout notre besoin de logique, de clarté, notre esprit de déduction, qui, partant d'un point précis, établit des cadres bien déterminés, topographiques et chronologiques, suivant un ordre rigoreux, où tout doit entrer et se classer méthodiquement" (*Revue archéologique*, 6me sér., II [1933], 327).

The study of art for Porter was part of the enterprise of practicing art, and, like it, was a passionate, deeply felt pursuit. In an essay written for delivery during a visit to the Sorbonne as an exchange professor in 1923, Porter mocked scholars who were uncomfortable experiencing pleasure before a work of art.[38] He chastised them for too hastily setting aside discussion of a possibile connection between desire and aesthetic sensation. "Yet I must confess I have never been entirely convinced that those who have championed the sexual view were entirely mistaken," he wrote. "We should, I think, confess that we are historians of art because we have been irresistibly attracted by the beauty of ancient monuments and that we study them because by that means our artistic enjoyment is increased."[39] He chided those who had forgotten that art is more important than history, that accuracy is a means, not an end, "a scaffolding which should enable us to climb up and see better" and not "prevent us from seeing at all. The purpose of the telescope," he continued, "is not the telescope but the stars."

A reviewer of *Beyond Architecture*, Frances Levine, thanked Porter in the *Art Bulletin* of 1929 for not sitting on the fence in critical matters. She added that the facility with which he wrote was both the charm and the defect of his work: "He strikes out one way or another. He is stimulating and says much that seems true. The principal quarrel with him is in regard to the way in which he arrives at his conclusions," she noted.[40] Nicky Mariano remarked on Porter's "meschugge" method in a letter to Mary: "He goes for one thing he has in his mind and does not look right or left at anything else."[41] For Porter, religious, poetic, and artistic individuals needed to escape the suffocation of the crowd. "Had the Buddha frequented the New York subway," he wrote sardonically, "he might have found serious difficulty in attaining Nirvana."[42] In these years Porter himself sought solace on the barren coast of Ireland; he even thought of resigning the endowed Boardman chair at Harvard, to which he had been elevated in 1924. He did not do so.[43]

Porter was described in Chandler Post's memorial minute to the Harvard faculty as "reserved to the point of shyness."[44] Though he avoided the limelight, he craved friendship, as the evidence of a prolific correspondence testifies. One of Porter's last and closest acquaintances was the Irish statesman and poet George William Russell, "AE," whom Porter referred to in the last letter he wrote as "the best the world has to offer."[45] They first met each

[38] Arthur Kingsley Porter, "Stars and Telescopes," published in English in *Beyond Architecture*, Boston (1928), 28–53. This book constitutes a 'second edition' of the 1918 publication of the same name (see note 11 above) even though only one of the eight essays in that volume was included and two new ones were added. Porter suggests in the preface to this volume that he did not, in fact, deliver the talk as planned since "it was hardly adapted for that public" (p. 5). For a critique of the lecture Porter gave at the Sorbonne, see Marcel Aubert, "La sculpture romane des routes de pèlerinage d'après M. Kingsley Porter," *Gazette des beaux-arts*, 5me sér., ix (1924), 372–376.

[39] A. K. Porter (as in note 38), 51. Lucy Porter quoted this passage toward different ends in her prefatory remarks in *Medieval Studies* (as in note 3), xiv.

[40] Frances Levine, review of *Beyond Architecture*, in *Art Bulletin*, xi (1929), 309.

[41] Mariano (as in note 26), 154 (written August 28, 1927).

[42] Arthur Kingsley Porter, "Parva Componere Magnis," in *Beyond Architecture* (as in note 38), 66.

[43] Nercessian (as in note 2), 144, n. 20.

[44] Post (as in note 15), 5.

[45] George William Russell [AE], *AE's Letters to Mínanlábáin*, with an introduction by Lucy Kingsley Porter, New York (1937), 86. What follows is based in large part, unless otherwise noted, on Lucy's account (1–19). Her remarks formed a

other in 1930 at Marble Hill, the Irish estate in Donegal that the Porters rented before they bought nearby Glenveagh, where Kingsley Porter spent a large portion of his final three years of life. AE then visited the Porters at Elmwood, in Cambridge, during a lecture tour of the States in 1931, and he stayed with them at Glenveagh for parts of the next two summers.

AE described Glenveagh, situated fifteen miles from the coast, as "remote from everything except mountains and lakes, with not even a village of ten houses nearer than four miles."[46] Lucy called it "a little kingdom of high mountains, wild moorlands, lakes and streams," which, because it was thought to have been the birthplace of St. Columba, offered Porter not only "wilderness of beauty" but also "holy solitude." Glenveagh's remoteness survived long after 1937, when Lucy Porter sold the castle and the vast deer park surrounding it to Henry McIlhenny of Philadelphia; electricity was not brought into the house until 1959, although the plumbing appears to have been "state of the art" while the Porters lived there![47] Touches of the Porters remain intact at the castle still; their decoration of the walls of the entry hall with shells set in tree patterns remains, as do several paintings done by AE during his visits; these hang in the library in the main tower.

AE had studied at the Metropolitan School of Art in Dublin in the mid-1880s; there he began a life-long friendship with the poet Yeats, whose interest in Irish nationalism he shared and whom he mentioned in his letters to Porter.[48] Painting was only a minor hobby, one that he pursued during his later years either on Sunday mornings or during the month of

prime source for Henry Summerfield's book, *That Myriad-Minded Man: A Biography of George William Russell "AE"*, Geward's Cross, Buckinghamshire (1975), 253–270, as well as for John Eglinton, *A Memoir of AE*, London (1937), 248–252.

[46] From a letter to Pamela Travers, quoted in Eglinton (as in note 45), 236–237.

[47] For a detailed discussion of the castle, see John Cornforth, "Glenveagh Castle, Co. Donegal, The Home of Mr Henry P. McIlhenny," *Country Life*, CLXXI, no. 4424 (June 3, 1982), 1636–1640; and CLXXI, no. 4425 (June 10, 1982), 1734–1737. For the post-Porter history of the house, see Joseph Rishel, *The Henry P. McIlhenny Collection: An Illustrated History*, Philadelphia (1987), esp. 85. I am grateful to Mr. Rishel for his knowledgeable comments on Porter's Irish lodgings. An interesting description of Glenveagh was provided by Adlai E. Stevenson, who planned to visit his wife's great-aunt Lucy in July 1937 before she sold the estate to McIlhenny; he finally saw it during a trip to Ireland with his wife in the spring of 1939. This description is extracted from a talk he gave to the Wayfarer's Club in Chicago: "It sits by a little lake in a dark ravine in the remote county surrounded by 20,000 acres of deer forest—a deer forest, you know, is rugged, stony highland and utterly treeless." (in *The Papers of Adlai Stevenson*, ed. Walter Johnson, 7 vols., Boston [1972–1977], I, *Beginnings of Education, 1900–1941* [1972], 516). Stevenson continued with an anecdote he credited to a Mrs. Sinclair, who reported ". . . an incident at Glenreigh [sic] a few years ago during the annual theatricals the Porters used to put on. She said without conscious embarrassment that a long line of ladies were lined up before the door to the toilet on the ground floor of the castle and as one emerged in front of her she exclaimed with 'my dear a perfect flush.'" For references to Stevenson's earlier plans to visit Glenveagh, see his letters to his sister Mrs. Ernest L. Ives ("Buffie") in March, May and August of 1937 (ibid., 353–354; 358–360; 368–369). My thanks to Mrs. Robert Branner for bringing the Stevenson connection to my attention.

[48] Richard Ellman, *Yeats: The Man and the Masks*, New York (1948), 31–32; for Yeats's own recollections of AE, see *The Autobiography of William Butler Yeats*, New York (1953), 145–151. AE's portrait of Yeats, in pastels, is reproduced in Jeanne Sheehy, *The Rediscovery of Ireland's Past: The Celtic Revival, 1830–1930*, London (1980), 97; on page 109 of the book is a portrait of AE by John Butler Yeats, dated 1903. AE had assisted Yeats's sisters in the establishment of a craft studio not far from Dublin early in the century; its aim was "to find work for Irish hands in the making of beautiful things." AE was directly involved with the embroidery projects. The name of the guild, Dun Emer (meaning Fort of Emer), honored the wife of the legendary Irish hero Cuchulain; she, like Penelope, wife of Odysseus, was famous for her weaving (ibid., 158–161).

vacation he regularly took in Donegal (even before he met the Porters). A biographer described his habit of working in the out-of-doors, rendering rapidly without preliminary drawing, and then finishing inside. The Porters put an empty room which was used only for storing fishing tackle at his disposal whenever he visited Glenveagh. AE did as many as thirty canvases or boards during a stay, smoking away on a pipeful of tobacco all the while.[49] Lucy noted that she, Kingsley, and any other visitors would spend hours listening to AE talk on the terrace after tea or in the library overlooking the lake where they gathered at night. In accepting the Porters' invitation for July 1933, AE had written: "We can compare pessimistic masterpieces of portraiture of our respective worlds. There is something nice and frank about the German idea that women's business is to breed soldiers and the ideal death is on the battlefield."[50] On July 7, AE wrote in a note to a friend that he intended to wear a red tie the next time he visited Porter in order to infuriate him by making him think he had become a communist. Their next meeting was scheduled for the morrow. But when AE stood alongside the Porters' chauffeur, waiting for his friends to return from a visit to their island cottage, only Lucy appeared in the boat. He had lost, AE said, one of the best friends of his later life.[51]

AE's letters to Porter, which Lucy saved and published after both were dead, refer to Porter's hatred of mechanism and his dislike of President Roosevelt (whom AE called the "Douglas Fairbanks of politics"),[52] his concern about the stock market and economic policy more broadly, a delight in rainy days, and a "liking for artistically complete pictures of decay."[53] Although the tone of pessimism and irony may be more that of AE than of Porter, whose letters to AE were sadly destroyed by their recipient, the surviving half of the correspondence identifies shared interests. The passion for Irish history and legends that is revealed in the letters was obviously a shared enjoyment. When AE received *The Crosses and Culture of Ireland*, Porter's last book—for which he had studied the ancient Celtic language and used stories of legendary Irish heroes to identify the iconography of medieval stone crosses—AE noted how pleased he was that St. Patrick had not put an end to art in Ireland. "You have certainly made a fine contribution to the culture of your adopted country," AE wrote.[54]

AE supported Porter's love of Druidic gods and of Finn and Cuchulain, the Irish heroes with whom he had become acquainted through Lady Gregory; he lamented the "blundering zeal" of the Christians which resulted in the destruction of so much pagan culture.[55] References to poems and ancient Gaelic songs dotted AE's correspondence. Even the image of the faithful wife, the role in which Lucy cast herself in the introduction she provided for *AE's Letters to Mínanlábáin*, was a familiar theme in the story of the dead Gaelic hero;[56] perhaps

[49] Eglinton (as in note 45), 65–66 and 251, quoting both Thomas Bodkin and Walter Muir Whitehead.

[50] George William Russell [AE], *Letters from AE*, ed. Alan Denson, London (1961), 82.

[51] Summerfield (as in note 45), 269; and AE (as in note 50), 204–205: a letter to Charles Weekes, July 9, 1933.

[52] AE (as in note 45), 78.

[53] Ibid., 57.

[54] Ibid., 30.

[55] Ibid., 42.

[56] William Butler Yeats, *The Cutting of an Agate*, New York (1912), 9–10. Lucy's identity with her husband is suggested by her adoption of the form Lucy *Kingsley* Porter after his death; informally, however, she was called Mrs. *Queensley*

that had something to do with her adoption of the Celtic 'trope' for her own contribution to the publication. Indeed, it is in these pages and in the brief biography she wrote for the memorial volumes in Porter's honor that the Irish "legend" of Kingsley Porter is most clearly limned.[57]

The year of Porter's tragic death, 1933, coincided with the relocation of the Warburg Institute to London and the first emigration of German scholars across the Atlantic. With these events came the absorption into American art history of attitudes and approaches that had been spawned on different campuses and in radically different circumstances. These, with their philosophical and scientific rather than political and pragmatic underpinnings would, in that dark decade, provide more support and satisfaction to the discipline's practitioners than Porter's pessimistic, publicly engaged rhetoric might have if he had lived. Indeed some wondered whether Porter hadn't gone off in despair over what the world was coming to when it was reported in the American press on July 10, 1933 that he had disappeared near the fisherman's cottage he had built on Inish Bofin, a small, bleak island off the coast north of Donegal.[58] The fishermen who inhabited the flatter stretches of the island never found Porter's body. Had it been claimed by the strong outgoing spring tide that morning? Or had Porter somehow swum ashore? It was reported that servants at Glenveagh said that Porter had returned there after his disappearance to visit his wife Lucy late at night.[59] Adlai Stevenson, recalling his visit to Glenveagh in 1939, suggested another scenario. Noting that Porter "has never been seen since" that July day, he went on: "The peasants loved him dearly in that region; he had done much to alleviate their condition—but his disappearance has never been explained and the peasants say he may have known too much about the little people that inhabit the dangerous, obscure nooks and crannies of the wild ancient country."[60] But to others, "who knew Kingsley's love of dangerous climbs combined with his so easily being lost in a dream world nothing seemed more likely than his absent-minded attempt to climb from one rock to the other in spite of the violent storm."[61] In death, whether by disaster or by

Porter according to Shirley Branner, who, as a graduate student at Yale in the 1950s, heard old acquaintances of Porter's refer to Lucy in that manner. I am grateful to Mrs. Branner for discussing so warmly with me the Porters, the lore that circulated about them, and her husband Robert Branner's own appreciation of Porter.

[57] In the postscript to her biographical note on Porter, Lucy (as in note 3, p. xv) quotes from his unpublished play based on the life of St. Columba, seeing in it an event that foreshadowed Porter's death: the sinking of the island of blessed beneath the sea.

[58] I am grateful to Martha MacFarlane for her diligence in searching out early news reports and making them available to me. The earliest report, which appeared on page one of the *New York Times* on July 10, said that Porter had gone out in a simple boat and that the craft had been overturned in a severe thunderstorm. But a follow-up piece on July 15 (p. 3) noted that a different version of the accident had been reported to relatives via cable. According to this account, Porter had gone on a morning walk on wet slippery cliffs and failed to meet his wife at an appointed rock. This became the official version. Another short item in the same edition (p. 12) quoted the coroner as saying that Porter had probably died from a "misadventure." The coroner indicated acceptance of Mrs. Porter's belief as to what had happened: "I think my husband must have slipped off the cliffs, fallen into the sea and been carried away. Our married life was very happy and we had no financial or other worries."

[59] Meryle Secrest, *Being Bernard Berenson, A Biography*, New York (1979), 328.

[60] Stevenson (as in note 47), I, 516.

[61] Mariano (as in note 26), 218.

design, Porter merged with the heroes of the Celtic legends he had been in the midst of researching; carried off by the current, he did not return.[62]

Porter's legend nearly rivals his prodigious legacy. In addition to his impact on more than sixty years of medieval studies, there is the output of his devoted students Kenneth John Conant, Henry-Russell Hitchcock, and Walter Muir Whitehill, each of whom paid tribute to Porter in warm words in publications of their own after his death.[63] (Was the use of three names by each of them mere coincidence, testimony to or evidence of brahminic roots, or further tribute to their beloved teacher?) Porter referred to the work of his students often, traveled with them, and invited them to join him and Lucy at Glenveagh. Glimpses of the vitality of his interactions with what was to be the next generation of art historians are provided by his correspondence with Meyer Schapiro.

In the mid-twenties, immediately after the appearance of Porter's volumes on the pilgrimage roads, Schapiro set out on his own remarkable investigations of Romanesque sculpture. These would bring him into productive discourse with Porter; the latter's letters reveal a sharing of information, inquiries, observations, and disagreements that proceeded with openness and affection.

Porter's generosity in responding to the young Ph.D. student at Columbia, to whom he first wrote in 1927, appears in his correspondence as a disinterested exchange of ideas in letters written in his customary large, round hand.[64] Porter graciously shared information with Schapiro and discussed differences of opinion concerning dating and inscriptions; he informed him of interesting new photos he acquired from Hamann and gratefully acknowledged Schapiro's suggestions and observations. In a letter of April 12, 1928, he regretted that Schapiro would not be "coming on to study with us here next year. I hoped that you might

[62] My words unintentionally echo Aubert's: "Il disparut dans la bourrasque: la mer le prit, la brume l'ensevelit; comme les héros des légendes celtiques, il n'est pas revenu" (Aubert [as in note 37] 328). Porter's last work involved pagan sculptures in Ireland on which he saw representations of the Irish hero Labraidh Loingseach and Conall Cernach, Cuchulain's foster brother. See the abstract of the talk he planned to deliver at the XIIIth International Congress of the History of Art, published in *Résumés des communications présentées au congrès*, Stockholm (1933), 62–63; and the "pencil draft" of the related article on which he was working when he died: "A Sculpture at Tandragee," *Burlington Magazine*, XLV (1934), 223–228.

[63] Hitchcock dedicated his study, *The Architecture of H. H. Richardson and His Times*, New York (1936), "To the Memory of A. Kingsley Porter"; Whitehill did the same for his *Spanish Romanesque Architecture of the Eleventh Century*, Oxford (1941), adding in the preface: "My deepest obligation is to the late Professor Kingsley Porter, for during the eight years in which I knew him I had constant opportunity to appreciate his never-failing generosity as a teacher, scholar, and friend. From his Harvard lectures came my first interest in the Romanesque style; later I had my first direct knowledge of Spain in his company As I cannot place the book in his hands, I do myself the honor of dedicating it to his memory" (p. ix). Conant, in the foreword to his volume on *Carolingian and Romanesque Architecture*, Harmondsworth (1959), acknowledged that the "greatest direct indebtedness of the author is . . . to his mentor, colleague and friend, Arthur Kingsley Porter, whose wide-ranging re-study of Romanesque art and chronology resulted in considerable activity on the part of art historians" (p. xxv).

[64] The unpublished letters to which I make reference in what follows belong to Professor Schapiro, who has generously made them available to me.

decide to." The following year he wrote in appreciation of Schapiro's thoughts on contemporary architecture. "I hope very much now that the tide has turned and I am sure you will be a force in directing it into new channels" (February 23, 1929). He invited Schapiro to join him in writing a handbook on Romanesque sculpture (December 25, 1930 and April 25, 1931), but both were too busy to advance the project in the next few years.

When the Porters returned to the States in January 1932 from nearly a year in Ireland, Schapiro was on the dock to greet them as the steamer came in. Porter invited Schapiro to lecture at the Fogg and to stay at Elmwood, the Porter's Cambridge mansion just off Brattle Street (February 24, 1932). In May of 1932 Porter read the first installment of Schapiro's dissertation on "The Romanesque Sculpture of Moissac," which had appeared in the *Art Bulletin* of September 1931. He wrote:

> Dear Schapiro,
>
> I have just finished reading the first installment of your Moissac monograph with so much pleasure that I must write to tell you so. It is a beautifully thorough and scholarly piece of work which I anticipate will hold down the lid on that particular corner of the history of art to the end of time . . . of course I am delighted you come out for the early dating of Silos[65]

Shortly before publication of his last book, Porter had written to Schapiro (on April 25, 1931) of his "naive confidence that its main thesis, i.e., that pagan subjects are represented on Irish crosses, will eventually turn out to be right, but I am nervous over much of the detail, especially that connected with the tricky Irish language in which I begin to despair of ever acquiring any competence." Porter acknowledged Schapiro's "always fruitful" references and comments in the prefatory remarks to *The Crosses and Culture of Ireland*, a book that he dedicated "To my teachers: My Harvard students." Porter, who suspected Coptic influences on Irish crosses, looked to the art of the Near East in this study: " . . . these monuments of the Viking age in Ireland . . . lead us back to the heroic days of Finn and the Fianna; to the early Celtic saints; to the shadow of the Pyramids; to the Early Christian East," he wrote.[66] His words call to mind Yeats's fascination with the East, whence the distinguished Irish poet "had snatched the clue to the interpretation of Druidic culture."[67]

In many ways, it was Schapiro, rather than Porter's own students at Harvard, who picked up the fertile seeds he had sown and transmitted a distinctly American medieval art history to successive generations. The social orientation of Porter's approach—whether he was identifying institutional economic determinants in his early study of architecture, focusing on the contributions of individual masons in his later inquiries into French and Spanish sculpture, or even exploring folkloric traditions in his final work on Ireland—all indicate paths that Schapiro, in his own distinctive way, also followed. At the centennial celebration

[65] A. K. Porter (as in note 64), letter of May 23, 1932.

[66] Arthur Kingsley Porter, *The Crosses and Culture of Ireland*, New Haven (1931), 128.

[67] S. B. Bushrui, "Yeats's Arabic Interests," in *In Excited Reverie: A Centenary Tribute to William Butler Yeats*, ed. A. Norman Jeffares and K. G. W. Cross, New York (1965), 280; the writer John Eglinton is being quoted.

that was planned in Porter's memory by the student-run Medieval Forum at Columbia University in the spring of 1983, Schapiro shared memories of Porter that were both vivid and moving. He told then an anecdote illustrating Porter's legendary thoughtfulness which I have heard him recount with pleasure on other occasions. It provides a fitting closure to this paper.

Schapiro had been invited by Porter to attend a dinner party at Elmwood during one of his visits to Cambridge to consult Porter's photo collection. Arriving directly from work in shirt-sleeves, he entered the house and found the other guests formally attired, and Porter, in black tie, on the landing at the head of the stairs about to join the party. In an instant, Schapiro recalled, Porter disappeared; moments later he joined the group downstairs in casual dress, garments that unequivocally identified him, not with Cambridge society, but with his young visitor.

It was a display of bountiful courtesy and aristocratic generosity that was at once characteristic of Porter and worthy of his heroes, Finn and Cuchulain.[68]

[68] For a discussion of the heroic virtues in Irish epics and their appeal to Yeats, see the comments by Alex Zwerdling, *Yeats and the Heroic Ideal*, New York (1965), esp. 52–60. Yeats's own career was framed by his publication of the *Wanderings of Oisin* (1889) and *The Death of Cuchulain* (1939), material that was known to Porter through AE.

Concerning Charles Rufus Morey (1877–1955)

CRAIG HUGH SMYTH

IN 1985, an Italian art-historical congress in Rome was dedicated to Charles Rufus Morey.[1] There was appropriateness in the decision to dedicate a congress in Rome to Professor Morey. It was in part an expression of gratitude for what he did at the end of the Second World War to rehabilitate the international scholarly and cultural life of the city, when he served as the first post-war cultural attaché at the United States embassy in Rome, after retiring from Princeton in 1945. But the dedication was also an expression of admiration for his scholarship and its specific benefits to the city. He had long been editor-in-chief of the Vatican's catalogues of art in the Museo Sacro, contributing two of them himself;[2] and in the Vatican there was and is a copy of the Index of Christian Art, Morey's brainchild and creation. It seemed to me particularly appropriate, however, because the roots of Morey's scholarship in the history of medieval art were in Rome, in the Rome of classical antiquity. It was from the study of the monuments of ancient Rome, pagan and Early Christian, that Morey began, under Rome's spell, to be an art historian.[3]

[1] Being in Italy and a former Morey student, I was asked to talk about him at the congress dedicated to him. For that reason I was asked to give this paper on Morey at the meeting of the College Art Association in Houston. The conference in Rome dedicated to Charles Rufus Morey took place November 25–30, 1985, under the auspices of the Centro di Studi Americani and of the Istituto di Storia dell'Arte, University of Rome. The present essay is adapted from the paper presented there in Italian, which has since been published in the acts of the congress: C. H. Smyth, "Charles Rufus Morey (1877–1955): Roma, archeologia e storia dell'arte," in *Roma, centro ideale della cultura dell'Antico nei secoli XV e XVI. Da Martino V al sacco di Roma, 1417–1527*, ed. S. Danesi Squarzina, Milan (1989), 14–20.

I am grateful to colleagues and students of Professor Morey whom I consulted in preparing to write about him—Harry Bober, David Coffin, George Forsyth, Alison Frantz, John R. Martin, Kurt Weitzmann, and Donald Wilbur—as well as to Mrs. Frederick Stohlman. I very much appreciate their interest and help in considering and supplementing my thoughts.

[2] C. R. Morey, *Gli oggetti di avorio e di osso del Museo Sacro Vaticano* (Catalogo del Museo Sacro della Biblioteca Apostolica Vaticana, I), trans. M. Barr, Vatican City (1936); idem, *The Gold-Glass Collection of the Vatican Library*, ed. G. Ferrari, Vatican City (1959).

[3] For accounts of Professor Morey's career, see especially the very fine obituary by Erwin Panofsky, "Charles Rufus Morey (1877–1955)," *Yearbook of the American Philosophical Society*, Philadelphia (1956), 482–491; and the obituary, excellent and informative, by Rensselaer Lee, in the *Art Bulletin*, xxxvi, no. 4 (Dec. 1955), iii–vii. See, too, Marilyn Aronberg Lavin, *The Eye of the Tiger. The Founding and Development of the Department of Art and Archaeology, 1883–1923, Princeton University*, Princeton (1983) for a full, absorbing account of the department before Morey joined the faculty and during his years there until he became chairman in 1924. Essential also is the "Bibliography of the Principal Publications of Charles Rufus Morey," *Art Bulletin*, xxxii (1950), 345–349, compiled by John R. Martin. I was unaware of Kurt Weitzmann's account of Morey's work, published during the year after my paper on Morey for Rome, until shortly before the present paper went to press. It is much to be recommended: K. Weitzmann, "The Contribution of the Princeton University

What began in Rome flowered into a career that combined teaching and scholarship fundamental to medieval studies with a capacity for leadership remarkable for its vision and efficacy. It has been said that Morey "did more to establish the history of art as a serious humanistic study" in the United States than anyone "of his generation."[4] Figure 5, a photograph of Morey in mid-career, and Figure 9, at about the age when my generation knew him, show him as very serious. But they are also, I think, a bit misleading: they do not convey the kindness, the quiet humor, or the élan he is known to have had.

As scholar and teacher, Rufus Morey devoted himself in great part to documenting, analyzing, and cataloguing works of art. But he also sought to discern the principles underlying the course of the history of art from antiquity through the Middle Ages. It was apropos of Morey's article on this theme, entitled "The Sources of Mediaeval Style," published in 1924, that Panofsky wrote: "[Morey] could recognize in the bewildering complexity of medieval art a pattern so boldly simple that his 'Sources of Mediaeval Style' startled the art historians of 1924 as Kepler's *Mysterium Cosmographicum* had startled the astronomers of 1596."[5]

Morey arrived in Rome in 1900 at age twenty-two, with bachelor's and master's degrees in classics from the University of Michigan. He was a fellow of the American School of Classical Studies, established only six years before, the cornerstone of the American Academy in Rome. In Rome, Morey branched out from classics toward archaeology and toward Early Christian studies. In doing so he must have been mostly self-taught, as he certainly was when he went on to medieval art. His first two articles were published in 1905, one on an Early Christian sarcophagus discovered at Santa Maria Antiqua while he was in Rome,[6] the other a penetrating review of articles on the history of the early Christians written by Leclerq for Cabrol's *Dictionnaire d'archéologie chrétienne*.[7] Morey's review was not about art history, but about religious history. There followed in 1906 a short publication of new inscriptions from Rome.[8]

In that same year, 1906, Morey was appointed to the faculty of the Department of Art and Archaeology at Princeton. The first course he gave at Princeton was on "The Topography and Monuments of Ancient Rome."[9] He started teaching where his roots were. In 1907 he had an article in the *American Journal of Archaeology* about the "arming of an ephebe," on

Department of Art and Archaeology to the Study of Byzantine Art," in *Byzantium at Princeton, Byzantine Art and Archaeology at Princeton University, Catalogue of an Exhibition at Firestone Library, Princeton University, August 1 through October 26, 1986*, ed. S. Ćurčić and A. St. Clair, Princeton (1986), 12–16.

[4] Lee (as in note 3), iii.

[5] Panofsky (as in note 3), 484.

[6] C. R. Morey, "The Christian Sarcophagus in S. Maria Antiqua," *Supplementary Papers of the American School of Classical Studies in Rome*, I (1905), 148–156.

[7] Idem, review of F. Cabrol, *Dictionnaire d'archéologie chrétienne et de liturgie*, fasc. II, in *Princeton Theological Review*, III (1905), 152–155.

[8] Idem, "Inscriptions from Rome," *American Journal of Archaeology*, X (1906), 427–428.

[9] The information given here on Morey's early courses at Princeton comes from departmental catalogues of the first years of this century in the archives of the Department of Art and Archaeology kept in the Seeley Mudd Library at Princeton.

a vase in Princeton.[10] In 1908 he again published something on Early Christian history, examining the archaeological evidence for the beginnings of saint worship.[11]

Then, in the academic year 1907–1908, came Rufus Morey's first course on medieval art. By its description we can see that he developed his life work as a scholar from the material of this course. It traced, says the catalogue, "the decadence and final breaking up of the classical tradition and the subsequent rise of medieval schools under the transforming influence of Christianity . . . down to the Revival of Learning."[12] (Although an admirer of Riegl, Morey never quite abandoned the view of Late Antique art as decadent.) The course included in its panorama "sculpture, painting, mosaics, manuscript illumination, ivory carving, jewelry, and textiles"—no small sweep for a novice. In years to come his courses and work on medieval art remained true to this breadth. When Alfred Barr founded the Museum of Modern Art between the wars, he decided to include all the arts and crafts because of having studied medieval art with Morey, as he once told Hellmut Wohl.[13]

How, we may ask, did Morey's study of medieval art relate to his background in philology and archaeology?

Let me start by saying that Morey was brought to the Department of Art and Archaeology at Princeton by Allan Marquand (Fig. 6), who, at the request of Princeton's President McCosh, had begun the department in 1883.[14] Marquand's graduate degree was in philosophy, and the courses he first taught at Princeton were in logic and Latin. When he started the new department, he moved on the one hand to classical art and archaeology, founding in the process the *American Journal of Archaeology* with a colleague, and on the other to the rebirth of classical antiquity in the Renaissance, from which came Marquand's fundamental books on the Della Robbias. In 1903 Marquand was professor of archaeology for a year at the American School of Classical Studies in Rome and must have met Morey. Probably they found common ground in archaeology and in their high standards. Morey later wrote in admiration of what he called Marquand's "extraordinary mastery of materials."[15]

[10] C. R. Morey, "The 'Arming of an Ephebe' on a Princeton Vase," *American Journal of Archaeology*, XI (1907), 143–149.

[11] Idem, "The Beginnings of Saint Worship," *Princeton Theological Review*, VI (1908), 278–290. The purpose of this paper was "to show by a review of the present archaeological evidence—that the essential features of the cult were all developed in the IVth century and are directly traceable to Constantine's recognition of Christianity."

[12] Department catalogue (as in note 9).

[13] Hellmut Wohl thoughtfully informed me of this in a letter, as follows: "[Alfred Barr] once told me that in thinking of the Museum of Modern Art as a place which should show not only paintings, sculptures, drawings and prints, but also posters, photographs, useful objects, architecture, and films, he was following Morey's course in medieval art in which paintings, sculpture and architecture were shown together with metalwork, textiles, ornamental objects and books."

[14] See Lavin (as in note 3), passim, for Marquand's career at Princeton and for Morey's appointment. See also C. R. Morey, "Allan Marquand," *Art Studies*, II (1924), two unnumbered pages; idem, "Allan Marquand, Founder of the Department of Art and Archaeology," *Art and Archaeology*, XX (1925), 105–108, 136. See also David Van Zanten's paper on pp. 175–182 of the present volume.

[15] These words about Marquand are in the lecture by Professor Morey cited below in note 20.

There is concern today to distinguish between the factual aspects of art history and its more subjective, critical aspects, and to trace both back to their beginnings—I think of Podro's book *The Critical Historians of Art*.[16] So-called factual art history is traced to nineteenth-century positivism, as represented by von Ranke and, at an early stage, by art historians like Kugler. Critical concerns are traced ultimately to Hegel. Marquand's graduate work was done at The Johns Hopkins University, which championed von Ranke.[17] It has become customary now to describe art history's factual concerns by the term "archaeological."[18] Marquand would probably have liked this designation. As for Morey's work, the term seems apt when we think of what the term implies—apt, that is, up to a certain point.

We know that the term "archaeology" had originally to do with the study of the "old" or "ancient" (in Greek, *archaios*) in relation principally to the discovery, assemblage, analysis, verification, and classification of cultural artifacts and art objects from classical antiquity. It is understandably associated, therefore, with the digging necessary to discover these materials, but also with the close factual study of the materials once found—and the study of them in relation, logically, to time, place, and history. From this comes the archaeologist's necessary dependence on the study of interrelationships, and thus stylistic interrelationships. Hence his need for connoisseurship of a sort and also for interpretation, which is required to order and make sense of the materials.[19] These are activities that are not purely factual. So it was with Morey. When he came to art history, his approach incorporated the purely factual with stylistic study and interpretation.

Late in life, in an unpublished lecture of 1947 entitled "Scholarship in the Fine Arts: Past and Future,"[20] Morey referred to his own beginnings as an art historian: "I date far back enough to remember the dominance of archaeological and philological method over research in our field, especially in this country" But he had also entered significantly upon critical history, as will be underlined in parts of what follows.

In the years subsequent to his first medieval course of 1907–1908, Mr. Morey went on to intense exploration of medieval art in all its phases—Early Christian, Byzantine, Carolingian, Romanesque, and Gothic. He habitually did so in the utmost detail, and soon with the help of graduate students, who began to form a circle around him and came in time to constitute the Princeton school of medievalists. At the same time Morey continued to keep his attention on ancient Rome, lecturing in 1911–1912 on Roman sculpture, architecture, and painting, and in 1912–1913 on Roman coins, then publishing a catalogue of the coinage of

[16] Michael Podro, *The Critical Historians of Art*, New Haven and London (1982).

[17] F. Gilbert, "Leopold von Ranke and the American Philosophical Society," *Proceedings of the American Philosophical Society*, cxxx, no. 3 (1986), 362–366.

[18] Podro (as in note 16), xvii.

[19] Cf. the thoughtful treatment of archaeology in J. S. Ackerman and Rhys Carpenter, *Art and Archaeology*, Englewood Cliffs, N.J. (1963).

[20] There is a copy of the lecture in the archives of the Department of Art and Archaeology, Seeley Mudd Library, Princeton University. It was delivered in 1947 on the occasion of the bicentennial celebration of Princeton Univesity.

Bostra from the Princeton archaeological expedition to Syria.[21] Simultaneously he offered, in the years 1911 to 1914, courses in "Early Christian Archaeology," "Byzantine Art," and "Medieval Illumination." Nowhere in the United States was there such a concentration of late classical, Early Christian, and medieval courses. That this was possible at Princeton is testimony to the foundation Marquand had established there, unique in its time, which led the way to professional art history in this country.[22]

Morey would pay much attention, and for a long time, to the study and teaching of manuscript illumination, especially because, as he wrote later, the Latinity of the past was preserved there with more continuity than in the other arts.[23] It was always basic to his view of the history of medieval art that medieval styles never lost their substratum of Latinity. Meanwhile he went on to publish books on *East Christian Paintings in the Freer Collection* (in 1914) and, turning to Rome again, on the *Lost Mosaics and Frescoes of Rome of the Mediaeval Period* (in 1915).[24]

As early as 1910 Mr. Morey had begun to pursue research in iconography with his students. In the crowded variety of his courses there soon appeared a course on "Christian Symbolism and Iconography." As a result of this interest, he originated the Index of Christian Art in 1917. At first he planned that it would extend no farther than the year 700 A.D.[25] Morey originated the Index principally because he and his students had become convinced that variations in iconography could help them distinguish and localize the schools of Early Christian art more reliably than could style, since Greco-Roman art showed so much uniformity. Out of this conviction came the dissertation of a student in Morey's circle, E. Baldwin Smith (Fig. 7), which was published in 1918 as a book that has been well known ever since for defining a school in Provence with the help of iconography.[26] Morey later extended the chronological limit of the Index to 1400—in response, I believe, to a need he already saw in 1915 when reviewing the volume by Emile Mâle on religious art in France in the thirteenth century. Morey was disappointed only on one score: that Mâle, in Morey's words, "treated iconography as a system fulfilled," without concern for its evolution in previous centuries.[27]

[21] C. R. Morey, "Dusores and the Coin-type of Bostra; Catalogue of the Coinage of Bostra," in *Syria: Publications of the Princeton University Archaeological Expedition to Syria in 1904–1905 and 1909*, Appendix to Division II, Section A, Part 4, Leyden (1914), xxvii–xliv.

[22] For the richness of the Princeton department's offerings in the history of art and archaeology soon after the turn of the century, unparalleled at the time, see Marilyn Aronberg Lavin's paper on pp. 7–10 of the present volume, and Appendix II documenting it.

[23] Morey (as in note 32), 46.

[24] C. R. Morey, *East Christian Paintings in the Freer Collection* (Studies in East Christian and Roman Art, Part I), New York and London (1914); idem, *Lost Mosaics and Frescoes of Rome of the Mediaeval Period. A Publication of Drawings Contained in the Collection of Cassiano dal Pozzo, Now in the Royal Library, Windsor Castle* (Princeton Monographs in Art and Archaeology, IV), Princeton (1915).

[25] See H. Woodruff, *The Index of Christian Art at Princeton University: A Handbook*, Princeton (1942), with an introduction by C. R. Morey; also two unsigned and undated brochures, different from each other in text, but both entitled *Index of Christian Art, Princeton University* (available from the office of the Index). I am grateful to Nigel Morgan and Elizabeth Beatson, formerly of the Index, for their talks with me.

[26] E. B. Smith, *Early Christian Iconography and a School of Ivory Carvers in Provence*, Princeton (1918). For a statement about the uses of iconography in defining schools, see ibid., 4.

[27] C. R. Morey, Review of E. Mâle, *Religious Art in France: Thirteenth Century*, London and New York (1913), in *Art and Archaeology*, I (1915), 175–176.

Morey created a tool for the history of Christian iconography—a tool for factual art history certainly, but also for religious and spiritual history, even social history.[28]

It comes as a surprise, in looking back to the year 1918, one year after the beginning of the Index—that most factual of tools—to find from Morey an essay on Rodin.[29] It is a sensitive and thoughtful critique of Rodin's work aiming to show that Rodin marks the end of the dominance of the classical tradition in European art. Although that tradition meant so much to Morey, he beautifully characterized what he saw as epoch-makingly new in Rodin. Still able to evoke expressions of admiration from Rodin scholars, the essay represents an aspect of Morey that is easily overlooked in generalizations about the early years of art history in the United States. It belongs to critical history on a major theme.

A contrast similar to that of 1917–1918 occurs again in 1924. Morey published a book in that year which exemplifies his philological-archaeological ideals, a book entitled *The Sarcophagus of Claudia Antonia Sabina and the Asiatic Sarcophagi*.[30] It deals with a sarcophagus from Roman imperial times—a pagan sarcophagus, not Christian—discovered at Princeton's excavation in Asia Minor. The book starts with the archaeology of the discovery, then presents a meticulous description of the sarcophagus, the provenance of its marble, its inscription, and its dating. It goes on to a comprehensive treatment and exhaustive catalogue of all known Asiatic sarcophagi, in which Morey distinguished numerous subdivisions according to type. The book climaxes with a masterly essay that is permeated with thinking about the evidence. For Morey, thinking about the evidence made such work humanistic, not only archaeological science. The roots of the book are in problems concerning the eastern versus western provenance of sarcophagi, problems that had first come to the fore about the time Morey arrived in Rome in 1900. By 1924, numerous scholars had dealt with them: from Ainalov and Strzygowski to Mendel and Muñoz, Strong and Dütschke, Reinach and Rizzo, Delbrueck, Weigand, Robert and Wulff. Strzygowski wrote a review of Morey's book, calling it a *capolavoro* of exact scholarship, adding that he was "amazed" by the richness of the material and the penetrating criticism.[31]

Very different was the article on the "Sources of Mediaeval Style," of 1924, about which Panofsky invoked the name of Kepler.[32] Brief, condensed, packed with observations, it presents a hypothesis about continuities and transformations from pagan to Early Christian to medieval, about the development of four varieties of medieval style across a wide sweep of time and space. Morey was as concerned with continuity as with transformation. He wrote

[28] A social historian has at his disposal in the Index of Christian Art an index of items found in works of Christian art—beds, for example, if he is writing the history of bedroom furniture or of sleeping habits.

[29] C. R. Morey, "The Art of Auguste Rodin," *Art Bulletin*, I, no. 4 (Dec. 1918), 145–154.

[30] Idem, *The Sarcophagus of Claudia Antonia Sabina and the Asiatic Sarcophagi* (Sardis: Publications of the American Society for the Excavation of Sardis, V, Part 1), Princeton (1924).

[31] J. Strzygowski, Review of *The Sarcophagus of Claudia Antonia Sabina and the Asiatic Sarcophagi . . . di Charles Rufus Morey*, in *Art Bulletin*, VII, no. 1 (March 1925), 71–73.

[32] C. R. Morey, "The Sources of Mediaeval Style," *Art Bulletin*, VII, no. 1 (March 1924), 35–50.

after years of close study, comparable in character to his study of Asiatic sarcophagi, devoted in this case to objects and groups of objects from the whole range of Early Christian and medieval art. But his main purpose now was interpretive. Against the background of studies by Wickoff and Strzygowski's *Orient oder Rom*, Morey saw two currents in the art of antiquity from the third century on: classicism and illusionism. He traced the way these currents were variously transformed by the interplay between them under the influence (as he saw it) of the Orient, of Latin realism, of cultural and religious change, and eventually, in the West, the influence of Celtic-Germanic dynamism. I can remember Hanns Swarzenski recounting how Morey's article stopped him, and other medievalists in Germany, short in their tracks and made them think anew. Meyer Schapiro wrote that Morey "alone provided a theory comprehensive enough to guide research" at the time.[33] This is what a theory can do. In his unpublished lecture of 1947 about the history of art, Morey spoke of favoring hypotheses if they arose from mastery of the material; he valued, to use his own words, "the unity afforded by an individual point of view . . . the humanistic consistency [and] . . . general historical fitness which an individual scholar, who has himself canvassed all aspects and facets of his job, can sometimes feel he has attained."[34] Morey himself had envisaged a far-reaching historical structure, to which the term critical history is again applicable.

Rufus Morey incorporated his theory later in two books of much substance, *Early Christian Art* and *Mediaeval Art*.[35] In the years since then his panorama of the history of style has gradually receded from prominence. Meyer Schapiro and others have taken issue with parts of it (especially its view of Alexandria as the source of Hellenistic illusionism and its dating of the Paris Psalter and related works before the tenth century).[36] Perhaps one must now simply consider it as woven into the fabric of thought about the history of medieval art.[37]

This is little enough about Morey's scholarship, but will have to suffice for a brief paper—except for two comments. First, subjective response to works of art was part of his concept of art history as a discipline—witness his sensitive, succinct descriptions of aesthetic and expressive qualities. Their example was part of his legacy. Secondly, he firmly believed in the relation of art history to cultural and religious history, and habitually invoked them, both as essential factors in artistic developments and as reflected in works of art.[38] My guess

[33] M. Schapiro, Review of C. R. Morey, *Early Christian Art: An Outline of the Evolution of Style and Iconography in Sculpture and Painting from Antiquity to the Eighth Century*, Princeton (1942), in *The Review of Religion*, New York (1944), 165–186.

[34] Morey (as in note 20).

[35] Idem, *Early Christian Art*, Princeton (1942), the subject of Schapiro's review (cited in note 33 above), and *Mediaeval Art*, New York (1942).

[36] Schapiro (as in note 33).

[37] Those who believe that "each view of history that can satisfy the historian's basic tests—internal consistency and apparent consistency with observed facts—has an element of validity—a facet of a whole historical truth" might view Morey's theory as a test case. (For the quotation, see S. Freedberg, "On Art History," *The New Criterion*, IV, 4 [1985], 20)

[38] As he did in his lecture of 1947 (as in note 20) as well as in two earlier essays: C. R. Morey, "Value of Art as an Academic Subject," *Parnassus*, I, no. 3 (1929), 7; and idem, "The Middle Ages," in *Historical Aspects of the Fine Arts*, addresses by Rhys Carpenter, C. R. Morey, Frank Jewett Mather, Jr., and Everett V. Meeks, Oberlin (1938), 31–41. A further example: C. R. Morey, *Christian Art*, New York and London (1935) (i.e., its beginnings to the Baroque).

is that Morey would have been sympathetic to the emphasis now on the study of art's context, providing that the social and cultural material of the context is fully mastered, as he would say, and that meanwhile the art under study is not overshadowed.

In a brief paper I am hard put to do justice to Morey's achievements as a teacher. Of the many scholars who studied with him I mention here only those who became Princeton faculty members when Princeton, under Morey's guidance, was at the center of medieval studies: E. Baldwin Smith, Albert Friend, Jr., Ernest DeWald, George Forsyth, Donald Egbert, Richard Stillwell, Frederick Stohlman. Many others were his descendants—and not just medievalists. They include women whose studies he guided, although women could not attend Princeton nor teach there: among them, Myrtilla Avery (Fig. 120), Marion Lawrence, Alison Frantz, and Helen Woodruff.[39] For years, too, his teaching was a cornerstone of graduate study at New York University.[40] From personal experience of his teaching at Princeton, I know that he had an eye for every detail of a student's research and writing done under his supervision. He was at great pains to be available and helpful, setting aside as much as an hour or more each week for a student writing a senior thesis under him, as I did. And he shared in detail his own methods of collecting and dealing with material. It was teaching at its most rigorous, leavened with the love of learning, modesty, and generosity. Mr. Morey inspired admiration and respect, and, in those who studied closely with him, great liking. It was a pleasure for students to see him on occasion at his house with his wife Sara Tupper Morey and his son Jonathan Morey.

In 1924, the year of the two publications we have just cited, Morey succeeded Marquand as department chairman. His undertakings and influence thereafter make still another story. Panofsky wrote: "The force of his personality acted on his surroundings much as the force of gravity operates in the physical world."[41] Any list of Morey's undertakings would have to include the further development of the Index of Christian Art during his chairmanship of the department, when he persuaded the university to put money behind the Index, the General Selection Board to support it, and donors to give funds to put it into quarters of its own in McCormick Hall (Figs. 11–13), with a larger staff and room to grow.[42] Looming large in the list must be also the excavation of Antioch by a French-American consortium, on Morey's initiative and long under his direction. The result was, so to say, a research laboratory, at one of the chief centers of antiquity, in which to trace the evolution of Late Antique

[39] Besides graduate courses at New York University (see the remarks on the early years of N.Y.U.'s graduate Department of Fine Arts on pp. 73–78 of the present volume), Morey gave on occasion courses available to women at other institutions, including Columbia and Harvard. He devoted much time and thought, in individual instruction, to the study and research of advanced women students.

[40] See the remarks on the N.Y.U. department on pp. 73–78 of the present volume. There is also a record of Morey's manner of teaching in the essay on "The Princeton Department in the Time of Morey," pp. 37–42 above.

[41] Panofsky (as in note 3), 487; Lee (as in note 3) gives an ample account of Rufus Morey's undertakings and influence.

[42] See the citations in note 25.

art;[43] here again, the combination of archaeology and the history of art. Besides accepting the position as editor-in-chief of the volumes that would catalogue the Vatican's Museo Sacro, mentioned before, and writing two of them,[44] Morey organized the notable Princeton series of books on illuminated manuscripts. He was one of the founders of the College Art Association of America and the *Art Bulletin*, and a founder of *Art Studies*, the periodical published jointly by Princeton and Harvard.[45] Morey's influence was felt profoundly in his own university far beyond his department. A prime example is the effect of the pamphlet he wrote in 1932 proposing principles for planning a new building to house the Princeton University library. Entitled *A Laboratory-Library*, it is in fact a prime source of the interior arrangements of Princeton's Firestone Library, arrangements designed to promote contact among faculty and students in each discipline and among related disciplines.[46]

Rufus Morey's judgment and guidance had their effect in one case of which few have been aware. When the Institute for Advanced Study first came into being, its focus was on mathematics, with a faculty that included Einstein, Veblen, and Von Neumann. Soon the founder and first director, Abraham Flexner, turned to Rufus Morey for advice about what provisions the Institute should make for humanistic studies.[47] Owing to Morey's advice, the School of Humanistic Studies began by concentrating on the history of art and archaeology—again these two in combination. Morey hoped the school would collaborate closely with Princeton's Department of Art and Archaeology. In support of his advice, Morey declared (quoting, he said, Panofsky) that "as things have developed, art history has become a kind of clearing house—for all the other historical disciplines which, when left alone, tend to a certain isolation." The first faculty members appointed to the School were all Morey's nominees: the Greek epigrapher Benjamin Merritt, the Persian archaeologist Ernst E. Hertzfeld, the Near Eastern archaeologist Hetty Goldman, the art historian Erwin Panofsky (Fig. 95), and the palaeographer E. A. Lowe. Archaeologists and art historians of many countries will realize how much Morey's advice to the director of the Institute for Advanced Study has

[43] Morey published summary reports beginning in 1932. We have his forewords to two volumes on the excavations, edited by members of the Princeton Department of Art and Archaeology George Elderkin (1932) and Richard Stillwell (1941); a paper on "The Excavation of Antioch-on-the-Orontes" *Proceedings of the American Philosophical Society*, LXXVI (1936), 637–651; and his book *The Mosaics of Antioch*, London and New York (1938)—which he caused to be followed later, however, by the monumental volumes on mosaics that he assigned to the Italian archaeologist Doro Levi: *Antioch Mosaic Pavements*, 2 vols., Princeton (1947).

[44] See note 2 above.

[45] For these and other undertakings, see especially Lee (as in note 3).

[46] C. R. Morey, *A Laboratory-Library*, Princeton (1932). In Morey's proposal, the books of each discipline were to be located together in close proximity to offices, seminar rooms, reading rooms, and carrels for that discipline's faculty and students—thereby providing for contact among students and faculty in immediate touch with the books in their field of study—while at the same time the area allotted each discipline was to be situated as close as possible to the areas of related disciplines. The proposal surely grew out of Morey's experience of the way Marquand Library in the Department of Art and Archaeology's McCormick Hall was related to faculty and students there. (For more on this, see the paper by Van Zanten on pp. 175–182 of this volume.)

[47] The information given here comes from an unpublished manuscript concerning the history of the Institute for Advanced Study that is kept in the Institute's archives and has been inaccessible. I am grateful to Harry Woolf for having given me permission to consult this material when he was director of the Institute, and to Irving Lavin, who, knowing something of what was to be found there about Morey, suggested I consult the archive.

meant for study and research in Near Eastern, Mediterranean, and Western art and archaeology: as a result, so many, and from so many countries, have been invited to the Institute for a precious year of work.

The majority of Morey's nominees for the Institute were from abroad. Morey welcomed, as he wrote later, "the deepening and enrichment of American scholarship in our field through the distinguished immigration of Europeans" to the United States in the 1930s.[48] He brought Kurt Weitzmann, newly arrived European, into his own department, although he knew how different were Weitzmann's views from his own on important issues in the medieval field. It was characteristic of Morey not to resent differences.

Morey was also in close touch with Dumbarton Oaks during its beginnings. At the outset he even took leave from Princeton for a year to serve as its director. It is safe to assume his views helped much in shaping that institution.

As cultural attaché of the United States Embassy in Rome after the war, Rufus Morey was the one especially responsible for creating the International Union of Archaeological and Historical Institutes, formed primarily so that the contents of the German libraries for study in Italy could be returned to Italy in its charge. He worked single-mindedly for their return and for their future as independent institutions.[49] It has long been rumored that the original suggestion for the entire Fulbright Program for scholarships came from Morey at that time. We know for certain, in any case, that he planned and achieved the Fulbright Program in Italy.[50] Early on, he reopened the American Academy in Rome, closed by war, and presided over it for two years until the appointment of a director from the United States. He lived there, in the *villino* inside the gate of the Villa Aurelia, while cultural attaché. He had returned to the place where as a scholar he had his roots.

I conclude now with another quotation from Erwin Panofsky—about an aspect of Morey I have not mentioned specifically, but can personally vouch for: "No one can number those who owe or owed to him their place in the world, their scale of values, their sense of

[48] As in note 20 above.

[49] What is known to me of this came partly from Mr. Morey and from John Ward Perkins, as well as from the account given by Rensselaer Lee (as in note 3).

A view of Morey's goals in his Roman post came to me from a long evening's talk together in Rome in 1947 a few hours after he was told that his efforts to have a chair for United States law established in an Italian University were going to be successful. He was joyful and went on to other issues of concern to him in Italy, and finally to scholarship, art historians, and his experiences in the history of art and archaeology, reminiscing thoughtfully and at other times humorously—words to have been preserved—*magari*.

[50] In an effort to learn about Morey's contribution to the Fulbright Program, I have seen nine letters of 1949 from the BCN file in Senator Fulbright's papers at the Special Collections Department, University Library, University of Arkansas, Fayetteville, Arkansas (for which I am grateful to Betty Holmes, Archivist, Special Collections). These letters—three from Professor Morey to Senator Fulbright (in file BCN, folders 12:9 and 12:20), three from the Senator to Morey (ibid.), and three letters related to these (ibid.)—demonstrate Morey's initiative in establishing the Fulbright program for Italy, indicate that he and the Senator were on good terms, and suggest that they may have been on such terms for some time previously. Richard Arndt, a later United States cultural attaché in Rome, is preparing a book on the Fulbright program, which will treat of Morey's role.

direction in life Had Morey lived in the Middle Ages, he might have been one of those good bishops or cardinals who were respected by the mighty and loved by the poor."[51] In fact, as students we used to refer to Rufus Morey as "Cardinal Rufo."

[51] Panofsky (as in note 3), 491. My own experience as an undergraduate majoring in classics, but taking courses in art history, is an example. Morey unexpectedly proposed that my senior thesis (I had no reason to suppose I was known to him) combine classics and art history on the subject of Vergil illustration in the Renaissance (my classics author was Vergil)—a proposal, in hindsight, illustrating the interdisciplinary spirit of the new Special Program in the Humanities that Princeton was then starting (see above, "The Princeton Department in the Time of Morey," p. 39, note 10). He supervised the thesis (acceptable to the classics department, no doubt, because Morey had been a classicist), taught me his methods, even the way he kept notes, and pondered the subject himself, making his student's mastery of the material a matter of course on the way to interpretation and conclusions—in the process exemplifying his belief in the necessity of art history, and in the study and interpretation of images as well as style. Later, as with so many during their graduate work in art history and afterwards, he helped with firm advice and support. One became devoted to him, and from then on always looked to him for his wisdom about decisions as to one's future.

American Backgrounds: Fiske Kimball's Study
of Architecture in the United States*

LAUREN WEISS BRICKER

THE APRIL 1925 issue of the *Pennsylvania Museum Bulletin* contained an article entitled "The American Background." Its author, Harvey M. Watts, defined the term as "the long inheritance and comeliness of beauty in surrounds of houses, in gardens and interiors, as well as in its achievements in the fine arts and the decorative arts that is indubitably American."[1] Watts suggested that exhibitions held at the Pennsylvania Museum and the Metropolitan Museum of Art had effectively demonstrated that American painting and decorative arts of the eighteenth century were equal to contemporaneous European works (and were so recognized at the time). In discussing architecture, Watts credited Fiske Kimball, through his volume *Domestic Architecture of the American Colonies and Early Republic* (1922), with having done "more than anybody else . . . to prove the high character of the American background in the domestic arts."[2]

Five months after Watts's article appeared, Kimball assumed the position of director of the Pennsylvania Museum (now Philadelphia Museum of Art) and the School of Industrial Arts; the author's accolades suggest the extent of Kimball's reputation and foreshadow the favorable reception he was to enjoy in Philadelphia. The latter was borne out in 1931, when Watts wrote a biographical piece about Kimball for the *T-Square Club Journal*. He cited Kimball's numerous accomplishments at the museum and in the restoration of the historic Fairmount Park houses (dating from the eighteenth through the early nineteenth century) as

* Portions of this article were incorporated into a paper delivered at a symposium sponsored jointly by the Center for Advanced Study in the Visual Arts, National Gallery of Art, and the Society of Architectural Historians (Washington, 1988). It has since been published: "The Writings of Fiske Kimball: A Synthesis of Architectural History and Practice," in *The Architectural Historian in America: A Symposium in Celebration of the Fiftieth Anniversary of the Founding of the Society of Architectural Historians* (Studies in the History of Art 35), ed. Elisabeth Blair MacDougall, Washington, D.C. (1990), 215–235. I would like to thank Joseph Rishel, Curator of European Painting and Sculpture before 1900, and Anne d'Harnoncourt, the George D. Widener Director, Philadelphia Museum of Art, for their encouragement and many insights into Kimball's professional contributions; Louise Rossmassler, former archivist of the Philadelphia Museum of Art, whose tireless efforts can never be adequately acknowledged; and my doctoral advisor, David Gebhard, University of California at Santa Barbara, for his generous advice and criticism.

[1] H[arvey] M. W[atts], "The American Background," *Pennsylvania Museum Bulletin*, xx (1925), 123.
[2] Ibid., 126.

reflecting an American's ability to succeed splendidly in fields where Europeans had traditionally dominated.[3]

Sidney Fiske Kimball (Fig. 104) exerted a singular influence on the emerging field of American architectural history during the period extending from the 1910s through about 1930. His scholarship moved from an early focus on historic American subjects, where specific themes were often applied to his criticism of contemporary architectural work, to the study of seventeenth- and eighteenth-century French architecture. Kimball's reputation was greatly extended by his abilities as an architect, educator, and administrator. These roles put him in a position from which he could present a comprehensive overview of American and European developments in architecture and the representational arts to both popular and professional audiences.

Kimball received his professional architectural training at Harvard University (B.A. 1909, M. Arch. 1912), where architectural history and aesthetics were among the distinguishing features of the curriculum. Herbert Langford Warren, founder of the School of Architecture, taught the history courses, which were so influential that the students "tended to graduate into teaching, writing, and editing rather than practice," according to Kimball.[4] In addition to the studio course work, essentially a beaux-arts program, the architecture students were required to take classes in the theory and history of aesthetics taught by George Santayana, whose investigations into the "origins and conditions [of aesthetic judgements]" were incorporated in his volume *The Sense of Beauty* (1896).[5] Kimball and his colleagues also took the design courses of Denman Waldo Ross (Fig. 27), whose treatise, *A Theory of Pure Design* (1907), was based on abstract principles interpolated from oriental art.[6] The combined influences of this instruction effectively encouraged in Kimball's generation at Harvard a catholic appreciation of the formal aspect of works from a broad range of periods and media. This training was indicative of the philosophical rift that existed between the architecture program and the Department of Fine Arts, where the Ruskinian hegemony established by Charles Eliot Norton (Fig. 24) was sustained by his disciple Charles Herbert Moore.[7]

[3] Harvey M. Watts, "Fiske Kimball: An Appreciation and Interpretation," *T-Square Club Journal*, I (1931), 4–9, 37.

[4] Fiske Kimball, "Architecture at the Turn of the Century," unpublished manuscript, Fiske Kimball Papers, Philadelphia Museum of Art Archives (hereafter Kimball Papers), series 17, SSA, folder 34. For biographical information on Warren, see R. Clipston Sturgis, "Herbert Langford Warren," *Journal of the American Institute of Arts*, V (1917), 352–353; John Taylor Boyd, Jr., "Professor H. Langford Warren," *Architectural Record*, XLII (1917), 588–591; Fiske Kimball, "Introduction," in Herbert Langford Warren, *Classic Foundations of Architecture*, ed. Fiske Kimball, New York (1919), ix; and more recently Anthony Alofsin, "Toward a History of Teaching Architectural History: An Introduction to Herbert Langford Warren," *Journal of Architectural Education*, XXXVII (1983), 2–7.

[5] George Santayana, *The Sense of Beauty: Being the Outline of Aesthetic Theory*, New York (1896), repr. New York (1955), 5–6.

[6] Denman W. Ross, *A Theory of Pure Design: Harmony, Balance and Rhythm*, Boston and New York (1907).

[7] Kimball's view of interdepartmental relations at Harvard is recorded in "Harvard in Transition," unpublished manuscript, Kimball Papers (as in note 4), folder 35; see also Roger B. Stein, *John Ruskin and Aesthetic Thought in America, 1840–1900*, Cambridge, Mass. (1967), 256. On the contributions of Ross and Norton to the Department of Fine Arts at Harvard, see also the contribution of Sybil Kantor on pp. 161–174 below, and, on Norton and Moore, the contribution of Agnes Mongan, pp. 47–50 above.

The field of architectural education was a logical first direction for Kimball. In the fall of 1912, he was appointed instructor of architecture in the Department of Architecture at the University of Illinois. During that year he met and married Marie Goebel, a woman in whom Kimball found his intellectual equal. In the architectural studio and history courses that Kimball taught at Illinois and, beginning in 1913, at the University of Michigan, he encouraged future practitioners to view the study of history as a means of widening their knowledge of architectural languages and systems of design, rather than as a device for gathering isolated elements to be applied to new projects.[8] Kimball's own work of the 1910s reflected this dictum.

In 1914–1916, Kimball designed a tract of houses to be built on speculation in Ann Arbor, Michigan for Charles Spooner, a local developer (Fig. 105). Sited on a triangular parcel of land that was originally a pear orchard on the estate of Evarts Scott, the new subdivision was known as "Scottwood." In an article about the project, Kimball suggested that the regular planting pattern of the surviving pear trees was an opportunity for "formal grouping . . . *allées* of trees parallel to the lot lines which give symmetrical settings and attractive vistas to more regular houses."[9]

In his article, Kimball placed Scottwood in the context of contemporary housing "enterprises" that were built throughout America for war workers in industrial communities and were modeled on the concept of the English garden suburb. He suggested that the challenge to the architect was not to "relinquish the ideal of an independent house and garden The problem will remain that of retaining for each the expression of individuality, while securing a community of character throughout the neighborhood."[10] At Scottwood, Kimball's solution to balancing individuality with a cohesive sense of design was a group of five residences representing distinctive types of early American domestic design, including Dutch Colonial, the American farmhouse, Republican or Federal, and Greek Revival, but with standard windows, doorways, and story heights to promote cohesion of design among the houses.

Of this group, the Greek Revival house made the most specific reference to historical prototypes.[11] Its design was based on early nineteenth-century examples found in Michigan. The exterior treatment of the house—a tall portico supported by four square antae, flanked by single-story wings—recalls the Sidney Smith house in Grass Lake, Michigan (1840), which Kimball had photographed (Fig. 106). Nineteenth-century pattern books, such as Minard Lafever's *The Modern Builder's Guide* (1833)[12] provided another historical source for this architectural type. In Kimball's publications on the Greek Revival in Michigan, he commented on the need to preserve existing examples of the style. His own interpretation of

[8] Fiske Kimball, "Exams, Outlines, 1915–1918," Kimball Papers (as in note 4).

[9] Fiske Kimball, "A Harmonious Residential Development in Ann Arbor, Michigan," *Architecture*, XXXVIII (1918), 273. Louise Pieper and her staff at the Historic District Commission, City of Ann Arbor, Michigan, provided valuable information for local sources on Scottwood.

[10] Ibid.

[11] Rodney Eiger, current owner of the Greek Revival house, provided photographs of the working drawings of the house.

[12] Minard Lafever, *The Modern Builder's Guide*, New York (1833).

the type functioned both as a reminiscence of recently destroyed examples and as a testament to the continuing vitality of the concept of the neoclassical house.[13]

Kimball's skills as an historian and critic developed rapidly during the early 1910s. Before leaving Harvard, he read Charles V. Langlois and Charles Seignobos's *Introduction to the Study of History* (1898).[14] In it, the authors proposed a historical method founded on the study of original documents and manuscripts. The impact of this work on Kimball was dramatic; it suggested a direction to channel his interest in architectural history and theory toward original and unexplored ends: "All my intellectual instincts and ambitions were sharpened and stimulated. It was in this indirect way that Harvard University did the most for me for which I can never sufficiently repay."[15]

In 1912, Professor George H. Chase of Harvard's Department of Fine Arts (Fig. 33) asked Kimball, who had been a teaching assistant in his course on ancient art, to write a history of architecture that would be included in the new Harper's Series on Fine Arts, of which Chase was the editor. The work was published in 1918 as *A History of Architecture*, with George H. Edgell, another Harvard colleague, providing the medieval section.[16] In the course of preparing the manuscript, Kimball became conversant with the architectural literature on a wide range of subjects. During this period, he contributed more than fifteen reviews of scholarly and popular works on European and American architecture and history to *The Dial*.[17] These literary efforts compelled Kimball to place American architecture, which was rapidly becoming the center of his scholarly interest, within the context of contemporary European developments.

By 1913, the study of the architectural works of Thomas Jefferson had become the focus of Kimball's interest in American architecture. His "discovery" in 1914 of the majority of Jefferson's architectural drawings in the Thomas Jefferson Coolidge collection (eventually donated to the Massachusetts Historical Society) was published in a series of studies, culminating in the monograph *Thomas Jefferson, Architect* (1916).[18]

The Jefferson drawings, the earliest of which dated to 1769, proved to be an invaluable resource for the study of architectural design and practice from the mid-eighteenth century through the early years of the next century. Fiske and Marie Kimball dated the majority of the drawings on the basis of watermarks, drawing technique, and paper quality. Their joint

[13] Fiske Kimball, "The Old Houses of Ann Arbor," *The Inlander*, xxi (1919), 3–6; idem, "The Old Houses of Michigan," *Architectural Record*, lii (1922), 27–40.

[14] Charles V. Langlois and Charles Seignobos, *Introduction to the Study of History*, New York (1898); trans. of *Introduction aux études historiques*, Paris (1898).

[15] Kimball (as in note 7).

[16] Fiske Kimball and George H. Edgell, *A History of Architecture*, New York (1918).

[17] In 1913–1917 Kimball published more than seventeen book reviews in *The Dial*. See Lauren Weiss Bricker, "The Contributions of Fiske Kimball and Talbot Hamlin to the Study of American Architecture," unpublished Ph.D. diss., University of California, Santa Barbara (1992).

[18] Fiske Kimball, *Thomas Jefferson, Architect*, Cambridge, Mass. (1916), repr. New York (1968). Prior to the publication of the monograph, Kimball's Jefferson publications included "Thomas Jefferson as Architect: Monticello and Shadwell," *Architectural Quarterly of Harvard University*, ii (1914), 89–137; "Thomas Jefferson and the Origins of the Classical Revival in America," *Art and Archaeology*, i (1915), 219–227; "Thomas Jefferson and the First Monument of the Classical Revival in America," *Journal of the American Institute of Architects*, iii (1915), 371–381, 421–433, 473–491.

analyses and Fiske Kimball's monograph—organized as a catalogue raisonné preceded by a brief narrative—represented approaches familiar to specialists of the representational arts.[19] Yet there were few precedents in the field of American architecture for basing a study upon original drawings as primary documents, indicators of architectural intent, and objects of independent aesthetic merit. With rare exceptions publications on American architecture were illustrated with photographs, supplemented by new measured drawings.[20]

The use of architectural drawings became Kimball's "signature" as a scholar. This was one aspect of his emerging historical method, which included the "scientific investigation" of material and documentary remains (an approach that he and his American peers associated with the field of archaeology), a dependence on primary documents as suggested by Langlois, and the interpretation of buildings as historic artifacts, as advocated by practitioners of the young field of American cultural history.

Kimball's publications definitively established that Jefferson had been the designer of Monticello, the Virginia Capitol, the original buildings of the University of Virginia, and numerous other projects. Jefferson's amateur status had previously prevented members of the "old guard" of American architectural history and criticism from crediting him with the design of these buildings. In his review of Kimball's monograph, the well-known architect-historian A. D. F. Hamlin summarized Jefferson's newly recognized professional status:

> He was no mere gentleman amateur or architectural dilettante, entrusting to others, better trained professionally, the revision and execution of his designs, but a competent and scholarly designer, who figured and specified in detail his quantities and materials and made all his own drawings, from preliminary sketches to large-scale details.[21]

Of fundamental importance to Kimball's view of American architecture was the realization that Jefferson's design for the Virginia Capitol of 1785–1789 (Fig. 107), based on the Roman Maison Carrée at Nîmes, pre-dated the major monuments of the European Classical Revival. For Kimball, Jefferson's work exemplified an American architect's ability to create designs that were innovative rather than merely derivative of recent continental precedents. America's classical inheritance, stemming from Jefferson, formed the basis of an "American style," which, in subsequent writings, Kimball traced down to his own time.

[19] For an assessment of American architectural drawings, see David Gebhard, "Drawings and Intent in American Architecture," in David Gebhard and Deborah Nevins, *200 Years of American Architectural Drawing*, exhib. cat., Whitney Museum of American Art, New York (1977), 24–27, 294. Gene Waddell has recently questioned Kimball's dependence on watermarks for the dating of the Jefferson drawings: G. Waddell, "The First Monticello," *Journal of the Society of Architectural Historians*, XLVI (1987), 27.

[20] Exceptional uses of historic architectural drawings include Glenn Brown, *History of the U.S. Capitol*, Washington, D.C. (1900); Charles C. May, "New York City Hall," *Architectural Record*, XXXIX (1916), 300–319, 474–490, 513–535; Aymar Embury II, ed., *Asher Benjamin, County Builder's Assistant*, New York (1917). More typical were the use of new drawings in Donald Millar, *Measured Drawings of Some Colonial and Georgian Houses*, New York (1916), and the combination of photographs and new drawings found in the *White Pine Series of Architectural Monographs*, ed. Russell F. Whitehead and Frank C. Brown, New York (1915–1931), after April 1932 in *Pencil Points*; reprinted under various titles, New York (1977), and Harrisburg, Penna. (1987) as the series *Architectural Treasures of Early America*, ed. Lisa C. Mullins.

[21] A. D. F. Hamlin, "Kimball: Thomas Jefferson, Architect," *American Historical Review*, XXIII (1917), 193–194.

Kimball was acutely aware of the division that existed between his approach to architectural history and that of many of his contemporaries. In submitting an article on the Virginia Capitol to Charles H. Whitaker, editor of the *Journal of the American Institute of Architects*, Kimball noted:

> I should be particularly glad if the paper could appear in the Institute journal rather than elsewhere, for I have hoped that by the method employed in it we might encourage more accurate and fundamental studies of our early monuments to replace the loose jumble of tradition and probability which fills too much of the writing of the subject.[22]

Kimball also hoped that an "exactitude of historical method" in published work on American architecture would translate into a heightened public appreciation of historic structures.[23] In response to his concern (which was doubtless shared by others), the Archaeological Institute of America formed, in 1915, the Committee on Colonial and National Art, following the precedent of its Committee on Medieval and Renaissance Art. Kimball was appointed chairman and his fellow committee members were among the leaders in the fields of preservation, archaeology, and architecture.[24] Their goal was to establish a national inventory of architectural and other monuments modeled on similar European endeavors; this was finally realized in America with the creation of the Historic American Building Survey in the 1930s.

Kimball found his scholastic circle among members of the Archaeological Institute rather than his fellow architects (although he enjoyed a lively correspondence with Ogden Codman and shared many common interests with A. Lawrence Kocher, and others).[25] The Institute membership included the leading American figures in the areas of art history, preservation, and, of course, archaeology. One of its members, the medieval art historian Arthur Kingsley Porter (Figs. 34, 35), was virtually the sole American scholar with whom Kimball perceived he shared a perception of historical time and research methods.[26] Among European scholars, Kimball developed early relationships with Hans Tietze and Werner Hegemann.[27]

[22] Fiske Kimball to Charles H. Whitaker, 5 June 1915, Kimball Papers (as in note 4), series 7, SSB, "A.I.A. Journal."

[23] Kimball "Thomas Jefferson as Architect" (as in note 18), 227.

[24] Other committee members were William Sumner Appleton, secretary of the Society for the Preservation of New England Antiquities; Glenn Brown, American Institute of Architects; George H. Chase, Harvard University; Allan Marquand, Princeton University; Charles Moore, President of the National Commission of Fine Arts; F. W. Shipley, ex-officio president of the Archaeological Institute of America.

[25] The Kimball/Codman correspondence (1918–1937) can be found in the Kimball Papers (as in note 4), series 7, SSD, "General Correspondence C, 1919–1923," series 16, SSA, "Ogden Codman, 1920–1942"; and in the Fiske Kimball Papers, Fogg Art Museum, Harvard University, box 11, folders 5, 5a. Among Kocher's early publications is his fourteen-part series on "Early Architecture of Pennsylvania," *Architectural Record*, XLVIII (1920), 513–540; XLIX (1921), 31–47, 135–155, 233–248, 310–330, 409–422, 519–535; L (1921), 27–43, 147–157, 214–226, 398–406; LI (1922), 507–520; LII (1922), 121–132, 434–444; and "The Early Architecture of Lancaster County, Pennsylvania," *Lancaster County Historical Society, Papers*, XXIV (1920), 91–106.

[26] See Fiske Kimball, review of Arthur Kingsley Porter, *Lombard Architecture*, New Haven (1915–1917), in the Kimball Papers (as in note 4), series 6, SSB, "Book Reviews." On Porter, see also the contribution of Linda Seidel on pp. 97–110 above.

[27] Kimball/Tietze correspondence (1920–1923), Kimball Papers (as in note 4), series 7, SSD, "T, 1919–1923"; see also Hans Tietze, *Die Methode der Kunstgeschichte*, Leipzig (1913), repr. New York (1973). Kimball/Hegemann correspondence (1916–1918), Kimball Papers (as in note 4), series 7, SSD, "General Correspondence H, 1919–1923"; and series 16,

In later years, professional experience and widening intellectual pursuits caused his sphere of associates to expand dramatically.

By the end of the 1910s, Kimball's diverse skills made him an attractive candidate for a number of administrative positions in educational institutions. In 1919, he was appointed professor of art and architecture and head of the new McIntire School of Fine Arts at the University of Virginia. The program marked the realization of Jefferson's 1814 proposal for a department of fine arts, embracing civil architecture, garden design, painting, sculpture, and the theory of music, with the ensemble of buildings framing the lawn intended to function "as specimens for the architectural lecturer."[28]

During the course of his four years in Charlottesville, Kimball designed and/or supervised the construction of six projects as part of the campus development fostered by university president Edwin A. Alderman.[29] Each project presented Kimball and his small staff with the challenge of adapting new works to the existing Jeffersonian vocabulary and formal axial plan, and to the shifts of grade characteristic of the local topography.

Among the projects was the new Memorial Gymnasium (1920–1923), designed by a committee, with Kimball in a supervisory role as University Architect. The building was sited at the western end of a cross-axis extending from a point immediately north of the Rotunda. The committee wanted the exterior of the building to express the structure's monumental interior character while maintaining the scale of the classical vocabulary of Jefferson's campus buildings.[30] Their solution was a Roman bath motif comprising five bays with arched windows articulated by engaged Corinthian columns (Fig. 108). A fragment of entablature connected the units and tied the shorter north and south ends of the building to the central block of the structure.

In 1923, Kimball's last year at the University of Virginia, Monticello was purchased by the Thomas Jefferson Memorial Foundation. During the following year Kimball was appointed chairman of their Monticello Restoration Committee, and for the next twenty-five years he remained closely involved with all phases of the restoration of the house and grounds, as well as the reacquisition of the original furnishings. Monticello was only one of many privately and publicly funded restoration projects for which Kimball functioned as an advisor or as restoration architect (frequently with his associate Erling H. Pederson).[31]

SSA, "Hegemann, 1920–1942"; see also Werner Hegemann and Elbert Peets, *The American Vitruvius: An Architect's Handbook of Civic Art*, New York (1922).

[28] Fiske Kimball, "The School of Architecture at the University of Virginia," *University of Virginia Journal of Engineering*, I (1921), 2; "New Courses to be Offered by the University this Fall," *University of Virginia Alumni News*, VIII (1919), 13.

[29] E. A. Alderman to Fiske Kimball, 13 February 1919, Kimball Papers (as in note 4), series 7, SSA, "September 1919– June 1923."

[30] Fiske Kimball, "The New Gymnasium for the University of Virginia," *Architecture*, XLVII (1923), 49–52.

[31] Among Kimball's restoration/preservation projects were Stratford Hall, Stratford, Virginia (1730s), for the Robert E. Lee Memorial Foundation, ca. 1931–1935; "Moors' End," Nantucket, Mass. (1829–1843), in association with Erling H. Pederson, for Edward F. Sanderson, 1925–1927; Gunston Hall, Lorton, Virginia, for the National Society of Colonial Dames of America, 1949–1952; and the Fairmount Park Houses, Philadelphia: Belmont (1742–1760), The Cliffs (1753); Mount Pleasant (1761), Lemon Hill (1798), Sweetbriar (1797), and Strawberry (1798; 1835), for the Fairmount Park Commissioners and others, 1925–ca. 1932. He was also chairman of the Committee on Historic Monuments and Scenic

These projects presented the opportunity for Kimball to train young preservation architects and to translate into built form his historical method. Consistent with his own scholarship, Kimball promoted the view that any restoration/preservation project (perhaps most notably the restoration of colonial Williamsburg) should be based on a thorough examination of original documents and close scrutiny of the buildings' physical remains employing archaeological practices. His approach to historic preservation strikes a peculiarly American balance between the restorationist's idealized vision of the past with the maximum retention of historic material advocated by the preservationist.[32]

Kimball's appointment in 1923 as Samuel F. B. Morse Professor of the Literature of the Arts of Design at New York University thrust him into the center of American cosmopolitanism. As was true of his previous post, the Morse chair was conceived early in the nineteenth century (1832), but had long remained dormant. It was revived under the joint patronage of the Altman Foundation, headed by Col. Michael Friedsam, and the Art-in-Trades Club, an organization of design professionals led by W. S. Coffin of the W. and J. Sloane furniture store. Under Kimball's leadership, the newly conceived department encompassed three programs: professional instruction for the interior designer; a series of combined college and art school courses taught in collaboration with the National Academy of Design; and a program in the history and criticism of fine and applied arts taught by scholars at the Metropolitan Museum of Art and the university's Washington Square campus. The potential for synthesis of scholarship and its practical application, inherent in Kimball's vision of the department, is suggested by the *House Beautiful Furnishing Annual 1926*, to which Kimball and other instructors in interior design and art history contributed articles and illustrative materials.[33] Kimball wrote the introduction and assisted in gathering the photographic images. At the conclusion of his text, Kimball succinctly summarized a dominant theme in his response to American architecture:

> Whether the house already stands or is still to be planned, unity of spirit, expressed in line and color may be achieved. For most people to-day the avenue to this unity will still be through the suggestions of historic tradition Conditions have not so changed here but that the simplicity of living which marked the Colonial still gives the characteristic American note.[34]

During the 1920s, Kimball produced two very different works on American architecture. His *Domestic Architecture of the American Colonies and Early Republic* (1922) was the product of a series of lectures delivered at the Metropolitan Museum in 1920.[35] Since the late nineteenth century the literature of historic American architecture had been

Beauties, A.I.A. (1923–1924), and a member of the Architects Advisory Committee, Restoration of Colonial Williamsburg (appointed 1928).

[32] Kimball's most concise statement of his own preservation philosophy is found in Laurence Vail Coleman, *Historic House Museums*, Washington, D.C. (1933), 19.

[33] *House Beautiful Furnishing Annual 1926*, Boston (1925).

[34] Fiske Kimball, "Interior Design," *House Beautiful Furnishing Annual 1926*, Boston (1925), 11.

[35] Fiske Kimball, *Domestic Architecture of the American Colonies and of the Early Republic*, New York (1922), repr. New York (1966).

dominated by local and regional studies of residential structures. Despite the value of many of these works, especially those which were intended as source material for new designs, Kimball believed that "the general development of domestic architecture had not yet been adequately handled."[36]

In *Domestic Architecture*, Kimball had the opportunity to present, to a much wider audience, the ideas and methodology formulated in his Jefferson volume. Kimball also sought to retain, through both language and images, the aesthetic appeal of the subject for the architectural practitioner (Fig. 109). Kimball's success in attracting the interest of both historians and practitioners is revealed in the reviews that appeared soon after the volume was published. The architectural historian Donald Millar characterized Kimball's study as a "summary of all available information, structural and documentary on the subject."[37] With an eye toward the practitioner, the reviewer of *Domestic Architecture* noted that "Professor Kimball, himself a trained architect, set out to write first a book of value to the professional; and he has succeeded in making it one that every architect should be grateful for."[38]

In contrast to his *Domestic Architecture*, Kimball's *American Architecture* (1928) presented a general survey of the subject that set the stage for his critical assessment of current architectural trends.[39] He argued that the architectural language of the "American Classic," founded on the precedent of Jefferson's works, provided direction for an American style in contemporary domestic, public, and commercial architecture. This view contrasted with the contention of other architectural critics, who held that the structural innovation embodied by the skyscraper was, in the words of the architect-critic Claude Bragdon, "the only truly original development in the field of architecture to which we can lay unchallenged claim."[40]

Kimball's interpretation of high-rise structures such as the Shelton Hotel in New York (Fig. 110), designed by Arthur Loomis Harmon (1924), was that they expressed "the larger unity of American modernism—toward the poles of which—functional expressiveness and abstract form—its masters have variously striven."[41] The Romanesque and Venetian Gothic detail articulating the structure interested him less than its powerful composition of masses. Kimball thus saw Harmon's design as a synthesis of several factors: the search for an appropriate expression of the tall building begun by Louis H. Sullivan and his contemporaries; the "elementary geometric purity" of the second Classical Revival associated with the works of McKim, Mead, and White and others; and, in painting, Paul Cézanne's rejection of nineteenth-century "realistic movements" in favor of what the art critic Roger Fry described as a "purely abstract art of form and color."[42]

[36] Fiske Kimball to Henry W. Kent, 10 October 1919, Kimball Papers (as in note 4), series 6, SSA, folder 3, "Correspondence with Metropolitan Museum of Art."

[37] Donald Millar, review of Fiske Kimball, *Domestic Architecture of the American Colonies and of the Early Republic*, in *Architectural Record*, LIII (1923), 86.

[38] Review of *Domestic Architecture*, in *Architecture*, XLVII (1923), 64.

[39] Fiske Kimball, *American Architecture*, Indianapolis and New York (1928).

[40] Claude Bragdon, "The Shelton Hotel, New York," *Architectural Record*, LVIII (1925), 1.

[41] Kimball (as in note 39), 216.

[42] Fiske Kimball, "What Is Modern Architecture?" *The Nation*, CXIX (1924), 129. See also Kimball (as in note 39), 160; and David Brownlee, *Building the City Beautiful. The Benjamin Franklin Parkway and the Philadelphia Museum of Art*, exhib. cat., Philadelphia Museum of Art, Philadelphia (1989).

In light of Kimball's accomplishments by the end of the 1920s, his appointment as director of the Pennsylvania Museum of Art in September 1925 was almost a foregone conclusion. As the leading figure in the field of American architectural history, he brought a vital commitment to the nation's architectural past, a past in which Philadelphians could feel a justifiable pride. Moreover, Kimball's scholarly interests were at that time increasingly shifting toward European subjects—witness his *The Creation of the Rococo* of 1943, a work of major importance.[43] The Philadelphia museum provided an environment for the display of a broad spectrum of the world's aesthetic achievements.[44] In addition to the completion of the museum's interior, a project that drew on Kimball's talents as architect as well as historian, his restoration of the Fairmount Park houses—or "Colonial Chain"—attest to the variety of his contributions to the definition of "American backgrounds."

[43] Fiske Kimball, *The Creation of the Rococo*, Philadelphia (1943).

[44] For more extensive discussion of Kimball's museum theory and practice see Lauren Weiss Bricker (as in the preliminary note to this paper).

Richard Offner and the Ineffable:
A Problem in Connoisseurship*

HAYDEN B. J. MAGINNIS

RICHARD OFFNER (1889–1965) was one of the great art historians and connoisseurs of this century (Fig. 97). Held in high regard internationally in his lifetime, he is now remembered for his passionate involvement with the individual work of art, for his fine measure of discernment, and for the felicitous prose with which he could convey, not only the specifics of things seen, but also their expressive content. He is remembered for his essays, particularly the magnificent "Giotto, Non-Giotto" of 1939, and for his life-long project, *A Critical and Historical Corpus of Florentine Painting*, the first volumes of which appeared in 1930.[1] By contrast, practically no attention is given to the theoretical basis of his work; he is regarded as a practitioner rather than a theorist. Yet questions of art-historical method and theoretical justification were very much a part of what he did, so much so that they determined the form and character of the *Corpus of Florentine Painting*.

We know comparatively little about Offner's early intellectual formation. He spent his undergraduate years (1909–1912) at Harvard University. In 1912, he was awarded a fellowship to the American Academy in Rome. Two years later, he completed his doctoral dissertation. The title of that dissertation, "Florentinische Zeichnungen des Überganges vom 15. zum 16. Jahrhunderts als Illustrationen der formalen Entwicklung," announced what were to be his principal scholarly preoccupations, style and formal development, and bespoke a conviction later expressed in his remark that "the essential aspect of the history of art is the history of artistic expression." For his final degree Offner had returned to the city of his birth, Vienna, and to the tutelage of the distinguished Max Dvořák.[2] Today, Dvořák is best remembered for his *Idealismus und Naturalismus in der gotischen Skulptur und Malerei* and

* This essay orginally appeared in *Annals of Scholarship*, VII, no. 1 (1990) 1–16. I am greatly indebted to Kathleen V. Wilkes of St. Hilda's College, Oxford, for invaluable conversations about Kant and about the content of this article.

[1] Richard Offner, "Giotto, Non-Giotto," *Burlington Magazine*, LXXIV (1939), 259–269; and LXXV (1939), 96–113; idem, *A Critical and Historical Corpus of Florentine Painting*, published by the Institute of Fine Arts, New York University, 1930–1981. Although the *Corpus* has been continued under the auspices of the Istituto di Storia dell'Arte of the University of Florence, all of Offner's remaining attributions were, after his death, collected and published in: Richard Offner, *A Legacy of Attributions*, ed. H. B. J. Maginnis, Locust Valley, New York (1981). That volume also contains a bibliography of Offner's other writings.

[2] Offner's parents came to the United States from Vienna in 1891.

for the volume of collected essays entitled *Kunstgeschichte als Geistesgeschichte*; but in retrospect, and given the character of Offner's later career, it must have been the Dvořák of *Der Rätsel der Kunst der Brüder van Eyck* (1904) who captured his student's imagination.[3] There, in his discussion of the brothers van Eyck, Dvořák sought to extend and refine the methods of connoisseurship first espoused by Giovanni Morelli (1816–1891) and subsequently developed by Bernard Berenson (1865–1959).

At the beginning of this century, young art historians had a rich variety of intellectual models and mentors from which to choose. For many, Giovanni Morelli was "the rationalizer and reformer of connoisseurship."[4] Trained as a medical doctor, Morelli had attempted to give connoisseurship the rigor of the natural sciences. In anatomy, botany, and zoology the great achievements of the nineteenth century stemmed, in large part, from use of the comparative method. Morelli was convinced that this approach could be applied to the sorting and categorizing of pictures. From his own observations he had become convinced that artists almost mechanically repeat 'signature' forms (what he termed *Grundformen*) in areas of a painting deemed to have minimal expressive content. Thus, in the depiction of an ear, a hand, the fingernails, an artist develops a convention, a habit of hand, which he repeats throughout his career. If the connoisseur would establish a standard repertoire of such forms for individual artists by inspecting the signed or securely documented works of each, he would have a basis for comparison, a means of accepting or rejecting the attribution of undocumented works to a specific painter.[5]

The appeal of Morelli's ideas, and their subsequent development by Bernard Berenson, lay not merely in the fact that they gave the connoisseur some claim to scientific accuracy. Their application, in a rapidly growing bibliography, seemed to have accomplished extraordinary things. Particularly in the field of Italian art, there was promise of a new clarity, a new sophistication, which would lead to a reliable reconstruction of the historical past. Thus, as Offner began his scholarly career, he chose early Italian art as his subject and the Morelli/Berenson method as his approach.[6]

[3] Max Dvořák, *Idealismus und Naturalismus in der gotischen Skulptur und Malerei*, Munich and Berlin (1918); idem, *Kunstgeschichte als Geistesgeschichte: Studien zu abendländischen Kunstentwicklung*, Munich (1921); idem, *Der Rätsel der Kunst der Brüder van Eyck*, Vienna (1904) (printed separately from the *Jahrbuch der Kunsthistorischen Sammlungen des allerhöchsten Kaiserhauses*, XXIV [1904]).

[4] The phrase is that of Bernard Berenson. Modern writers have challenged the validity of Morelli's method on various grounds; and, indeed, it may be that Morelli's contribution to connoisseurship was of a nature that he himself could not have imagined. See H. B. J. Maginnis, "The Role of Perceptual Learning in Connoisseurship: Morelli, Berenson and Beyond," *Art History*, XIII (1990), 104–117.

[5] Giovanni Morelli's major statement of method is found in *Kunstkritische Studien über italienische Malerei. Die Galerien Borghese und Doria Panfili in Rom*, Leipzig (1890). This work was translated by Constance Ffoulkes and appeared in English as: Giovanni Morelli, *Italian Painters: Critical Studies of their Works*, 2 vols., London (1892–1893).

[6] Berenson developed the theory of the Morellian method in an essay entitled "Rudiments of Connoisseurship," written in the 1890s, but first published only in 1902 as part of Bernard Berenson, *The Study and Criticism of Italian Art*, second series, London (1902), and later in his *Three Essays on Method*, Oxford (1927). Berenson's famous "lists" of the 1890s were among the most impressive monuments of the Morellian tradition: Bernard Berenson, *The Venetian Painters of the Renaissance*, New York (1894); idem, *The Florentine Painters of the Renaissance*, New York (1896); and idem, *The Central Italian Painters of the Renaissance*, New York (1897).

For eleven years Offner's publications consisted of reviews and short articles on very specific problems.[7] Then, in 1927, appeared two volumes: a book on early Italian pictures at Yale University and *Studies in Florentine Painting*.[8] Both were much in accord with his earlier production; in fact, the latter was essentially a collection of earlier pieces, rewritten and expanded, and now grouped to define three stylistic currents in Florentine trecento painting. But the book also contained what was to be Offner's only extended statement of approach: an essay without notes, in two parts, entitled "An Outline of a Theory of Method."[9]

If truth be told, practically no one now reads this essay. After introductory remarks and a few pages of readily intelligible comments about the historical circumstances of early Italian artistic production, there come four pages of which few can make any sense, four pages that have little to do with any of the methodologies currently discussed in considerations of art-historical approaches. Students derive no practical guidance from them, and the concepts strike many as needlessly complex, if not bizarre. As an essay, it is often regarded as eccentric.

The essay is, instead, fundamental to our understanding of Offner's work.

The reasons behind the appearance of "An Outline of a Theory of Method" at this date, and almost as an appendix to the *Studies*, are various. In the opening paragraphs Offner indicates his dissatisfaction with the state of scholarship, particularly criticism. As he begins his theoretical discussion, he rejects one of the central tenets of Morellian connoisseurship: "The technique of approach from authenticated works is prejudicial to an objective conclusion." From an historical point of view, the origins of this attitude are not difficult to discern. As the "Morellian" bibliography grew, it became increasingly apparent that the method could exert no control on its practitioners. Then, as today, its strict application could lead to ridiculous attributions. Even those who claimed to take a thoroughly Morellian approach could end with very divergent views of the *oeuvre* of the same painter. To a large extent, the problem was inherent in the method. Even in the unlikely event that several scholars might agree on a schedule of *Grundformen* from the authenticated pictures, they might still disagree about the allowable degree of variation in unauthenticated works. Moreover, no list of specific features could be totaled to convey an overall impression. Berenson had also recognized these problems and sought to remedy them by extending the categories of Morellian criticism and by introducing relational aspects for discussion. Most important of all, Berenson moved toward the conviction that a sense of quality was the connoisseur's primary equipment. But here, too, there were difficulties (which continue to this day). Estimates of quality appear notoriously subjective and generate no end of disagreement. There were, then, reasons for disenchantment.

[7] See the Offner bibliography cited in note 1.

[8] Richard Offner, *Italian Primitives at Yale University: Comments and Revisions*, New Haven (1927); idem, *Studies in Florentine Painting*, New York (1927).

[9] Offner, *Florentine Painting* (as in note 8), 127–136. Although this volume was reprinted in 1972, it remains rare. Thus I have included an appendix that quotes the section of the essay that is discussed below.

But Offner faced problems of his own, problems arising from the very material with which he dealt. Increasingly his attention had focussed on trecento painting, where signed or documented works are far fewer than in later periods and the problems of attribution are therefore greater. A single signed but undated work might constitute our only firm record of a particular painter. Still more problematic, and critical for Offner's future endeavours, were cases of anonymous masters, artists for whom there was no signed or documented work, where the critic had to select a picture that was to be his touchstone.[10]

In spite of these problems, Offner was not willing to part with all of Morellian practice. It seemed efficacious; it had shown itself, at least in part, a necessary condition of modern scholarship. He had, however, rejected one of the central principles of the method, and one upon which the method's claim to validity depended. Thus, the larger issues of knowledge and certainty returned to the fore. What was the touchstone of critical judgment? Wherein could the connoisseur find assurance of the validity of his conclusions? Could he be sure that those conclusions could, and would, be shared by others, that they could claim universal acceptance? Without answers to these questions, the connoisseur might well be engaged in a futile exercise.

Four pages of "An Outline of a Theory of Method" are Offner's attempt to resolve these issues by grounding the connoisseur's activity in aesthetics and offering philosophical justification for a method originally borrowed from the natural sciences. To do so, he had turned to Immanuel Kant, to the *Critique of Pure Reason* and the *Critique of Judgment*.[11] There he seemed to find, not only explanation of the broad theoretical problems, but also justification for the massive project he was about to undertake.

Kant had distinguished among types of judgment: judgments of perception, judgments of experience, and judgments of the beautiful, what we would call aesthetic judgments. The first two are readily intelligible. Judgments of perception are simply subjective feelings shared by animals as well as men, and expressed in remarks such as "I am cold." Judgments of experience, however, are quite different. They are characterized by being conscious, cognitive, and determined by the categories (that is, the Kantian categories) of the understanding. They are reflected in remarks such as "This room is rectangular," and are the substance of rational discourse.

Kant's conception of aesthetic judgment is much more complex.[12] In marked contrast to judgments of experience, aesthetic judgments are unconscious and occur without cognition, and they arise from very special and particular circumstances. Confronted with an aesthetic

[10] Offner had faced both problems in preparing the *Studies*. His discussion of Jacopo del Casentino is based on one signed picture; the Master of the Fogg Pietà is an anonymous artist.

[11] Immanuel Kant, *Kritik der reinen Vernunft*, Riga (1781); English edition: *Immanuel Kant's Critique of Pure Reason*, trans. N. Kemp Smith, London (1929). Immanuel Kant, *Kritik der Urteilskraft*, Berlin (1790); English edition: *Immanuel Kant: Critique of Judgment*, trans. J. H. Bernard, New York (1951). We do not know whether Offner read Kant in the original or read about Kant in secondary literature. "An Outline of a Theory of Method" is not itself helpful in resolving the question. It may be that certain difficulties (see the "Note to the Appendix" below) arise from an inadequate grasp of his source. It is just as likely that Offner's purposes led to modifications. His demonstrated knowledge of Kantian philosophy is limited; thus in the following discussion I have restricted myself to the most basic and general exposition of Kantian thought.

[12] For a modern discussion see D. W. Crawford, *Kant's Aesthetic Theory*, Madison, Wisconsin (1974).

object, the beholder's imagination acts upon unsorted and uncategorized sensations, synthesizing them into a *direct* apprehension of form. And we recognize such judgments of the beautiful in the occurence of aesthetic pleasure. This pleasure arises from the fact that, in the free play of the imagination and the understanding, there comes a point where it is *as if* the form of the object contemplated had been designed for our cognitive powers, although no concept can in fact be applied to it. The form finds an analogue in the understanding and its structure without the beholder being conscious thereof.[13]

When Offner came to write "An Outline of a Theory of Method," he was perhaps less than candid about his sources. The only (rather vague) reference to Kant occurs in the first half of the essay: "And yet science or no science, I seriously believe that the art historian has this in common with the better part of thinking humanity, that he knows by a sort of Kantian intuition when he is right, or at least when the tendency of his conclusion is."[14] This reticence may have stemmed from the fact that he realized the piece was a hybrid, that, given his aims, he needed to add both personal ideas and concepts borrowed from the Morellian tradition to his Kantian foundation. He had, for example, substituted the word "shape" for the more general "form." Kant's own vocabulary permitted this substitution, but it had another use as well.[15] For the linking of one picture to another, for the making of attributions, Offner needed the concept of the "typical shape," the identifying "mark" of a single artist. For this, there was no equivalent in Kant. By the same token the idea of "the term common to a given series of works" is another non-Kantian means of relating picture to picture. Offner also needed to refer to the function of memory in the making of attributions. "Typical shape," "common term," and memory were the three dimensions of the connoisseur's practice, the materials that allowed for the grouping of single works into an *oeuvre*.[16]

Brief passages of the essay are devoted to trying to explain how these three components interact in the making of an attribution. Attribution is described as "the recognition of a recurring experience," the aesthetic experience, and presumably it is memory that permits such recognition. It must be admitted, however, that there is an unresolved problem here, inasmuch as the role of the typical shape (in the sense of "the shape that typifies" the artist) remains elusive.[17]

The wish to deal, in a few short pages, with the question of critical validity, the method of making attributions, and the problem of finding verbal equivalents for pictorial modes, led to a dense amalgam of various ideas. Nonetheless, Kant pervades the essay, sometimes directly and sometimes as the foundation for other speculations. "Style cannot be known save through its direct experience," an experience producing "the ecstasy of perfect adjustment"; and, "Shape is the ultimate unit of style." Thus the "ecstatic experience" arises from the

[13] See Kant, *Critique of Judgement* (as in note 11), 51–54.

[14] Offner, *Florentine Painting* (as in note 8), 129.

[15] In the original German text, Kant employs both *Figur* (figure) and *Gestalt* (shape) in his discussion of visual experience. Because he seems to use the two without distinction, translations do not always make his use of "shape" explicit.

[16] See also Kant's remarks on comparisons (*Critique of Judgement* [as in note 11], 70–72) which may have appealed to Offner.

[17] See the "Note to the Appendix" below.

direct encounter with form/shape in an "instant resolution"; and Offner makes it quite clear that this experience is unconscious, that it occurs before the intervention of cognition.

The appeal of Kant's aesthetic theory for Offner is clear. Large sections of that theory are formalist, concerned with the object's structure or formal organization.[18] In this much it was a theory apparently related to the Morelli/Berenson tradition of criticism. But it was also a theory that addressed the fundamental issue of critical validity. Because, for Kant, aesthetic judgments are not directed to, nor for the purpose of, cognition or knowledge of the object seen, because they are not determined by the understanding, they are subjective. But because the imaginative synthesis accords, or harmonizes, with the categories of the understanding—as it conforms to them—aesthetic judgments are, in Kant's view, valid, universal, and necessary.[19] Here, then, Offner found assurance of the validity and universality of the connoisseur's judgments.

There may well have been another appeal as well. Although Kant never developed a full theory of criticism, his aesthetic theory allows room for one kind of critical debate.[20] To simplify matters, criticism becomes a kind of verbal pointing, designed to ensure that the audience is apprehending a common object, to guarantee that the work is being assessed on aesthetic as opposed to extra-aesthetic grounds, and to alert the viewer to all the factors which must be considered in arriving at a judgment. Here there seems to be a place for Offner's essays. The richness and specificity of his prose, the use of metaphor and analogy, his attempts to formulate a synthetic psychology for each artistic personality: these were all means to fulfill the purposes, and respect the limitations, of written criticism. And there were limitations, limitations that arose, not merely from the incompatibility of verbal and pictorial modes, but from the very nature of the aesthetic experience.

The touchstone of Offner's method, Kant's aesthetic judgment, is pre-cognitive and therefore non-verbal.[21] In Kant's scheme of things, comment or discussion can occur only when the categories of the understanding have asserted themselves, when aesthetic judgments have been converted into judgments of experience. But in that conversion the particular is, necessarily, subsumed under the general; the material of aesthetic judgment becomes the material of debate and discussion. Offner himself says "But that instant [of aesthetic impact] once passed, *shape* becomes material for the *cognitive faculty* There precisely *actual shape* forfeits its ultimate but fugitive reality, and becomes generic, *typical shape* or *represented shape*." It loses its specificity, its distinctive and unique character, through a necessary conformity to the categories of the understanding. Thus we find ourselves, in discussion, at a significant distance from the "thing-in-itself." (After the initial experience, Offner says, "the

[18] See Kant, *Critique of Judgement* (as in note 11), 73, for Kant's famous summary: "Beauty is the form of the *purposiveness* of an object, so far as this is perceived in it *without any representation of a purpose*."

[19] On the subjective nature of aesthetic judgments see ibid., 48–51; on their universality, see ibid., 120–138 and 183–187.

[20] This point is made by Crawford (as in note 12), 164–171.

[21] Kant: "The judgment of taste is therefore not a judgment of cognition, and is consequently not logical but aesthetical ..." (trans. Bernard [as in note 11], 37). "Now the judgment of taste is applied to objects of sense, but not with a view of determining a *concept* of them for the understanding; for it is not a cognitive judgment" (ibid., 184). "An *aesthetical idea* cannot become a cognition because it is an *intuition* (of the imagination) for which an adequate concept can never be found" (ibid., 187).

aesthetic crisis [actual shape] tends to forfeit its peculiar formation and its explicit character.") We may talk about these generalities; we cannot actually talk about the specific individual form or about the aesthetic judgment *per se*. The very foundation of Offner's criticism is, strictly speaking, ineffable.

The variety of Offner's aims, the variety of his sources, and problems in his use of terminology make "An Outline of a Theory of Method" difficult to follow. It is therefore not surprising that many readers have suspected it has comparatively little relevance for understanding Offner's work. Moreover, the elegant and sensitive prose of his essays (now his most frequently read publications) might well lead one to believe that he thought attributional debates could be settled by careful argumentation. His subsequent, post-1927 career demonstrates that was not the case. Indeed, the essay was the justification for the *Corpus*, the project that was to occupy the remaining years of his life.

The year that *Studies in Florentine Painting* appeared, Offner set forth the plan for his *Corpus of Florentine Painting*. His intention was to document and survey all of Florentine painting from the thirteenth to the fifteenth century in some thirty volumes. The corpus format was much a part of early twentieth-century scholarship. Bode's work on the Renaissance bronze statuette came out between 1907 and 1912; Schubring's *Cassoni* had appeared in 1915; Goldschmidt's *Elfenbeinskulpturen* between 1914 and 1926; Hill's *Corpus of Italian Medals* and Weitzmann's corpus of Byzantine ivory caskets would both appear in the same year as the first volumes of the *Corpus of Florentine Painting*.[22] But Offner's corpus was unique. Its form was distinctive, conditioned by aims he outlined in his "General Introduction," written in 1931, but published only in 1933.[23] His objective was to free "the object of the verbal system with which the literature of art has overlaid it, and especially the word-picture which generalizes its actual form until it has forfeited its physical character. For the nature of language is such that the object must surrender its physical attributes before it can be converted into words."[24] In other words, and as Offner had already indicated, discourse requires the conversion of aesthetic judgments into judgments of experience, the conversion of the actual shape into the generic. Yet aesthetic judgments are the foundation of criticism.

"An Outline of a Theory of Method" and the "General Introduction" explain for us many of those features of the *Corpus* which most bewilder and not infrequently annoy the modern reader. Although whole volumes may be devoted to a few artists or even to a single painter, the introductory essays are brief. The individual entries for specific pictures do not date the work, unless there is external evidence, and they never include argumentation about

[22] W. Bode, *Die italienischen Bronzestatuetten der Renaissance*, Berlin (1907–1912); P. Schubring, *Cassoni: Trühen and Trühenbilder der italienischen Frührenaissance*, Leipzig (1915); A. Goldschmidt, *Die Elfenbeinskulpturen*, Berlin (1914–1926); G. Hill, *A Corpus of Italian Medals of the Renaissance Before Cellini*, London (1930); A. Goldschmidt and K. Weitzmann, *Die byzantinischen Elfenbeinskulpturen des X.–XIII. Jahrhunderts*, vol. I, *Kästen*, Berlin (1930).

[23] The "General Introduction" appears in Section III, Volume I of the *Corpus* (as in note 1), iii–xiii. The title page of this volume bears the date of 1931; the foreword is dated January, 1933. It seems clear that 1933 was the year it appeared. Offner explains in the foreword that the volume had been largely printed earlier and then held up while he made changes.

[24] Ibid., iv.

either the attribution or the chronological placement of a picture. On the other hand, an extraordinary percentage of each volume is given over to plates, about which we know Offner was obsessive. Each of these features is perfectly intelligible when we realize what the *Corpus* is: a monument to Kantian aesthetics. Within Offner's Kantian framework, the ultimate demonstration *must* lie in the works themselves, not in the accompanying text. The plates are not illustrations for the *Corpus*, essentially they are the *Corpus*; they are the materials for independent aesthetic judgments to be made by the reader. As Offner himself said in the "General Introduction": "The stylistic demonstrations for my conclusions lie in the reproductions "[25] The relationship between the photograph and the original is, of course, problematic. Offner himself discussed the limitations of photography in his essay on method, but concluded: "Nevertheless, photography remains the best available simulation of the original, and the only corrective of the *verbal system*."[26]

In the "General Introduction" Offner promised to supplement his project with a two-volume *History of Florentine Painting*, which never appeared. Indeed, he explicitly says that the *Corpus* "prepares the material for sound historical induction."[27] He was making a clear distinction between history and criticism, claiming that history could only follow from the critical activity. It was, however, not enough that critical judgments be made by the individual connoisseur. Their validity, their universality, depended on—indeed were determined by—others being able to come to the same conclusions through their own ineffable aesthetic experience. And that, in turn, depended on their experiencing the objects for themselves. Historical narrative, we might say, could only stem from the unspoken and the unspeakable.

Only when we grasp the philosophical background and the theoretical framework of Offner's scholarship do we fully understand the character of his work.

Offner's teaching career was spent largely at the Institute of Fine Arts of New York University. In the positivist, one might say archaeologically minded, climate of American scholarship, his thoughts on method and his interest in Kantian philosophy had little impact. None of his more famous students shared his philosophical and methodological interests. Today, the problems he sought to address are unfashionable in art-historical circles and, in consequence, are more often ignored than examined. They are real problems nonetheless, and problems that belong to the heart of the art-historical discipline. For if the subject can lay claim to being an autonomous discipline, distinct from general history, it can do so only

[25] Ibid., xiii.

[26] Offner, *Florentine Painting* (as in note 8), 136.

[27] Offner, *Corpus* (as in note 1) iii. This page also contains a remark quoted at the beginning of this article, which now should appear in its original context: "The *Corpus* itself isolates the monuments, since it assumes as a first principle that the essential aspect of the history of art is the history of artistic expression. It has matured to its present form, accordingly, in the belief that the history of art—and any portion of it—should be evolved directly out of its concrete examples, that these, primarily, should give shape to the historic panorama It involves a method that begins with the single object, and which by scrupulously allowing it its physical character, by seeking its substance and outline, should lead us at the last to something like its actual aesthetic individuality. Only then will the object disclose its affinities to some objects and its differences from others, and thus finally, by the weight of its own physical attributes, will it settle into its proper place in the historical field."

inasmuch as it claims there is both a unique structure in the history of style and a valid method for the resolution of stylistic problems. Even for those who practice the currently prevalent social and cultural history of art the issues are critical. Their building blocks are various, but not infrequently they rest upon the chronologies of the critic/connoisseur. And these, in turn, arise from attributions and sequential orderings. The validity of critical judgment thus remains an issue of primary importance.

APPENDIX

From "An Outline of a Theory of Method," in Richard Offner, *Studies in Florentine Painting*, New York (1927), 132–135.

To find a personality one must discover *the term* common to a given series of works. The technique of approach from authenticated works is prejudicial to an objective conclusion. A personality *discloses* itself in certain terms common to a group of works, which the limited number of authenticated ones may contain in a misleading measure or combination. Moreover it is not the social and human identity, not the name of a master that we are seeking, but the *intrinsic artistic personality*. Finally, the method of the *common term* leaves us free to work from the heart of the problem, regardless of all external or fortuitous incident.

But to evolve a conception of an *artistic personality* one must have found its *style* in the individual work. *Style cannot be known save through its direct experience.* If such an experience be positive—and none other concerns us—it is exclusive and unique. By the last attribute it is also differentiable, furnishing the first condition of connoisseurship.

In normal susceptibilities it produces a kind of *ecstasy*, the *ecstasy* of perfect adjustment, distinguished from mystic and sensual rapture of love or prayer, by its instant resolution into its constructive factors, that may be called *shapes*. *Shape* is the ultimate *unit of style*—as the *condition of style* is an *ecstatic experience*. This has its systole and diastole: it contracts with the binding synthesis; and expands again in flyingly noting the relation of *individual shapes* to the *total shape,* wherein they stand in sharply and swiftly perceived relation to each other.

It is thus in terms of *shape* that we divine style; it is in *shape* that we arrive at it. But so long as our total consciousness is suffused, so long as its content is single and synthetic, we assimilate *shape* in *denominations of visual measure too fine and elusive for the mind to hold.*

We *know* it neither through the mind nor primarily through vision, but *directly* by its correspondence in *function.* At that instant we are organized by the *aesthetic impact.* A new lucidity is struck out of our chaos. Our life-cells are reassembled in accordance with the pattern of the object, our organic rhythms timed by it, and our structure caught in a new tension. But that instant once passed, *shape* becomes material for the *cognitive faculty*—at the point at which chemistry becomes physics. There precisely *actual shape* forfeits its ultimate but fugitive reality, and becomes generic, *typical shape* or *represented shape.* It ceases to exist as a work of art: it describes something else to which it directs the attention. As long,

however, as it remains an *experience*, the *actual shape* carries the *radical rhythm*, that per-vades the whole work of art. *This rhythm sustained at its own pitch, holds the constructive vitality of a work of art.* By it every part is absorbed in the whole in a *synthetic tension*, as every sense is absorbed in *its experience*; and by it all the *associated aspects* of *the shape* are drawn into the *aesthetic vortex*. The greater the work of art, the more swiftly will this happen, the more surely will the binding *radical rhythm* lead us to the whole from any of its parts.

It would be falsifying the psychology of *aesthetic experience* to suppose that it contains nothing besides these abstract values. It is true it reveals itself primarily as *shape*, but as such it is only a manifestation—its immediate manifestation. In so far as the *artistic object* is *representative*—and it is representative art that concerns us here—so long as it contains animate figures related in action, it is charged with the atmosphere and the ethical implica-tions of the action, so that the *object* has at one moment direct vibrations as *shape*, at the next, suggestions of its action, and its identity in nature; the intrinsic material denotations of *shape*, that is, alternate with the connoted meaning of its action, and of its identity; but none of these is capable of separate existence, *each being a manifestation of all the others in an inextricable oneness*. Thus a certain length, bend and position of a line *describe* a figure and its gesture, even as that line releases its own force and quality.

It is the critical fact about art as distinguished from practical life, that the effect it produces in a normal consciousness is felt in the terms of *the object*; the more explicitly in a visual art like painting, as it works with definite and concrete images. It is accordingly in the instantaneous evolution of the *aesthetic series* that the suffused consciousness of the *aesthetic crisis steadies itself* in the *shapes* that first produced it; and only the voluptuary or hysteric would content himself with the *ecstasy* without returning to its *basis*. It is in this return from the *ecstasy* to the objective source, from a suffused to a seeing consciousness, from rapture to vision, that the *critical moment* consists; whereas on the contrary, the "aesthete" would avail himself of art as he might of a scent, to set him drifting through a state of the consciousness, rendered delicious by its sensual analogies of effortless and uninhibited, lulling or gliding, movement through space. The imagery of such a consciousness is uncontrolled. It has neither pattern nor organization. In fact it is by its independence of any controlling principle, that the sensation is capable of sustaining and reproducing itself. And every instant bears it farther away from the premises of *the object*. The content of the sensation will consequently tend to become arbitrary, and its end will be the unfolding of a series of sensations and images drawn from the stock of an intimate and eccentric dream-world, varying with each individual.

But the normal person, who has *experienced* the object, who has consequently *appropri-ated* it, grants it its artistic prerogative, by forever correcting the sum of his reactions with it, carrying them back to their *visible terms*, checking them up with the *shapes* in which they arose. By this process criticism accomplishes an *objective*, if it fails—as it must do to the end of time—in reaching a *scientific* validity.

Scarcely then, have we become aware of the *principle of unity* (of the *actual shape*), than it resolves itself into its conventional substitutes, *generic* or *geometric shapes*. The memory, at one remove from authenticity, being a sort of blind vessel, in order to retain what is submitted

to it and stored in it, by first-hand experience, is reduced to simplifying its material by generalizing it, by grouping it according to kind. That is how—as the incessant chemistry of mind and body bears us from state to state, from mood to mood, varying our imagery in atomic units of change, in focus and in sharpness—the *aesthetic crisis (actual shape)* tends to forfeit its peculiar conformation and its explicit character. So that by the rule, that no tension can sustain itself beyond its moment within the human organism, the *aesthetic experience* perpetually drifts towards *a fading memory of function* and *a simplifying memory of vision*. On the other hand, the object's *intimate correspondence in function* tends to hold it for us. One might put it differently by saying that *the experience* wavers between *actual shape* and *generic shape*. Just how far *actual shape* will tend to become *generic shape* will depend on the practical question of purpose. When that is—as it is here—*to find the personality*, then *actual shape* will seek its type—*typical shape*, before, that is, it has lost those *vital terms*, which corresponding in function, hold it together; while it isolates those *fortuitous terms*, that are primarily *visual*, and that vary from work to work.

The *vitality*, being constant, belongs to the creative *individual*, the *fortuity* to the work—just as, letting the *fortuitous terms* drop away from the *actual shape*, we have left the *typical shape*: the shape that typifies him.

Thus by moving from the *actual shape* to the *typical shape*, we are relating one work to others by the same *creative identity*. Such grouping of one work with others of its kind, however, is an inner gesture, enacted spontaneously in the *function* itself, before the extinction of the *aesthetic moment*, when the faculties are still vibrant with it, and before experience becomes the *object of memory*.

This is the act of attribution—attribution, in reality, being no more than the *recognition of a recurring experience*, with free variations.

The confusion, to say nothing of wilful distortion, of two or more masters is, therefore, at its best, a failure of function; and frequently simply recklessness, incompetence or insensibility.

Now, as the *aesthetic* moment gives us the *actual shape*, the object is *classified* by its *generic shape*. In language the *generic shape* would be described by a *conceptual* word (a noun), the *actual shape* by a combination of them or by qualifying ones (adjectives). But even then language would have described *the actual shape* partially, for language cannot really reach beyond generic suggestions, beyond the *generic shape* or the *geometric shape*.

Language is conceptual; it consists of classified terms, capable of describing only the ideated *experience of sense*; it begins to capture that *experience* at the point at which it becomes the *object of memory*—at which it becomes memory. And as memory generalizes all such experience by classification, all adventures of the eye like those of touch, of taste, of smell, of hearing, elude language. Language can barely approximate them, and then only by analogy or example. The farther a *shape* is removed from the geometric, the less capable will language be of rendering it.

Language has only one conceivable means of reproducing the *actual shape*, and that is by indicating the exact position of every one of its points. But even then, a point being a theoretical concept, those concrete agents of texture and color under which it manifests itself to

sense would still be inaccessible to literary statement. It is for such reasons that literary and pictorial modes are eternally irreconcilable; and it is a fair presumption that if *shape* could be presented in words, it would never have been painted.

Note to the Appendix: On "Shape"

One of the obstacles to understanding the passage above lies in the various changes which Offner rings on his use of "shape." As noted above, Offner's "shape" is Kant's "form." As he first uses "actual shape" it is clear that it is the unique, individual form, specific to a particular picture, but he also wishes to use it to designate the synthesis of the imagination. Thus it can be contrasted with the "generic, typical shape" or "represented shape," these the products of cognition. As the essay progresses these definitions are repeated; for example, "Now, as the *aesthetic* moment gives us the *actual shape*, the object is *classified* by its *generic shape*." But, unfortunately, they become mixed with other usages so that, again for example, we encounter the "typical shape" as an identifying mark of a particular painter: " . . . letting the *fortuitous terms* drop away from the *actual shape*, we have left the *typical shape*: the shape that typifies him." And in passages such as "But even then language would have described *the actual shape* partially, for language cannot really reach beyond generic suggestions, beyond the *generic shape* or the *geometric shape*," or "Language has only one conceivable means of reproducing the *actual shape*, and that is by indicating the exact position of every one of its points," Offner shifts back to a usage of "actual shape" which is much more like "particular shape." The same seems to be true in the sentence "One might put it differently by saying *the experience* wavers between the *actual shape* and the *generic shape*," but the context makes it unclear. One fears that Offner himself may have had difficulties.

Part III

INSTITUTIONALIZING ART HISTORY:
THE EARLY DISCIPLINE IN
THE UNITED STATES

Introduction to Part III

DONALD PREZIOSI

ACCOUNTS of the historical development of art history have often resembled veritable bibles of begatting, genealogical trees of who did what when and where, and with or against whom. Within such scenarios, those of us in the present have predictably seen ourselves as perched on one or another outermost branch, persuaded that our particular twig is the tree's central growing crown, and convinced that our own downward view emblematizes and poignantly summarizes the growth of the whole organism.

Such games of anamorphosis have long served to emplot the narratives we fabricate about the history of art history as a linked chain of theories, methods, personalities, and schools of interpretation, each link comprising yet another point of resolution or revelation more powerful, pertinent, or encyclopedic than the one before. It has long been a commonplace to frame the history of our discipline as a progressive evolution of advances, survivals, hero(in)es, and avatars, main streams and minor rivulets.

Such suave entrapments comprise the very warp upon which we play out the weft of modern disciplinarity: certain modes of speaking which assume some panoptic point or perspectival slant from which disciplinary history might be frozen and fixed in place, perhaps even once and for all.

Yet the essays comprising this volume make strikingly clear what should not have been so easily forgotten: that critical rethinkings of art-historical practice have constituted the very foundation of the discipline since its academic formations a century and a half ago. Indeed, there has rarely been a time when the discipline has been untroubled by conflicting and often strongly opposed visions of art, and of art's history. A perusal of this volume and its accounts of the differing models and blueprints for the new academic discipline will provide eloquent testimony of that complex and multifarious history. To use current terminology, there has been yet another "new" new art history, and art history has always seemed to be "in crisis."

At the same time, these essays attest that art history in America has become increasingly self-aware over the past decade as more art historians come to re-read the history of their field in a more critical and searching light, as an area worthy of study in its own right. These writings offer an opportunity to distinguish between what it might once have been comfortable to believe about art history's history in America, and the discipline's often astonishingly complex and diverse developments. The institutional space cleared for itself by academic art history (both in Europe and America) was no *tabula rasa*, but an already densely textured philosophical, epistemological, and ideological landscape. The contested arena emerging in

these accounts is sharply at odds with many of the biographies and recuperative genealogies of art historians, institutions, and ideas we have been accustomed to construing (perhaps all too precipitously) as representing the "history" of art history.

No doubt our discomfort will be increased by the accumulation of all those small stories that have lain forgotten for a few generations and cannot so easily be reduced to the familiar narratives of progressive evolution we have taken for granted. On balance this will have been a good thing if recognized for what it signifies: pointers to a thoroughgoing archaeology of art-historical knowledge and of the epistemologies that have worked to frame (and at the same time have been the product of) particular modes of institutional practices.

What such an archaeology or critical history would comprise, however, remains largely unclear. But the present volume should make it very clear indeed that such an enterprise would be more than simply a larger album of biographies of founding fathers and mothers, longer histories of particular institutional frameworks (such as universities, museums, or marketplaces), or merely a thicker chronology of all those material technologies that paradoxically both support and define historical, critical, and pedagogical practices.

It would, in short, be the sum of these and more—the intersection of all these strata both within the field and with the broader problems and potentials of modern disciplinary knowledge as such. Even in its most serene and seemingly autonomous moments, art history has been both product and producer of the epistemological enterprises we have inherited from the Enlightenment, all of which have worked in tandem to fabricate our own modernity. Any "crises" art history may have faced in its history are inescapably at one with those of modernity itself.

As we come closer to understanding in their fuller complexities some of the foundational problems that art history has shared with other fields, as these came to be systematized and institutionalized in the late nineteenth and early twentieth centuries, our attention to these problems may raise for us the possibly uncomfortable specter of the limits of what we call art history, and of its possible transitoriness in modern life. The possibility, if you will, that just as there was once no such thing as "art history" (as there was once no such "thing" as art), so may there no longer be such a thing in years to come.

This might still seem somewhat paradoxical. Art history has surely never seemed so secure, so successful, so universal in its ken, or so necessary. The purview of the art historian seems ever to expand, so that its object-domain is practically coterminous with the limits of artifactual culture *tout court*. On those horizons, which both reflect and legitimize the purview of the modern museum, art history might very well seem endless and unlimited in its potential scope.

And yet any such expansions almost inevitably engender stresses to a disciplinary fabric already stretched over a number of contradictions, ambiguities, and unresolved conflicts between the various strands of art-historical knowledge played out over the past century and a half. Not least of these has been art history's dream of scientific objectivity: the dilemma of articulating an historical "science" of objects construed as unique.[1]

[1] In December 1940, the Carnegie Corporation sponsored a conference on the state of art education in America, featuring testimony by many individuals prominent in art history, aesthetics, art education, and museums. One of the more nota-

We can no longer easily assume that there might (or should) exist somewhere some basic single core of art-historical theory or practice that has remained unchanged or unmoved (like the eye of a hurricane) amidst the marginal swirl of the latest fashions in theory and criticism. To assume so would be to project backwards upon disciplinary practice a uniformity or untroubled orthodoxy that—as the essays in this volume make clear—never really existed. Nor can we readily assume that there might be a single "cure" for what might appear to be various disciplinary ills: to assume the latter would be to fall into a trap by which a number of critical movements, but most notoriously the "social" history of art of the 1970s, came to be hoist by their own epistemological petards from their very beginnings. Neither reductive panopticism nor blithe pluralism have served to enlighten us very much about the nature and development of the discipline of art history: its power and success are attributable neither to a single strongly deployed orthodoxy nor to the simple accumulation of instrumental methods designed for diverse contexts and problems.[2]

What is emerging today behind the scrim of the rhetorical ceremonials of various 'new' art histories is a more highly nuanced archaeology of the discipline, along with an awareness of two separate frontiers on which the very possibility of an enterprise that calls itself art history is being raised: its future and its past. Whilst distinct in one sense, these two horizons intersect and share a common problematic: the ways in which our picture of the past and of the future of art history frame its presentness, its seeming ordinariness, are what is at issue today.

Art history is neither unique nor alone in this, but neither is it a simple reflection of other modern disciplinary formations. The essays in this collection work to bring into the foreground a number of the paradoxes attending any disciplinary formation. The diverse languages of early art history in America have produced a complex palimpsest of agendas,

ble and controversial interchanges during the conference involved an informal debate between Christian Gauss, Dean of the College, Princeton University, and George Boas, Professor of the History of Philosophy at Johns Hopkins. In response to Boas's observations on the inabilities of art historians to contextualize works of art realistically within the complex social and cultural circumstances in which they were produced, Gauss took strong issue with what he termed the "historical method of presentation" of works of art. His remarks are worth citing here at length:

> We have gone very far along these lines, even in my own lifetime. We teach everything now as French art or German art or Italian art, or Roman, or Greek, or whatever it is; and the poor student thinks that they are all different. Then we tell him that French art or literature of the 17th century is one thing, and French art of the 18th century is another. Naturally, the conception of art as such, poetry as such, painting as such, disappears. We make it relative.

Boas, in contrast, objected to the tendencies of art historians to collapse historical, cultural, and social differences in visual imagery to a single abstract category of "art" or "painting *überhaupt.*" This, he argued, reified a modern western practice into a universal, ontological category (*Proceedings of the Informal Conference on the Arts*, held under the auspices of the Carnegie Corporation of New York; December 16–17, 1940, Hotel Biltmore, New York [typescript: 137, 91]).

Gauss's remarks resonate with those of a standard art-historical primer written thirty years later, W. E. Kleinbauer's *Modern Perspectives in Western Art History*, New York (1971), 1: "A work of art can be defined as a man-made object of aesthetic significance, with a vitality and reality of its own. Regardless of the medium of its expression, a work of art is a unique, complex, irreducible, in some ways even mysterious, individual whole." Elsewhere, he writes (34): "The data of the art historian are unique, while those of the scientific historian are specimens of a class, cognate occurences under a law."

[2] These and other issues related to the epistomelogical formation of the modern discipline are taken up at length in D. Preziosi, *Rethinking Art History: Meditations on a Coy Science*, New Haven and London (1989).

assumptions, and practices which our contemporary primers have more often than not reduced to progressive moments in a linear genealogy.

By patiently separating out these founding developments and by attending to the language(s) of the new discipline, we may begin to appreciate just how a critical history or archaeology of art history might look. The essays in Part III, originally presented at the annual meeting of the College Art Association in San Francisco in February, 1989, attend very closely both to what was said about the new discipline as well as what was not said—both equally important to our understanding of the development of art history in America. They move beyond the surface rhetoric of current competing methodologies or schools of thought, and demonstrate very clearly indeed that the contemporary rethinking of art history's present and possible futures depends in the first instance upon a comprehensive and detailed understanding of its various pasts. Their merit lies in their keen sensitivity to the fact that the very apparatus of academic art history has in itself been no neutral or innocent stage set for the articulation of art-historical knowledge, but rather has had a profoundly formative role to play in defining what art-historical knowledge might be.

In that sense, the important essays by Sherman, Kantor, Van Zanten, and Stankiewicz below suggest that an effective history of the discipline must move beyond biography, genealogy, or those idealistic histories of "ideas" we have become so accustomed to, wherein theories and methodologies are invariably portrayed as proliferating in a vacuum, above and beyond the institutional mechanisms that work to make them seem possible, natural, productive, and unproblematic.

Taken collectively, these essays make it clear that the "tree" of art history is a grove of diverse and competing growths which appear singular only at a safe distance. By collapsing that distance, they work to dispel some of the easy and comfortable fictions that have haunted our understanding of what we do as art historians, and what we have been. And they also afford us a better opportunity to see where we might be going.

The Departments of Art, Wellesley College, and the History of Art and Classical Archaeology, Bryn Mawr College, 1875–1914*

CLAIRE RICHTER SHERMAN

INTRODUCTORY NOTE

THE DEVELOPMENT of the departments at Wellesley and Bryn Mawr colleges from 1875 to 1914 indicates two different directions from which American academic institutions approached the historical study of the visual arts. I will discuss this process within a broader context: the founding of these colleges as elite institutions for the higher education and professional training of middle- and upper-class American women. The main part of this paper considers the formulation of distinctive curricula, research programs, and study facilities in the two departments in accordance with the separate visions of women's education at Wellesley and Bryn Mawr. The concluding section of the paper briefly summarizes the effect of the departments' training on the professional status of women archaeologists and art historians.

WELLESLEY AND BRYN MAWR: THE FOUNDING IDEALS AND THEIR MODIFICATION

Both Wellesley, which opened in 1875, and Bryn Mawr, in 1885, were founded by male liberal reformers with strong religious orientations. They desired to improve women's status by establishing separate women's institutions modeled on male four-year liberal arts colleges. Vassar College (opened in 1865) was an influential model for Wellesley, whose founders were Henry Fowle Durant, a wealthy Boston lawyer and evangelical reformer, and his wife, Pauline. Greatly impressed by the dedicated female community created at Mount Holyoke Seminary by Mary Lyon, the Durants envisaged the improvement of American culture through the moral and intellectual influence of educated women. Although the conservative,

* I wish to thank the following archivists for their assistance: Caroline S. Rittenhouse, Bryn Mawr College; Wilma Slaight, Wellesley College; and Elaine D. Trehub, Mount Holyoke College. Leo M. Dolenski, Manuscripts Librarian at Bryn Mawr, was extremely helpful in locating visual material in the Bryn Mawr Archives.

patriarchal aspects of the Durants' benefactions are clear, certain of their proposals were quite radical.

Within the Christian and domestic framework created at the college, the Durants believed that young women could transform their intellectual, spiritual, and physical potentials. Quite daring, too, was their plan for a female faculty and president.[1] While Durant lived, he maintained control over all aspects of college life. Shortly after his death, Alice Freeman (1855–1902), later Palmer, became the second president of Wellesley. A firm believer in women's intellectual equality, her tenure from 1881–1887 marked both the considerable raising of academic standards and the strengthening of the position and power of the female faculty. Yet she saw the primary goal of a women's liberal arts education as cultural enrichment of the domestic sphere.[2]

As at Wellesley, the ideas of the benefactor of Bryn Mawr were altered by strong female influences. In 1877, Joseph Wright Taylor, a physician and member of the Society of Friends, decided to found near Philadelphia a liberal arts college for women modeled on nearby Haverford College for men, a Quaker foundation. After Taylor's death in 1880, the Quaker board of trustees chose James Rhoads as the college's first president. But the daughter of a member of the board from Baltimore, M. Carey Thomas (Fig. 111), had boldly offered herself as a candidate for the presidency. Thomas (1857–1935), a graduate of Cornell, had attempted unsuccessfully to study for the Ph.D. at the newly founded Johns Hopkins University. She succeeded in her efforts at the University of Zurich, where in 1883 she was awarded a doctorate in medieval philology. An ardent feminist, Carey Thomas, as dean of faculty and then as second president of Bryn Mawr from 1894 to 1922, changed the original character of the institution.

Consciously elitist, Thomas insisted that, from admission to graduation, Bryn Mawr's well-prepared students meet the challenges posed by a series of very stiff intellectual requirements. At Thomas's urging, Bryn Mawr audaciously chose a curriculum and faculty that, like Johns Hopkins, followed the model of the modern German research university. Bryn Mawr became the first women's institution to offer a doctorate. While dedicated to achieving educational and professional equality for women, Thomas rejected the idea of female cultural separatism embodied in Wellesley's adherence to an all-woman faculty and its primary goal of educating women to improve the quality of domestic life.[3] Carey Thomas vowed to educate independent, competitive women trained to pursue professional careers.

[1] Patricia Ann Palmieri, "In Adamless Eden: A Social Portrait of the Academic Community at Wellesley College, 1875–1920," unpublished Ph.D. diss., Harvard Graduate School of Education (1981). Palmieri (23–25) discusses Ann Douglas's ideas about the cultural association between Protestant clergymen and American women in A. Douglas, *The Feminization of American Culture*, New York (1977). An official history is *Wellesley College, 1875–1975: A Century of Women*, ed. Jean Glasscock, Wellesley, Mass., Wellesley College (1975).

[2] For an illuminating contrast between the educational philosophies and cultural orientation of Wellesley and Bryn Mawr as well as an account of Alice Freeman's career after her marriage to George Herbert Palmer, see Roberta Wein, "Women's Colleges and Domesticity, 1875–1918," *History of Education Quarterly,* XIV (Spring 1974), 33–43.

[3] Ibid., 35. Thomas never accepted the requirement at Wellesley that students participate in domestic work; see "Closing Address by the President of the College," *Bryn Mawr College, Twenty-Fifth Anniversary, October 21 and October 22, 1910,* Bryn Mawr (1910), 45–46. For a short biography of Thomas, with references to the earlier literature, see Laurence R. Veysey, "Martha Carey Thomas," in *Notable American Women: A Biographical Dictionary, 1607–1950,* ed. Edward

The early buildings and environments of the two schools illustrate different approaches to women's education in general, and to the visual arts in particular. Wood engravings printed in early catalogues of Wellesley show that the secluded and picturesque setting of the college on the Durants' estate provided a healthy and safe climate for the education of young women.[4] The Durants oversaw every detail of improving the landscape and of constructing College Hall, a building that combined the qualities of palace, chapel, and hotel. They spared no expense in providing spacious accommodations in which aesthetic considerations played a major role. College Hall was designed by Hammatt Billings in a picturesque Gothic style associated with John Ruskin and William Morris.[5] Situated above Lake Waban, the central pavilion of Wellesley's first building rose five stories and was filled with an immense conservatory that served as the heart of the campus. Paintings and sculptures of women, intended as models for the students, filled the central area. College Hall's most lavishly decorated space was the Elizabeth Barrett Browning reading room, designed and decorated by Durant. Stained glass windows depicting women from her poems, a bust of the poet, and a manuscript of one of her poems commemorated the achievements of a woman genius.[6]

At Bryn Mawr Carey Thomas's influence in determining the environment for training the student was paramount.[7] Thomas put forth a building plan modeled on the Oxford and Cambridge colleges, in which all students were housed in separate residence halls. Unlike the early centralized buildings at Wellesley and Vassar, in which the students were subject to surveillance, strict rules, and shared in domestic work, Bryn Mawr students had privacy in separate rooms or suites. Thomas pioneered in choosing a late Gothic and Jacobean style of architecture designed by Cope and Stewardson. She insisted that the Bryn Mawr campus offer a dignified and monumental environment modeled on the all-male, Anglo-Saxon preserves of Oxford and Cambridge.[8] The requirement that students and faculty alike wear academic dress reinforced the emphasis on a genderless, scholarly atmosphere based on English male institutions.

THE WELLESLEY ART DEPARTMENT

From the earliest days of the college, the Wellesley atmosphere encouraged the prominent role of art in the curriculum. The tradition of female amateurism gave the practice of art

T. James, Janet W. James, and Paul S. Boyer, Cambridge, Mass. (1971); this publication will henceforth be cited as *Notable Women*. For a history of the institution, see Cornelia Meigs, *What Makes a College? A History of Bryn Mawr*, New York (1956).

[4] The engravings are collected in *Souvenir of Wellesley, Illustrated*, Wellesley, Mass. (1888).

[5] For a plan, illustrations, and analysis of College Hall, see Helen Lefkowitz Horowitz, *Alma Mater, Design and Experience in the Women's Colleges from their Nineteenth-Century Beginnings to the 1930s*, Boston (1984), 46–53. For the association of the building with the Gothic Revival, see Palmieri (as in note 1), 31.

[6] Palmieri (as in note 1), 32. For an illustration, see Horowitz (as in note 5), 52.

[7] As Helen Horowitz (as in note 5), 107–111, has shown, Thomas rejected the familial and domestic style of college buildings and residences borrowed by the Bryn Mawr founders from Smith College. For photographs of the campus and early buildings, see Caroline S. Rittenhouse and Leo M. Dolenski, *Bryn Mawr College*, Bryn Mawr, Penna. (1985).

[8] Horowitz (as in note 5), 117–130. On many occasions Thomas expressed her pride in the Bryn Mawr style of architecture and noted that the college had taken a pioneer role in adopting "Collegiate Gothic." Thomas (as in note 3), 46–49.

respectability, and women's cultivation of good taste in aesthetic matters was stressed. Following Vassar, Wellesley established a separate School of Art in 1878 and adopted a five-year program in which art studies were combined with the requirements for the B.A.[9]

Under the auspices of the School of Art, the curriculum and facilities expanded to include art-historical concerns.[10] The annual college catalogues meticulously record a rapidly growing art library and a collection for study purposes of stereoscopic views, photographs, graphic arts, and painting (Fig. 112). By the academic year 1883–1884, lectures were offered on ancient, classical, and modern art.[11] Three years later, a separate department of the history of art was established, with courses offered in Early Christian and Renaissance art.[12]

The importance of art at Wellesley is evident from the opening in September, 1889 of the Farnsworth Art Building (Fig. 113). Architects Arthur Rotch and Thomas Tilden designed a handsome classical structure that housed in its symmetrical plan a lecture room with stereopticon, studios, "two laboratories containing art material related to courses, and exhibition rooms for student work."[13] The building also contained the art library and a museum of the art collections.[14]

In 1897, Alice Van Vechten Brown (1862–1949) was brought in to restructure the art department (Fig. 114).[15] Trained as a painter at the Art Students' League in New York, she had since 1894 been director of the Norwich Art School in Connecticut, which was affiliated with the Norwich Free Academy and the Slater Art Museum. This complex of institutions had intimate ties with the most progressive currents in American art and cultural circles.[16] When the Slater Art Museum was dedicated in 1888, the chief speaker was Charles Eliot

[9] For a discussion of "the relation between the liberal arts curriculum and the fine arts," see Horowitz (as in note 5), 84. Instruction was arranged in two courses: drawing and painting, and modeling. *Wellesley College Calendar* (1880–1881), 43.

[10] For example, the presence of a lecture on the "history of painting and sculpture" is noted as part of the curriculum for fourth-year students of the art school: *Wellesley College Calendar* (1880–1881), 47.

[11] *Wellesley College Calendar* (1883–1884), 54. The next year, topics covered included not only Greek, but Egyptian, Italian, German, French, and English art. In 1877 art history entered the curriculum through instruction in archaeology and the arts of Greece and Rome, offered to students in the Classics Department, although no separate courses were given at this time. See Priscilla Hiss and Roberta Fansler, *Research in Fine Arts in the Colleges and Universities of the United States*, New York (1934), 163.

[12] But the School of Art continued to offer instruction in drawing, painting, and modeling: Hiss and Fansler (as in note 11), 163.

[13] The structure was the gift of a close friend of Henry Durant, Isaac D. Farnsworth, who left $100,000 for a building that would house a museum and the School of Art. Alice Payne Hackett, *Wellesley: Part of the American Story*, New York (1949), 111; for the architecture, see Horowitz (as in note 5), 84–85.

[14] The latter included "stereoscopic views," photographs, paintings and watercolors, "one hundred statues and busts," and diverse collections of casts and works in various media including armor, pottery, baskets, and laces and embroideries. *Wellesley College Calendar*, 1899–1900, 14.

[15] Although she had no college degree, Brown came from a New England family prominent as educators and theologians. Agnes A. Abbot, "Alice Van Vechten Brown," *Notable Women* (as in note 3).

[16] For information about the buildings and program of the Norwich institutions, see Henry Watson Kent, *What I Am Pleased to Call My Education*, New York (1949), 23–52. Kent was the curator of the Slater Art Museum. A librarian by training, he later became secretary of the Metropolitan Museum, where he introduced accession and registration systems based on the methods of library science developed by Melvil Dewey.

Norton (Fig. 24).[17] Brown's familiarity with Norton's ideas may have influenced her subsequent philosophy of art education at Wellesley.

While at the Norwich Art School, Alice Van Vechten Brown had developed what was considered a revolutionary approach to teaching art history: she called it the "laboratory method." Students had to draw or model from casts, photographs, or works of art in order to distinguish among them and learn the basics of their techniques (Fig. 115).[18] Apparently Brown's use of the term "laboratory" was designed to overcome initial and continuing skepticism at Wellesley that the "trustees should allow practical art to count toward the degree on the same basis as scientific experiments."[19] The "laboratory method" combined a formalist emphasis on material and technique with claims of scientific objectivity.

At the time of Brown's appointment the School of Art was abolished as an independent entity and absorbed into the academic curriculum.[20] The imposition of a more scholarly and academic framework for art studies was also typical of other American colleges and institutions during this decade.[21] This new phase in the institutionalization of American art history reflects the growing application of a "scientific method" borrowed from the natural sciences and classical philology. These "scientific" credentials, applied first to classical archaeology and architecture, rationalized sustained programs of graduate work at Princeton and other universities.[22]

Brown's introduction of the laboratory method led to the successful expansion of the department.[23] By 1900 Wellesley was the only American college with a major in the history of art.[24] In that year President Caroline Hazard reported that the art department "is now equipped with a full professor, four instructors, a librarian, and caretaker for the Art Building, besides the janitor. It is the only department, except Chemistry and Music, which has its

[17] Ibid., 44–48.

[18] According to her colleague and biographer Agnes A. Abbot, Brown's method was intended "as a means of developing and sharpening observation, thus serving a purpose parallel with that of laboratory experimentation in science. Miss Brown shrewdly adopted the term *laboratory work* to designate it." "Alice Van Vechten Brown," Wellesley College Faculty Biography Files, 1. This material was brought to my attention by Wilma Slaight, Wellesley College Archivist.

[19] Myrtilla Avery, "Methods of Teaching Art at Wellesley," *Parnassus*, III/IV (1931), 21.

[20] *Annual Report of the President and Treasurer of Wellesley College* (1896), 4. This publication will henceforth be abbreviated as *Wellesley Annual Report*. The Annual Report for 1896 cites the findings of a special committee on the School of Music and the department of art appointed by the board of trustees at a meeting of November, 1895. The declining interest and enrollment in the School of Art was noted by President Helen A. Shafer in ibid. (1893), 24.

[21] Claire Richter Sherman, in *Women as Interpreters of the Visual Arts, 1820–1979*, ed. Claire Richter Sherman with Adele M. Holcomb, Westport, Conn. (1981), 29. See also Marilyn Aronberg Lavin, *The Eye of the Tiger: The Founding and Development of the Department of Art and Archaeology, 1883–1923, Princeton University*, Princeton: Department of Art and Archaeology and the Art Museum (1983), 17, as well as the papers by Marilyn Lavin and Craig Smyth in Part 1 of this volume.

[22] Wellesley's awareness of the importance of classical archaeology is shown by the appointment of Alice Walton (Ph.D., Cornell, 1892). From 1896–1900 she gave courses in classical archaeology in the department of art, and from 1900–1909, in the department of Greek and Latin. At an early date Wellesley supported the American Schools of Classical Studies at Athens and at Rome, to which its women students were admitted. *Wellesley Annual Report* (as in note 20) (1896), 15; *Wellesley College Calendar* (1895–1896), 35.

[23] The first offering of an experimental course that featured the "laboratory method" resulted in the enrollment of three times as many students as could be accepted: *Wellesley College Calendar* (as in note 20) (1897), 20.

[24] Abbot, "Alice Van Vechten Brown," in *Notable Women* (as in note 3). In addition, two master's degrees were awarded, and 176 electives in the subject were declared. *Wellesley Annual Report* (as in note 20) (1900), 9.

own building, and consequently its own heating and lighting. This makes the department the most expensive of any in the College."[25]

From 1900–1914, the art department developed steadily. Survey courses offered by Brown and others were very popular. The curriculum also included studio courses, sometimes associated with the art-historical program. A scholarship for graduate study in art history was established. Original works of art were bought for the museum, while students used the collections of the Boston Museum of Fine Arts in seminars conducted by instructors who held curatorial positions there.

THE BRYN MAWR DEPARTMENT OF THE HISTORY OF ART AND ARCHAEOLOGY

Compared to the Wellesley art department, the development of the Bryn Mawr Department of the History of Art and Archaeology took an erratic course in the years 1885 to 1914.[26] The Quaker orientation of the founder and the board of trustees may have initially discouraged study of the visual arts.[27] Moreover, guided by the Johns Hopkins model of the research university, Bryn Mawr chose to focus on classical languages, science, philosophy, and history.[28] The Bryn Mawr ideal of the serious, scholarly woman undergoing training for an independent career did not permit dilution by traces of female amateurism in the arts.

During the first decade of Bryn Mawr's existence, interest in art history and archaeology was shown in public lectures and then elective courses on archaeology and the history of ancient art given in the classics department.[29] Their primary function was to round out the knowledge of students majoring in classics. At that time only limited resources were available for photographs and other teaching aids.

In the first annual report of her presidency (1894–1895), Carey Thomas enthusiastically expounds plans for creating within the classics department a lectureship in the history

[25] *Wellesley Annual Report* (as in note 20) (1900), 9.

[26] The changes in the name of the department in the annual course catalogue is one indication of an early lack of direction.

[27] Indeed, in his opening speech President Rhoads wonders "how far attention can usually be given in a college to art, as expressed in form, color, and sound" While Rhoads eliminated music as a subject for study, he did concede that "lectures upon the history and principles of art, properly illustrated, shall be given to the more advanced students." *Addresses at the Inauguration of Bryn Mawr College by President Rhoads and President D. C. Gilman of the Johns Hopkins University, Bryn Mawr, 1885*, Philadelphia (1886), 17.

[28] Wein (as in note 2), 35.

[29] For example, in 1887–1888, Arthur L. Frothingham, Jr., professor of archaeology at Princeton, lectured fortnightly for five months on Greek and Roman architecture. *Bryn Mawr College Program* (1887–1888), 26. Then, in 1888–1889, Prof. Herbert Weir Smyth of the classics department offered weekly a course on "the history of Greek sculpture from the earliest times to the Graeco-Roman period," to "post-major" and graduate students: *Annual Report of the President, Bryn Mawr College* (1888–1889), 15. This publication will henceforth be cited as *Bryn Mawr Annual Report*. For the academic year 1891–1892 a free elective course on the history of pre-classical, Greek, and Roman architecture and sculpture was given by the reader in the history of art, Dr. Agnes M. Wergeland: *Program, Bryn Mawr College* (1892), 66–67. For a detailed account of these and other events, see Machteld J. Mellink, "Bryn Mawr Archaeologists and the Near East," *Bryn Mawr Now*, XVII, no. 1 (Fall/Winter 1988), 12–15.

of art.[30] Carey Thomas herself had a non-Quaker aesthetic sensibility[31] and was in touch with the most advanced international aesthetic and art-historical circles of the day.[32] The person selected by the trustees for the lectureship was Richard Norton (1872–1918), son of Charles Eliot Norton.[33] Norton gave courses from 1896 to 1898 on the history of Greek and Italian art, elected by one-quarter of Bryn Mawr undergraduates. During the two years of Norton's lectureship, Thomas reports expenditures of over two thousand dollars for art books and photographs.[34] Norton designed cases for the photographs and a catalogue of them for the seminar room on the third floor of Taylor Hall (Fig. 116).

Norton's successor in 1898 was his close friend Dr. Joseph Clark Hoppin (1870–1925), trained at Harvard and at the University of Munich (Fig. 117).[35] During the five years of his leadership, the department—now called Classical Art and Archaeology—expanded and offered a wide variety of courses on the undergraduate and graduate levels.[36] Hoppin was sensitive to the problems facing female archaeologists, as indicated by the fellowship established by his family to overcome discrimination against women students at the American School of Classical Studies at Athens.[37]

The third phase in the department's development, from 1907 to 1910, began under the aegis of Caroline Louise Ransom, later Williams (1872–1952), a graduate of Mount Holyoke (A.B. 1896) and the second woman awarded a doctorate in archaeology, in 1905 from the University of Chicago (Fig. 118).[38] Ransom, an expert in the decorative arts of Egypt,

[30] Also announced at this time "was an elective course in Greek and Roman art open to all students of Greek and Latin, and of graduate courses in archaeology." *Bryn Mawr Annual Report* (as in note 29) (1894–1895), 11.

[31] On one level, she declared herself a Ruskinian. Thomas also had a love of theater and pageantry, which led her to support Bryn Mawr's elaborate May Day festival: Horowitz (as in note 5), 121. Horowitz discusses the lavish decoration of the Deanery, the president's residence, furnished at the expense of Thomas's wealthy companion, the philanthropist Mary Garrett: ibid., 130–133.

[32] Her first cousins were Mary Smith Costelloe (whose second husband was Bernard Berenson), Alys Pearsall Smith (the first wife of Bertrand Russell), and their brother, the writer Logan Pearsall Smith: ibid., 122.

[33] *Bryn Mawr Annual Report* (as in note 29) (1894–1895), 11.

[34] Funds for books and photographs for the department came from the trustees ($500), an anonymous donor ($1,300), and a gift by the graduate students in memory of the late president, Dr. Rhoads. "A friend of the college" supplied "a very large collection of Braun carbon photographs and an extensive collection of other photographs, including almost complete sets of French and English architectural monuments, and photographs of Egyptian and Japanese buildings and works of art." Thomas notes the need for a collection of casts like those of Cornell and Princeton: ibid., 12. In her report of 1898–1899, Thomas stated that $2,150 "was spent under the direction of Mr. Norton in equipping the department with books and photographs": ibid., 22. For further details of the Norton years, see Mellink (as in note 29), 14.

[35] For details of Hoppin's career, see *Dictionary of American Biography*, s.v.

[36] Hoppin specialized in Greek vase painting. He came to Bryn Mawr after teaching for a year at Wellesley. By 1904, the year when Hoppin resigned, the courses included twelve hours of lectures, eight hours of free electives, and four hours of graduate work. The subjects covered were the history of Greek art, elements of archaeology, Greek and Roman mythology, the Mycenaean age, classical topography and geography, and the private life of the Greeks. An archaeological "seminary" was offered to graduate students. *Program, Bryn Mawr College (1903–1904)*, 120–121.

[37] For further details, see Sherman (as in note 21), 35, 43, and 281. Carey Thomas was also instrumental in establishing separate living accommodations for women at the school: ibid., 32.

[38] *Bryn Mawr College Calendar* (1908), 13. Note that the title of the yearly catalogue of courses changed from *Program* to *Calendar*. For a short account of Williams's career, see "Class Notes," *Mount Holyoke Alumnae Quarterly* (Spring 1988),

taught many archaeology courses, including new subjects such as Greek and Roman industrial arts. She also added courses in the history of western art from the early Christian and medieval periods to the eighteenth century that were clearly differentiated from archaeology.[39] The widening of the Bryn Mawr curriculum may reflect a significant phase in the institutionalization of American art history, marked by the founding in 1906 of the American Association of Museums and, in 1911, of the College Art Association.

In her last year at Bryn Mawr, Ransom shared the directorship of the department with the Reader in English, Georgiana Goddard King.[40] King, a close friend of Carey Thomas, was a Bryn Mawr B.A. and M.A. who had no formal training in art history. In contrast to Ransom, her lack of formal training illustrates the heterogeneous background of her generation of art historians.

In 1912, Mary Hamilton Swindler (Fig. 119) joined the faculty.[41] Swindler (1884–1967) received her doctorate from Bryn Mawr in 1913. She exemplifies the highly respected woman scholar whose career unfolded at, and was limited to, affiliation with a woman's college. In 1914, together with Rhys Carpenter, she headed the Department of Classical Archaeology, which became a department separate from that of the history of art, which was directed by Georgiana Goddard King.

Conclusion

The emphasis on classical archaeology as a method of studying the visual arts at Bryn Mawr from 1885 to 1905 was consistent with the college's approach to women's education. Bryn Mawr's pioneering efforts on behalf of equal graduate education for women bore fruit in the women of the faculty who from 1905 to 1913 gradually assumed leadership positions in the teaching of archaeology and art history. Bryn Mawr graduates, the notable Hetty Goldman '03 for one, personified the new breed of independent, professionally trained women. Goldman (1881–1972) was one of a cluster of pioneering female archaeologists who delighted in the freedom and challenges posed by life in the field.[42]

49. I am grateful to Elaine D. Trehub, Mount Holyoke College Archivist, for making this and other biographical material available to me.

[39] *Program, Bryn Mawr College* (1907–1908), 133. In addition, Ransom taught Egyptian art in 1909–1910 and seventeenth- and eighteenth-century painting the next year. She also established the Archaeological Journal Club, in which "the graduate students and the instructor meet for the presentation and discussion of topics of current archaeological literature." Mellink (as in note 29), 14.

[40] King, who is listed as directing the department in 1911, added Gothic architecture and Italian Renaissance painting to the course offerings. For an informative and lively account of King's life and work, see the essay by Susanna Terrell Saunders, "Georgiana Goddard King (1871–1939): Educator and Pioneer in Medieval Spanish Art," in Sherman, ed. (as in note 21), 209–238.

[41] *Bryn Mawr College Calendar* (1912), 150. For a short biography, see Emily Vermeule and Sara Anderson Immerwahr, "Mary Hamilton Swindler," *Notable American Women, the Modern Period: A Biographical Dictionary*, ed. Barbara Sicherman and Carol Hurd Green, Cambridge, Mass. (1980), s.v.

[42] For a short biography, see Machteld J. Mellink, "Hetty Goldman," in Sichermann and Green, eds. (as in note 41), s.v.

At Wellesley College, the study of art formed an integral part of women's undergraduate education and cultural mission. An innovative museum-training course—the first in an American college—was introduced in 1911 by Alice Van Vechten Brown and her colleague Myrtilla Avery.[43] Avery (1868–1959), a Wellesley alumna, was one of the first women awarded a doctorate in art history (in 1927) from Radcliffe (Fig. 120).[44] When Paul Sachs (Fig. 37) started the famous museum-training courses at Harvard in 1921, he sought Avery's advice. Yet it is significant that, while the Wellesley course aimed at "the training of museum assistants," the Harvard program envisaged the instruction of future museum directors and curators.

Despite the excellent training and education of both Wellesley and Bryn Mawr alumnae, until recently few attained tenured positions or taught in graduate programs of male-dominated research institutions. While museums were more open to female professionals, studies have shown that women's professional advancement in mainstream museum departments, particularly of major art museums, did not progress to the same levels as men's.[45] Despite the large numbers of women art historians and archaeologists—or perhaps because of them—their standing continues the long tradition of being respected, but not equal.

[43] For details of this pioneer course, see Sherman (as in note 21), 48–49.
[44] For Avery's career, see ibid., 47–48; and for biographical notes, 445.
[45] Ibid., 53.

The Beginnings of Art History at Harvard and the "Fogg Method"*

SYBIL GORDON KANTOR

IT WAS James Ackerman who designated Charles Eliot Norton (Fig. 24) the father of art history in America.[1] In 1874, Norton, Harvard class of 1846, was invited by his cousin, President Charles William Eliot of Harvard, to teach a course created for his particular abilities as a Dante specialist. He was appointed "Lecturer on the History of the Fine Arts as Connected with Literature."[2] Like other early art historians important to the establishment of the discipline, Norton entered the academic world as a collector, an "amateur," and led the program in an object-oriented direction. Henry James, in a memorial tribute published in the *Burlington Magazine* in 1908, wrote about his close friend Norton, who had been his editor at the *North American Review*,[3] and his mentor and advisor in art matters. James described Shady Hill (Fig. 25), Norton's home in Cambridge, and characterized the American scene for his English readers:

> His so pleasant old hereditary home, with its ample acres and numerous spoils at a time when . . . spoils at all felicitously gathered, were rare in the United States . . . [reflected] an old society, or otherwise expressed, that "Europe" which was always, roundabout one The pilgrimage to the Shady Hill of those years had, among the "spoils," among pictures and books, drawings and medals, memories and relics and anecdotes . . . very much the effect of a sudden rise into a finer and clearer air and of a stop-gap against one's own coveted renewal of the more direct experience The main matter of his discourse offered itself just simply as the matter of *civilization*—the particular civilization that a young roaring and

* I dedicate this paper to Franklin Ludden, Professor Emeritus and former chairman of the Department of History of Art at the Ohio State University, whose "oral history" of his experiences at Harvard University contributed to the substance and tenor of this study.

[1] James S. Ackerman and Rhys Carpenter, *Art and Archeology*, Englewood Cliffs, New Jersey (1963), 187. Ackerman was professor in the Department of Fine Arts from 1960–1990 and chairman of the department from 1963–1968, and again from 1982–1984.

[2] Samuel Eliot Morison, ed., *The Development of Harvard University: Since the Inauguration of President Eliot 1869–1929*, Cambridge, Mass. (1930), 130. The chapter on the fine arts department was written by George H. Chase, who in 1925 was named Dean of the Graduate School, having served as the chairman of the department for fourteen years. Norton was made a Professor of the History of Art in 1875 and taught for twenty-three years.

[3] See Kermit Vanderbilt, *Charles Eliot Norton: Apostle of Culture*, Cambridge, Mass. (1959), 89. Norton served as editor of the *North American Review* from 1864 to 1868. He edited James's first published article.

money-getting democracy, inevitably but almost exclusively occupied with "business suc-
cess," most needed to have brought home to it.[4]

Norton attracted to Shady Hill some of the most important figures in the intellectual life of
America.[5] Together they extended the notion of "good taste" as a protection against the
crudeness of modern life in the New World.

By 1911, James's "old society" and "young money-getting democracy" had become fur-
ther polarized, in the view of Harvard philosopher George Santayana. Santayana saw the
part of the American mind involved with "invention" and "industry" leaping forward, a
product of a strong, aggressive "will." He saw the "intellect" part of the American mind—
involved with religion, literature and all the "higher emotions"—strongly emphasized to in-
sure a moral climate, in what he called "The Genteel Tradition."[6] Conflating what was
considered "good taste" and "morality," the phrase "Genteel Tradition" became famous and
ubiquitous; it came to dominate art-historical education. Norton did not relinquish his hold
on the imagination of Harvard students until the twenties when, as described below, modern-
ism found a voice in Cambridge. As the "machine" became the central motif in the art of the
pragmatic inventive world of the early twentieth century, the emphasis in the aesthetic ap-
proach changed to allow the "will" to supersede the "intellect."

Norton's importance to Harvard was that as an anglophile he kept in close contact with
John Ruskin (Fig. 26) and Thomas Carlyle, and had intellectual connections with John
Stuart Mill, Elizabeth and Robert Browning, Charles Dickens, Edward Burne-Jones, and
William Morris.[7] "This was the Norton," wrote his student Van Wyck Brooks, "who never
set foot in England without feeling that he was at last at home."[8] The Harvard tie to Euro-
pean culture, particularly British, was sustained by an imitation of their manners, their tradi-
tional education, and their appreciation of the arts.[9] Norton went to Europe from 1855–1857

[4] Henry James, "An American Art-Scholar: Charles Eliot Norton," *Burlington Magazine*, XIV (Dec. 12, 1908), 201–
204. Shady Hill was built in the early 1800s by the Wendell Phillips family. In 1821, it was presented to Catherine Eliot
Norton, bride of Andrew Norton, as a wedding present from him. Andrew Norton was the Dexter Professor of Sacred
Literature and Librarian of the Divinity School at Harvard. His son, Charles Eliot Norton, created the house as "an intel-
lectual center that became a byword for a gracious era in Cambridge life." When Norton died in 1908, Edward W. Forbes
occupied Shady Hill briefly, and in 1912 it was bought by Walter C. Arensberg '00, a classmate of Paul J. Sachs. Sachs
bought Shady Hill from Walter Arensberg in 1919 and lived there for thirty-four years. Sachs willed it to the university and
it was subsequently demolished. "Shady Hill," *Harvard Alumni Bulletin*, LVII, no. 3 (October 23, 1954), 106–107.

[5] The Cambridge circle alone included Ralph Waldo Emerson, Henry Wadsworth Longfellow, James Russell Lowell,
Louis Agassiz, Francis J. Child, and Oliver Wendell Holmes. See Priscilla Hiss and Roberta Fansler, *Research in Fine
Arts in the Colleges and Universities of the United States*, New York (1934), 20.

[6] George Santayana, *Winds of Doctrine: Studies in Contemporary Opinion*, New York (1913), 187f. The essay "The
Genteel Tradition in American Philosophy" was given as a lecture by Santayana in Berkeley, California, in 1911 and
printed in the *University of California Chronicle*, XIII, no. 4 (October 11, 1911).

[7] See Hiss and Fansler (as in note 5), 20.

[8] Van Wyck Brooks, *Scenes and Portraits: Memories of Childhood and Youth*, New York (1954), 103f.

[9] Harvard faculty and students alike, for example, Henry Adams, Van Wyck Brooks, and T. S. Eliot, were linked with
England until the twenties, when Paris became the center of intellectual life. See Henry F. May, *The End of American
Innocence: A Study of the First Years of Our Own Time 1912–1917*, New York (1959), passim. See also Warren I. Sus-
man's unpublished doctoral dissertation, a study of the movement of Americans sojourning in Europe during the years
1920–1934: "Pilgrimage to Paris: The Backgrounds of American Expatriation," University of Wisconsin, 1953. Susman

and again from 1868–1873, intent on the nineteenth-century notion of broadening his education. He studied the art and the documentary sources of the medieval churches in Italy, particularly the great cathedrals at Siena, Florence, and Venice.[10] He then traveled to Oxford and attended Ruskin's lectures on Italian art. Ruskin, already widely popular in America,[11] became Norton's devoted confidant and mentor. They shared common views on the intrinsic connection between art and life, based on the intense admiration they both had for the art of the Middle Ages and its guild system. But this connection, essential to the establishment of art history as a discipline, was focused by Ruskin and Norton, not on art in a quotidian, material sense, but on art as an expression of the moral life of a nation and on "the ethical and social implications of the Fine Arts."[12]

Norton had been encouraged by Ruskin to give a course in art history in America. At the time of his appointment, he wrote to Ruskin about his plans for his course "The Rise and Fall of the Arts in Athens and Venice." He wanted to show the similarities and the differences between the principles of the two Republics. With this method his lectures would demonstrate that:

> . . . there cannot be good poetry, or good painting, or good sculpture or architecture unless men have something to express which is the result of long training of soul and sense in the ways of high living and true thought.[13]

Norton was said to have lectured in the rhapsodic manner of his friend Ruskin, a personal style that drew crowds of students. He instilled enthusiasm for works of art in his students by his rhetoric alone, as no illustrations were available to him. Norton wrote to Ruskin " . . . all your books are on my table. After fitting up the skeleton of my lectures with the dry bones of German erudition, I come to you always to help me to clothe it with living flesh. I am never disappointed."[14] Edward W. Forbes, class of 1895, who became director of the Fogg Museum in 1909, took Norton's classical course in 1892–1893 and the medieval course in 1894–1895 with, he said, "profit and pleasure." Forbes also reported that Norton was dismayed at the popularity of his courses, for he feared that many attended because they considered them a "snap." But Forbes added "those who came to scoff stayed to pray."[15]

With few textbooks available in English, Norton expected his students to read Greek, German, French, and Italian. The catalogue for 1879–1880 announced "No student who is

(110) concentrates mainly on the American involvement in France, which he sees as "the end of the dominant Anglo-Saxon influence that occurred in much of American intellectual history in the nineteenth century."

[10] Charles Eliot Norton, *Notes of Travel and Study in Italy*, Boston (1859). Selections appeared in *Crayon*, III (March–December 1856).

[11] It was *Crayon* that was largely responsible for spreading Ruskin's ideas in America. See Roger B. Stein, *John Ruskin and Aesthetic Thought in America: 1840–1900*, Cambridge, Mass. (1967).

[12] Morison (as in note 2), 130.

[13] *Letters of Charles Eliot Norton*, with biographical comment by Sara Norton and M. A. DeWolfe Howe, 2 vols., Boston (1913), vol. II, 34 (letter of February 10, 1874).

[14] *The Correspondence of John Ruskin and Charles Eliot Norton*, ed. John Lewis Bradley and Ian Ousby, Cambridge (1987), 346 (Norton to Ruskin, October 30, 1874).

[15] Edward W. Forbes, "The Beginnings of the Art Department and of the Fogg Museum of Art at Harvard," *Cambridge Historical Society*, XXVII (1941), 16.

unable to use a German text-book will be admitted to Fine Arts 2 or 3." The students were expected to read the untranslated works of Edward Müller, Viollet-le-Duc, Franz von Reber, Karl Schnaase, and Jacob Burckhardt, among others.[16] The reliance on German text-books did not presuppose Norton's admiration of German "Wissenschaft" and German doctoral programs. On the contrary, he had no understanding or sympathy for either. Investigations in science and art history usually were conducted privately, by wealthy "amateurs" until the last quarter of the nineteenth century when, following the German example, they were established as disciplines at American universities. Norton felt that Germany, like America, was becoming too materialistic and practical by specializing in the sciences. He cautioned that to ignore the cultivation of the imagination through the study of the fine arts was to leave unfulfilled a pressing need in America, "for it is in the expression of its ideals by means of the arts that the position of a people in the advance of civilization is ultimately determined."[17] Norton's approach to art history—that is, using the imagination as the path to moral truth and beauty—differed from the practical point of view found in the few other colleges and universities in America that offered studies in art, such as Yale, Vassar, or Rochester.[18] Those colleges appended art history courses to studio curricula in painting or drawing.

But Norton, who imbued art with moral overtones in obeisance to Ruskin, did not neglect the technical aspects of art, also endorsed by Ruskin. Norton established from the very beginning that "the training of eye and hand is no less important than the training of memory,"[19] when he engaged the services of Charles Herbert Moore for the fine arts department at Harvard. Moore, appointed in 1871,[20] was the first Harvard instructor in free-hand drawing and water-color. He taught exclusively in the Lawrence Scientific School, on the Harvard campus, because drawing was generally considered a necessary component of scientific studies. The new department had a semi-official status: the catalogue for 1874 offered Fine Arts 1, "Principles of Design in Painting, Sculpture, and Architecture," by Moore; and Fine Arts 2, "History of Fine Arts and Their Relation to Literature," by Norton.[21] After this technical course was added to the syllabus, Moore, with an introduction from Norton, went to Venice in 1876 to study under Ruskin, the Slade Professor of Art, and later modeled his courses on

[16] Hiss and Fansler (as in note 5), 22.

[17] Charles Eliot Norton, "The Educational Value of the History of the Fine Arts," *Educational Review*, IX (April, 1895), 343–348. Forbes related that, though Norton could annoy the students with his "attacks on the crudeness of our civilization, they lived to feel that he gave them one of the great experiences of their lives—a lasting interest in art." Forbes (as in note 15), 16.

[18] See Hiss and Fansler (as in note 5), 17ff. See also other papers in the present volume.

[19] Morison (as in note 2), 131.

[20] George Chase, Arthur Pope, Chandler Post, "Faculty of Arts and Sciences," *Harvard Gazette* (1930). Charles Herbert Moore (1840–1930) was instructor in freehand drawing and watercolor, 1871–1879; instructor in drawing and principles of design, 1879–1891; assistant professor of design in fine arts, 1891–1896; professor of art, 1896–1909; curator of the Fogg Museum, 1895–1896; director, 1896–1909. He was introduced to medieval architecture by Ruskin. His most important piece of scholarship was *The Development and Character of Gothic Architecture*, London and New York (1890).

[21] The *Harvard Annual Report of the President for the Year 1877–1878*, 48–49, refers to "the regular appropriation annually made for the Fine Arts Department" during the years 1876–1877 and 1877–1878. This information was supplied by Agnes Mongan's assistant, Priscilla S. England, in the department of drawing, and by Phoebe Peebles of the Archives of the Fogg Art Museum.

Ruskin's book *Elements of Drawing*.[22] Like Ruskin, Moore required his students to make paintings and drawings themselves, duplicating the techniques of the old masters, so that they would understand the difficulties of making art. The course was called "Principles of Deline-ation, Color, and Chiaroscuro."

This insistence on studying the technical basis of the arts, as well as the fundamental principles of design, opened the way for an aesthetic structured on the analysis of formal elements of the visual arts, which would come to be known as the "Fogg Method." It func-tioned under the shadow of scientific inquiries, from which it borrowed its vocabulary and organization, despite Norton's emphasis on the moral earnestness of the Genteel Tradition. Norton followed Ruskin's responses to art as outlined in his book *The Stones of Venice* of 1851, where Ruskin adumbrated the formalist approach to aesthetics, writing that "the ar-rangement of colours and lines is an art analogous to the composition of music, and entirely independent of the representation of facts. Good colouring does not necessarily convey the image of anything but itself."[23]

The formative period of the department ended in 1898, when Norton retired. Since no replacement of the caliber of Norton could be found, President Eliot decided that "'the young fellows,' who were products of the department, should see what they could do."[24] This second generation included Denman W. Ross, class of 1875 (Fig. 27), who gave a course primarily for architectural students on the theory of design. When Moore retired in 1909, Ross was his replacement in the fine arts department. Ross, another significant collector, gave important works of oriental art to the Fogg Museum when it opened in 1895, as well as study material of drawings, paintings, textiles, prints, and photographs. Moore was appointed first as cura-tor of the museum and then director when the museum opened. It was at this time that the Division of the Fine Arts was housed at the Fogg. The pairing of the museum and the fine arts department was one of the crucial factors in the shaping of the "Fogg Method." It pro-moted a concern for museology and supported research that was directed towards the accu-mulation of documentation and the publication of catalogues by the faculty. Besides showing the collections of the Fogg (Fig. 29), it was an ongoing policy for the museum to mount other important collections and special exhibitions (Fig. 30). One of the earliest, in 1909, was a loan exhibition of Ruskin's drawings, in memory of Norton, with a catalogue written by Arthur Pope, class of 1900, a student of Ross.

Ross, along with Bernard Berenson, refined Norton's Ruskinian theories[25] and set the tone of connoisseurship known by the thirties as the "Harvard Method" or "Fogg Method."[26] It was a connoisseurship that was concerned directly with an examination of the "grammar"

[22] John Ruskin, *Elements of Drawing and Elements of Perspective*, New York (1907).

[23] John Ruskin, *The Stones of Venice*, 2 vols., London (1853), vol. II, 182.

[24] Morison (as in note 2), 136, passim. Much of the information about the second generation comes from this source.

[25] Ross, not oblivious to Norton's teachings, also visited Ruskin in Oxford in 1879. See Mary Ann Stankiewicz, "Form, Truth and Emotion: Transatlantic Influences on Formalist Aesthetics," *Journal of Art and Design Education*, VII, no. 1 (1988), 83f.

[26] The history of the development of connoisseurship at Harvard was imparted to the writer in a series of interviews in 1986–1987 with Franklin Ludden, a graduate of this method, Harvard B.A. '39, Ph.D. '56. See also the preliminary note above.

of objects. Ross devised a so-called scientific language of art to define, classify, and give order to the principles of design, which he published in his books *A Theory of Pure Design: Harmony, Balance, Rhythm*, of 1907, and *Drawing and Painting*, of 1911.[27] The method, whose influence was widespread, was based on formal analysis of the order and structure of a painting, including color and composition. Ross further developed a twelve-color system, using two-dimensional "constant-hue" triangles, to describe the values and intensities of individual colors. Darkness was plotted vertically, white to black, intensity along the horizontal. It has been suggested that Ross's concepts were an important theoretical source for Roger Fry's formalist approach to art.[28]

But Ross was against the inclusion of modern art at the Fogg. In his book *Painter's Palette*, of 1919, he explained the logic of his dissent:

> The rule is to study what interests you and to express what interests you Apart from interest and ideas, is the Art of Painting; with its materials, its modes, its methods, and its laws. The Art of Painting has been very slowly developed and established, by good precedents, and by the exercise of reason and common sense in connection with them. In ignoring or disregarding the Art so established; in using strange materials; in following unprecedented methods and modes; in disobeying the rules and laws of the Art; you are not expressing yourself in the Art but experimenting with it; perhaps with a view to changing it. That may or may not be worthwhile. In the meantime the Art of Painting is the same for all painters, for all artists. It is like the language we all use.[29]

Ross admired the painters of the Middle Ages and the Renaissance "who used carefully set palettes and definite tone relations." He felt threatened by modern painters who, he said, "were mistakenly depending on visual feeling or native genius There is no getting on properly and successfully in any art without metrical systems and modes, in which it is possible to think definitely and to express oneself in what will be recognized as good form."[30] Matisse, in this system, would be considered by Ross to be an intuitive painter who broke all the rules.

Arthur Pope (Fig. 33) expanded Ross's theories of technical methods in books that included *Tone Relations in Painting*, of 1922, and *An Introduction to the Language of Drawing and Painting*, of 1929–1931.[31] Pope, who also claimed his theories were indebted to Ruskin, in 1909 extrapolated Ross's system of triangles of color into a three-dimensional

[27] Denman W. Ross, *A Theory of Pure Design: Harmony, Balance, Rhythm*, Boston (1907), repr. New York (1933). Idem, *On Drawing and Painting*, Boston (1912), repr. New York (1971).

[28] Stankiewicz (as in note 25), 81–95.

[29] Denman Ross, *The Painter's Palette; A Theory of Tone Relations, an Instrument of Expression*, Boston (1919), 39.

[30] Ibid., 41.

[31] Pope published books that supplemented, and were inspired by, his teacher Ross's theories of technical methods: *Tone Relations in Painting*, Cambridge, Mass. (1922), which subsequently became the first volume of the two-volume treatise *An Introduction to the Language of Drawing and Painting*, Cambridge, Mass. (1929–1931); and *Art, Artist, and Layman*, Cambridge, Mass. (1937). His scientific enquiry was further explicated in "A Quantitative Theory of Aesthetic Values," *Art Studies*, III (1925), 133–139. Pope also wrote the *Catalogue of the Ruskin Exhibition in Memory of C. E. Norton*, 1909–1910 and a catalogue for *A Loan Exhibition of Paintings and Drawings by H. G. E. Degas*, which he curated for the Fogg in 1911 and which Sachs deemed the earliest show of the artist's works in the United States. Pope wrote a catalogue for the exhibition *George C. Bingham, The Missouri Artist*, for the Museum of Modern Art, January 30–March 7, 1935.

wooden cone. This organized the hue, value, and intensity of colors and plotted them in an absolute relationship with an axis that went from white to black, with each color extending to 100% intensity at the perimeter of the solid.[32] Pope also developed another course on techniques called "General Theory of Representation and Design," covering the principles of drawing. Pope, an artist himself, led his students through a practicum of drawing and painting, not to increase artistic abilities, but to intensify the experience of seeing and understanding the work of art as a connoisseur.

Along with the medievalism that fascinated the collective Harvard intellect was an older art-historical passion, the Renaissance. Bernard Berenson permanently fixed this style in Boston when he helped form the art collection of Isabella Stewart Gardner. According to Van Wyck Brooks, class of 1910, the Gardener Museum "filled the Harvard mind with images that cropped out in scores of novels and poems—in [T. S.] Eliot's phrase about Umbrian painters, for instance."[33] Berenson (Fig. 103) was the first Harvard critic who gained a prominent international reputation. He had graduated from Harvard in 1887, where he studied literature and came under the influence of Norton, who had taught Renaissance art in addition to medieval art. Although Berenson paid homage to Ruskin, he turned away from Norton's moral tone and made a reading of Walter Pater the basis for his own aestheticism and a cult for Harvard students for the next two decades. Norton, on the other hand, who read Pater's *Studies in the History of the Renaissance* on Berenson's recommendation, returned the book, reportedly saying that "it was only fit to be read in the bathroom." That apocryphal statement might also have been, "My dear boy, it won't do."[34] Berenson's reputation, made partly on the lists of pictures that he considered authentic, is well known. Using his keen visual memory for works of art, as well as photographs, Berenson sought the "personality of the artist."[35] Focusing like Giovanni Morelli on the idiosyncratic "handwriting" of the details of the works, he based his attributions in part upon these minute features of the artist's style. Berenson's interest, too, was more in elucidating the forms of art rather than in interpreting the works within an historical context, as was favored by German theorists.

Although Harvard and Princeton began their programs in art history within a decade of each other, there was a sharp contrast from the beginning between the investigative historical and iconographical approach at Princeton and the hands-on exploration of styles and technical processes at Harvard.

Edward W. Forbes, class of 1895, was one more collector important to Harvard (Figs. 32 and 33). In 1909 he succeeded his teacher, Moore, who had been the founding director of the Fogg Museum. Forbes, with no room at home to hang his collection, started in 1899 to deposit at the museum, on indefinite loan, many works of Italian painting from the ducento to

[32] See Janet Cox, "Color in Art," *Harvard Magazine*, LXXVI, no. 10 (June 1974), 29–39.

[33] Brooks (as in note 8), 114.

[34] David Alan Brown, *Berenson and the Connoisseurship of Italian Painting*, Washington, D.C., National Gallery of Art (1979), 38f. Ernest Samuels, *Bernard Berenson: The Making of a Connoisseur*, Cambridge, Mass. (1979), 37, attributed a similar remark "I don't like the book. It makes me feel as if I were sitting in a bath," to William James, and the comment of Norton to Berenson to be "My dear boy, it won't do."

[35] See Ackerman (as in note 2), 204ff., and Michael Rinehart, "Bernard Berenson," in the present volume.

the quattrocento, as well as examples of classical sculpture (Fig. 31).[36] Forbes placed the original work of art at the center of the education of the Harvard student by replacing the Fogg's collection of reproductions and casts with his own collection of Italian paintings. The casts were relegated to the basement. By becoming director, he was able to be near his collection.

A practicing artist, Forbes reactivated Moore's program in 1915 in a course called "Methods and Process of Italian Painting." It required not only that the students replicate oil paintings, frescoes, and tempera panels in the Renaissance manner, but that they prepare their own plaster, their own gesso, and lay on their own gold leaf. It came to be known as "the egg and plaster course" (Fig. 32).[37] Forbes also established at the Fogg one of the first conservation laboratories; it serviced an international art world and further strengthened the Fogg notion of art as process. The flourth-floor conservation laboratory is still decorated with a fresco after Signorelli, the only fresco still extant from Forbes's classes. By 1927, the new Fogg building was rededicated as "a laboratory of the Fine Arts,"[38] and Pope and Ross, as well as Forbes, gained for Harvard a reputation of focusing on the work of art as a physical object.[39] This second generation, not trained specifically as art historians, introduced technical, philological, and archaeological methods as a counterpoint to the moral and aesthetic values of the Ruskin-Norton-Berenson era.

Among the professors of the second generation (Fig. 33) who contributed an archaeological approach to the Harvard method and continued the strong documentary interest in medieval studies and architecture that Norton inaugurated were George Chase, Martin Mower, Chandler R. Post, George H. Edgell, Kenneth J. Conant and A. Kingsley Porter. All had doctoral degrees from Harvard, except Porter, who had simply B.A. and B.F.A. degrees from Yale. They were the teachers of the generation of the twenties.

George H. Chase (Fig. 33), class of 1896, received his doctorate in classical studies in 1900 and became an instructor in Greek literature. In 1902–1903 he offered a course on "The Topography and Monuments of Athens," and in the next year a course on "The History of Greek Vase Painting." He was made Professor of Classical Archaeology in 1906, and in 1909 was appointed chairman of the Department of Fine Arts, a post he held until 1925, when he was made Dean of Graduate Studies. This was the route commonly taken by many professors in the early years of the century when departments of art history were formed.

[36] Forbes (as in note 15), 18f.

[37] Author's interview with Agnes Mongan, 1986.

[38] "The New Fogg Art Museum," *Harvard Alumni Bulletin*, Cambridge, XXIX, no. 35 (1927), 1005. This article was unsigned, but it is generally considered to have been written by Forbes and Sachs.

[39] In November 1944 an exhibition was arranged at the Fogg of paintings and drawings of the faculty of the Department of Fine Arts, starting with Moore's watercolors painted under Ruskin's direction in Venice, and including works by Ross, Forbes, Pope, Paul J. Sachs, and Martin Mower, an artist who shared teaching assignments with Pope. Also included were works by professors from the next generation who were graduates of the process: Kenneth J. Conant, Benjamin Rowland, James Carpenter, and Eric Schroeder. The works of art were demonstrations of the experimental, technical tradition that prevailed at Harvard from the beginning to teach the principles of design: "they have felt that actual practice is almost indispensable as an aid to study and teaching It is felt that a student with such a foundation has a basis for understanding and judgment of the quality of works of art that can be acquired in no other way." Margaret E. Gilman, "Studies in the Art of Drawing and Painting," *Bulletin of the Fogg Museum of Art*, x, no. 3 (March 1945), 74–80 (esp. 75 and 79).

Professors were enlisted from departments of languages and classical archaeology to teach art history, without the benefit of advanced degrees in the fine arts. This phenomenon explains the firm hold that classical scholarship had in fine arts departments until the mid-twentieth century.

The Harvard catalogue of 1903–1904 illustrates the interdisciplinary character of studies in the fine arts department. Related subjects from other departments were listed under the fine arts department, such as "The History of Architecture and Landscape Architecture," (given for the first time in 1900–1901 by Frederick Law Olmsted, class of 1894), Santayana's aesthetics, anthropology, and classical archaeology, as well as "The Life of the Greeks and Romans," "German Religious Sculpture," and "French Life in the Seventeenth and Eighteenth Centuries."

Martin Mower (Fig. 33), class of 1894, an artist who had been Moore's assistant for several years, shared the course on the principles of drawing and painting with Pope in 1909. It was in 1909, when Moore retired, that a general expansion of the department took place. Mower had started by teaching architectural students; he then became a lecturer in the fine arts department. In 1927 an exhibition of his oil paintings was installed at the Fogg. His paintings are now in the Isabella Stewart Gardner Museum.[40]

Pope gave the first specialized course in Italian painting with Chandler R. Post in 1909. Post, whose 1905 doctorate was in romance languages, functioned in three departments at Harvard: romance languages, Greek literature, and fine arts. In 1919, a whisper of modernism was heard when Post gave a course in Modern Sculpture. Post's course was especially popular with students, and we can conjecture—given his interest in the new art of film—that it was because he had something of a contemporary outlook.[41] His linguistic abilities and passion for detail place him, however, in the objective rather than the theoretical camp. Post published a history of Spanish painting in twelve volumes, from the Romanesque period to the sixteenth century, which stands as an example of factual research.[42]

George Edgell (Fig. 33), class of 1909, wrote his doctoral dissertation in 1913 on "The Development of the Architectural Background in the Painting of the Umbrian Renaissance." With Fiske Kimball, Edgell wrote *A History of Architecture*, published in 1918.[43] He became head of the Department of Architecture in 1922. But he had begun in 1909, as a graduate student, by taking over Moore's old courses on the Middle Ages and the Renaissance as well as "The History and Principles of Engraving" with Francis G. Fitzpatrick '01. Edgell

[40] Mower was an advisor to Lincoln Kirstein's undergraduate literary success, *Hound & Horn*. Kirstein named Mower as one of the leading influences in his life. See below in this article.

[41] Chandler Post, in his book *A History of European and American Sculpture from the Early Christian Period to the Present Day*, Cambridge, Mass. (1921), reveals a limited understanding of modernism. The book ends with a description of what he calls "Post-Impressionist sculpture," covering such artists as Brancusi, Archipenko, and Boccioni. His hedging comment is: "Since the substance of Post-Impressionistic productions is very far removed from the sphere of ordinary experience, is not the effect upon the spectator so unrelated that he will fail to absorb adequately the emotional or aesthetic result desired by the artist?" (ibid., 268).

[42] Chandler R. Post, *A History of Spanish Painting*, 12 volumes, Cambridge, Mass. (1930–1966).

[43] George Harold Edgell and Fiske Kimball, *A History of Architecture*, New York and London (1918).

continued teaching in both the Department of Fine Arts and the Department of Architecture.[44] Eventually he became director of Boston's Museum of Fine Arts.

Members of this generation of scholars acquired a reputation for seeking and documenting works of art in uncharted places. Arthur Kingsley Porter (Figs. 34 and 35), who graduated from Yale in 1904 and attended Columbia University as a graduate student, traveled continually. Thanks to his *Medieval Architecture: Its Origins and Development*, of 1909, *Lombard and Gothic Vaults*, of 1911, and *Lombard Architecture*, in three volumes, of 1915,[45] his reputation obviated the need for a doctoral degree. He taught at Yale from 1915–1919 and was brought to Harvard as a research scholar in 1920, teaching one course a semester. Porter, an incessant photographer, traveled through Europe photographing the sculptural decorations of churches. His method may be compared with Berenson's empiricist connoisseurship: in the face of existing accounts, he created a new chronology based on comparisons of the formal qualities of sculpture in his photographic evidence. A major work was his *Romanesque Sculpture of the Pilgrimage Roads*, of 1923,[46] consisting of one volume of text and nine of photographic plates. Through his method, attention was concentrated on objects themselves, with a fastidious attention to details and facts. Porter amassed a collection of photographs, some 40,000—his own and others—and these he gave to Harvard.

Kenneth Conant (Fig. 33) became a member of the department in 1920, the first graduate who was a product of the teaching methods of the second generation. He received his B.A. in 1915 and his Ph.D. in 1925, with a dissertation on "The Early Architectural History of the Cathedral of Santiago de Compostela," which was published as a monograph.[47] We can conjecture that his advisor was Porter. Documentary scholarship in architectural history, instituted by Norton, was a major occupation of the department.

Paul Sachs (Fig. 37), class of 1900, also became part of the second generation of art historians in 1915, when Forbes invited him to be his assistant at the Fogg Museum.[48] He trained a group of students in the twenties and thirties who staffed most of the newly built museums in America.[49] Like Berenson, Sachs helped form the collections and taste of many Americans. In his teaching methods, Sachs used Berenson's techniques of concentrating on the object to develop a visual memory, of relying on photographs for comparison. He was concerned with tracing scientific documentation, and he made a point of encouraging future

[44] Edgell's work on the history of painting is exemplified by his once well-known book, *A History of Sienese Painting*, New York (1932).

[45] A. Kingsley Porter, *Medieval Architecture: Its Origins and Development*, New York (1909); *The Construction of Lombard and Gothic Vaults*, New Haven (1911); and *Lombard Architecture*, 3 vols., New Haven (1915). For much on Porter, see the contribution by Linda Seidel in the present volume.

[46] A. Kingsley Porter, *Romanesque Sculpture of the Pilgrimage Roads*, Boston (1923).

[47] Kenneth John Conant, *The Early Architectural History of Santiago de Compostela*, Cambridge, Mass. (1926).

[48] Sachs served in a double role of teacher and associate museum director. In 1927, he was made a full professor, and in 1933 he became chairman of the Department of Fine Arts. He was associate director of the museum from 1924 until 1945, at which time Sachs and Forbes retired together. *Memorial Exhibition: Works of Art from the Collection of Paul J. Sachs*, exh. cat., Fogg Art Museum, Cambridge, Mass. (1966).

[49] In twenty-seven years of teaching his museum course, from 1921–1947, he had 388 students. He placed 160 students in 85 of the 100 best-known museums in the land: 42 were directors, assistant directors, and administrators, 45 were curators; and the rest were docents and librarians. See the essays on Harvard in Part 1 of this volume.

benefactors who needed assistance. Sachs was a financier and an "amateur" of prints and drawings who brought a specialized knowledge to his second career at Harvard. From 1915 to 1953 Sachs occupied Shady Hill with his own "spoils" of European art. Forbes and Sachs, known as the "heavenly twins," incorporated what had been private rituals of the "Genteel Tradition" into the academic system. These customs had been enjoyed only by men of wealth who could travel extensively and collect stores of information from dealers in order to enhance their collections. Sachs built the collections of the Fogg with gifts from other professors and from his own collection, but also from his wealthy friends, with whom he maintained close relationships, and, in a self-perpetuating system, from his former students who, under his inspiration, had developed into collectors. Through the years, he gave courses in the history of prints and acquired examples of various European schools to show his students.

Sachs's guiding principle was, as he wrote, that "every distinguished collection is . . . a work of art in itself, revealing qualities of proportion and harmony which spring from a controlling idea; a true collection manifests a sense of design."[50] His contacts with dealers, museum administrators, and other collectors in the art and book worlds (which overlapped) were cultivated and developed for both present and future use. He evolved, over many years, what would now be called an "old boy" network and used it as a resource for the neophyte museum directors in his class. The method was to engage the students in the further creation of this resource, as they wrote articles for publications or mounted exhibitions at the Fogg, many of which showed works loaned by Sachs's associates and Harvard alumni who had already passed through the Sachs method. Sent forth to Europe with dozens of introductory letters (it wasn't unusual for a student to be clutching over one-hundred such letters and cards), students were expected to add detailed information about conditions in the art world, country by country, to the lists of names and addresses, books, collections, paintings, galleries, etc., that Sachs had accumulated.

The teaching process in his museum course was, Sachs wrote, "centered on the close observation of the object; and the careful recording of that observation." Some of his former students have told me that, faced by a table full of objects, some junk, some important works of art, they had to assess each object, its probable origin, its meaning, and the state of its conservation, citing a comparable object and bibliographical data (Fig. 38).[51] The students also made frequent visits to local museums, at times accompanied by Sachs, where they would be required to choose "the best painting" in the gallery or memorize the works of art in the order they were hung on the walls. Sachs's teachings systematized museum ethics and practices, creating a professional self-consciousness in the process. His aim was to produce generations of students who would become collectors, and curators who also would be

[50] Paul J. Sachs, "Tales of an Epoch," unpublished typescript completed in 1958, Paul J. Sachs Archives, Fogg Art Museum. Sachs was quoting W. G. Constable, an Englishman who was first the assistant director of the National Gallery in London, and in 1930 became director of the Courtauld Institute. In 1940 he was appointed the curator of painting at the Boston Museum of Fine Arts. He lectured to the students in the museum course. The archives include a vast correspondence that Sachs maintained, with what seems like every player in the art world, for the years between the teens and the sixties, when he died. Unless otherwise noted, the material on Sachs comes from this source.

[51] Among those interviewed were Agnes Mongan, Milton W. Brown, Beaumont Newhall, Henry-Russell Hitchcock, as well as Franklin Ludden.

scholars. He explicitly charged the curator with the responsibility of being a connoisseur who knows by his senses. He defined "sensibilité" as a combination of knowledge, senses, and instinct. Besides books and photographs, "[one] must also, each day, study originals." Sachs explained that the connoisseur, before the introduction of art history into universities, developed knowledge "by traveling, collecting, by comparison of works of art, by combining visual experience with the knowledge of literary sources, laying the foundation for the art historian." Sachs, of course, was talking about himself. He cited Berenson as "combining instinct, *sensibilité*, with solid scholarship. Something more than connoisseurship has developed within the last fifty years."

Sachs was here coming to grips with the fact that the connoisseur had moved into the academic environment, where he studied art as if it were a scientific discipline, in contrast to the nineteenth century when, as part of the "Genteel Tradition," he would approach the study of art for its moral utility. Sachs's unmistakable passion in his approach to all forms of art—an attitude that put him in Berenson's rather than Norton's camp—mitigated his Harvard-bred sense of "good taste." His longtime correspondent Berenson wrote to him:

> Your training is sensible It will not be if you should ever take into your midst spellbinders whose main tendency might be to turn art into literature, riding over the infinitely painful learning of form as pure form and feeding students with information utterly irrelevant to the real problems of art.[52]

This may be a direct cut at Norton's literary method, but it must be viewed as the establishment of parameters for a newly formed art history program and is fascinating to look back to now.

By the mid-twenties the educative mold at Harvard had barely changed its shape. In a memoir, Lincoln Kirstein (Fig. 40) described the Harvard atmosphere: "To be sure I was a 'brilliant' Harvard Sophomore equipped with perfect taste. I took a course in the attribution of quattrocento Italian panel paintings according to the gospel of Bernard Berenson."[53] More importantly, it was Ruskin's aesthetic stance, which, when dispossessed of its moral content, validated art as an extension of all experience, that had its impact on Kirstein's generation. Kirstein wrote of his attitudes at the time:

> The memory of Norton had a great influence on Harvard through Norton's advocacy of John Ruskin who was a guiding and abiding influence in the development of my visual taste and in liberation from received ideas about art. Directly from Ruskin would develop, burgeon, and then rot my interest in most of contemporary art.[54]

Kirstein could call on the same sensibilities of an artist *manqué* that Ruskin revealed in his writings, a peculiar blend of the visual and verbal that makes of the aesthetic response an

[52] Quoted in "Tales of an Epoch," (as in note 50), 368f.

[53] Lincoln Kirstein, "Loomis: A Memoir," *Raritan*, II, no. 1 (Summer 1982), 5–40, the quotation on 20.

[54] Lincoln Kirstein, "A Memoir: The Education," *Raritan*, II, no. 3 (Winter 1983), 27–65, the quotation on 43. See also Warburg's and Coolidge's "glimpses" of Harvard in Part 1 of the present volume.

equally creative work. Kirstein's mission, like Ruskin's, was to infect a larger public with his own reverence for art.

Kirstein and a coterie of Harvard students followed earlier generations of students by finishing their education in Europe. There they assimilated the spirit of modernism and on returning to America penetrated the bulwarks of conservatism. Kirstein and his friends, without any material guidance from their professors, drawing on the energies of the emerging twentieth century, became part of the legacy of modern culture.

As with many of his contemporaries, Kirstein's interests in artistic life were multifarious. A dilettante, when the word still had merit, he was interested in the broadly based concept of culture nourished by literature, history, photography, radio, dance, and films, as well as painting, sculpture, and architecture. He shared these interests with a circle of students around Sachs who had taken his museum course in 1927.[55] Though still elitist in aim and manner, the students rebelled against the tradition of gentility at Harvard in the twenties. The concept of elitism, though it shifted in the decades after the twenties to a more pejorative meaning, was a fully self-conscious position at the time, concerned with maintaining the standards of a culture that was hard won. With the help of other students, such as Alfred H. Barr, Jr., Jere Abbott, Philip Johnson, Henry-Russell Hitchcock, Edward Warburg and John Walker III,[56] Kirstein pushed modernism through the gates of Harvard.

In 1927, when he was a sophomore, Kirstein founded the *Hound & Horn*, a campus publication that found its place among the most respected of the period's radical "little magazines." In its pages, edited by Kirstein for seven years, a modernist criticism emerged which would soon be labeled the "New Criticism."[57] Kirstein claimed: "I feel the *Hound & Horn* has a definite function to fill, which generally speaking, is to provide as good technical criticism, for intelligent laymen as possible, with the minimum of rhetoric and rhapsody."[58] In 1928, with fellow undergraduates Warburg and Walker, Kirstein co-founded the Harvard Society for Contemporary Art "in an effort," he wrote, "parallel and comparable to the

[55] The first class, a half-year course, was offered in 1922 and had one student, Arthur McComb. After a one-year hiatus, 1924–1925 saw five students enrolled in the course. Sachs's reputation was spreading; and in the pivotal year 1926–1927, when it was offered again, there was a surge of interest in the course, with over thirty attending. Alfred Barr was listed as attending the course, but he no longer was registered as a graduate student, and it doesn't appear on his record. He attended several sessions of the course. Among those listed in the museum course in 1926–1927 were Henry-Russell Hitchcock and Jere Abbott. John Walker and Agnes Mongan took the course in 1928–1929, and Beaumont Newhall attended in 1930–1931.

[56] These students, of course, went on to establish ground-breaking institutions in the history of modernism in the United States, notably when Sachs recommended Barr as the first director of the Museum of Modern Art and Jere Abbott became his assistant. Barr never wrote a thesis for his doctorate, but subsequently Harvard accepted his 1946 book *Picasso: Fifty Years of His Art*, as a doctoral thesis and awarded him his degree. Hitchcock went on to a distinguished career in modern architecture, but his proposal for a thesis on the architecture of Henry Hobson Richardson was refused by A. Kingsley Porter as an improper subject for a Ph.D. Philip Johnson, after serving as the unpaid director of the Department of Architecture at the Museum of Modern Art, returned to Harvard, where he obtained his graduate degree in architecture in 1943.

[57] Among the co-editors who shared Kirstein's job were Varian Fry, Richard Blackmur, Bernard Bandler, Alan Tate, and Ivor Winters.

[58] *The Hound & Horn Letters*, ed. Mitzi Berger Hamovitch, foreword by Lincoln Kirstein, Athens, Georgia (1982), 16 (Kirstein, letter to Roger Sessions, June, 1931).

magazine."[59] They brought the latest in modern art to the campus, including one of the first exhibitions in America of the art of the Bauhaus, in 1931.[60] They also mounted one of the earliest one-man shows by Alexander Calder, which included his *Circus*, fabricated on the spot. These were only two exhibitions among many that indicate the leadership of those students in shaping the taste of modern America.

In 1929, Sachs, who supported the students but could not commit the Fogg Museum to a program of avant-garde art, arranged an exhibition of modern French painting from the nineteenth and twentieth centuries (Fig. 30).[61] Simultaneously, at the Coop, Kirstein and his friends showed the School of Paris of the preceding twenty years: those artists who had not been covered by the Fogg show, such as Modigliani, Man Ray, Guy de Ségonzac, Rouault, Soutine, and some post-impressionists and cubists, including the painters Laurencin, Braque, de la Fresnaye, Gris, Léger, Lhote, Lurçat, Marcoussis, Metzinger, and Vlaminck.

The line between Norton and succeeding generations remained unbroken. His legacy included the preference for employing the principles of design as a basis for aesthetic judgments. This connoisseurship, although it started with Norton's transcendental morality and excessively personal responses to art, and with Berenson's aestheticism, became more rational, more scientifically inclined, and more object-oriented with the advent of the second generation of professors. The "good taste" of the genteel tradition had given way to a connoisseur's empiricism—a formalist strategy that would become known as the "Fogg Method." In this setting, then, emerged the students' concern with modern art.

[59] Ibid., xiv. See also Nicholas F. Weber, *Patron Saints. Five Rebels who Opened America to a New Art 1928–1943*, New York (1992).

[60] Philip Johnson was in Germany gathering material for an architectural exhibition for the newly established Museum of Modern Art. He brought back material from the Bauhaus which he lent to Kirstein for one of the first "comprehensive" exhibitions of the German school mounted in the United States, seven years before the profoundly influential one at the Museum of Modern Art. Barr and Jere Abbott lent the material that they had collected at the Bauhaus in 1927.

[61] *Exhibition of French Painting of the Nineteenth and Twentieth Centuries, March 6–April 6, 1929*, foreword by Arthur Pope, Cambridge, Mass. (1929). Although Sachs acquired works by Picasso, they were from the more conservative "blue period" of the artist's *oeuvre*.

Formulating Art History at Princeton and the "Humanistic Laboratory"

DAVID VAN ZANTEN

THE STUDY of art history on the graduate level, introduced in America around 1900, claimed to be a uniquely scientific form of higher humanistic scholarship because of its precise techniques for reading mute cultural remains. It was thus proclaimed, at least at Princeton during the 1920s, to constitute a fourth branch of the humanities next to philosophy, history, and literature.

I am not referring here to the emergence of single chairs in art history, like that of Charles Eliot Norton at Harvard in 1874, but rather to the formulation of whole graduate programs. Initially, these programs were for individuals, as in the case of the doctoral degrees awarded to the archaeologists David Robinson by the University of Chicago, and T. Leslie Shear by the Johns Hopkins University, both in 1904. Then came departmental programs, as at Princeton after 1905. Likewise, I am not referring to general courses in art history, where the well-turned phrase and the passionately held sentiment prevailed, in the style of Ruskin or Norton. On the contrary, I am concerned with the essentially archaeological method of making physical objects yield up their meaning to dispassionate scientific examination.

I

The basic facts of the evolution of Princeton's Department of Art and Archaeology have been summarized by Marilyn Lavin in her history.[1] In 1882, Allan Marquand (Figs. 1 and 6), son of the New York banker, scholar, and amateur Henry Marquand, was named professor of the history of art within the philosophy department, where he had been an instructor in 1881. In that same year, university patrons William Cowper Prime and General George McClellan proposed a university museum with an unpaid professor serving as curator, backing their

[1] Marilyn Aronberg Lavin, *The Eye of the Tiger, The Founding and Development of the Department of Art and Archaeology, 1883–1923, Princeton University*, Princeton (1983). The Department is chronicled in the *Bulletin of the Department of Art and Archaeology of Princeton University* and in the *Princeton Alumni Weekly*. I have discussed some details of this subject in "'The Princeton System' and the Founding of the School of Architecture, 1915–1921," in *The Architecture of Robert Venturi*, ed. Christopher Mead, Albuquerque (1989), 34–44.

proposition with funds and the promise of the Prime pottery and porcelain collection. The first section of that building, designed by A. Page Brown, opened in 1889 (Fig. 3). In 1886, Arthur Frothingham was hired as Associate Professor of Archaeology. From its founding in 1885 to 1895 he was editor of the *American Journal of Archaeology*. An initial effort to locate a site for archaeological exploration had failed with Marquand's falling ill in Sicily in 1883, but in 1895 his student, Howard Crosby Butler (Fig. 2), was added to the staff, replacing Frothingham. In 1889, Butler led an expedition to study Late Roman sites in Syria, followed by other Syrian expeditions in 1904 and 1909, then by the full-scale excavation of Sardis in Turkey in 1910–1914.[2]

In 1905, the department came into its own; it was cut loose from the philosophy department and reorganized as the Department of Art and Archaeology. A more extensive staff was hired: Oliver Tonks (Fig. 57) in 1905 (Ph.D. Harvard, 1903), Charles Rufus Morey (Figs. 5 and 9) in 1906 (A.M. Michigan, 1900), Frank Jewett Mather, Jr. (Fig. 4) in 1911 (Ph.D. Johns Hopkins, 1892), George Wicker Elderkin in 1912 (Ph.D. Johns Hopkins, 1906), and Earl Baldwin Smith (Fig. 7) in 1916 (Ph.D. Princeton, 1916).[3] In 1917 Morey (Fig. 5) founded the Index of Christian Art. In 1919 the School of Architecture was inaugurated as a "section" of the department, with Butler as its director and soon with four of his students as professors—Earl Baldwin Smith, Richard Stillwell, George Forsyth, and Donald Drew Egbert. After Butler's unexpected death in 1922, Jean Labatut arrived in 1928 as chief design critic, altering Butler's idea of rotating design critics.

The department's physical manifestation was now defined. From at least 1908, extensions to Brown's museum building were projected to house the department. In 1917–1923 Butler and the university architect, Ralph Adams Cram, projected and erected an architecture school, McCormick Hall (Figs. 11–13), at one side of the museum building. It proved inadequate, so that new architecture studios were erected behind the museum in 1927–1928, and the architecture school was appropriated as the home of the department. By the Depression, the department had eighteen teaching staff (including five design instructors) and was poised to embark on several major archaeological projects—primarily the excavation of Antioch—as well as push forward the Index of Christian Art at a cost of $160,000. The department had its own building, albeit the one cast off by the architecture school. There Charles Rufus Morey—chairman from 1925–1945—created what he called a "humanistic laboratory." It was as large and active as the history, philosophy, or English departments and indeed constituted a fourth branch of the humane studies at Princeton University.

II

Three important concepts were projected during the early years of the department: Morey's Index of Christian Art of 1917, the most enduring; Prime, McClelland, and Marquand's

[2] On Butler, see V. Lansing Collins, ed., *Howard Crosby Butler, 1872–1922*, Princeton (1923), with a complete bibliography of his publications.

[3] On Morey, see Craig Smyth's essays in this volume. On Mather, see H. Wayne Morgan, *Keepers of Culture: The Art-Thought of Kenyon Cox, Royal Cortissoz, and Frank Jewett Mather, Jr.*, Kent, Ohio (1989).

"Museum of Historic Art," opened in 1889, the most tentative; and Butler's archaeological explorations of 1899–1914, concrete, but not so conceptually cosmic, as the Index.

1. The Index of Christian Art is a photo archive embracing all works of art of Christian subject matter produced over a span of 1400 years, catalogued by subject and organized by medium and location, rather than by style, school, or date.[4] By 1941 it occupied the south end of the third floor of McCormick Hall and employed a staff of eight. Technically, it was simple, requiring only the modern technology of photography—but applied to all the art collections of the world—and a certain amount of time and money. It was also illuminating, permitting scholars to follow iconographic configurations over the length of the medieval period. The first telling product was Earl Baldwin Smith's *Early Christian Iconography and a School of Ivory Carvers in Provence*, his Princeton dissertation of 1916, published in the Princeton Monographs in Art and Archaeology series in 1918, complete with fold-out iconographic tables. This was an attempt to map Early Christian ivories by means of iconography rather than style, since style had proven equivocal while iconography reflected "indigenous customs, local liturgies, distinctive ceremonies and special apocryphal gospels." The result, Smith concluded, is that the ivories, when quantified by iconography, fall into groups; these groups coalesce around certain primary models that can be precisely localized; and finally an important school in Provence emerges.

As a card system, the Index was reminiscent of those pre-computer statistical systems perfected around 1910 in the dawning age of American economic and scientific quantification, for example, the celebrated card systems created to categorize the skills of army draftees during World War I, overseen by James B. Angell, soon to be president of Yale, and the son of Morey's mentor at the University of Michigan. Helen Woodruff, writing in 1942, explained the Index's origins in terms of business and library filing systems. As a photographic card system, it paralleled late nineteenth-century police files. The eventual failure of these systems likewise pointed up the limitations of the Index of Christian Art; it could only discover groupings of imagery in certain senses.[5]

2. In contrast to the highly specialized Christian index, the original 1889 Museum of Historic Art was a typical late-nineteenth-century establishment (Fig. 3). The contents seem to have been quite heterogeneous in spite of the objective of comprehensiveness, with Prime's collections of pottery and porcelain, a few casts of significant monuments, and a scattering of paintings donated by alumni or well-wishers. In the early years, the janitor of the univerity chapel next door was relied upon to open the museum afternoons, upon request. It was never expanded to include the wings shown in A. Page Brown's original rendering, and its plan was simply a basement (partly above ground), two galleries on each of the two upper floors, plus a professor's office on the second level and the curator's on the third. Marquand's and Frothingham's course lectures, when serious art history offerings were made in the 1890s,

[4] Helen Woodruff, *The Index of Christian Art*, Princeton (1942).

[5] The subject of classification by physical form or image is a very long and interesting one. See Donald Preziosi, *Rethinking Art History: Meditations on a Coy Science*, New Haven (1989), 72ff.; and Alan Sekula, "The Body and the Archive," *October*, xxxix (Winter 1986), 3–64.

were held in nearby Dickinson Hall. A functional art history library came with Marquand's transfer of his collection of books to the top floor in 1900 (deeded in 1908), augmented by the Barr Ferree Library, bequeathed in 1924. The building was thus basically an "art box" rather than a modulated research establishment, much like other early American university museums, for example, Trumbull's gallery at Yale of 1831 (Fig. 81) and McKim's Walker Gallery at Bowdoin of 1891–1894. It was a far cry from the extensive and carefully arranged collections of the leading art schools on the South Kensington model—the Boston Museum of 1870, the Philadelphia Museum and School of Industrial Arts of 1876, and the St. Louis School of Art of 1879. Nor was it as articulated as Richard Morris Hunt's Fogg Museum at Harvard (1895) or the first structures built to house architecture programs: Robinson Hall at Harvard (1899–1902) and Avery Hall at Columbia (1911–1912)—both by McKim, Mead and White—with their libraries, studios, and (in the case of Robinson Hall) cast room. Not until Cass Gilbert's Allen Art Center at Oberlin, designed in 1917, does one see something like a "humanistic laboratory" laid out *ex novo*, with museum, library, professors' offices, and studios in considered relation to each other. The motivating force of the Oberlin department in this period was Butler's first student, Clarence Ward.

3. Butler's archaeological projects were the middle term between Morey's Index of Christian Art and Marquand's "Museum of Historic Art." The earliest American excavations seem to have been undertaken to make palpable some fundamental beliefs of received European culture—the Wolfe expedition to Nippur in 1880–1890, for example, and Breasted's Egyptian explorations, giving substance to the Bible, or the works of the Americanized amateur, Schliemann, at Troy and Mycenae in 1870–1890, concretizing the *Iliad*. More sophisticated was the first American classical excavation, that of Assos in 1881–1883, undertaken as part of a scholarly study of the evolution of the Doric order by its architect/excavators, Joseph Clarke and Francis Bacon. Marquand's aborted Sicilian explorations of 1883 may have had a similar objective. Here the project of making palpable the history of architecture replaced that of concretizing literature or religious beliefs. American students, holding various traveling scholarships, beginning with the Rotch Fellowship, established in 1882, restricted themselves to studying a very narrow canon of unimpeachable masterpieces, rather than exploring on their own.[6]

Butler's two explorations were apparently meant to carry on this documentation of the history of style, but also to illuminate problems in that history. Since Layard's and Botta's dramatic discovery of Mesopotamian art in the 1840s there had been a fascination with the Asian contribution to classical design, manifested most impressively in de Vogüé's *Syrie centrale* (1865–1877) and Charles Chipiez's *Origine des ordres grecs* (1876). By the 1890s in Strzygowski's researches the Asian contribution had become a central scholarly concern.[7]

[6] Joseph T. Clarke, *Report on the Investigations at Assos, 1881* Boston (1882); idem, *Report on the Investigations at Assos, 1882, 1883*, New York (1898); Joseph T. Clarke, Francis H. Bacon, Robert Koldewey, *Investigations at Assos*, Boston (1902–1921). Clarence Blackhall, *A History of the Rotch Travelling Scholarship*, Boston (1930); *The Rotch Travelling Fellowship: A Review of its History, 1883–1963*, Boston (1963).

[7] Josef Strzygowski, *Orient oder Rom*, Leipzig (1901). In a celebrated essay, Morey surveyed, and proposed to resolve, this problem: "The Sources of Mediaeval Style," *Art Bulletin*, VII (1924), 35–50.

Butler, in the work that began in 1899 with the cooperation of de Vogüé's son, went straight to the pressure points: Late Roman Syria (with photographic equipment to test the accuracy of the French discoverers) and Lydia. In the latter area the passage of ideas from Asia to Greece could be explored, and suggestions arising from the discovery of the Artemision at Ephesus (published in D. G. Hogarth's volumes of 1908) could be followed up.[8] But Butler interpreted the discoveries at Sardis with a strange fancifulness, reconstructing the west end of the ruinous (and, in fact, never completed) Artemis Temple in the style of Ephesus, as well as scattering the site with compositions of architectural members, like that of the breathtaking Sardis column tableau which, six years after his death, was set up in the south wing of the Metropolitan Museum of Art (Fig. 14). Butler was infinitely more careful than Schliemann, but in the end his attitude seems similar, making conventional ideas theatrically concrete.

III

Butler's responsibilities extended well beyond archaeology. He was master of the Princeton Graduate College from its founding in 1905, helping plan its Gothic building, erected by Ralph Adams Cram in 1911–1913.[9] Beginning in 1915, he was the animating spirit and then, in 1919, the director of the School of Architecture, organized within the Department of Art and Archaeology. From 1917 to his death in 1922 he was responsible for the planning and erection of McCormick Hall, the Architecture School building, which was again by Cram, the university architect. These were among the most characteristic creations of Princeton: the Graduate College with its monastic setting and ritual, so different from Hopkins and Chicago, and the Architecture School with its peculiar lack of a lead designer and its emphasis upon history.

It is difficult to recognize in Butler's extra-archaeological work a unifying thread of commitment to the Greco-Roman principles he had wanted to elucidate. During the nineteenth century, designer-theorists like Henri Labrouste, Gottfried Semper or E.-E. Viollet-le-Duc had worked out their ideas through archaeological study. Butler's archaeology, however, did not have a similar application. On the other hand, in Butler's avoidance of a lead designer for the Architecture School or in his patronage of the Sienese Gothic for McCormick Hall there is no indication that he was a closet Gothicist. Instead, he apparently envisioned each building as a separate entity, conceived in terms of contemporary wisdom. Cram's monastic Gothic fitted with the Oxbridge ideal of graduate education that Butler shared with Woodrow Wilson and Andrew Fleming West, the dean of the Graduate College; the atelier system of his Architecture School reflected the historically neutral attitude towards

[8] David George Hogarth, *Excavations at Ephesus: The Archaic Artemisia*, London (1906).

[9] Douglass Shand Tucci, *Ralph Adams Cram, Medievalist*, Boston (1975); Mr. Tucci will shortly publish a more extended study. Sarah P. Lanford, "A Gothic Epitome: Ralph Adams Cram as Princeton's Architect," *Princeton University Library Chronicle*, XLIII (1982), 184–220 (on the Graduate College, 194–206). See also Paul V. Turner, *Campus: An American Planning Tradition*, Cambridge, Mass. (1984), 233–234.

style established by Cret at Penn and later confirmed by Labatut at Princeton. McCormick Hall (Fig. 11) was a multivalent building linking the "collegiate Gothic" parts of the campus with the older, more Romanesque or classical sectors.[10] The one quality that runs through all Butler's enterprises is perhaps disengagement. Everywhere he was building on established thought rather than on personal principle. The same is true of his own small architectural production: the sesquicentennial arch at Princeton of 1896, imitating the Roman arch at Benevento; the Presbyterian Church in Croton Falls, New York, of 1899 (Fig. 15), designed in the suburban wooden Gothic of Westchester County; and his Tiger Inn Club at Princeton of 1895, reminiscent of the Tudor of Maxfield Parrish or the Lampoon in Cambridge.

IV

Charles Rufus Morey, who became chairman in 1924 upon Butler's and Marquand's deaths, likewise accomplished more than just the organization of the Christian Index. By 1929, he had formulated for the department the idea of the "humanistic laboratory." This was extended during the early 1930s to control the layout of the projected university library. In the *Bulletin of the Department of Art and Archaeology* of October 1929, Morey cited the focusing of undergraduate study in the humanities (paralleling the sophistication of scientific training), which had resulted in the "house" system at Harvard. Noting that the comprehensive departmental examinations at Princeton were an equivalent, he proposed, instead of a system of residential colleges, one of departmental "workshops" and "humanistic laboratories." There would be four—philosophy, history, literature, and art. Each would center around a research library, with professors' offices, graduate and undergraduate reading rooms, and seminar spaces attached.

By this time the old university library, which Chancellor Green erected in the 1870s, was inadequate, and members of the Department of Art and Archaeology led the planning for a new structure. In 1931, five master's theses in architecture were submitted under Jean Labatut's direction, embodying Morey's program (Figs. 16–21). These were published in the *Bulletin of the Department of Art and Archaeology of Princeton University* in June 1931, together with the program, and with reference to Morey's arguments of 1929 for the coalescence of the humanistic departments in a coordinated structure (both conceptually and physically), separate from and balancing the scientific laboratories. It concludes:

> Such a library must add to its normal services the features which will provide a center for the working of each of these [humanistic] departments. To attain the latter result, provision must be made not only for undergraduate departmental working space, but also such features as lounges to be shared by graduate students and undergraduates; working space and the necessary seminar rooms for graduate students, in a situation that will insure convenient access to the stacks, easy communication with the staff and some contact with undergraduate departmentals; and finally commodious offices for the staff of each department,

[10] Butler explained the genesis of the design in "McCormick Hall and the School of Architecture," *Princeton Alumni Weekly*, XXII, no. 5 (November 2, 1921), 99–102.

situated near enough to the departmental reading-room to provide easy contacts, secluded enough to insure against unnecessary interruptions.

The designs show the library as a core, from which wings extend in a variety of configurations to house eight humanistic departments, the whole a microcosm of a liberal university.

In 1935, an official scheme for a central library with departmental offices (Figs. 22 and 23) was unveiled by Cram's successor as university architect, Charles Z. Klauder. It was described by E. Baldwin Smith with evocative warmth:

> Should the student, while working in his study room, need advice upon some point raised by his reading, he may either consult the graduate students ... who will be working in an alcove nearby, or better, he may refer his question to his faculty advisor whose study is in an adjoining room. The advisor in turn may leave books or instructions on the student's desk [11]

Financial problems delayed the construction of the new university library until the 1940s, when a rather disappointing compromise arose in the form of Firestone Library. But if the "humanistic laboratory" in its purest and most general form was not, in the end, realized, Morey had at least had the satisfaction of taking over Butler's architecture school building of 1923 to realize such a laboratory *ad hoc*, with a library at the center, a collection of casts in the huge room below (in later years used for displaying the photographs of each course in a given semester), and with offices, seminar rooms, and study rooms fitted in at both ends.

V

By the Depression, the Princeton Department of Art and Archaeology balanced the departments of history, English, and philosophy in its staff and its research programs. Art history had, indeed, emerged as a fourth branch of humane study. Yet in 1990, almost sixty years later, we are only beginning to see the first glimmerings of the study of images as a fundamental branch of the humanities, and the impetus has come largely from outside art history. Did some sort of stagnation set in after 1930? In 1960, research departments in art history were much the same as they had been thirty years before.

In closing this swift delineation of art history at Princeton, let me express some ambivalence. I was led to this subject by an interest in the striking unity of Princeton's historicizing architectural setting and in Butler's peculiar interpretations of the ruins at Sardis. I thought that an examination of this suggestive coincidence might provide a deeper grasp of America's relation to "history"—the European past—around 1900 than does the study of phenomena like Woolworth's "Cathedral of Commerce" in New York by Cass Gilbert or Maxfield Parrish's bar murals or suburban house designs. But I am frustrated at the indecisiveness of the results.

[11] E. Baldwin Smith, "The Idea of the New Princeton Library and Its Plan," in *The New Princeton Library*, Princeton (1935), 11–23.

There were some large concepts in what I have sketched here, but in the end little that would constitute a new formulation of the significance of cultural artifacts. There is also much of the immediately practical and the academically political in Butler's architecture or Morey's humanistic counterpart to the sciences. Marquand, Butler, and Morey were all strong personalities, but perhaps more significant sociologically than intellectually: they were men of their time rather than visionaries. They were representative men from three successive generations who tried to accommodate English monastic education and German *Kunstwissenschaft* by means of American systematization and, especially in the case of Butler's archaeology and architecture, sentiment.

Virtue and Good Manners: Toward A History of Art History Instruction

MARY ANN STANKIEWICZ

P RIOR TO THE early twentieth century, when, under German influence, art history was first recognized in America as a distinct professional discipline, the history of art was often part of an integrated collegiate fine arts curriculum that encompassed both art theory and studio practice. In order to examine some of these roots of art history instruction in American higher education, I shall focus on the period before the professionalization of the discipline and before the development of the comprehensive university.

Writing in the 1880s, President Frederick A. P. Barnard of Columbia distinguished three stages in the history of his university, creating a model that also applies to other universities: 1) the liberal arts college, frequently denominational, with its classical or scientific curriculum; 2) the addition of various professional schools such as medicine, law, science, and theology, often with loose ties to the original college, and with low standards and little support from the college faculty; and 3) the development of the comprehensive university with its graduate programs, laboratories, seminars, and specialized lectures—all derived from German models.[1] While the college dominated higher education in the early nineteenth century, and the university was preeminent in the latter part of the century, the growth of professional schools occurred over a broad span of years: the earliest professional schools appeared about 1814; many did not develop until after the Civil War.

According to educational historian Douglas Sloan, comparisons of early nineteenth-century colleges with late nineteenth-century universities oversimplify the situation. He suggests that "the totality of institutions in each period that carried out the tasks of higher education" needs to be examined.[2] Accordingly, this paper will investigate the rationale for art history in the nation's first two professional schools of fine art at Yale and Syracuse, art history in women's colleges of the period, and, finally, art history in other, non-collegiate educational institutions.

[1] John S. Brubacher and Willis Rudy, *Higher Education in Transition*, 3rd ed., New York (1976), 182.

[2] Douglas Sloan, "Harmony, Chaos, and Consensus: The American College Curriculum," *Teachers College Record*, LXXIII (December 1971), 226.

I

Yale, under the conservative presidency of Noah Porter (ca. 1871–1886), developed professional schools, but refrained from completing the transition to a true university until Timothy Dwight the younger became president in 1886. One of those professional schools was the first school of fine art in this country. When Street Hall, the building of the Yale School of Fine Arts (Fig. 82) was dedicated in 1866, a minister and professor of homiletics in Yale's department of theology gave the dedication address. Reverend James Mason Hoppin seems to have published his first article on "The Principles of Art" in October 1865, just a year before his speech at the dedication of the Yale building appeared in *The New Englander*. Although Hoppin was only beginning his career as a critic and art historian, he had developed a coherent point of view that sought to balance an emphasis on truth to nature, learned from Ruskin, with an idealistic belief that spiritual expression should be the primary purpose of art.[3] According to Hoppin, the artist "mediates between the material and spiritual worlds, making the first the means and basis of his expression of the last."[4] The artist was special because he alone could correctly read and represent the beauty of God's mind in the natural world.[5] For Hoppin, religion must come first and art follow as the expression or representation of faith and as a means to stimulate pious emotions.

While believing that religion was the primary means of spiritual refinement, Hoppin also thought that "true Art ennobles The simple truth is, that a man who does not feel something of the true and sweet influence of nature, or who does not know at all how to appreciate a noble work of Art, is a rude person."[6]

Throughout his career Hoppin argued that Americans needed art to improve character, to teach virtues, to memorialize heroic deeds, to demonstrate the spirit of freedom, to evoke positive effect, to enhance liberal education, and, last but certainly not least, to strengthen Christian faith.

As historian Louise Stevenson has explained, Hoppin, like his fellow New Haven scholars in the period between college and true university, sought a balance of scholarly method "that was a middle way between pre-Civil War Romantic idealism, in this instance John Ruskin's, and late-nineteenth-century positivism, in this instance art critic Bernard Berenson's."[7] Hoppin used idealized abstractions such as "character" or "the Greek mind" to justify his attributions or interpretations. He developed a theory or set of principles prior to analyzing the composition of a work of art, then used his idealized abstractions to relate the object to a larger whole. While Berenson conceived of art history as a distinct field of endeavor, Hoppin saw it as a means to increase historical understanding. For Hoppin, both religion and

[3] On Hoppin's role as a disciple of Ruskin see Roger B. Stein, *John Ruskin and Aesthetic Thought in America 1840–1900*, Cambridge, Mass. (1967).

[4] James Mason Hoppin, "Principles of Art," *The New Englander*, XXIV (October 1865), 677.

[5] Throughout this paper, use of the male pronoun reflects nineteenth-century usage and the assumption of the day that most artists and college students were male.

[6] Hoppin (as in note 4), 682.

[7] Louise L. Stevenson, *Scholarly Means to Evangelical Ends: The New Haven Scholars and the Transformation of Higher Learning in America, 1830–1890*, Baltimore (1986), 133.

history were means to individual development, the ultimate goal of higher education. Thus, while some terms used by Hoppin resonate with the civic humanistic theory of art recently examined by John Barrell, Hoppin contributed to the nineteenth-century attenuation of that theory, which privatized values and transformed art from public monument to commodity.[8]

In his Yale speech Hoppin outlined his views on the relation of art to other branches of higher education. His argument, based on the principle that true education seeks harmonious development of human nature, "neglecting nothing essential, and cultivating nothing disproportionately,"[9] offered a kind of "golden mean" for middle-class college students.[10] Hoppin stipulated that training the moral and religious nature must be the foundation of education; next must follow discipline of the intellect. The third task was to develop that portion of the human being that contains both emotion and rational mind, the region of imagination and sentiments, the source of feelings for truth, beauty, and goodness. In Hoppin's scheme, imagination was the creative power of mind that assimilates mankind to God. He recognized that Americans had excluded art from their education out of fear that it might lead to a refined but degenerate civilization. On the contrary, Hoppin argued, art corrupts only when joined with heresy, corrupt philosophy, or perverted public feeling. True art combines sensuous qualities with higher rational qualities of mind and a deeply moral element. Defining the imagination as both spiritual and rational, as Hoppin did, not only connected art with the first two tasks of education, but also brought it under moral and intellectual control.[11]

Hoppin offered at least seven reasons why aesthetic culture should be part of higher education: 1) art is an intellectual pursuit; 2) art can elevate people above materialism into a new freedom of spirit; 3) true art is an ethical influence; 4) art helps counteract the narrow education promoted by a focus on science, because it too presents truths of nature, but in living, concrete forms; 5) art helps one cultivate perceptive powers of the mind; 6) art aids the study of other subjects; and, finally, 7) art promotes kind feelings, drawing people together in common interests. He wrote: "True aesthetic culture develops those feelings and those tendencies of mind that are thus favorable to virtue, and good manners, and even to a higher faith."[12]

How should art be taught to achieve such ends? Hoppin had an answer: theoretically, historically, and practically. True to his idealistic roots, Hoppin put theory first, even though art was commonly supposed to bring a practical element into higher education, in order to balance the classical and scientific curricula. Theory, of course, was prerequisite to professionalizing art, and Yale was establishing a professional school. History, he explained, provided "instruction in the development and progress of Art in the various epochs of the world's

[8] John Barrell, *The Political Theory of Painting from Reynolds to Hazlitt*, New Haven (1986).

[9] James Mason Hoppin, "The Relations of Art to Education," *The New Englander*, xxv (October 1866), 603.

[10] For a discussion of the middle class and the development of higher education in nineteenth-century America, see Burton J. Bledstein, *The Culture of Professionalism*, New York (1976).

[11] Neil Harris, *The Artist in American Society*, Chicago (1982), 300–312. Although writing a generation after the antebellum ministers that Neil Harris discusses, Hoppin illustrates the continuing spread of "clerical art interest" and the continuing viability of moral arguments for the value of art.

[12] Hoppin (as in note 9), 609.

civilization, and in connection with the different phases of human thought and life."[13] As far as the practical component, Hoppin recommended that architecture be the chief study. He concluded by pointing out the need for models in all departments: a gallery of good pictures, casts of original sculptures.

Hoppin became professor of history of art at Yale's School of Fine Art in 1879 and continued to write on art in higher education, art criticism, and art history.[14] There is little evidence that Yale actually implemented Hoppin's tripartite scheme of theory, history, and practice; however, we can find a school of fine arts based on that model at Syracuse University.

II

The charter of Syracuse University, completed in March 1870, provided for professional education as well as undergraduate instruction by stating that the university should include a college of law, a college of medicine, and a college of fine arts.[15] Chancellor Alexander Winchell of Syracuse, like the conservative Noah Porter of Yale, favored preserving the values of the traditional college rather than moving toward the new German model of the university, with its liberal approach to freedom of learning and of teaching. Thus, although Syracuse was a younger institution than Yale, it had somewhat the same climate, supporting emergent professional schools, but resisting the trend toward graduate programs. The development of professional schools which were loosely tied to the original college, vaguely coordinated with the undergraduate curriculum, and only hinting at the specialization of the new graduate research programs, raised questions about the scope and purposes of higher education on some campuses.[16] However, like Yale, Syracuse emphasized religious values, having been founded as a Methodist institution. Syracuse and Yale shared with many other nineteenth-century institutions of higher education the traditional goal of liberal education, symmetrical development of all human powers, and the production of the cultured man, the friend, and the citizen.[17]

Rev. George Fisk Comfort (Fig. 121), founding dean of Syracuse's School of Fine Arts, had been writing on art in higher education in Methodist journals since his return from Europe after the Civil War. He first presented his argument for theoretical, historical, and practical collegiate instruction in the fine arts in 1867, just a year after Hoppin's dedication

[13] Ibid., 615.

[14] In 1889, Hoppin contributed the second article to a series on the fine arts in *The Forum* founded by Charles Eliot Norton; in 1893, he presented a paper at the International Congress on Education held in conjunction with the World's Columbian Exposition in Chicago. See James Mason Hoppin, "Art in Popular Education," *The Forum*, VII (1889), 331–338; and "Methods of Art Education for the Cultivation of Artistic Taste," in *Proceedings of the International Congress of Education,* Chicago (1893), 476–486.

[15] Mary Ann Stankiewicz, "Art Teacher Preparation at Syracuse University, The First Century," Ph.D. diss., The Ohio State University (1979), 18.

[16] Jurgen Herbst, "Liberal Education and the Graduate Schools: An Historical View of College Reform," *History of Education Quarterly*, II (December 1962), 244–258.

[17] Edgar Burton Cole, "The College of Fine Arts of Syracuse University 1894–1922," Ph.D. diss., Syracuse University (1957), 5–6.

address. Following scholarly conventions of his day, Comfort did not note his sources, and he never mentioned Hoppin, but the similarity between their ideas is startling, owing perhaps to mutual roots in German Idealism. While I have no concrete evidence that Comfort had read Hoppin's address, circumstantial evidence suggests the possibility that he had. Thus, I assign Hoppin priority in the development of this tripartite model, speculating that Comfort, who had attempted to establish a school of fine arts and college museum at Allegheny College, where he was teaching aesthetics, probably followed the developments at Yale and read Hoppin before writing his own arguments.[18]

Whether Hoppin's or Comfort's theories evolved first, the important point is that these ideas and the argument for the cultural value of art history in the undergraduate curriculum were not isolated during the decades following the Civil War. The most notable proponent of art history's cultural value was, of course, Charles Eliot Norton of Harvard (Fig. 24). I suspect that other versions of the cultural rationale they shared can be found in nineteenth-century journals and college archives.

In his 1867 article Comfort pointed to the need for reform in American higher education and argued for a clearly defined system of four levels: primary, academic, collegiate, and university. Reviewing the history of higher education, Comfort pointed out that American colleges had been modeled on English residential colleges at a time when such colleges were a century and a half behind continental universities.[19] Since the establishment of the classical curriculum in American colleges, scholars—predominantly German—had created new sciences, among them art history (which Comfort credited to Schnaase [misspelled "Schnaser" in his text] and Kugler) and aesthetics (which Comfort credited to Vischer). Comfort asserted that colleges were adding graduate programs that ignored some branches of knowledge while fostering those taught by charismatic professors.

Like Hoppin, Comfort relied on an *a priori* scheme rooted in Idealism to explain which branches should be taught, and he described instruction in fine arts as necessary to symmetrical development of the God-given faculties within each man. Man, according to Comfort, is a twofold being, composed of body and spirit. It went without saying that higher education should appeal to the spirit. The activities of the spirit were to be examined in three ways, with reference to subject matter, to method, and to qualities. In Comfort's scheme, there were three classes of subject matter: theology, or knowledge of God; anthropology, or knowledge of man; and cosmology, or knowledge of the material universe. The three methods one could use were the theoretical, the historical, and the practical. The three qualities were the good, the true, and the beautiful. While Comfort declared that each of these three triads could be used to classify collegiate studies, he found the third "the most available and the most natural."[20] Moral and religious education should develop the good in the human spirit, while instruction in the various sciences helped one appreciate and value the true. Although most colleges

[18] According to Betsy Fahlman, author of a forthcoming monograph (to be published by Cambridge University Press) on John Ferguson Weir, Director of the Yale School of Fine Arts, Comfort did apply to teach at Yale shortly after the school was founded in 1864, before there was a building or funds to hire instructors. Betsy Fahlman, letter to author, 26 February 1989.

[19] George Fisk Comfort, "Esthetics in Collegiate Education," *Methodist Quarterly Review* (October 1867), 578.

[20] Ibid., 580.

ignored the third quality, in a balanced system of education appreciation of beauty should be developed through theoretical, historical, and practical instruction in the arts.

Comfort explained that the historical study of the rise and fall of the fine arts in different ages helped one understand those ages, and that without such study Americans would remain ignorant of culture. One component of this argument views art as a means of teaching students material that, with the decline of the classical curriculum and the spread of the elective system, was no longer universally taught. Art history thus might bear the same relationship to the works of Virgil and Homer that Charles and Mary Lamb's tales bear to Shakespeare's plays, or that the classic comic books of the 1950s have to Scott's *Ivanhoe*.

Since textbooks were lacking, Comfort recommended that lectures in the history of art be given during the last year of college and be supplemented by museums which could illustrate characteristic periods of art through casts, photographs, and engravings. The proposed timing of these lectures would have made them parallel to the traditional senior course in moral philosophy taught by American college presidents, again confirming the moral function of art. As actually implemented at Syracuse, however, Comfort's curriculum gave more scope to art history. In both the architecture and painting courses, one lecture in the "History of the Fine Arts in Outline" was required each week during the second and third terms of the junior year. A weekly lecture on the "History of Architecture" and one on the "History and Styles of Engraving" were required during the first term of the senior year, "History of Sculpture" during the second term, and "History of Painting" during the final term. In addition, senior painting students during the first term heard a weekly lecture on "Classical Mythology" illustrated by art, and, during the second term, another on "Christian Archaeology and Symbolism in Art." Required courses in ancient and modern history and the history of civilization provided a larger context in which to view the rise and fall of the epochs of art and their relationship to other elements of civilization.

Just as the rhetoric underlying the professional schools of fine arts at Yale and Syracuse was similar, so were the student populations. Syracuse University was coeducational from its founding. Although Yale College was a men's school, the School of Fine Arts was coeducational. The ministers who spoke at the inauguration of Syracuse's College of Fine Arts in September 1873 used phrases such as: "aesthetic development is a part of man's normal growth" and "The study of art . . . completes the development of the whole man . . . educates him and saves him from a narrowness of thought and bigotry of view."[21]

These phrases, almost interchangeable with those Hoppin had used at Yale, had been transformed by the time Syracuse dedicated its fine arts building, the John Crouse Memorial College for Women, in September 1889. When the Crouse building was dedicated, the ministers who spoke addressed the role of art in the home and the necessity of art education for wives and mothers who wanted to adorn their homes, "give an upward turn to society," and teach their children aesthetic culture.[22] The speakers noted that patronage of the arts had

[21] "Inauguration of the First College of Fine Arts in America," anonymous newspaper article dated 19 September 1873: Syracuse University Archives, Colleges-Schools-Departments-Courses, Fine Arts, 1887–1930.

[22] "A Grand Gift," anonymous article, *Syracuse Daily Journal* (18 September 1889): Syracuse University Archives (as in note 21).

shifted from the church and princes to the home, so that women were the caretakers of society and culture. By the time of this dedication, the College of Fine Arts at Syracuse was virtually a women's coordinate college for the predominantly male College of Liberal Arts.[23]

At Yale, too, most students in the School of Fine Arts were women, perceived by a later writer as dilettantes who "prepared themselves for the responsibilities of matrimony by learning to paint china."[24] By the last decades of the nineteenth century not only had artistic culture been feminized, but the professional art schools which had been founded at both Yale and Syracuse with high hopes for the development of the American (male) artist and the balanced education of the gentleman were devoting most of their efforts to women students.

Comfort had written that the "feminine mind inclines naturally to the pursuit of aesthetic studies," encouraging art education for women as a means to induce "a healthy tone of body and mind" and to call them "away from groveling and debasing pursuits and pleasures."[25] The rhetoric which identified the study of art as a path to spiritual development, moral virtue, and good manners now applied to women: the phrases of civic humanism had indeed been appropriated by the unenfranchised.[26]

III

Fine art was a recognized necessity in the curricula of those women's colleges that supported traditional roles for educated women. Matthew Vassar proposed including an art gallery in the building for his Vassar Female College as early as 1861.[27] A collection of paintings was

[23] Mary Ann Stankiewicz, "'The Creative Sister': An Historical Look at Women, The Arts, and Higher Education," *Studies in Art Education*, XXIV (1982), 48–56.

[24] Robert L. Duffus, *The American Renaissance*, New York (1928), 38. Again, on page 44, Duffus derides women students as merely passing time before marriage, an attitude toward fine arts students found in student publications at Syracuse as well (see Stankiewicz [as in note 23], 52). Fahlman (as in note 18) states that her research revealed no evidence of china painting at Yale; in fact, she found "surprising equality in [women's] treatment there." Duffus's book is not scholarly in tone; rather, he describes it as a collection of "travellers' tales" (p. 4) based on visits to only a few of the art institutions of the day. It is interesting, not only for its content (sexist and erroneous as it might be), but also for the fact that it was a product of the Carnegie Corporation's fine arts program (1925–1939). Research sponsored by this program led to several books, including Priscilla Hiss and Roberta Fansler's *Research in Fine Arts in the Colleges and Universities of the United States*, New York (1934); Arthur Pope's *Art, Artist, and Layman*, Cambridge, Mass. (1937); and Laurence Vail Coleman's three-volume *The Museum in America*, Washington, D.C. (1939)—all valuable sources for contemporary researchers.

[25] George Fisk Comfort and Anna Manning Comfort, *Women's Education and Women's Health*, Syracuse (1874), 75. Comfort wrote this book with his wife, a physician, to argue against the notorious Dr. Edward H. Clarke, whose book *Sex in Education*, Boston (1874) asserted that women could not both receive an education and maintain the physical health necessary for future motherhood.

[26] Barrell (as in note 8), 55. Ann Douglas has analyzed the joint contributions of ministers and women to the sentimentalization of Victorian culture, pointing out that both disestablished groups sought a base of power in literature and, I would argue, other arts as well. See Ann Douglas, *The Feminization of American Culture*, New York (1977).

[27] James M. Taylor and Elizabeth H. Haight, *Vassar*, New York (1915), 210. Taylor and Haight (113) quote from a student publication, *The Vassar Transcript*, a review of one guest lecture of the year 1869: "Professor Comfort, who came to lecture on 'The Fine Arts,' was announced as a gentleman perfectly conversant with the subject, having studied it carefully, both in this country and Europe; but though we waited patiently through the lecture for some acquisition to the notebook with which, at his suggestion, we had come prepared, we heard nothing but a series of obvious classifications and commonplace

acquired even before the college building, with its top-floor art gallery (Figs. 42, 44, and 47), was completed in 1864.[28] Dutch-born artist Henry Van Ingen (Figs. 49 and 50) was among the first faculty members; he seems to have taught history and criticism as well as linear drawing until his death in 1898. By 1874–1875, Vassar required history of art for all first-semester seniors.[29] A little more than a decade later, art history lectures were allowed as electives for all classes.[30]

At Wellesley College, too, fine art was part of the curriculum from the time the college opened in 1875, as discussed by Claire Richter Sherman in her paper in this volume.[31] Mount Holyoke opened its art gallery in 1876 and required history of art for students in both the classical and scientific courses after its college department was established in 1888.[32] Smith offered lectures on the history and principles of fine arts to all students in 1877.[33]

Thus it is not surprising that the student magazine of Rockford Female Seminary, a midwestern school with collegiate aspirations, would announce that the weekly lectures on art given in the school chapel in the spring of 1879 were "the fashion" at eastern women's colleges. However, the writer noted that better motives included cultivating all the faculties with which the young ladies had been endowed and learning about "the moral and aesthetic nature of man" as revealed in art.[34] Rockford had had a department of drawing and painting as early as 1861, when the catalogue described the benefits of art study "in cultivating the habit of observation, in refining the taste, and increasing the love for the beautiful in nature, thus lifting the heart upward with devout reverence for the Creator"[35]

Although they lacked professional schools, women's colleges used virtually the same rhetoric as Yale and Syracuse to justify the teaching of art history. In women's colleges, too, art history was often integrated into a program that included studio work and some attention to art criticism and art theory. While art instruction was expected to contribute to balanced

definitions, unrelieved by illustration or discussion, unenlivened by learning or wit. Of the popular estimate of this lecture in the College, the most charitable expression will be silence."

On the basis of the topic and the classifications and definitions, I would argue that this speaker was indeed George Fisk Comfort. Unfortunately, the record is silent as well on faculty and administration response to his ideas.

[28] Jean C. Harris, *Collegiate Collections 1776–1876*, exhibition catalogue, Mount Holyoke College, South Hadley, Massachusetts (June 15–December 15, 1976), 36–39. See also the contribution of Pamela Askew on pp. 57–63 of this volume.

[29] Mabel Louise Robinson, *The Curriculum of the Woman's College*, Washington, D.C. (1918), 15.

[30] Ibid., 31.

[31] When Wellesley College opened in 1875, it had its own galleries and art collection. A year later, history of art was required in the junior year. In 1878, a new five-year art course included lectures on the history of architecture, ornament, painting, and sculpture. A college museum was established in 1883, and by 1886 two of the art history courses included work in the "art laboratory," studying pictures and books. Alice Van Vechten Brown (Fig. 114) initiated the "direct approach" to instruction in art history in 1897, when she required studio work as a prerequisite to credit in art history. See [Henry Barnard], "Wellesley College. Notes of Repeated Visits," *The American Journal of Education*, xxx (1880), 167; Robinson (as in note 29), 20; Wellesley College Archives, *Wellesley College Calendar (1878–1879)*, 33; Sirarpie Der Nersessian, "The Direct Approach to the Study of Art History," Appendix D in *Report of the Committee on the Visual Arts at Harvard University*, Cambridge, Mass. (1956), 137.

[32] *Collegiate Collections* (as in note 28), 66; Robinson (as in note 29), 54.

[33] Hiss and Fansler (as in note 24), 6, n. 2. See also the contribution of Phyllis Williams Lehmann on pp. 65–77 of this volume.

[34] "Editorial Notes," *Rockford Seminary Magazine*, VII (April 1879), 104.

[35] Rockford College Archives, *Rockford Seminary Catalogue, 1861–1862*.

development, to raise the mind to thoughts of God, and to refine manners and morals, women were not expected to display their aesthetic culture on a public stage; their domain was expected to be the home. Arguments for the importance of art history turned increasingly away from its benefits to the public-spirited citizen (the editors, orators, pastors, and successful men of business cited by Comfort)[36] and toward its benefits to the private individual, male and female.

IV

Arguments for the cultural value of instruction in art history did not die with the nineteenth century, but continued into the twentieth in articles by Charles Eliot Norton in 1895; by A. Howry Espenshade of State College, Pennsylvania, in 1903; by T. Lindsey Blayney, who taught history of art at the Central University of Kentucky[37] and served as vice president of the American Federation of Arts in 1910; and by Edward Robinson, Director of the Metropolitan Museum of Art, in an address of 1918 before the College Art Association.[38] Robinson spoke of the professional benefits of the study of art history in leading to careers in museums, in criticism, and in writing scholarly catalogues, and then turned his attention to its benefits for the nonprofessional. He argued that art history should be taught as it was by his early master, Charles Eliot Norton, who stimulated his students to love and collect art, and aided in developing their characters and powers of observation. Finally, after arguing for the personal benefits of art study, Robinson mentioned the need of citizens to cultivate aesthetic judgment, that they might provide sound guidance in matters of local architecture and monuments.

One should not be surprised to find a museum man entering the dialogue on the cultural benefits of art history. Comfort had been one of the most influential speakers before the new trustees of what would become the Metropolitan Museum of Art. The plan for the Metropolitan, in large part based on Comfort's recommendations for the educational function of the art museum, was adopted by the Boston Museum of Fine Arts and others. Just as the undergraduate art education proposed by Hoppin, Comfort, and the founders of women's colleges required collections of casts, engravings, and original works of art, so the first American museums, with their similar collections, were broadly educational in their aims. Comfort recommended that even small cities establish their own museums to cultivate community taste, and perhaps artistic genius, and to encourage local residents to purchase art rather than material luxuries.[39] This balance between public and private interests can also be seen in the last sites of art history instruction on this brief tour.

[36] Comfort (as in note 19), 583–584.

[37] Earl Baldwin Smith, *The Study of the History of Art in the Colleges and Universities of the United States*, Princeton (1912); reprinted on pp. 12–36 above.

[38] Charles Eliot Norton, "The Educational Value of the History of the Fine Arts," *Educational Review*, IX (1895), 343–348; A. Howry Espenshade, "The Study of Art in American Colleges," *Education*, XXIII (January 1903), 290–298; T. Lindsey Blayney, "The History of Art as a College Discipline," *Education*, XXXI (1910), 21–31; Edward Robinson, "The Study of Art in Our Colleges," *Association of American Colleges Bulletin*, XII (1926), 63–71.

[39] George Fisk Comfort, *Art Museums in America*, Boston (1870), 12.

Frequently discriminated against by predominantly male colleges, women sought higher education in a variety of ways, including such voluntary organizations as the woman's club. In Syracuse, a Social Art Club was established in 1875 under the leadership of the local high school art teacher, Mrs. Mary Dana Hicks.[40] The membership was limited to forty ladies who met each Tuesday from November through April to discuss readings in early Italian painters and study photographic reproductions.[41] Club programs featured guest lectures, visits to the art gallery in Rochester, loan exhibitions, and *tableaux vivants* in celebration of Raphael's birthday. While women joined such clubs for their personal development, for "self-culture," the skills in public speaking and committee work gained there were often applied in the larger community.[42]

Private art history instruction can also be found during the last quarter of the nineteenth century. One model of art-historical entrepreneurship is Eliza Allen Starr, an artist originally from Massachusetts, who began to give lectures on art to Chicago ladies and gentlemen during the 1870s (Fig. 122). After the great fire of 1871, she taught at St. Mary's Academy in South Bend, Indiana, before returning to the city. The house she built for herself included a small auditorium where her lectures, illustrated by her collection of photographs, were given. Like Hoppin and Comfort, Eliza Starr was a disciple of Ruskin and conscious of the relationship of art to nature and to religion. She was remembered as a dramatic speaker, which may explain the popularity of her lectures, where "an Opera Glass is always desirable."[43]

Perhaps Eliza Starr's precept that "to put within reach of the poorest the best photographs of great paintings and sculpture was a noble form of charity,"[44] inspired her niece, Ellen Gates Starr, to teach art history in the early days of the settlement house she co-founded with Jane Addams. Ellen Starr met Addams when both were first-year students at Rockford Seminary; their friendship continued while Ellen taught art history and other subjects in private girls' schools in Chicago. Although Addams developed the plans for Hull House, based on the model of London's Toynbee Hall, Starr took responsibility for the first college extension classes, illustrating her lectures with photographs of works of art and architecture.[45] Thus, the study of art history had become a source of private pleasure and entertainment and also a means of charity in Chicago of the 1890s.

Some might argue that what I have described in these pages is not instruction in art history at all, since it was delivered by ministers and women, not by trained scholars, and was

[40] For more on Mrs. Hicks's contributions to art education see Mary Ann Stankiewicz, "Mary Dana Hicks Prang: A Pioneer in American Art Education," in *Women Art Educators II*, ed. Mary Ann Stankiewicz and Enid Zimmerman, Bloomington, Indiana (1985), 22–38.

[41] Jane Cunningham Croly, *The History of the Woman's Club Movement in America*, New York (1898), 907–908.

[42] For a study of the importance of the woman's clubs from a feminist perspective see Karen Blair, *The Clubwoman as Feminist: True Womanhood Redefined, 1868–1917*, New York (1980).

[43] Printed program for "Eliza Allen Starr's Illustrated Lectures on Art Literature, November 1896 to January 1897": Smith College, Sophia Smith Collection, Ellen Gates Starr Papers, box 6, folder 45 (Lectures and Art Courses).

[44] "Miss Starr's First Lecture," undated newspaper article: Starr Papers (as in note 43).

[45] For more information on art education at Hull House, see Mary Ann Stankiewicz, "Art at Hull House, 1889–1901: Jane Addams and Ellen Gates Starr," *Woman's Art Journal*, x (1989), 35–39.

so frequently combined with studio practice. In all these cases, the motive for teaching and learning the history of art was cultural, a belief that the virtue and good manners of the upper classes would be transmitted to the middle and lower classes along with knowledge of artists, dates, and styles.

Although they were moving toward the professionalization of art history, the nineteenth-century academics discussed here could not have known how such a profession might look. As they explored their developing domain, they drew on past educational models, revising rhetoric and programs to meet new needs. A history of the early days of the College Art Association reports that, as recently as 1910, the academics who would become the founders of the association were discussing the proper relationship of practice in drawing to the study of the history and theory of art.[46] By 1912, inquiries from Europe about the burgeoning state of art history in the U.S. led Earl Baldwin Smith of Princeton to survey the study of history of art in colleges and universities.[47]

If art history was flowering rapidly on American campuses in the years before the First World War, it obviously grew from roots that had been planted at an earlier time. This paper has been an attempt to sketch one set of those roots.

[46] W. L. M. Burke, "Early Years of the College Art Association," *College Art Journal*, I (1942), 101.
[47] Smith (as in note 37), reprinted on pp. 12–36 above.

Index

PLATES

1. Allan Marquand, ca. 1882
(photo: Princeton University Libraries)

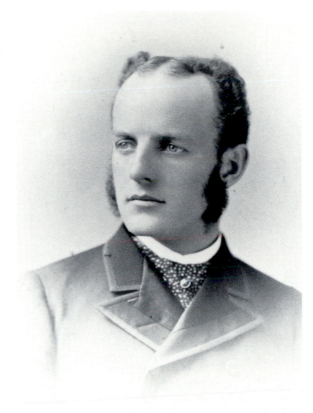

2. Howard Crosby Butler, ca. 1902
(photo: Department of Art and
Archaeology, Princeton University)

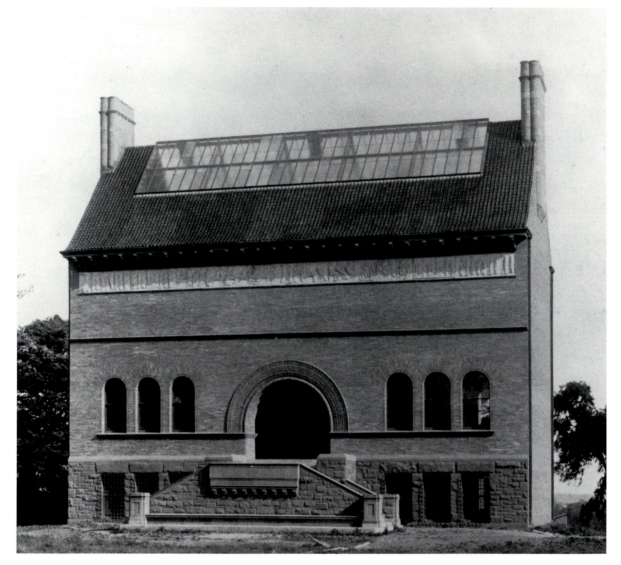

3. Original building of the museum and the Department of Art and Archaeology, Princeton University, 1888 (demolished 1963), architect A. Page Brown (photo: Princeton University Libraries)

4. Frank Jewett Mather, Jr., 1909
(photo: Princeton University Libraries)

5. Charles Rufus Morey, 1920s
(photo: Department of Art and
Archaeology, Princeton University)

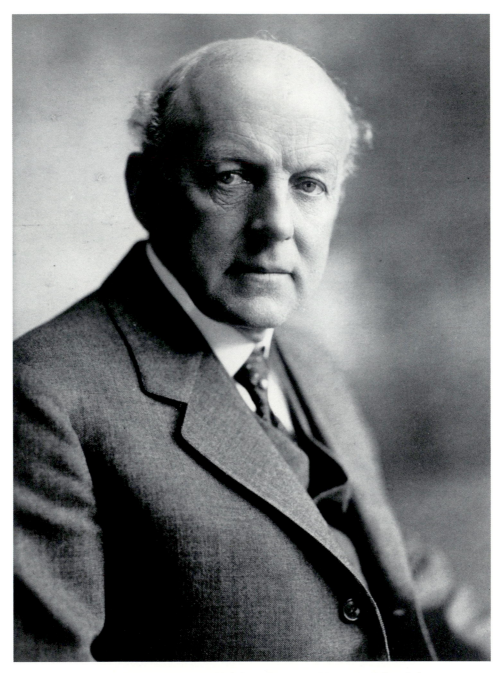

6. Allan Marquand, ca. 1922 (photo: Princeton University Libraries)

7. E. Baldwin Smith, 1920s
(photo: Department of Art and
Archaeology, Princeton University)

8. Albert M. Friend, Jr., 1920s
(photo: Department of Art and
Archaeology, Princeton University)

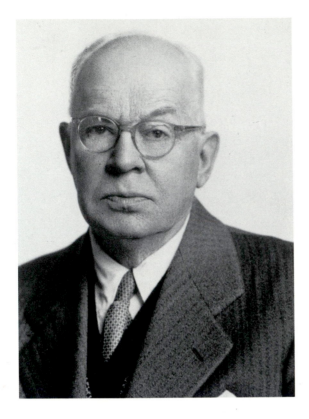

9. Charles Rufus Morey (photo: Princeton University Libraries)

10. George Rowley, 1920s (photo: Princeton University Libraries)

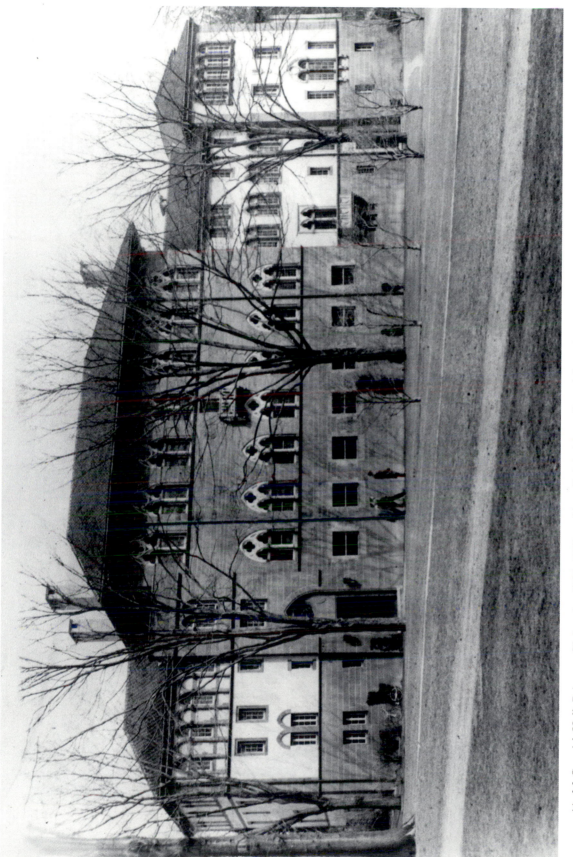

11. McCormick Hall, Princeton University, 1921–1923, architect Ralph Adams Cram (photo: Department of Art and Archaeology, Princeton University)

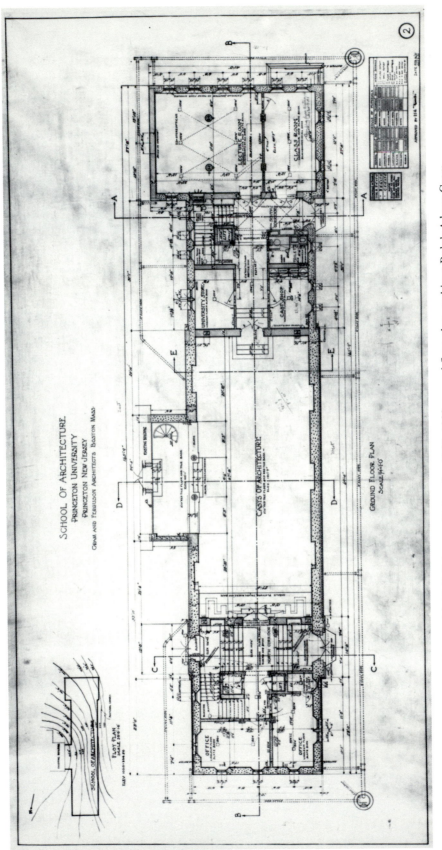

12. McCormick Hall, Princeton University, 1921–1923, ground floor plan, architect Ralph Adams Cram

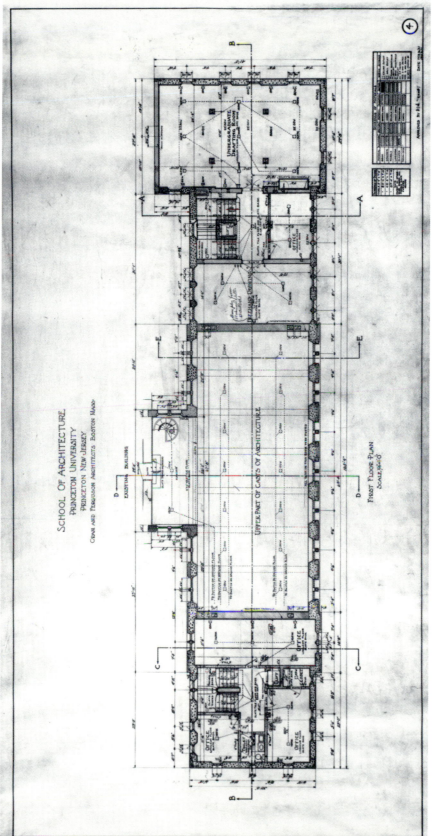

13. McCormick Hall, Princeton University, 1921–1923, first floor plan, architect Ralph Adams Cram

14. Installation of fragments from the Temple of Artemis at Sardis in the Metropolitan Museum of Art, New York (photo: Metropolitan Museum of Art)

15. Presbyterian Church, Croton Falls, New York, 1899, architect Howard Crosby Butler

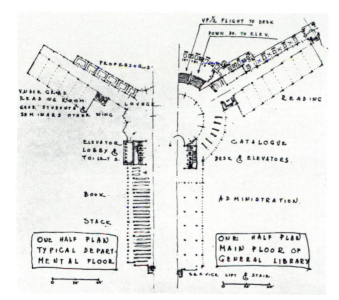 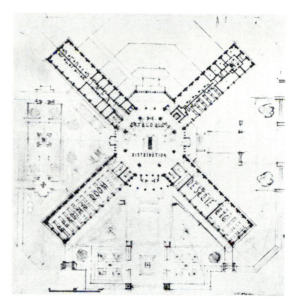

16. M.F.A. project for a "humanistic library," Carter Hewitt, Princeton University School of Architecture, 1931 (after *Bulletin of the Department of Art and Archaeology of Princeton University* [June 1931], 6)

17. M.F.A. project for a "humanistic library," Charles K. Agle, Princeton University School of Architecture, 1931 (after *Bulletin of the Department of Art and Archaeology of Princeton University* [June 1931], 10)

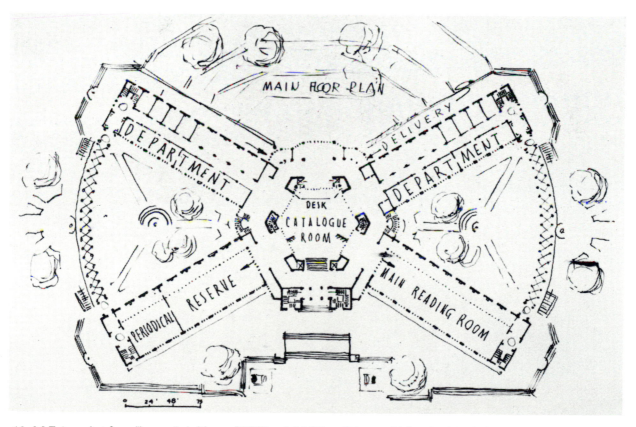

18. M.F.A. project for a "humanistic library," William McMillan, Princeton University School of Architecture, 1931 (after *Bulletin of the Department of Art and Archaeology of Princeton University* [June 1931], 14)

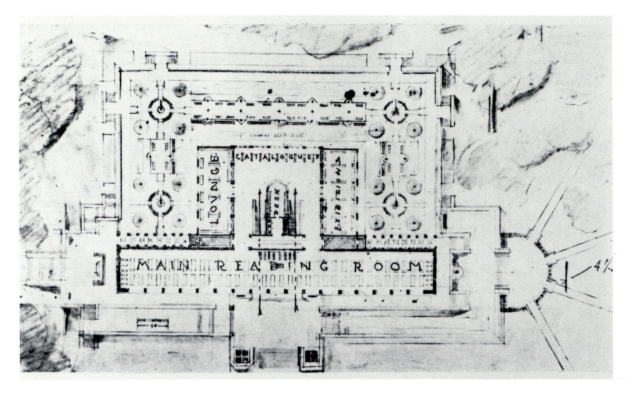

19. M.F.A. project for a "humanistic library," George O'Bryan Bailey, Princeton University School of Architecture, 1931 (after *Bulletin of the Department of Art and Archaeology of Princeton University* [June 1931], 16)

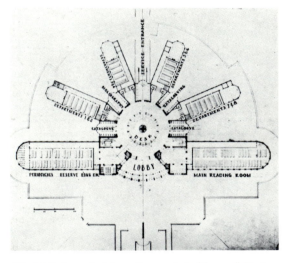

20. M.F.A. project for a "humanistic library," R. A. Ruge, Princeton University School of Architecture, 1931 (after *Bulletin of the Department of Art and Archaeology of Princeton University* [June 1931], 18)

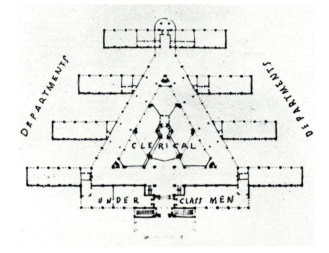

21. M.F.A. project for a "humanistic library," Vernon Kenneth Mangold, Princeton University School of Architecture, 1931 (after *Bulletin of the Department of Art and Archaeology of Princeton University* [June 1931], 20)

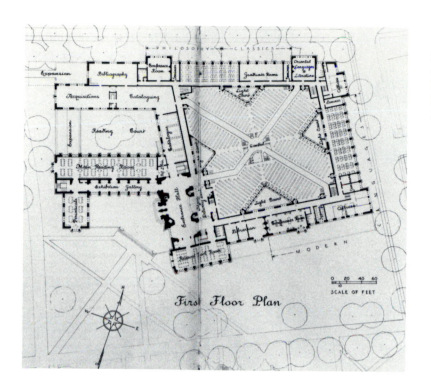

22. First floor plan for library and departmental offices, Princeton University, architect Charles Z. Klauder (after *The New Princeton Library*, Princeton [1935], 12–13)

23. Plan and elevation for library and departmental offices, Princeton University, architect Charles Z. Klauder (after *The New Princeton Library*, Princeton [1935], 20–21)

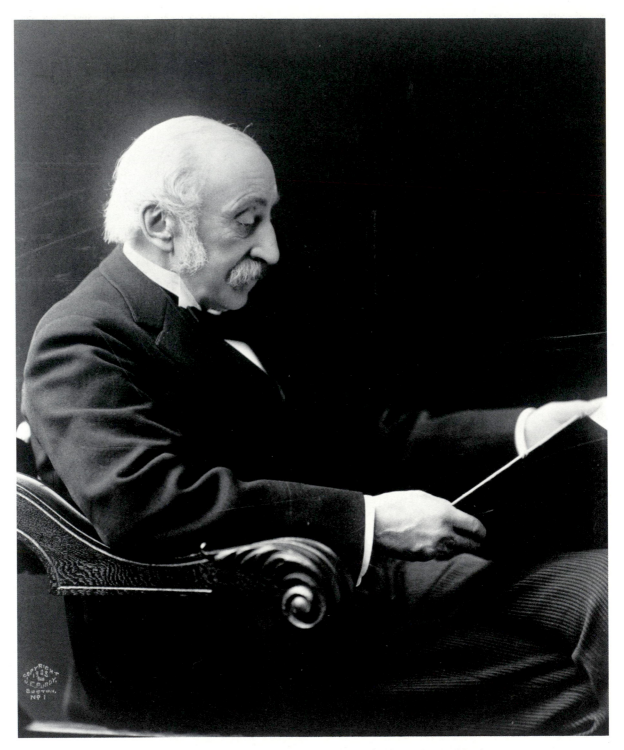

24. Charles Eliot Norton, 1903 (photo: Harvard University Archives)

25. Charles Eliot Norton at Shady Hill, Cambridge, Massachusetts (photo: Fogg Art Museum, Harvard University Art Museums)

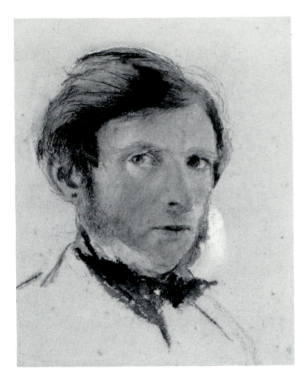

26. John Ruskin, self-portrait, 1861. The
Pierpont Morgan Library, New York, 1959.22
(photo: Pierpont Morgan Library)

27. Denman W. Ross, portrait by
Durr Freedley. Fogg Art Museum
(photo: Fogg Art Museum, Harvard
University Art Museums)

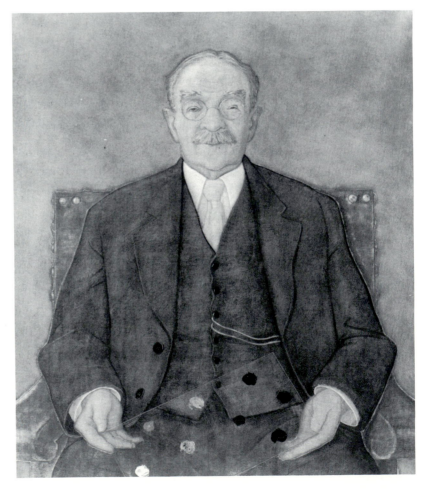

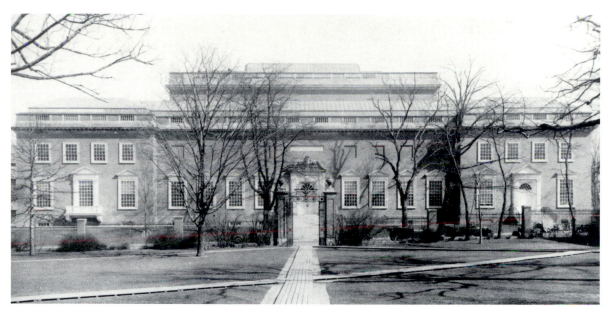

28. Fogg Art Museum, Harvard University, ca. 1927 (photo: Harvard University Archives)

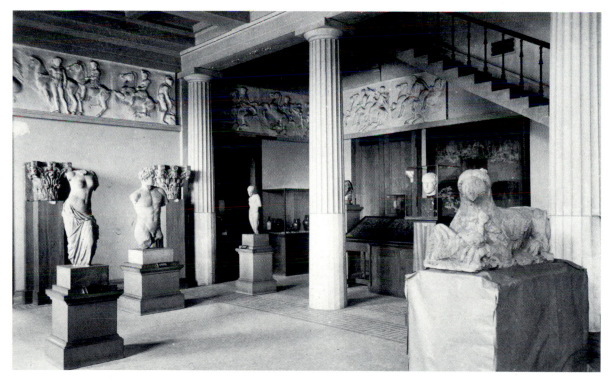

29. Old Fogg Museum, Harvard University, sculpture gallery (photo: Fogg Art Museum, Harvard University Art Museums)

30. Fogg Art Museum, Harvard University, gallery XIV, French exhibition, March 1929
(photo: Fogg Art Museum, Harvard University Art Museums)

31. Old Fogg Museum, Harvard University, Edward Forbes's office (photo: Fogg Art Museum,
Harvard University Art Museums)

32. "Egg and plaster course," Fogg Art Museum, Harvard University, ca. 1932. From left: James S. Plaut, Perry Townsend Rathbone, Henry McIlhenny, Katrina van Hook, Elizabeth Dow, Charles C. Cunningham, Edward W. Forbes, Mr. Depinna, and John Murray (photo: Fogg Art Museum, Harvard University Art Museums)

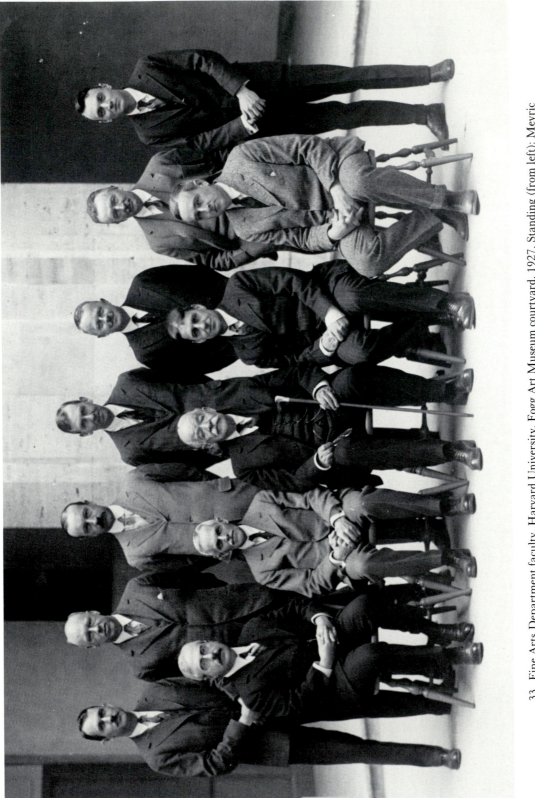

33. Fine Arts Department faculty, Harvard University, Fogg Art Museum courtyard, 1927. Standing (from left): Meyric R. Rogers, Langdon Warner, George H. Edgell, Arthur Kingsley Porter, Chandler R. Post, Martin Mower, Kenneth Conant; seated (from left): Paul J. Sachs, George H. Chase, Denman Ross, Edward W. Forbes, Arthur Pope (photo: Harvard University Archives)

34. Arthur Kingsley Porter, ca. 1904
(after *Twenty-Fifth Anniversary Record
of the Class of 1904, Yale College*, ed. H.
Stebbins, Jr., Brattleboro, Vermont [1930])

35. Arthur Kingsley Porter (after *Medieval Studies in
Memory of A. Kingsley Porter*, ed. W. Koehler,
Cambridge, Mass. [1939], vol. I, frontispiece)

36. Wilhelm Koehler (photo: Harvard University Archives)

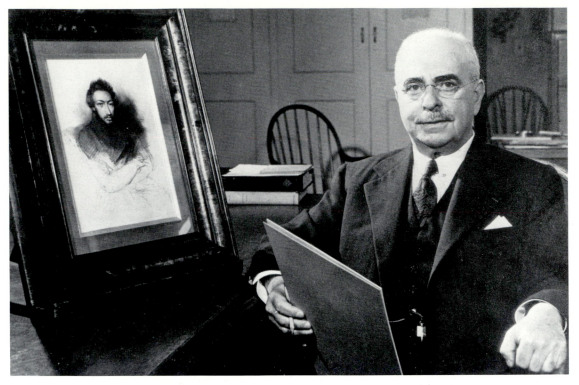

37. Paul Sachs with Degas's self-portrait (photo: Harvard University Archives)

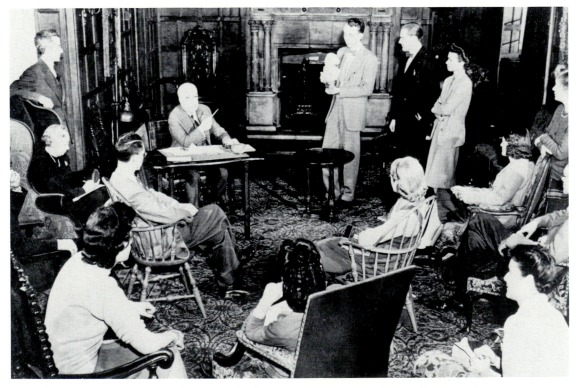

38. Paul Sachs with students in the Naumburg Room, final class, 1943 or 1944
(photo: Fogg Art Museum, Harvard University Art Museums)

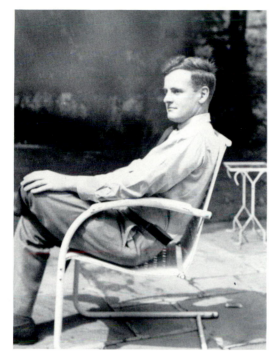

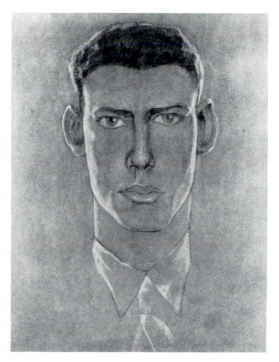

39. John Coolidge (courtesy C. H. Smyth)

40. Lincoln Kirstein, self-portrait, ca. 1932
(photo: Jerry L. Thompson)

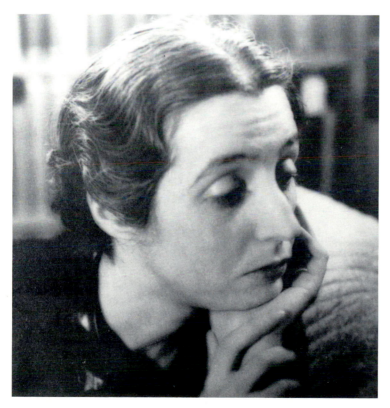

41. Agnes Mongan, 1929 (photo: Fogg Art Museum, Harvard University Art Museums)

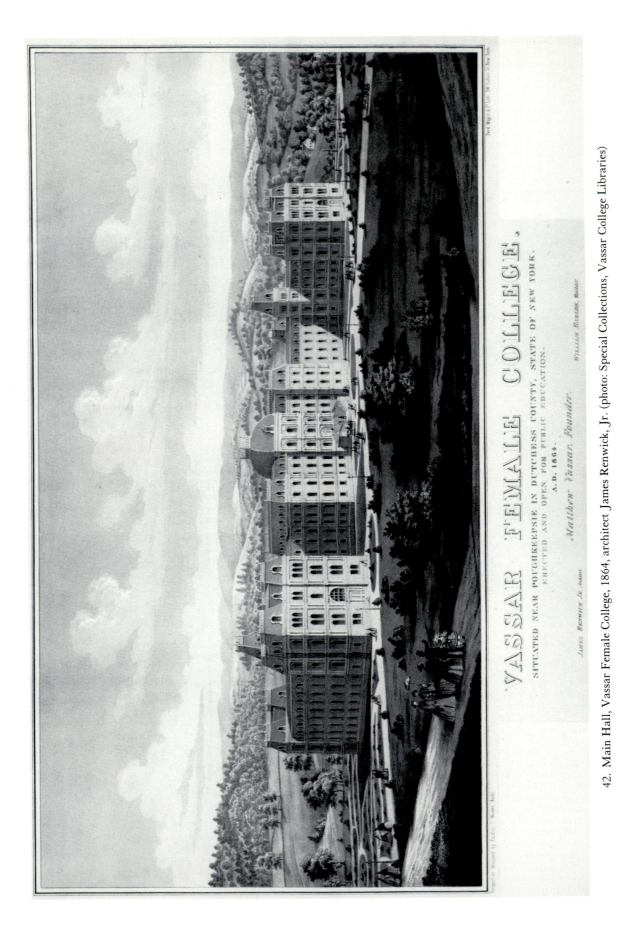

42. Main Hall, Vassar Female College, 1864, architect James Renwick, Jr. (photo: Special Collections, Vassar College Libraries)

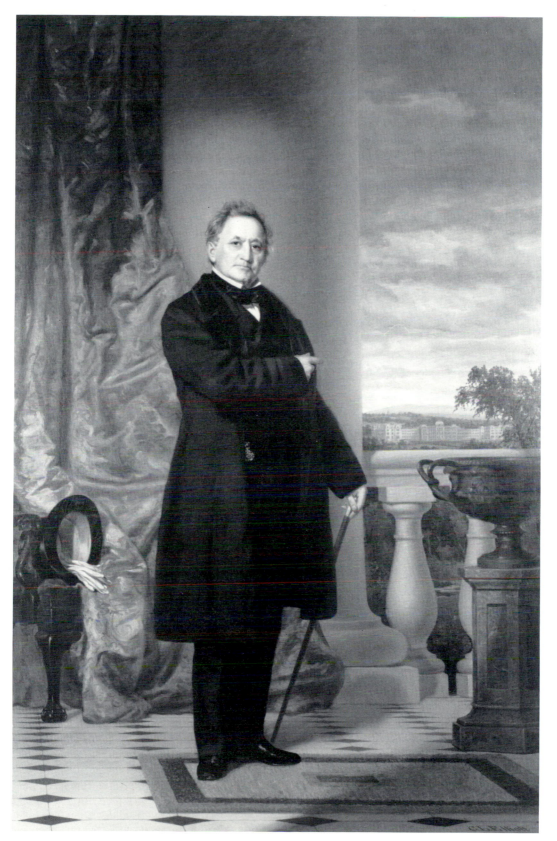

43. Matthew Vassar, portrait by Charles Loring Elliott, 1861. Vassar College Art Gallery
(photo: Vassar College Art Gallery)

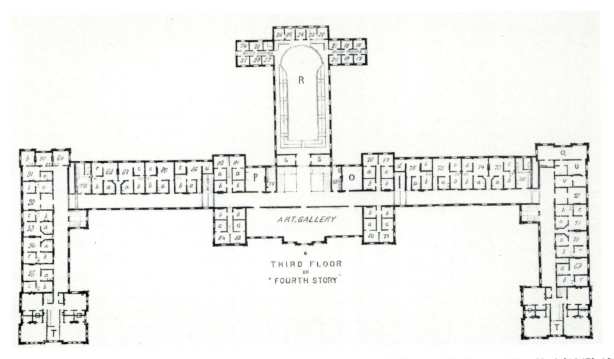

44. Main Hall, Vassar College, plan of fourth story (after B. J. Lossing, *Vassar College and Its Founder*, New York [1867], 130)

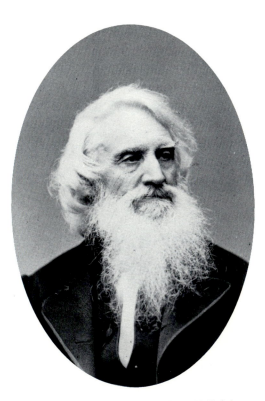

45. Samuel F. B. Morse, ca. 1861–1865 (photo: Special Collections, Vassar College Libraries)

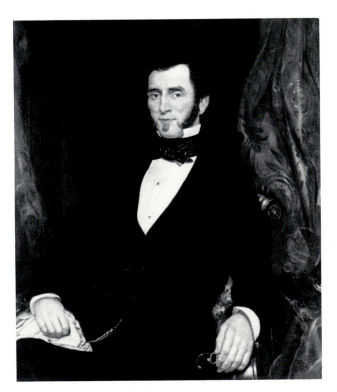

46. Elias L. Magoon, portrait by Samuel F. B. Morse, 1853. Vassar College Art Gallery (photo: Vassar College Art Gallery)

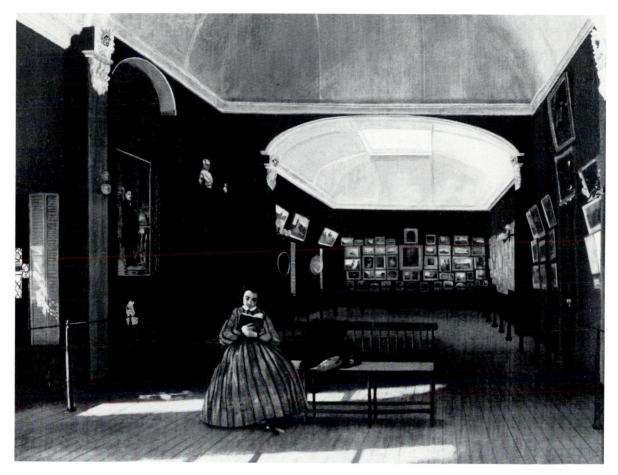

47. Art gallery, Main Hall, Vassar College, ca. 1870. Vassar College Art Gallery
(photo: Vassar College Art Gallery)

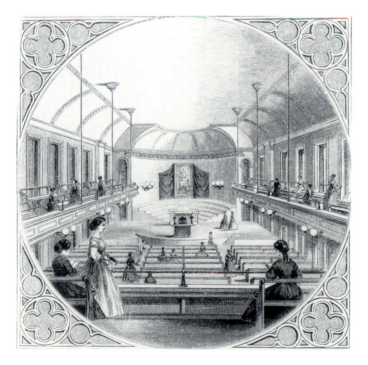

48. Chapel, Main Hall, Vassar College
(after B. J. Lossing, *Vassar College and Its Founder*,
New York [1867], 126)

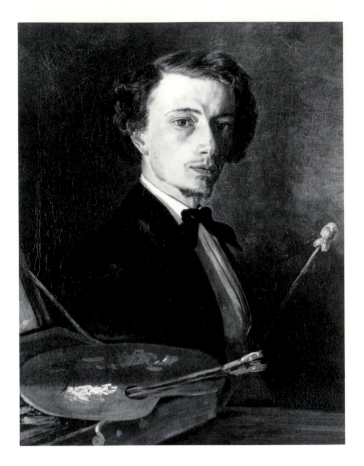

49. Henry Van Ingen, self-portrait, ca. 1865.
Vassar College Art Gallery (photo: Vassar College
Art Gallery)

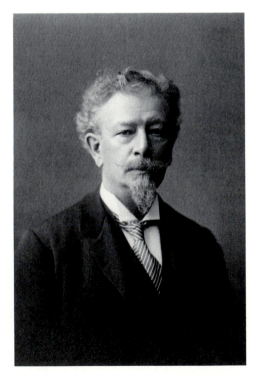

50. Henry Van Ingen, ca. 1896
(photo: Special Collections, Vassar
College Libraries)

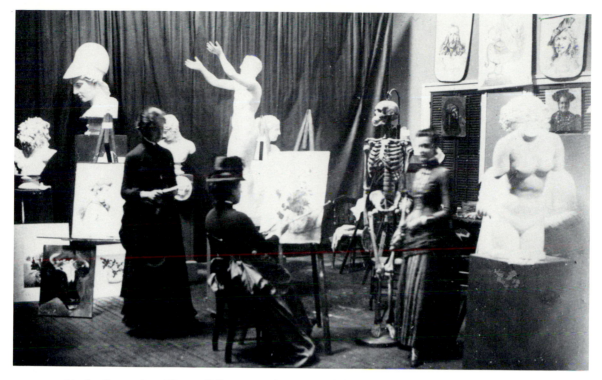

51. Studio art class, Vassar College, 1887 (photo: Special Collections, Vassar College Libraries)

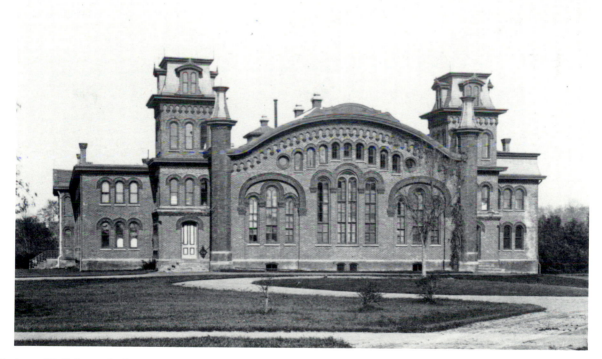

52. Avery Hall, formerly the museum, Vassar College, ca. 1890–1894 (photo: Special Collections, Vassar College Libraries)

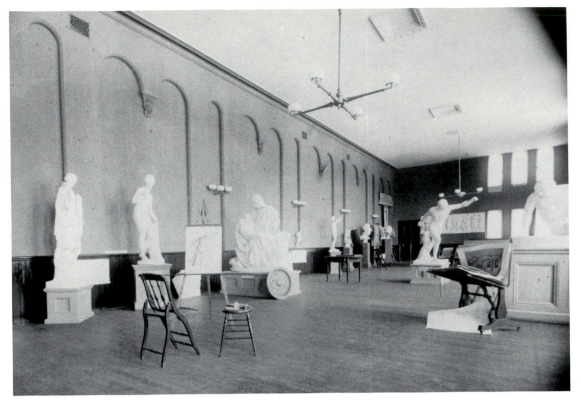

53. Hall of casts, Avery Hall, Vassar College, 1889 (photo: Special Collections, Vassar College Libraries)

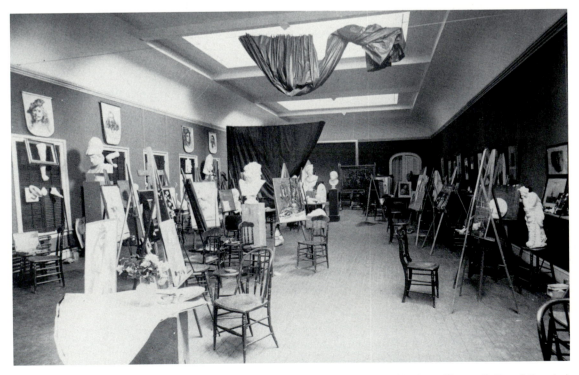

54. Art studio, Avery Hall, Vassar College, ca. 1881–1888 (photo: Special Collections, Vassar College Libraries)

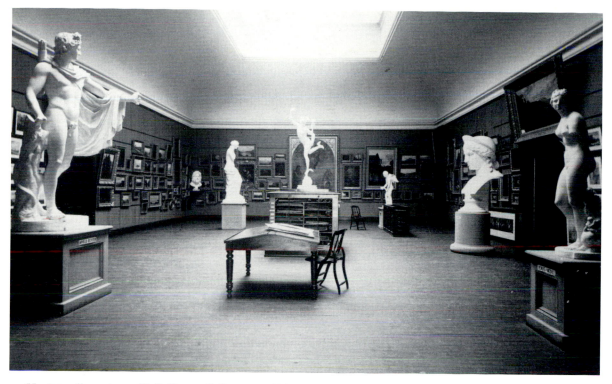

55. Art gallery, Avery Hall, Vassar College, ca. 1902–1914 (photo: Special Collections, Vassar College Libraries)

56. Lewis Frederick Pilcher, ca. 1900–1911 (photo: Special Collections, Vassar College Libraries)

57. Oliver Tonks, ca. 1932 (photo: Special Collections, Vassar College Libraries)

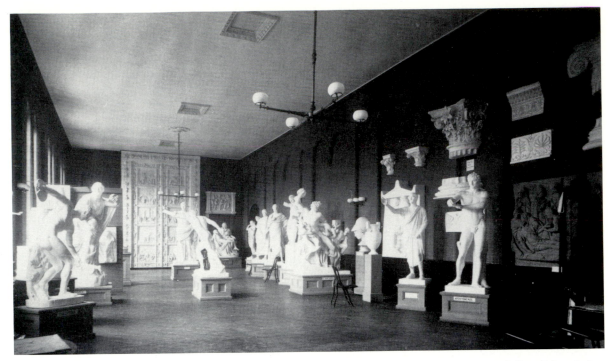

58. Hall of casts, Avery Hall, Vassar College, ca. 1890–1894 (photo: Special Collections, Vassar College Libraries)

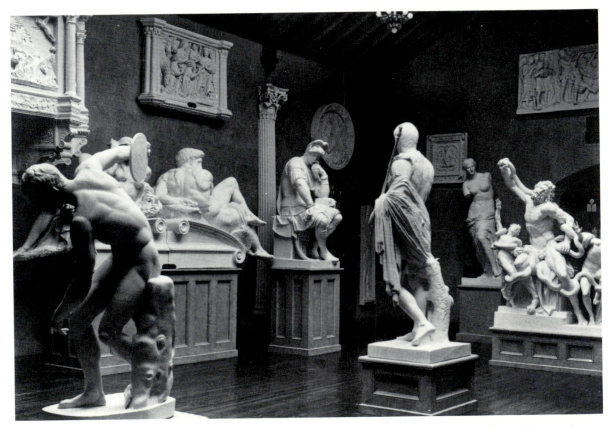

59. Art gallery, Taylor Hall, Vassar College, ca. 1915 (photo: Special Collections, Vassar College Libraries)

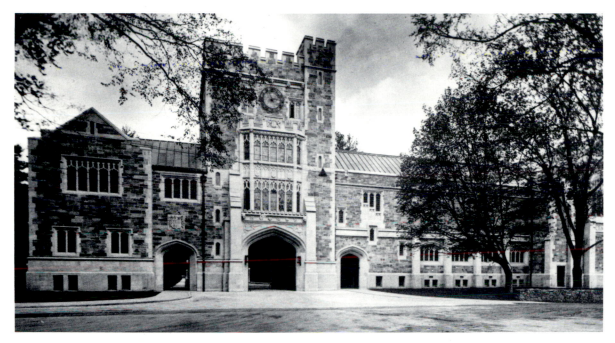

60. Taylor Hall, street facade, Vassar College, ca. 1915 (photo: Special Collections, Vassar College Libraries)

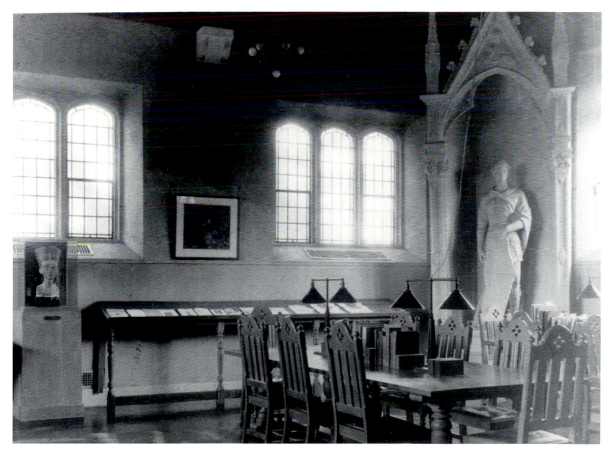

61. Interior of Taylor Hall, Vassar College, ca. 1915 (photo: Special Collections, Vassar College Libraries)

62. Interior of Taylor Hall, Vassar College, ca. 1915
(photo: Special Collections, Vassar College Libraries)

63. Art gallery, Taylor Hall, Vassar College, ca. 1915–1938 (photo: Special Collections, Vassar College Libraries)

64. Agnes Rindge Claflin, 1939;
photograph by George Platt Lynes
(courtesy Pamela Askew)

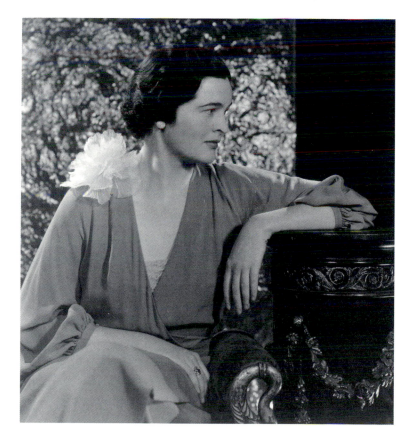

65. Leila Cook Barber, ca. 1935;
photograph by George Platt Lynes
(courtesy Pamela Askew)

66. L. Clark Seelye, 1910
(photo: Smith College Archives)

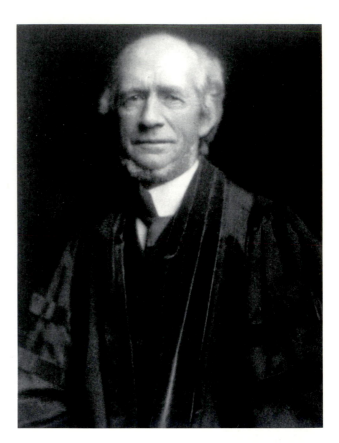

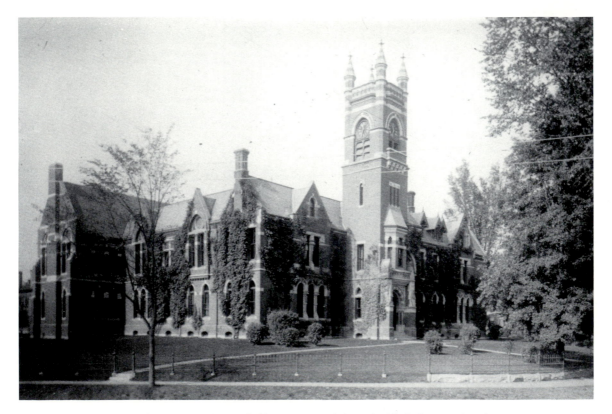

67. College Hall, Smith College, ca. 1900 (photo: Smith College Archives)

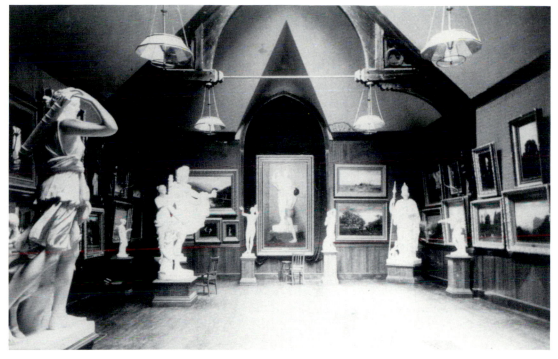

68. First museum, College Hall, Smith College, 1880 (photo: Smith College Archives)

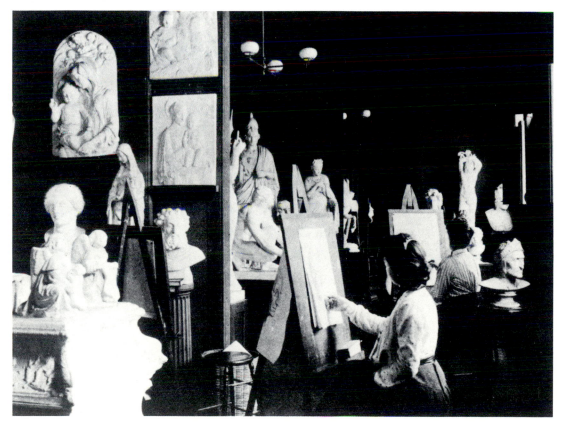

69. Students drawing from casts, Hillyer Gallery, Smith College, 1904 (photo: Smith College Archives)

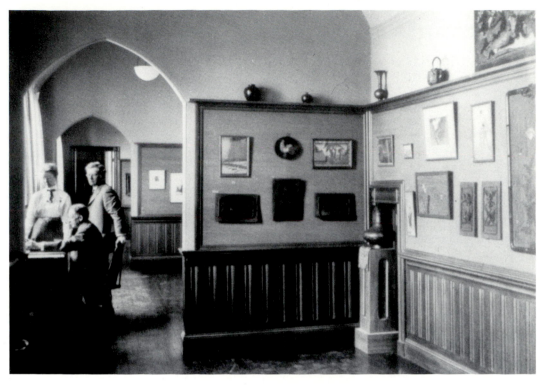

70. Dwight W. Tryon, Alfred Vance Churchill, and Beulah Strong in Hillyer Gallery, Smith College, 1912 (photo: Smith College Archives)

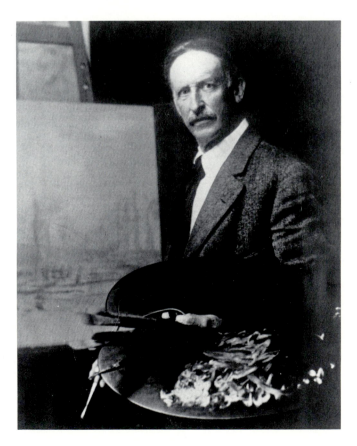

71. Dwight W. Tryon, ca. 1920
(photo: Smith College Archives)

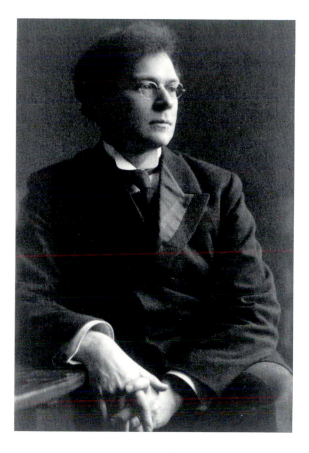

72. Alfred Vance Churchill, ca. 1910
(photo: Smith College Archives)

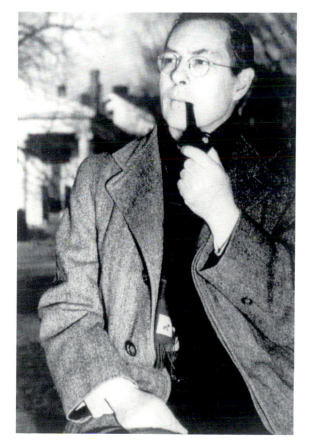

73. Oliver W. Larkin, ca. 1955
(photo: Smith College Archives)

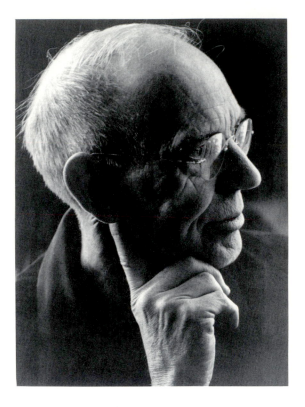

74. Clarence Kennedy; photograph by Ansel Adams (copyright © 1993 by the Trustees of the Ansel Adams Publishing Rights Trust, All Rights Reserved)

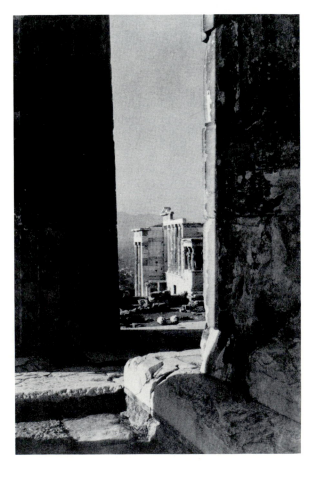

75. The Erechtheum seen from the Parthenon, Athens; photograph by Clarence Kennedy (courtesy P. W. Lehmann)

76. Delphi Charioteer, detail; photograph by Clarence Kennedy (courtesy P. W. Lehmann)

77. Rossellino, *Tomb of the Cardinal of Portugal*, S. Miniato, Florence, detail; photograph by
Clarence Kennedy (courtesy P. W. Lehmann)

78. Francesco Laurana, *Ippolita Maria Sforza d'Aragona, Duchess of Calabria*, Staatliche Museen, Berlin; photograph by Clarence Kennedy (courtesy P. W. Lehmann)

79. Ruth Wedgwood Kennedy; photograph by Ansel Adams (copyright © 1993 by the Trustees of the Ansel Adams Publishing Rights Trust, All Rights Reserved)

80. Art gallery, Yale University, Chapel Street, corner view
(photo: Department of the History of Art, Yale University)

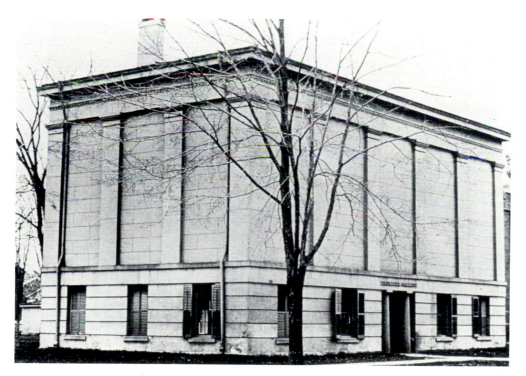

81. Trumbull Art Gallery, Yale University, 1831, architects John Trumbull and Ithiel Town
(photo: Department of the History of Art, Yale University)

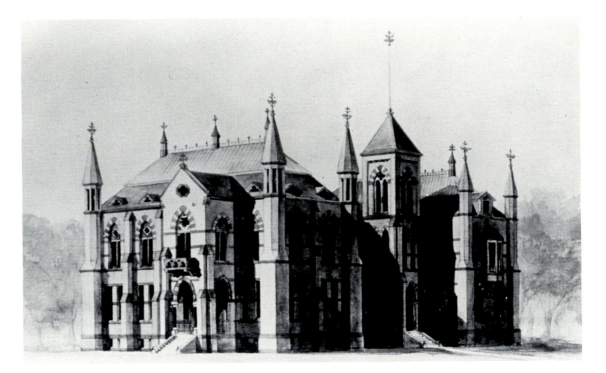

82. Street Hall, Yale University, 1863–1864, proposed view from southeast, watercolor, architect P. B. Wright (photo: Department of the History of Art, Yale University)

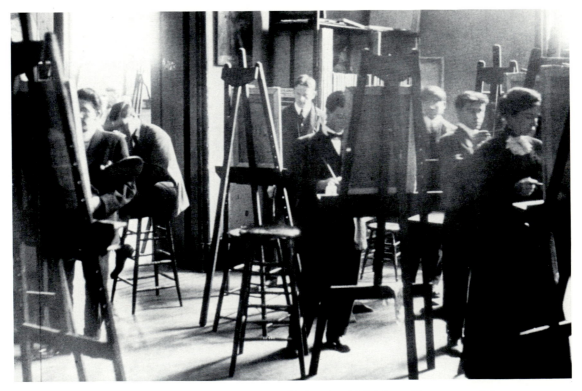

83. Art School students, Street Hall, Yale University, 1918 (photo: Department of the History of Art, Yale University)

84. Henri Focillon (photo: Department of the History of Art, Yale University)

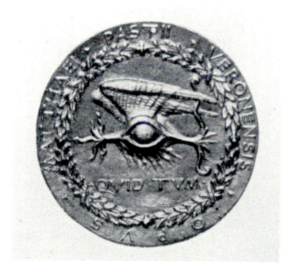

85. Portrait medal of Leone Battista Alberti, ca. 1438, verso. Yale University Art Gallery (photo: Department of the History of Art, Yale University)

86. Directional design by Joseph Albers for the Graduate Program in the History of Art at Yale University, 1960

87. Theodore Sizer, self-portrait with his wife, Christmas card, 1947 (photo: Department of the History of Art, Yale University)

88. John Ferguson Weir, 1913, portrait by J. W. Alexander. Yale University Art Gallery (photo: Department of the History of Art, Yale University)

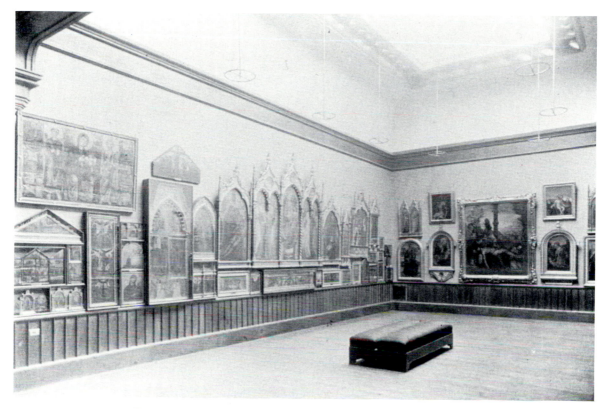

89. Exhibition hall, Street Hall, Yale University, 1911, architect Peter Wight
(photo: Department of the History of Art, Yale University)

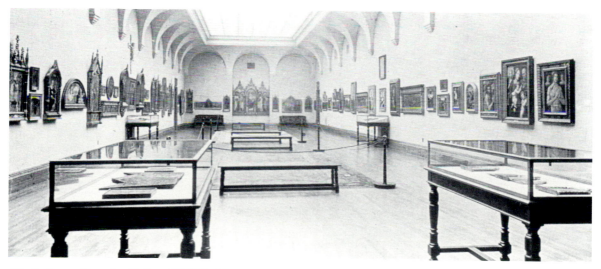

90. Italian gallery, Art Gallery III, Yale University, 1929 (photo: Department of the History of Art, Yale University)

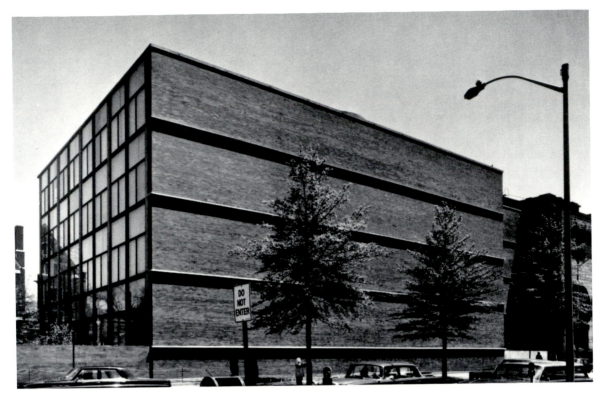

91. Art Gallery IV, Yale University, 1953, Chapel Street side, architect Louis Kahn
(photo: Department of the History of Art, Yale University)

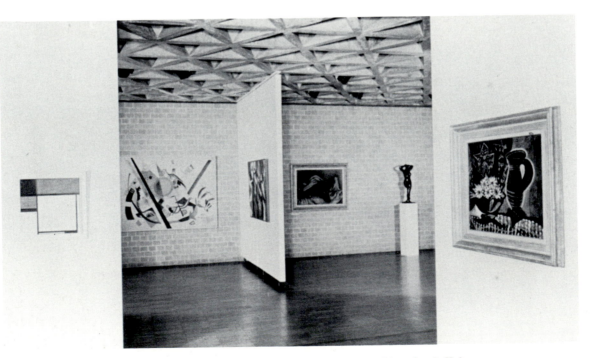

92. Art Gallery IV, Yale University, 1953, interior, architect Louis Kahn
(photo: Department of the History of Art, Yale University)

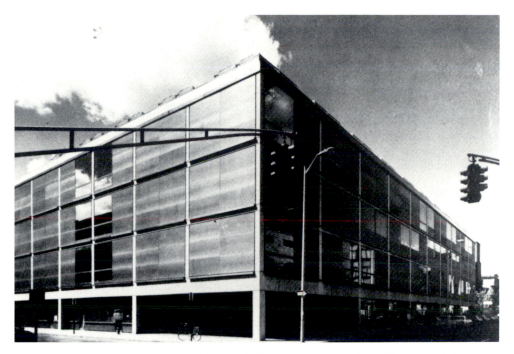

93. Art and Architecture Building, Yale University, 1961, architect Paul Rudolph
(photo: Department of the History of Art, Yale University)

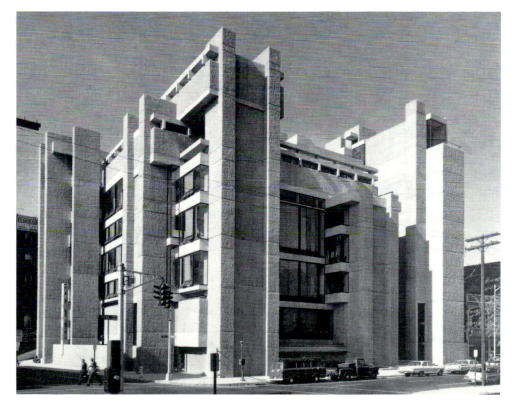

94. British Art Center, Yale University, 1977, architect Louis Kahn
(photo: Department of the History of Art, Yale University)

95. Erwin Panofsky, 1950s
(courtesy Gerda Panofsky)

96. Walter W. S. Cook
(courtesy C. H. Smyth)

97. Richard Offner (after *A Legacy of Attributions*, ed. H. B. J. Maginnis, Locust Valley, New York [1981], frontispiece)

98. Meyer Schapiro, 1957
(photo: Columbia University,
Columbiana Collection)

99. Millard Meiss (courtesy
Mrs. Margaret Meiss)

100. William Bell Dinsmoor (photo: Columbia
University, Columbiana Collection)

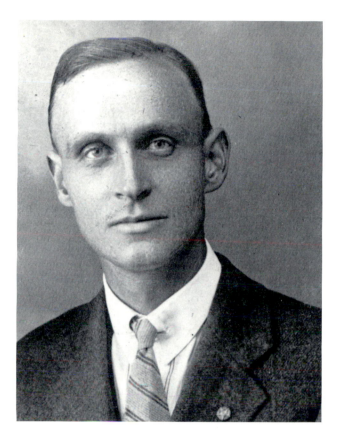

101. Emerson Swift, 1926 (photo: Columbia University, Columbiana Collection)

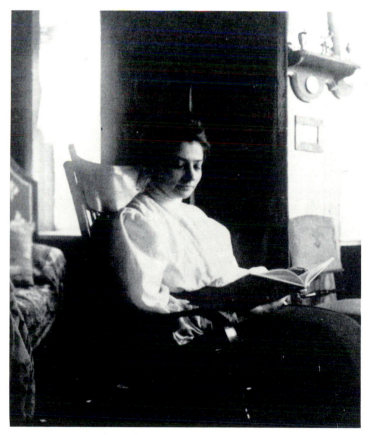

102. Margarete Bieber (after *Women as Interpreters of the Visual Arts, 1820–1979*, ed. C. R. Sherman, Westport, Conn. [1981], fig. 14)

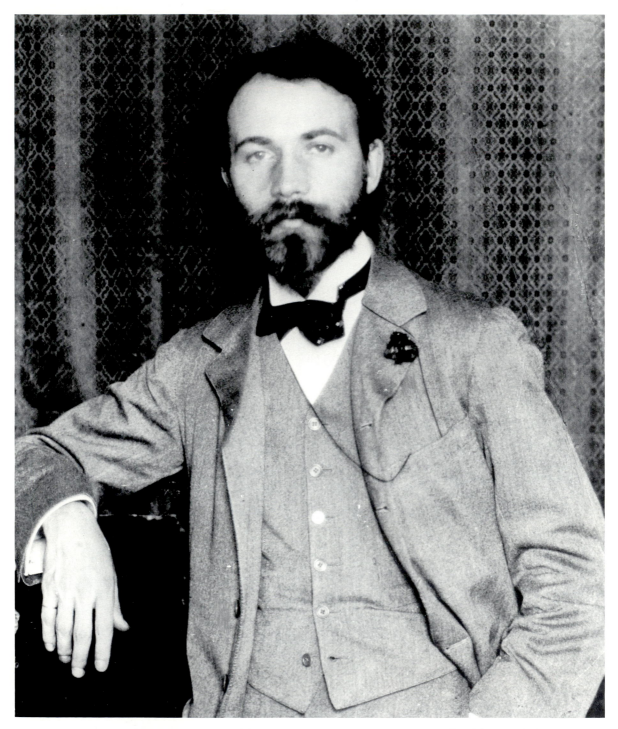

103. Bernard Berenson, ca. 1900 (photo: Berenson Archive, Florence. Reproduced by permission of the President and Fellows of Harvard University)

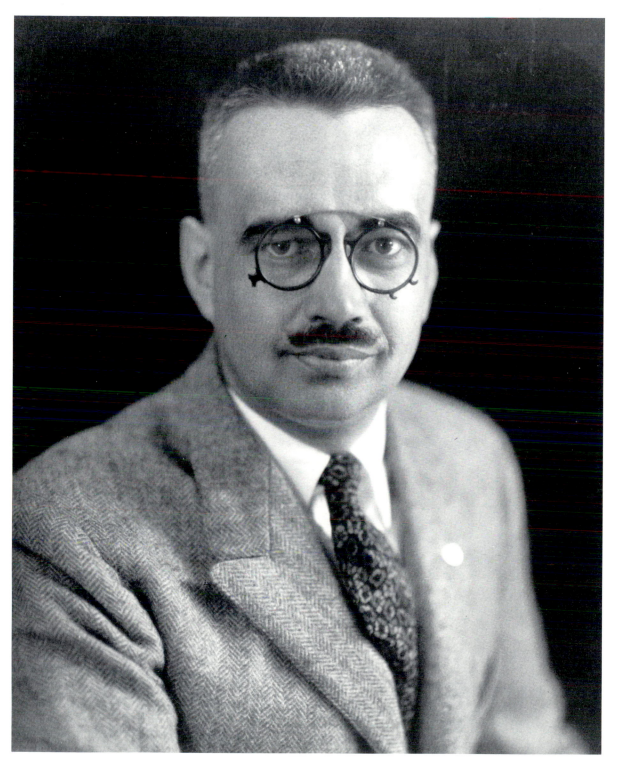

104. Sidney Fiske Kimball, ca. 1925 (photo: Philadelphia Museum of Art Archives)

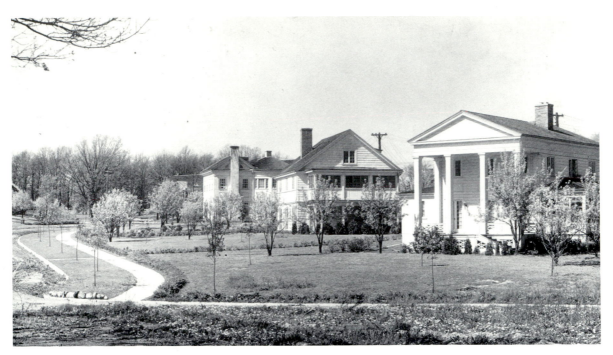

105. "Scottwood," Ann Arbor, Michigan, 1914–1916, view looking north, architect Fiske Kimball
(photo: Philadelphia Museum of Art Archives)

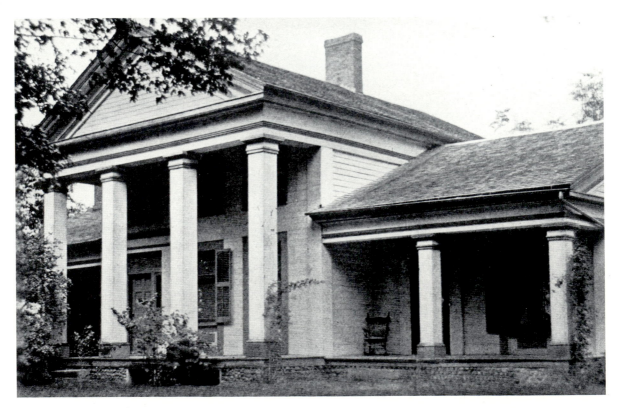

106. Sidney Smith residence, Grass Lake, Michigan, 1840; photograph by Fiske Kimball
(photo: Philadelphia Museum of Art Archives)

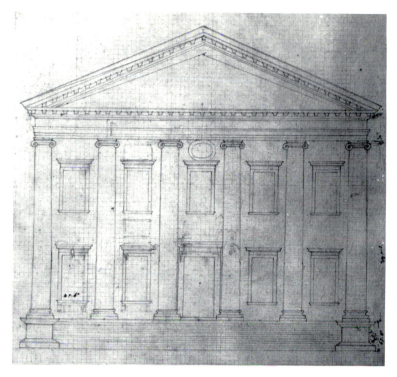

107. Thomas Jefferson's study for front elevation of Virginia Capitol, Richmond, Virginia, 1785–1789 (courtesy Coolidge Collection, Massachusetts Historical Society)

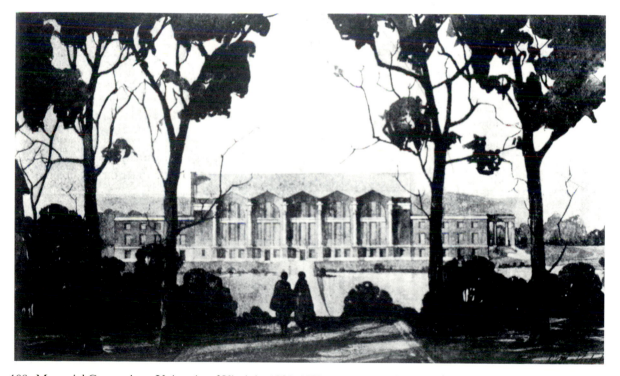

108. Memorial Gymnasium, University of Virginia, 1921–1923, presentation drawing of east elevation by S. J. Makielski; architects John Kevan Peebles, Walter D. Blair, W. A. Lambeth, R. E. Lee Taylor, Fiske Kimball; supervising architect Fiske Kimball (after *University of Virginia Alumni News* x, no. 5 [November 1921]).

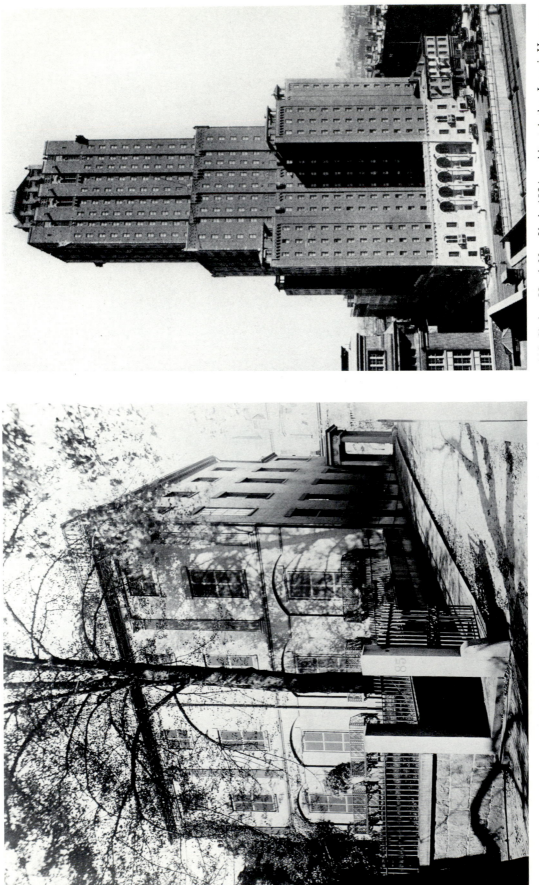

110. Shelton Hotel, New York, 1924, architect Arthur Loomis Harmon; view published in Fiske Kimball, *American Architecture*, New York (1928)

109. Harrison Otis Gray residence, Boston, 1800–1801, architect Charles Bulfinch; view published in Fiske Kimball, *Domestic Architecture of the American Colonies and the Early Republic*, New York (1922) (photo: Society for the Preservation of New England Antiquities)

112. Art gallery, College Hall, Wellesley College (photo: Wellesley College Archives)

111. M. Carey Thomas, middle years (photo: Bryn Mawr College Archives)

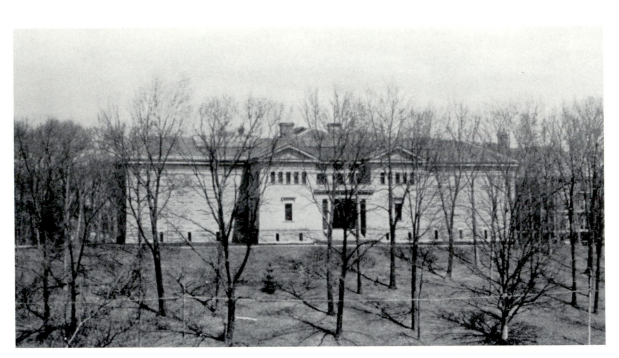

113. Farnsworth Art Building, Wellesley College (photo: Wellesley College Archives)

114. Alice van Vechten Brown,
from the 1911 Wellesley *Legenda*
(photo: Wellesley College Archives)

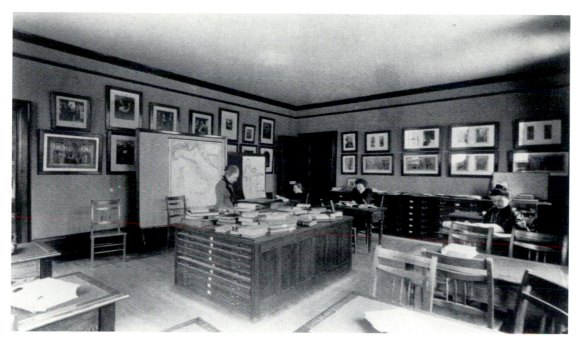

115. College Hall, Wellesley College, History of Art Laboratory I, Art Library, College Hall classrooms, ca. 1893 (photo: Wellesley College Archives)

116. Seminar Room, Taylor Hall, Bryn Mawr College, 1908 (photo: Bryn Mawr College Archives)

117. Joseph Clark Hoppin, from the 1901 Year Book,
Bryn Mawr College (photo: Bryn Mawr College Archives)

118. Caroline Louise Ransom, ca. 1905
(photo: Bryn Mawr College Archives)

119. Mary Hamilton Swindler
(photo: Bryn Mawr College Archives)

120. Myrtilla Avery, portrait on ivory by Artemis Tavshanjian, 1938.
Wellesley College Museum (photo: Wellesley College Museum)

121. George Fisk Comfort seated in front of paintings in the Syracuse University Art Museum
(photo: Syracuse University Libraries)

122. Eliza Allen Starr teaching in her Chicago auditorium (photo: Sophia Smith Collection, Smith College)